ONE-TO-ONE

THE VISUAL CULTURE
OF INTERNATIONAL TICKETS

COLLECTED BY

TANJA BACKE

ACTAR
A

PLEASE SAVE
YOUR RECEIPT.

ONE TO-ONE presents a worldwide collection of more than 1,500 tickets of all kinds from the past 22 years: airplane, train, ferry, bus, metro, cloakroom and parking tickets, bank and taxi receipts, check labels, tickets for museums, theatres, cinemas, circuses, operas, zoos, concerts, ballets and snake shows. The collection documents a whole spectrum of events and cultural sights. Non-chronological and non-linear, the book can be read in the reader's own logical sequence. The collection consists of original tickets in their original size, one-to-one, non-scaled and organized in colour groups. The designer Tanja Backe guides us through a wealth of typefaces in a variety of languages, formats, shapes, graphic styles, background patterns, illustrations, graphic elements and identities. It is fascinating to compare the qualities of the different graphic treatments used to set out the maximum amount of essential information on a necessarily small ticket, and the different ways of invalidating the ticket: stamping, cutting, clipping, punching and so on, either by hand or with some special machine.

excursion tickets / extra tickets / flight tickets / free tickets / documentation / high-speed ferry tickets / cards with implemented chips / reservation forms / mini bar charge voucher / dry cleaning ticket / voucher / security-relevant documents / security check baggage tickets / train tickets / ferry tickets / payback cards / exchange certificates / reservation cards / ski passes / vouchers / tickets / lottery tickets / adhesive labels / order tickets / parking tickets / labels / accompanying ticket / passports / air tickets / annual tickets / borrower's tickets / single tickets / tram tickets / bus tickets / 4-trip tickets / taxi receipts / ferry tickets / postage labels / cloakroom tickets / bankcards / VIP cards / passenger coupons / encoded labels / cinema tickets / access control / adhesive labels / multiple trip tickets / trade fair travel tickets / permits / menu cards / quality control references / express cards / cabin baggage tickets / 24-hour ticket / priority checked baggage tickets / visitor's tickets / passenger receipts / long-term tickets in public transportation / cards with magnetic strips / boat tickets / family cards / sales receipts / parcel slips / label with self-adhesive clips / plastic cards / radio frequency ID cards / event tickets / metro tickets / one-day tickets / receipts / tag / airport tickets / concert ticket / zoo tickets / admission tickets for museums / theatres / cinemas / castles / circuses / operas / monuments / cultural sites / zoos / jazz clubs / concerts / palaces / art fairs / ballet and snake shows / taxi receipts / customer advices / hotel voucher / rental tickets / departure cards / party ticket / security tickets / exhibition tickets / first class tickets / tennis championship tickets / stand-by tickets / club cards / departure tickets / registration papers / certificates / season tickets / monthly tickets / one-way tickets / chips / supplementary tickets / room passes / coins / luggage tags / foreign currency exchange memos / university enrolment receipts / article tags / tokens / zone ticket / order forms / plastic cards / self-adhesive strips / invoices / baggage deposit receipts / queuing tickets / strip tickets / highway certificates / return tickets / rover tickets / sales tickets / season tickets / customs declarations / tickets with identification numbers / transfer fare receipts / participant's cards / special day tickets / transaction receipts / railway tickets / shipping voucher / packing slip / transponder tags / route cards / press cards / pawn tickets / registration numbers / plane tickets / platform tickets / thermo transfer tags / raffle tickets / permanent ticket/ travel passes / guest voucher / baggage identification tags / boarding cards / playing protocol / entrance permits / meal coupons / numeration tickets / museum tickets /

shuttle bus tickets / magnetic strips / charge notes / key cards / vehicle
passes / guest tickets / student tickets / free cards / quality assurance
control tickets / article passes / reclamation tags / restaurant receipts /
long-term tickets / beer tokens / booking tickets / info tickets / commutation
tickets / complimentary tickets / correspondence tickets / discount tickets /
group tickets / individual tickets / tickets with a thermoresistant surface /
job tickets / library tickets / time tickets / integrated cards / butterfly
cards / single tickets / coupons / token forms / member ID cards / customer
cards / petrol station receipts / receipts for toll payments / contributor
cards / bar-coded forms /

to buy a ticket / to punch / to punch one's ticket / to tear up / to crumple up /
to wrap chewing gum in it / to drop something unnoticed / to validate one's
ticket / to keep / to stick a memo note / to cancel one's ticket / to tear off /
to stamp one's ticket / to validate / to tear / to stamp / to retain /
to crumple up / to roll something into a tube in one's trouser pocket while
waiting in the queue / to ticket / to add to one's tax file / to use again /
to redeem / to lose / perforate / to forget / to lose in one's handbag /
to write up notes / bookmark / to take with the jacket to the dry cleaner's /
to throw away / to leave behind / to recycle / to push in / to can / to stick on /

ticket canceller / ticket collector / ticket puncher / computer / printer /
scissors / stamps / hands / 2 index fingers und 2 thumbs / ticket inspector /
ticket machine / ticket office / ticket reader / ticket sale / ticket validator /
ticket window / ticket counter / ticket cancelling machine /

security marks / PIN number / sensitive strips / scratch-off-fields /
implantation of chips / perforations / natural and digital watermarks /
melier fibres / holograms as images / microtypes / ID-numbers / fluorescent
printing / guilloches / silver stripes / visible or invisible colour inks /
numbers / dynamic barcodes / CDPs / magnetic strips / radio frequency ID
technology / copy protection / forgery-proof / reference marks / visible and
invisible forgery prevention / inks with chemical reactions / personalisation /
barcodes / numbering / multifunctional materials / integrated manipulation
protections / invisible UV images / non-forgeable paper components /
autodestructible tickets / VOID technology / static barcodes / holograms
as strips / inks with mechanical reactions /

Vincent van Baar

The Boss of Russia

Hi there, you in the ticket booth! Are you happy? You should be. Your clients are the nicest people. They use public transport, they visit museums and go to the theatre. No. People selling tickets can be quite nasty, extremely reluctant to sell, whereas the ticket itself can be such a highly coveted piece of paper. The right ticket gives you the key to the most sensible things in life. A story to illustrate this. I will never forget the morning we planned to visit the Hermitage in what was then Leningrad. A well-scheduled arrival was half an hour before opening time (we had heard stories of endless queues). What we found was beyond our worst fears. A queue that stretched around a quarter of the Hermitage's footprint. How long had these people been gathering there? Two hours? Two days? I decided to see what was happening around the real moment of opening and discovered the doors were open already. I couldn't see much, though, except that there was no progress. Little did I know that the word 'progress' was only used in this country as a name for rockets. Progress 1, Progress 2... Then my companion discovered a small flock of people waiting outside an unattractive little door, which turned out to be the group entrance. We thought we'd give it a try and tagged on. The door opened, we went in and of course the ticket lady had no trouble picking out a couple of tall red- & fair-haired Caucasians from the group of small suntanned Peruvians. Niet, niet and more niet. Yet somehow I managed to convince her that queuing was no option and—y*e#s@—she did me the great favour of allowing me to go to the front ticket booth THROUGH the museum! As long as I left my girlfriend as surety.

How often does a mere mortal get the chance to run through the breathtaking splendour of the largest museum in the world when it's empty? The guards were only just arriving and seemed completely absorbed in stowing the day's assortment of plastic carrier bags beneath their chairs. After trotting half a kilometer in two minutes I arrived at what only can be described as the Battle of the Tickets. Visitors were shouting at each other and at the ladies inside the two (2) ticket booths. The 2 (two) ladies in the ticket booths were shouting back through their circle of tiny pinholes in the booth windows. Bags were swept above heads. War. Meanwhile, not a single ticket was being sold. I walked back, head down, here and there greeting a disturbed guard and the occasional astonished Peruvian. I told the lady at the group entrance what I had gone through, she looked at me, straight in my eyes—and let us in. 10.30 a.m. We had the museum to ourselves for almost two hours before the crowds started to get in.

Ticket-sellers are at the far end of the spectrum of power. Between them and the boss is the body of the organization, a hierarchy of at least eight layers. Every layer is important but don't underestimate the most important one of all. Their ticket-room-without-a view turns them sarcastic and—ultimately—drives them to play power games with their customers. At the moment when she made that decision, the lady who let us in was the boss of the Hermitage, the boss of Leningrad, the boss of all Russia. It was her day. Lucky us. (I can't remember if we actually bought tickets from her.)

REMEMBER. YOU MUST VALIDATE YOUR TICKET BEFORE ENTERING.

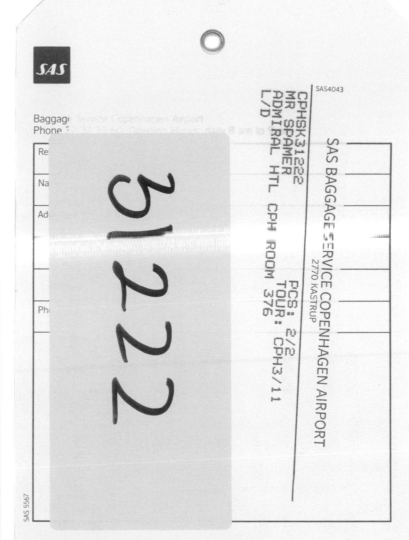

SAS4043

SAS BAGGAGE SERVICE COPENHAGEN AIRPORT
2770 KASTRUP

CPHSK31222
MR SPAMER
ADMIRAL HTL CPH ROOM 376
L/D

PCS: 2/2
TOUR: CPH3/11

31222

SAS 5567

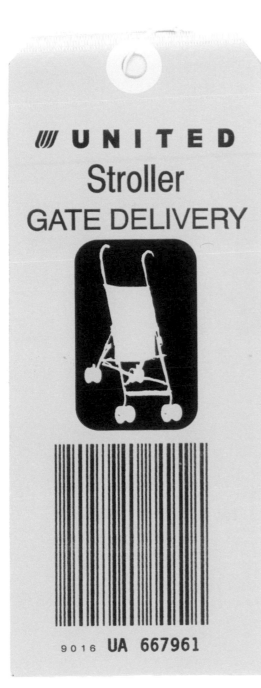

⍩⍩UNITED
Stroller
GATE DELIVERY

9016 UA 667961

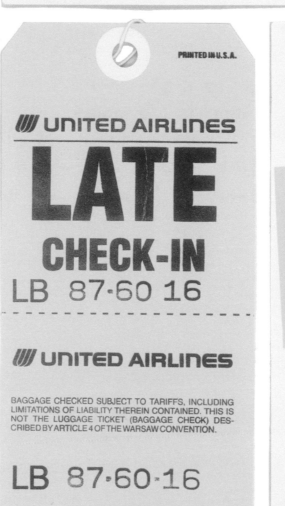

PRINTED IN U.S.A.

⍩⍩ UNITED AIRLINES
LATE
CHECK-IN
LB 87·60 16

⍩⍩ UNITED AIRLINES

LB 87·60·16

art..........55790
col..........493
tg...........m.

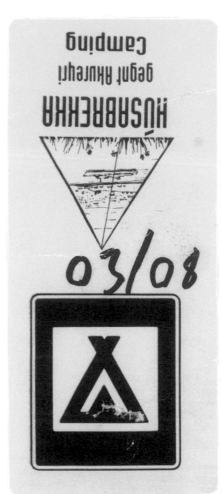

03/08

Teile 1

NACHKASSE #282

Abholzeit: Dienstag

1 x 8,00
SAKKO-LEINEN 8,00

10249

16:38 26.08.2005

Rechnung **7609** ✳

Datum 19.10.04 | Hemden | Preis (incl. MWSt.) |
gewaschen / gestärkt / gebügelt

NICHT BEZAHLT

Name

Adresse

7609 ✳

✳ **609L**

STADT FRANKFURT
AM MAIN
Gebühr
€ 0,50
11703

ROB
4.00

Zoo/Aquarium
Tierpark Berlin

1,– €

zur Deckung zusätzlicher
Zuschuss-Kürzungen 2004

118132

FEUERSTEIN'S
KINDER-EXPRESS
1 Fahrt
· 1 KIND ·
nicht zurückzahlbar
00404 MAHAWO-DRUCK WORMS 00404

FEUERSTEIN'S
KINDER-EXPRESS
1 Fahrt
· 1 KIND ·
nicht zurückzahlbar
00658 MAHAWO-DRUCK WORMS 00658

L.G.E. Textilpflege GmbH
MARTINIZING-Reinigung
Schweizer Straße 66
Tel. 61 20 94
60594 Frankfurt 70

7395 ✳

Name **NICHT BEZAHLT**

Adresse

TAG	Mo	Di	Mi	Do	Fr	Sa
STUNDE	7 8 9	10 11	12 13	14	(15) 16	17 18
Anzug / Kostüm						
Hose						
Rock						
Jackett S - Str						
Mantel						
Popeline-Mantel						
Kleid						
Pulli / Pullover	2					

DATUM 2.12.04 TOTAL 7,20

◆ ALPHA-CHEM-Auszeichnung „M"

147414
MÉTROPOLE 4
LILLE
ENTRÉE

147468
MÉTROPOLE 4
LILLE
ENTRÉE

149180
MÉTROPOLE 4
LILLE
TARIF RÉDUIT

ascom Elsydel

NE PAS
PLIER

043721 01 11.002.00 11 03/09/96 19:53

Conservez ce ticket
sur vous
paiement aux caisses

 hr

Hessischer Rundfunk

Dienstag
29. Juni 1993, 20 Uhr
Funkhaus am Dornbusch
Sendesaal

Forum Neue Musik

DM 10,—

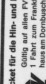

FVV-Ticket für die Hin- und Rückfahrt.
Gültig auf allen FVV-Linien für
1 Fahrt zum Frankfurter Funk-
haus am Dornbusch und zurück.
Hinfahrt frühestens 3 Stunden
vor Veranstaltungsbeginn. Rückfahrt bis Be-
triebsschluß am Veranstaltungstag. 1. Klasse
nur mit Zuschlag. Es gelten die Gemein-
samen Beförderungsbedingungen und Tarif-
bestimmungen.

Flughafen
Frankfurt Main AG

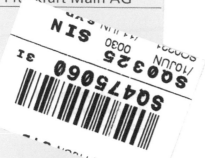

SIN
0030
SA0325
/10JUN

31

SQ475060

COMMUNAUTÉ URBAINE
DE LILLE

MUSÉE D'ART MODERNE
A VILLENEUVE D'ASCQ

TARIF NORMAL

12 D F.

№ 010086

imp ROUBAIX

standby

KUL
KUALA LUMPUR

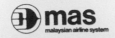 **mas**
malaysian airline system

**GOLDEN CLUB
CLASS**

033770

KUALA LUMPUR

mas
malaysian airline system

0222/32

001

3993900

0222/32

001

3993900

0222/32

001

3993900

San Remo Hotel
Since 1906
2237 Mason St San Francisco CA 941.33

Tel (415) 776-8688
Fax (415) 776-2811

DATE: 9/21
Received From Olivier Tarlore Room # 28
Rent:: From 9/21 To 9/24 19 92
Rent:: 3x55 165
Tax: 18.15
Parking
_____ 183.15
Total Received:
Payment Made By ☐ CASH ☐ M.O. ☐ Trav. Check ☒ Other MC
Change Due _____ CHECK OUT TIME 11:00 AM
Credit to Account _____ Rent is not Refundable
Balance Owing _____
Received By C. Rideau

7181
7180 11112 09:08 21 ABR

Precio incluido el I.V.A. y S.O.V.
Conserve el billete a petición de cualquier empleado

autocares
MALLORCA, S.
C.I.F. B. 0703990A

Precio incluido el I.V.A. y S.O.V.
Conserve el billete a petición de cualquier empleado

IOA PLAYA ESPERANZA-ALCUD 1 1.55 Pt+t.

autocares
MALLORCA, S.
C.I.F. B. 0703990A

Um dieses Kleidungsstück haben
wir uns besonders bemüht.
Dennoch sind die verbliebenen

Flecken

nicht besser zu entfernen,
ohne Stoff und Farben anzugreifen.

SALES DRAFT

KIHEI RENT A CAR
1819 SOUTH KIHEI ROAD
KIHEI, HI 96753
TERMINAL 1939735

160653868
04/06/94 04:11PM
MC EXP. 1195
INV. 47012 002
AUTH. CODE 318441

SALE TOTAL $87.09

X_____
I AGREE TO PAY ABOVE TOTAL AMOUNT
ACCORDING TO CARD ISSUER AGREEMENT
(MERCHANT AGREEMENT IF CREDIT VOUCHER)

004164481998

DFS EAST
J.F.K. AIRPORT RM 2123 IAB
JAMAICA, NY 11430

TIME 05:12 PM DATE 09/27/92
ACCT#
EXP DATE 9408
CARD TYPE MC
TRAN TYPE SALE
AUTH CODE SWT6C5
RECORD # 014
SERVER ID 017
TICKET # 890
TERMINAL # 063015

AMOUNT $35.99
TIP AMOUNT _____
TOTAL AMOUNT 35.99

SIGN X_____
I AGREE TO PAY ABOVE TOTAL AMOUNT
ACCORDING TO CARD ISSUER AGREEMENT
THANK YOU
COME AGAIN

OCBC BANK

OVERSEA-CHINESE BANKING CORPORATION LIMITED
CHANGI AIRPORT TERMINAL 2 BRANCH
SINGAPORE

No. S 0725135

19 NOV

Singapore, _____

SOLD	FOREIGN CURRENCY		RATE	LOCAL EQUIVALENT (ROUND UP)	
	Kp 190	000	79.7	151	45

Transaction done is irreversible.
Please check your money before
leaving the counter. Thank you.

E73/SPL

Customer Copy

BG 9.98

Zurück an den Absender,

☐ weil die Anschrift unvollständig ist

☒ weil an dem zu ent-richtenden Entgelt _____ **200** _____ Pf fehlen.

Sehr geehrte Kundin, sehr geehrter Kunde,

bitte, reißen Sie den Zettel an der Markierung ab, ergänzen Sie das fehlende Entgelt oder die Anschrift und geben die Sendung dann wieder zur Post. Einlegen in den Briefkasten genügt. Die wichtigsten Entgelte finden Sie in den „Service-Informationen Produkte und Preise der Deutschen Post", Einzelheiten über die Versendungsbedingungen erfahren Sie bei Ihrer Filiale.

Bereits gestempelte Briefmarken behalten auf dem Originalumschlag selbstverständlich ihre Gültigkeit.
Für uns zu erkennen an der verbleibenden Markierung.

915-001-100

Deutsche Post

GiroCom 01.02 / 8765432

Zurück an den Absender, 60316

☐ weil die Anschrift unvollständig ist

☒ weil an dem zu ent-richtenden Entgelt _____ **106** _____ Ct fehlen.

Sehr geehrte Kundin, sehr geehrter Kunde,

bitte reißen Sie den Zettel an der Markierung ab, ergänzen Sie das fehlende Entgelt oder die Anschrift und geben die Sendung dann wieder zur Post. Einlegen in den Briefkasten genügt. Die wichtigsten Entgelte finden Sie in den „Service-Informationen Produkte und Preise der Deutschen Post", Einzelheiten über die Versendungsbedingungen erfahren Sie bei Ihrer Filiale. Oder rufen Sie unseren Kundenservice an: Geschäftskunden 01805.5555 (0,06 EUR je angefangene 30 sec im Festnetz) Privatkunden 01802.3333 (0,06 EUR je Anruf im Festnetz)

Bereits gestempelte Briefmarken behalten auf dem Originalumschlag selbstverständlich ihre Gültigkeit.
Für uns zu erkennen an der verbleibenden Markierung.

915-001-100

Deutsche Post

1232 D 11-95 K

YORCK-D. BACKE

X

55 1859
WOOLWORTH 1859
WAIKIKI BC, HI

Cardholder acknowledges receipt of goods and/or services in the amount of the Total shown hereon and agrees to perform the obligations set forth in the Cardholder's agreement with the issuer.

CUSTOMER SIGNATURE

X

5084667

QUAN.	CLASS	DESCRIPTION	PRICE	AMOUNT	
		Meals		24	80

DATE 4/1/94	AUTHORIZATION 36	CLERK		SUB TOTAL	24	80
		DEPARTMENT		TAX	1	03
M C 204010795				TOTAL	25	83

CUSTOMER COPY

IMPORTANT: RETAIN THIS COPY FOR YOUR RECORDS.

FORMULE1 CARTE N° _____
35392 JOURNÉE DU **2** CL ZONES
1 2
2 J 12 020

PREU SEGONS TARIFES VIGENTS 004
Inclós IVA i assegurança accidents
BITLLET SENZILL 30831
Presenteu-lo a petició de qualsevol empleat. C.I.F. A - 08016081

M.A.M.A.C
promenade des arts
93 62 61 62

Ville de Nice

20/03/97 13:21 0006
000000#3503

ETUDIANT *15.00

Um dieses Kleidungsstück haben
wir uns besonders bemüht.
Dennoch sind die verbliebenen

Flecken

nicht besser zu entfernen,
ohne Stoff und Farben anzugreifen.

PREU SEGONS TARIFES VIGENTS 070
Inclós IVA i assegurança accidents
BITLLET SENZILL 34138
Presenteu-lo a petició de qualsevol empleat. C.I.F. A - 08016081

PREU SEGONS TARIFES VIGENTS 076
Inclós IVA i assegurança accidents
BITLLET SENZILL 30227
Presenteu-lo a petició de qualsevol empleat. C.I.F. A - 08016081

927

**Für
Ihre Bank**

UB MEDIA Verlag
Tel. 0 80 85 / 8 01 · Best.-Nr. 70-26
Post-it™ Haft-Notizen

PREU SEGONS TARIFES VIGENTS 004
Inclós IVA i assegurança accidents
BITLLET SENZILL 30833
Presenteu-lo a petició de qualsevol empleat. C.I.F. A - 08016081

820 **821** **822**

SOORT PREI 602

KLASSE I Land HOLLAND

PRIJS

PER 500 GRAM 2.50

STEEDS VERSE AANVOER

16

VOUCHER	✱ 006080	PREMIANT CITY TOUR
NOT REFUNDABLE		

<table>
<tr><td>Hotel/Rubber stamp:

K+K Hotel Central
Hybernská 10, 110 00 Praha 1
CZECH REPUBLIC
tel.: +420 225 022 000</td><td>Client:

203</td><td colspan="2">Starting point:
Na Příkopě 23, Praha 1
Tel.: 606 600 123</td></tr>
<tr><td></td><td>Price:

420 × 3
= 1260</td><td colspan="2">Date: 3/05
Departure: K+K Central

Pick up time: 10:45</td></tr>
<tr><td>Prodal dne: 3/05</td><td>Persons:
3</td><td>Tour No.:</td><td>Language:
E G F I S R</td></tr>
</table>

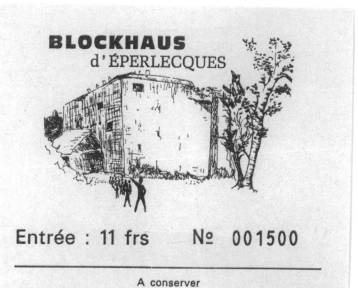

BLOCKHAUS
d'ÉPERLECQUES

Entrée : 11 frs № 001500

A conserver

Imp. Dubocquet - Éperlecques

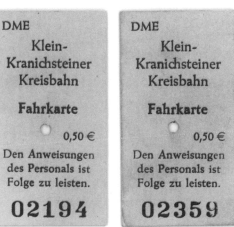

DME

Klein-
Kranichsteiner
Kreisbahn

Fahrkarte

0,50 €

Den Anweisungen
des Personals ist
Folge zu leisten.

02194

DME

Klein-
Kranichsteiner
Kreisbahn

Fahrkarte

0,50 €

Den Anweisungen
des Personals ist
Folge zu leisten.

02359

Um dieses Kleidungsstück haben
wir uns besonders bemüht.
Dennoch sind die verbliebenen
Flecken
nicht besser zu entfernen,
ohne Stoff und Farben anzugreifen.

MADAMA BUTTERFLY

Friday Evening 8:00PM
GR TIER

Row	Seat	Price
D	10	$135.00

Jan
28
2005

MBUT04 1 8700982

Metropolitan Opera

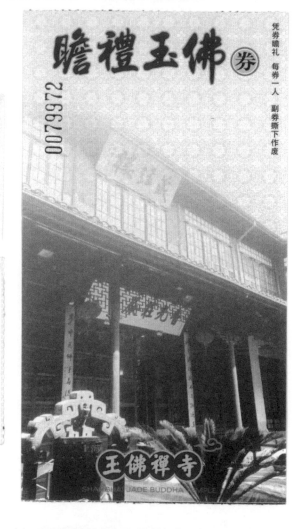

瞻禮玉佛 券

0079972

凭券瞻礼 每券一人
副券撕下作废

玉佛禅寺

7395 *

KRAWATTE 2.30
15:32 1 10 1
4362 9-10-2002
 4362 A - 2

2419 *

PULLOVER 3.60
ABH.DIENSTAG
.26* (1)
0525 20-12-2004
 0525 A - 1

9462 *

PULLI V 4.90
13:48 (2)
9765 3-02-2003
 9765 M - 1

2784 *

11623 *

2419 *

. . . V 12.10
12:07 3 *
4834 24-03-2003
 4834 P - 1

7395 *

MARTINIZING
TEXTILPFLEGE
SCHWEIZERSTRASSE 66
60594 FRANKFURT
TELEFON:069/612094

3523 *

 ABH.FREITAG
PULLOVER 3.60
 533 AS 0.00
TEILE 1
TOTAL 3.60
NACHKASX3.60
15:27 BED.A
 A 6-11-2003
 9489 A 1

4717 *

ROCK 4.40
 ABH.DIENSTAG
12:34 (2)
9889 11-08-2003
 9889 A - 1

9462 *

PULLOVER 3.60
 ABH.FREITAG
12:22 (4)
3638 18-07-2002
 3638 A - 4

DATE: 09/11/92 TIME: 22:48

6021809200A
VAN NESS HOTEL
2850 VAN NESS AVENUE
SAN FRANCISCO, CALIFORNIA 94109

CLERK 10

 DESCRIPTION
Room # 112 - 10.34
phone calls

 SUB
R . . 41411015 TAX
A . . . 871439
T . TYPE SALE TOTAL 10.34
ACCOUNT # EXP
 0894

SIGNATURE X_____
I AGREE TO PAY ABOVE TOTAL AMOUNT
ACCORDING TO CARD ISSUER AGREEMENT
(MERCHANT AGREEMENT IF CREDIT VOUCHER)

TOP COPY-MERCHANT BOTTOM COPY-CUSTOMER

```
38
    UTRECHT CS-KOELN HBF

    11.04   178   9

    85
        UTRECHT CS-KOELN HBF

        21.08   181   5

    67
        UTRECHT CS-KOELN HBF

        18.07   177   0
```

BLOCKHAUS
d'ÉPERLECQUES

Entrée : 11 frs № 001501

A conserver

Imp. Dubocquet - Éperlecques

BAR TREUMAL
N.I.F.: 40.148.297-A

Playa Santa Cristina - BLANES

Mesa nº _____ 24 _____ 13 de ___ 8 ___ de 19 ___ 79 ___

COMIDAS	Precio	Total	BEBIDAS	Precio	Total
_____ Ensalada			_____ Vino		
_____ Paella			_____ Agua mineral		
_____ Mejillones			_____ Gaseosa		
_____ Calamares			_____ Cerveza		125
_____ Tern. con setas			_____ Vermut o Bitter		
_____ Tortilla española		350	_____ Fant., Trin o Schw.		
_____ Tortilla francesa			_____ Coca-Cola		
_____ Lomo plancha			_____ Tónica		
_____ Gambas plancha			_____ Cacaolat		
_____ Pollo con patatas			_____ Café con leche		
_____ Bistec			_____ Café		
_____ Costillas			_____ Carajillo		
_____ Butifarra			_____ Cortado		
_____ Merluza			_____ Licores		
_____ Hamb. huevo, pat.			_____ Helados		
_____ Huevo Frank. pat.					
_____ Pan					

COMIDAS ___ 350		**2954**	BEBIDAS ___ 125		
I.V.A. (6%) ___ 20			COMIDAS ___ 370		
Son ___ 370			TOTAL ___ 495		

```
8078340000000100021
        BATCH: 040

   HILO HATTIE FASHIONS #10
    700 NORTH NIMITZ HWY
    HONOLULU, HAWAII 96817
        (800) 544-3500
    ALOHA AND MAHALO!

        DATE: 04/04/94
        TIME: 10:53

     S-A-L-E-S D-R-A-F-T

     CLERK# 0002

   REF:      4661
   CD TYPE: MCI
   TR TYPE: PR

   AMOUNT:       $194.80

   ACCT:                EXP: 1195
   A#: 538041

   I AGREE TO PAY ABOVE TOTAL AMOUNT
   ACCORDING TO CARD ISSUER AGREEMENT
   (MERCHANT AGREEMENT IF CREDIT VOUCHER)

   TOP COPY-MERCHANT BOTTOM COPY-CUSTOMER
```

No.A 088353

**Rental Ticket
for Personal Audio Guide**

**The Grand Palace
and Temple of The Emerald Buddha
open daily from 8.30 a.m. - 3.30 p.m.
(last entrance at 3.00 p.m.)**

This ticket is valid for one day only

Baht 100.-/2 hours

The Office of the Royal Household. The Office of the Royal Household.

BAR FREIGEMACHT
TAXE PERÇUE
AUTRICHE

LEOBEN
19.02.01
8701

006600

04-11 88 21-51 0076558

BRUXELLES-CENTRAL
BRUXELLES-MIDI

2CL SIMPLE 35F

SA.,08.01.94 23:00 Uhr 08.01

THEATERSAAL T

HIP HOP

PARTY

Nr. *435 *435

VV DM 7,-- AK DM 7,-- ERM DM 7,--

(incl. 7 % MwSt)

OFF-TAT FRANKFURT
**WALDSCHMIDTSTRASSE 4 · 6000 FRANKFURT
TELEFON 069 / 40 58 95-20**

The Clipper Lounge

MANDARIN ORIENTAL
JAKARTA

Open Daily : 10 am - 11 pm

1021 ZAELANI CL

```
CHK 7629 TBL   13 GRP  2 COV   0
     19-NOV-93 17:45

SPLIT FROM CHK    7615
1 FRS PINEAPPLE JC       8000
1 FRESH FRUIT            8000
SUBTOTAL                16000
SERVICE CHG 10%          1600
TAX                       880
TPC                       320
TOTAL DUE         18800

TOTAL FOOD               8000
TOTAL BEVERAGE           8000
SERVICE CHG 10%          1600
TAX                       880
TPC                       320
# F219481 R1123
ROOM CHARGE             18800
---281----21-CHECK CLOSED-17:48
```

Name (please print) Room number

Signature Number

03464

Mandarin Oriental, Jalan M.H. Thamrin, PO Box 3392 Jakarta Pusat, Indonesia
Telephone 62 (21) 321307 Telex 61755 MANDA IA
Facsimile 62 (21) 324669 Cable MANDAHOTEL

A Mandarin Oriental Hotel

19.-23.10.2005

FRANKFURTER BUCHMESSE
GASTLAND ›KOREA‹

Name, Firma

ACTAR

Halle:
Nr.: 4.1 J 138

Stand-Nr.
Nicht übertragbar

06641

Abholzeit: Mittwoch

HOSE 5,20
10:49 28.11.2005

15777-1/2

Abholzeit: Donnerstag

SAKKO OK 6,50
12:?? 11.10.2005

12993-1/4

Teile 1

NACHKASSE #280

Abholzeit: Mittwoch

S 1 x 8,00 8,00
SAKKO-LEINEN
1? 14620
11:34 07.11.2005

Teile 2

NACHKASSE #140

Abholzeit: Mittwoch

1 x 5,20
HOSE 5,20
1 x 6,50
SAKKO 6,50
10:49 28.11.2005 15777

Sie haben eine
Straftat nach § 12 StVO
begangen!

Gegen Sie wird Strafanzeige
nach § 12 StVO erstattet.

Um die zwangsweise Stillegung Ihres
Fahrzeugs zu vermelden, melden Sie
sich bitte umgehend bei Ihrem
zuständigen Polizeiabschnitt.

Um dieses Kleidungsstück haben
wir uns besonders bemüht.
Dennoch sind die verbliebenen

Flecken

nicht besser zu entfernen,
ohne Stoff und Farben anzugreifen.

Eckhart

SALES SLIP

1232 D 08-94 A
OLIVIER TARTARE

159 82305 000 0
AX 6315303537
ALLE'E SHOES INC 092692
NEW YORK NY

Cardholder acknowledges receipt of goods and/or services in the amount of the Total shown hereon and agrees to perform the obligations set forth in the Cardholder's agreement with the issuer.
CUSTOMER SIGNATURE

X

5463648

QUAN.	CLASS	DESCRIPTION	PRICE	AMOUNT
		3983-01		80

DATE	AUTHORIZATION OB-847	CLERK	REG/DEPT	SUB TOTAL	
M/C	**SALES SLIP**			TAX	6 60

IMPORTANT: RETAIN THIS COPY FOR YOUR RECORDS TOTAL 86 60

CUSTOMER COPY SAFEIPERF U.S. Pat. 4,403,793

Passaporto N.	**A**			Nº 04016/M1

Valuta BB	Quantità	Cambio	Importo in Lit.
dm	50	885	44.250
fl	100	258	25.800

Rilasciato a
.................... il
Nazionalità

Valuta TC	Quantità	Cambio	Importo in Lit.

Nome

Cognome

Domiciliato

Via

CODICE OPERATORE	/	70.050
FIRMA		

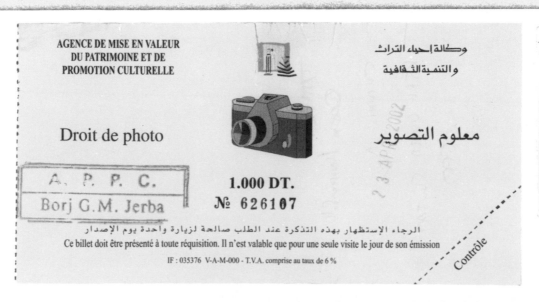

AGENCE DE MISE EN VALEUR
DU PATRIMOINE ET DE
PROMOTION CULTURELLE

وكالة إحياء التراث
والتنمية الثقافية

Droit de photo

معلوم التصوير

A.P.P.C.
Borj G.M. Jerba

1.000 DT.
№ 626107

2 3 APR 2002

الرجاء الإستظهار بهذه التذكرة عند الطلب صالحة لزيارة واحدة يوم الإصدار
Ce billet doit être présenté à toute réquisition. Il n'est valable que pour une seule visite le jour de son émission

IF : 035376 V-A-M-000 - T.V.A. comprise au taux de 6 %

BAVAK Tel.(01718) 233 44
TURN-O-MATIC® Octrooi No. 171.100

⑨40

Contrôle

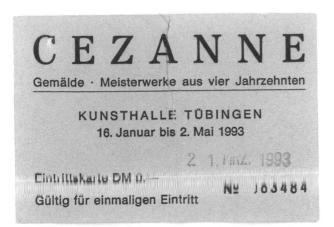

CEZANNE

Gemälde · Meisterwerke aus vier Jahrzehnten

KUNSTHALLE TÜBINGEN
16. Januar bis 2. Mai 1993

2 1.MRZ. 1993

Eintrittskarte DM 0.—
Gültig für einmaligen Eintritt

Nº J63484

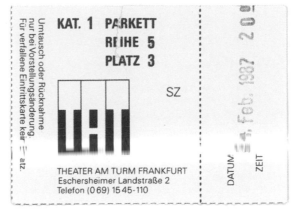

KAT. 1 PARKETT
REIHE 5
PLATZ 3

SZ

Umtausch oder Rücknahme
nur bei Vorstellungsänderung.
Für verfallene Eintrittskarte kein ...atz.

UII

THEATER AM TURM FRANKFURT
Eschersheimer Landstraße 2
Telefon (069) 1545-110

24. Feb. 1987 20

DATUM ZEIT

32 UTRECHT CS-KOELN HBF

11.04 178 9

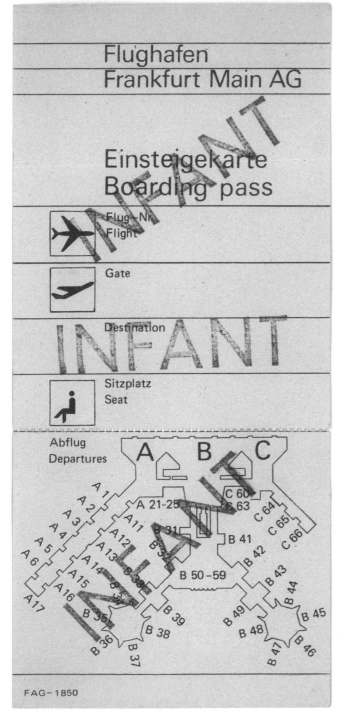

Flughafen
Frankfurt Main AG

Einsteigekarte
Boarding pass

Flug-Nr
Flight

Gate

Destination

Sitzplatz
Seat

INFANT

Abflug
Departures

FAG-1850

Röntgen-Paß

für Röntgen- und
nuclearmedizinische Untersuchungen

Name ___BACKE___

Vorname ___Tanja___

geboren am ___11.4.68___

Diesen Röntgen-Paß sollte der Patient stets bei sich tragen
und darauf achten, daß alle Röntgenaufnahmen und nuclear-
medizinischen Untersuchungen eingetragen werden. Diese
Eintragungen sind für den behandelnden Arzt wichtige Hinweise.

ampionships
...ledon 1995

STAND BY
AERO LLOYD
STAND BY
AERO LLOYD
STAND BY
AERO LLOYD
STAND BY
AERO LLOYD

19
frottier-hammer
ARTIKEL
Calida 9209
31303 /00
Da-Nachthemd
75,00
1 GRÖSSE L
VERK. PREIS

voluassene/adult
erwachsene **V**

MADURODAM

19-04-2003

1X Eu.11.00

nk 112
06-034-0627984-001 (2/3)
Madurodam

kind / child **K**

MADURODAM

19-04-2003

1X Eu.8.00

nk 112
06-034-0627985-003 (3/3)
Madurodam

Bundesgrenzschutz
BGSAMT – Flughafen Frankfurt/Main
Sicherheitskontrolle Reisegepäck
Security Check Baggage
...äckstück geröntgt. Gepäckstück nicht geöffnet.

KONTROLLIERT AM 31 JAN 2005,

Datum

BGS 1 20 0171 08 01

KUL
KUALA LUMPUR

mas
malaysian airline system

KUL
KUL
312487
MH A312487
KUALA LUMPUR

SEQ. No.

Nederlandse Spoorwegen

Geldig op/van	Geldig tot en met		Klasse
09.05.97			2

Dagretour

H DEN HAAG CS T
AMSTERDAM CS

Via

Afgiftepunt	Reductie	Nummer	Prijs
895.28 .0928	40%	674654	16,75

Bijz. VOORDEELUREN:ZIE FOLDER KAARTSOORT

TT 030361

Nederlandse Spoorwegen JE 509157

Geldig op/van	Geldig tot en met	Afgiftedatum	Klasse
10.08.00			2

Dagretour

H ZANDVOORT A ZEE T
AMSTERDAM C

Via

Afgiftepunt	Reductie	Nummer	Prijs NLG
733.60.1142	40%	305160	8.50

Bijz. VOORWAARDEN VOORDEELUREN:
ZIE FOLDER KAARTSOORT

Lufthansa

Herr
Eckert

FRA - DV

27.10.2003

Besucher

Frankfurt/Main

FRA

ex:

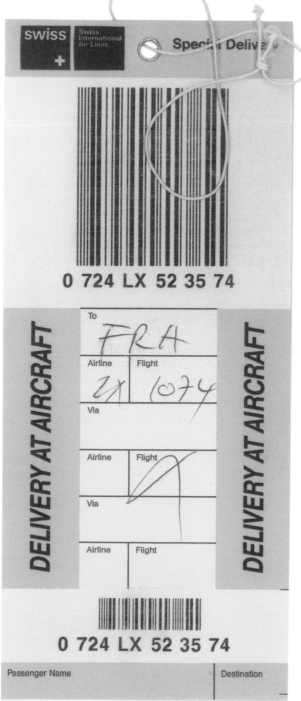

swiss +
Swiss International Air Lines

Special Delivery

0 724 LX 52 35 74

DELIVERY AT AIRCRAFT

To	FRA	
Airline	Flight	
LX	1074	
Via		
Airline	Flight	
Via		
Airline	Flight	

DELIVERY AT AIRCRAFT

0 724 LX 52 35 74

Passenger Name | Destination

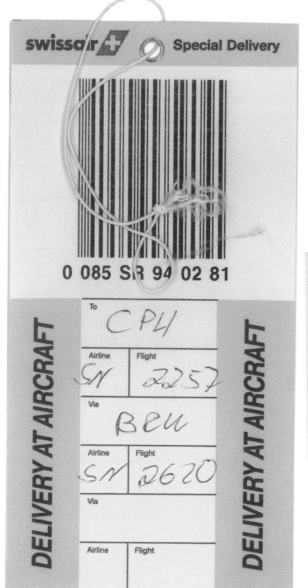

swissair +

Special Delivery

0 085 SR 94 02 81

DELIVERY AT AIRCRAFT

To	CPH	
Airline	Flight	
SN	2257	
Via	BEU	
Airline	Flight	
SN	2620	
Via		
Airline	Flight	

DELIVERY AT AIRCRAFT

456

AG REEDEREI NORDEN-FRISIA
Gepäckkarte

18795

Container-Nr:	Hinfahrt	Rückfahrt

je Gepäckstück bis 30 kg

Rückfahrt

von **Norddeich** nach **Juist**

Preis: 5,50 DM

einschl. Umsatzsteuer erm. Satz

Die Beförderung erfolgt auf Grund unserer Allge-
meinen Beförderungsbedingungen, die in den
Geschäftsräumen aushängen.

AG REEDEREI NORDEN-FRISIA
Gepäckkarte

18795

**Abschnitt für die Rückfahrt
am Koffer lassen!**

je Gepäckstück bis 30 kg

Rückfahrt

von **Norddeich** nach **Juist**

Diesen Abschnitt bitte nach Entfernen
der Folie auf das Gepäckstück kleben!

BGS 1 20 017a 07 98

(Datum)

Bundesgrenzschutz

BGSI – Flgh. Berlin-Tegel

Sicherheitskontrolle Reisegepäck

Security Check Baggage

Reihe · Row	Platz · Seat
15	**A**
Rangée · Fila	Siège · Asiento

Via
Vordere Tür
Front door
Porte avant
Puerta delantera

Flug – Flight
Vuelo – Vol

HF

Hapag-Lloyd Flug

Sitzplatzkarte + Einsteigkarte
Seating card + Boarding pass
Carte d'acces à bord
Tarjeta de embarque 107

Bus-Linienverkehr
MÜNCHEN HBF – FLUGHAFEN RIEM

Fahrkarte X 27300 ✳

für eine Fahrt

München Hauptbahnhof — Flughafen Riem

oder

Flughafen Riem — München Hauptbahnhof

Fahrpreis DM 5,–
inkl. 7 % MWSt.

Autobus „Oberbayern" GmbH, München 45
Heidemannstraße 220 Telefon (089) 31 89 10

Firmengruppe „Autobus Oberbayern"
Bus-Reisen — Vermietung
Ausflüge — Stadtrundfahrten
IATA-Flugreisebüro
im Reisebüro Lenbachplatz 1,
Telefon 55 80 61

16MAG91 1111 444

▲
LATO DI INSERIMENTO
INSERT THIS SIDE UP

✳ 393402

OPERA S. MARIA DEL FIORE • FIRENZE

CERRAI - Pisa

CRIPTA

LIRE 5.000
ESENTE IVA - ART. 10.22 D.P.R. 633/72
CONSERVARE IL BIGLIETTO FINO ALL'USCITA
VISITORS MUST KEEP THE TICKET DURING THE VISIT

H. Sch.

Serie 0544

Kombinieren Sie die
Sternzeichen

Versuch's nochmal Versuch's
nochmal Versuch's nochmal
Versuch's nochmal Versuch's
nochmal Versuch's nochmal
Versuch's nochmal Versuch's
nochmal Versuch's nochmal
Versuch's nochmal Versuch's
nochmal Versuch's nochmal

Leider verloren

Versuch's nochmal Versuch's

SNCF · RATP Réseaux ferrés
AEROPORT CDG 2
PARIS-

2 CL

70-10 U

FRF 50.51
EUR 7.70

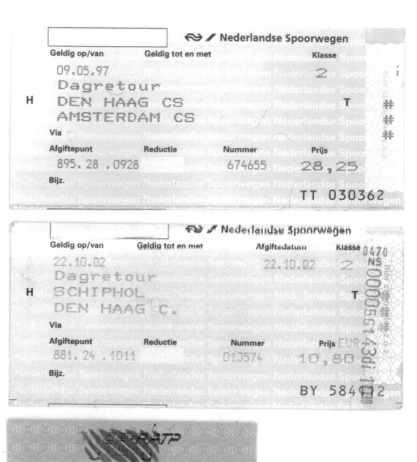

Nederlandse Spoorwegen

Geldig op/van	Geldig tot en met		Klasse
09.05.97			2
H Dagretour			T
DEN HAAG CS			
AMSTERDAM CS			
Via			

Afgiftepunt	Reductie	Nummer	Prijs
895.28 .0928		674655	28,25
Bijz.			
			TT 030362

Nederlandse Spoorwegen

Geldig op/van	Geldig tot en met	Afgiftedatum	Klasse
22.10.02		22.10.02	2 NS 0470
H Dagretour			T
SCHIPHOL			
DEN HAAG C.			
Via			

Afgiftepunt	Reductie	Nummer	Prijs
881.24 .1011		013574	EUR 10,80
Bijz.			
			BY 584012

Bundesgrenzschutz
BGSAMT – Flughafen Frankfurt/Main
Sicherheitskontrolle Reisegepäck
Security Check Baggage

BGS 1 20 017f 08 01

09. Jan. 2004

Datum

Gepäckstück geröntgt. Gepäckstück nicht geöffnet.

Bundesgrenzschutz
BGSAMT – Flughafen Frankfurt/Main
Sicherheitskontrolle Reisegepäck
Security Check Baggage

BGS 1 20 017f 08 01

1 8. März 2004

Datum

Gepäckstück geröntgt. Gepäckstück nicht geöffnet.

RATP

SECTION URBAINE

2

000001971 3108 RER METRO

AERO LLOYD

EINSTEIGKARTE
BOARDING PASS

FLUG/FLIGHT

AEF

REIHE/ROW	PLATZ/SEAT
	20 E

Ausgang/Gate

AERO LLOYD

EINSTEIGKARTE
BOARDING PASS

FLUG/FLIGHT

AEF

REIHE/ROW	PLATZ/SEAT
	20 F

Ausgang/Gate

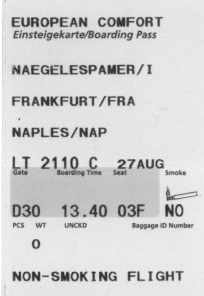

EUROPEAN COMFORT
Einsteigekarte/Boarding Pass

NAEGELESPAMER/I

FRANKFURT/FRA

NAPLES/NAP

LT 2110 C 27AUG

Gate	Boarding Time	Seat	Smoke
D30	13.40	03F	NO

PCS	WT	UNCKD	Baggage ID Number
0			

NON-SMOKING FLIGHT

DM 6,50
Sicherheitsgebühren
der Länder
Security fee
incl. Inkassokosten
SERIE A
DE 998914

ECONOMY 046
Bordkarte/Boarding Pass

Name of passenger API
WIPPERMANN/HANNA MRS
ETKT 220 2131246009
SFO
FRA
LUFTHANSA

Carrier	Flight No./Class	Date
LH 455	V	24AUG

Gate	Boarding Time	Seat
G94	1335	50C
		NONSMOKER

ZONE 5

Pcs	Ck. Wt.	Unck. Wt.	Pcs.	Ck. Wt.	Unck.Wt.
00					

0,81 € 1,59 DM

CAMPINA YOGHO YOGHO
ORANGE M.6—VITAM.500G

V 64190 8715300505644 15039 Z 10
159270

1,02 € 1,99 DM

A&P ZITRONENTEE 400G

64190 4008535123603 08029 Z 12
780360
PREISGESENKT SEIT: 29.06.1998

0,40 € 0,79 DM

MP SAHNEKAENNCHEN
200G 12%

64190 4008535027437 01039 Z 20
161576
PREISGESENKT SEIT: 15.02.1999

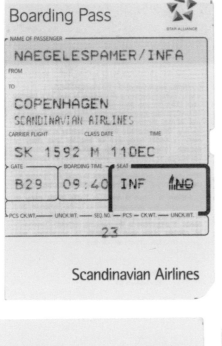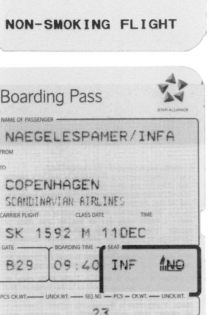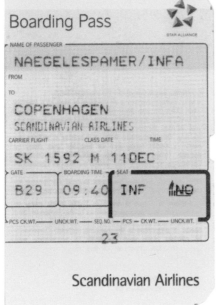

Boarding Pass

STAR ALLIANCE

NAME OF PASSENGER
NAEGELESPAMER/INFA

FROM

TO
COPENHAGEN
SCANDINAVIAN AIRLINES

CARRIER FLIGHT	CLASS DATE	TIME
SK 1592 M 11DEC		

GATE	BOARDING TIME	SEAT
B29	09:40	INF NO

PCS CK.WT.— UNCK.WT.— SEQ. NO.— PCS — CK.WT.— UNCK.WT.
23

Scandinavian Airlines

BVG · BVG · BVG

VG Tarif A FAHRSCHEIN

KURZSTRECKE

2.30 DM
WITTENBERGPLATZ
21.07.94
13:55 A
120 1932 113 LINIE 129

Potsdamer Straße 188
10783 Berlin ☎ 2561

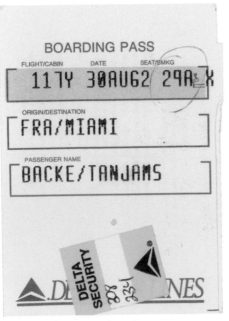

BOARDING PASS

FLIGHT/CABIN	DATE	SEAT/SMKG
117Y	30AUG2	29A X

ORIGIN/DESTINATION
FRA/MIAMI

PASSENGER NAME
BACKE/TANJAMS

DELTA SECURITY

DELTA AIR LINES

BOARDING PASS

FLIGHT/CABIN	DATE	SEAT/SMKG
446Y	15EP2	42D X

ORIGIN/DESTINATION
ATL/LOS ANGELES

PASSENGER NAME
BACKE/TANJAMS

REBOARD

DELTA AIR LINES

BVG

Berliner Verkehrsbetriebe

EINZELFAHRAUSWEIS
REGELTARIF

Berlin AB

B1 2,00 EUR
Breitscheidplatz
22.09.04 12:35 A

LINIE 100 Uagen 3891
1911 31 2691

VBB

Nachdruck verboten. Bitte Rückseite beachten.

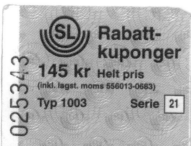

SL Rabatt-
kuponger
145 kr Helt pris
(inkl. lagst. moms 556013-0683)
Typ 1003 Serie 21

025343

29.03.98-01.04.98 288

2.Klasse

Brennero/Brenner
Kufstein
über KI - 754

110 km
VP 1E OK

ATS**180.--

Deutsches Museum
München
Eintrittskarte
DM 1,-
Aufbewahren und auf
Verlangen vorzeigen

Beckerbillett Hamburg
079499

Controlled by
461

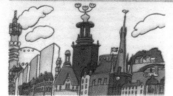

3513 B2 02×13³⁵	↑20
	↑19
	↑18
3539 X1 01×22¹⁵	↑17
	↑16
3541 X1 30×23¹⁵	↑15
	↑14
	↑13
	↑12
2502 B3 30×16³⁰	↑11
	↑10
	↑9
	↑8
3515 B2 21×06³⁰	↑7
	↑6
	↑5
N290 X1 17Ⅶ22⁰⁰	↑4
	↑3
	↑2
	↑1

025343
025343
025343

Vid stämpling
i automat,
se instruktion
på baksidan!

北京前門飯店梨園劇場
LI YUAN THEATRE QIAN MEN HOTEL
楼上 2 排 6 号
入場請走前門飯店正門

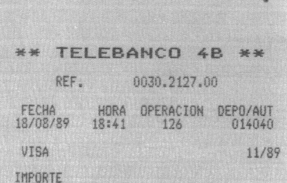

北京前門飯店梨園劇場
LI YUAN THEATRE QIAN MEN HOTEL
楼上 2 排 4 号
入場請走前門飯店正門

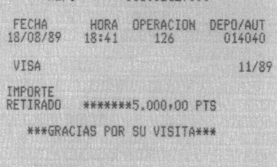

** TELEBANCO 4B **

REF. 0030.2127.00

FECHA HORA OPERACION DEPO/AUT
18/08/89 18:41 126 014040

VISA 11/89

IMPORTE
RETIRADO *******5.000,00 PTS

GRACIAS POR SU VISITA

KAT. PARKETT
 REIHE
 PLATZ

Umtausch oder Rücknahme
nur bei Vorstellungsänderung.
Für verfallene Eintrittskarte kein Ersatz.

Studentenkarte

SZ
10.- DM

THEATER AM TURM FRANKFURT
Eschersheimer Landstraße 2
Telefon (0 69) 15 45-110

Eintrittskarte
Preis siehe Anschlag
Nicht übertragbar
Aufbewahren und auf
Verlangen vorzeigen

69655

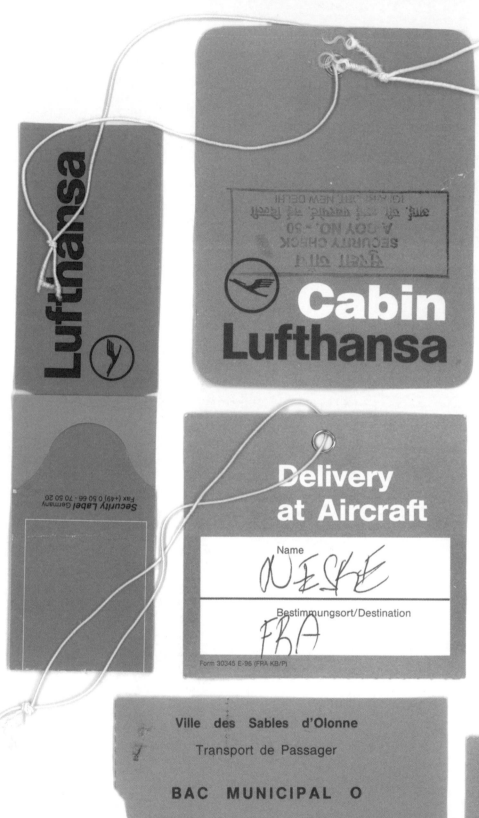

Lufthansa

Security Label Germany
Fax (+49) 0 50 66 - 70 50 20

Cabin
Lufthansa

SECURITY CHECK
A. DOY NO. – 50

Delivery
at Aircraft

Name

NESKE

Bestimmungsort/Destination

FRA

Form 30345 E-96 (FRA KB/P)

///// UNITED

Priority
Checked Baggage

9016 UA 920321

Ville des Sables d'Olonne

Transport de Passager

BAC MUNICIPAL O

PRIX : 2,35 Frs № 71981

Delivery
at Aircraft

0220 LH 091215

Actv

№ 180340 ZA

Biglietto 24 ore
24 Stunden Fahrkarte
24 hours ticket
Billet 24 heures

0221
22340MeP01 35

8008

Lire

Vedi avvertenze a tergo. Für Gebrauchsanweisungen bitte umwenden.
For use: please turm over. Mode d'emploi: voir au verso.

Bordkarte/Boarding Pass

Name of passenger
NESKE/MAJA MRS

LHR
FRA
LUFTHANSA

Carrier	Flight No./Class	Date
LH 4739 W	28JUL	

Gate	Boarding Time	Seat
	1830	37F

NONSMOKER

ZONE 3

| Pcs | Ck. Wt. | Unck. Wt. Pcs. | Ck. Wt. | Unck.Wt. |

Bordkarte/Boarding Pass

Name of passenger
NESKE/CHRISTIAN MR

LHR
FRA
LUFTHANSA

Carrier	Flight No./Class	Date
LH 4739 W	28JUL	

Gate	Boarding Time	Seat
	1830	37D

NONSMOKER

ZONE 3

| Pcs | Ck. Wt. | Unck. Wt. Pcs. | Ck. Wt. | Unck.Wt. |

Bordkarte/Boarding Pass

Name of passenger
NESKE/CHARLOTTE MI

LHR
FRA
LUFTHANSA

Carrier	Flight No./Class	Date
LH 4739 W	28JUL	

Gate	Boarding Time	Seat
	1830	37H

NONSMOKER

ZONE 6

| Pcs | Ck. Wt. | Unck. Wt. Pcs. | Ck. Wt. | Unck.Wt. |

ECONOMY 046
Einsteigekarte/Boarding Pass

Name of passenger
BACKE M

From DUS
To XRY
CONDOR

Carrier	Flight No./Class	Date
DE 5602 M	06OCT	

Gate	Boarding Time	Seat
C41	0540	23k

NONSMOKER

Lufthansa

Bordkarte/Boarding Pass

Name of passenger
NESKE/MAJA MRS

LUFTHANSA

Carrier	Flight No./Class	Date
LH 4739	28JUL	

Gate	Boarding Time	Seat

| Pcs | Ck. Wt. | Unck. Wt. Pcs. | Ck. Wt. | Unck.Wt. |

ECONOMY 270
Bordkarte/Boarding Pass

Name of passenger
LISTMANN/ILKA MRS
ETKT 220 2103787632
FRA
HAM
LUFTHANSA

Carrier	Flight No./Class	Date
LH 016 T	22DEC	

Gate	Boarding Time	Seat
A13	1155	26G

NONSMOKER

ZONE 5

| Pcs | Ck. Wt. | Unck. Wt. Pcs. | Ck. Wt. | Unck.Wt. |

SHVV

Einzelkarte
2. Kl. Nahbereich

U KLOSTERST./A 97179 A 01
12.01.05 08:44 1.50 EUR

🚇 HOCHBAHN _SHVV_

9-Uhr-Karte 1 Erw.+ 3 Kinder
2. Kl. Großbereich Hamburg
Sa und So ganztägig gültig
Schlump 00094838 A 01
27.02.05 11:02 4.65 EUR

Operating Crew

Baggage
Identification Tag only

Lufthansa

0220 LH 78 05 77

To FRA

Airline	Flight
LH	721

A STAR ALLIANCE MEMBER

Lufthansa

"LIEBER MALER, MALE MIR..."
RADIKALER REALISMUS NACH PICABIA
15. JANUAR 2003 – 06. APRIL 2003

GEFÖRDERT VON: ZUSÄTZLICHE UNTERSTÜTZUNG DURCH: MEDIENPARTNER:
 FREUNDE DER SCHIRN KUNSTHALLE E.V. journal

مطعم جوهر **MANICKAL** RESTAURANT

SULAIMANIA
4616027 - 0501621814

CASH INVOICE

From: .. Date: 21-/3/0t

Description البيان	سعر الوحدة Unit Price Riy ريال \| H.هـ	العدد Quantity	المبلغ الاجمالي Total Riy ريال \| H.هـ
Peel			60
Total المجموع			60

Salesman : البائع

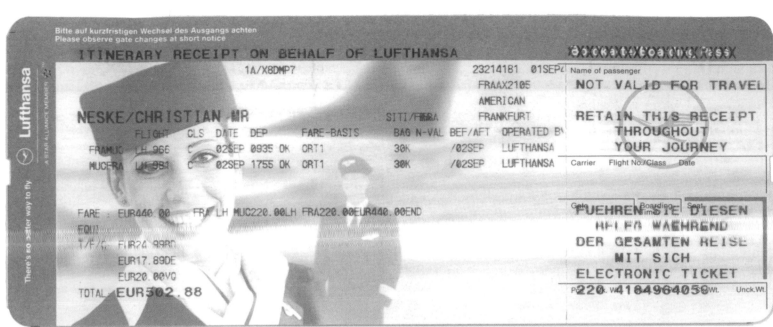

ITINERARY RECEIPT ON BEHALF OF LUFTHANSA

XXXXXXXXXXXXXXXXXX

1A/X8DMP7

23214181 01SEP2
FRAAX2105
AMERICAN
FRANKFURT

Name of passenger

NOT VALID FOR TRAVEL

NESKE/CHRISTIAN MR

SITI/FRRA

RETAIN THIS RECEIPT
THROUGHOUT
YOUR JOURNEY

FLIGHT	CLS	DATE	DEP	FARE-BASIS	BAG N-VAL	BEF/AFT	OPERATED BY
FRAMUC LH 966	C	02SEP	0935	OK CRT1	30K	/02SEP	LUFTHANSA
MUCFRA LH 981	C	02SEP	1755	OK CRT1	30K	/02SEP	LUFTHANSA

Carrier Flight No./Class Date

FARE : EUR440.00 FRA LH MUC220.00LH FRA220.00EUR440.00END

EQUI :

T/F/C: EUR24.99RD
 EUR17.89DE
 EUR20.00VQ

TOTAL: EUR502.88

Gate Boarding Time Seat

FUEHREN SIE DIESEN
HELEG WAEHREND
DER GESAMTEN REISE
MIT SICH
ELECTRONIC TICKET

220 4184964059

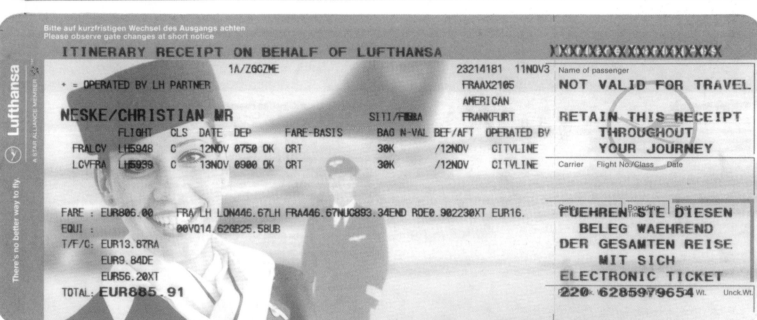

ITINERARY RECEIPT ON BEHALF OF LUFTHANSA

XXXXXXXXXXXXXXXXXX

1A/ZGCZME

23214181 11NOV3
FRAAX2105
AMERICAN
FRANKFURT

Name of passenger

NOT VALID FOR TRAVEL

+ = OPERATED BY LH PARTNER

NESKE/CHRISTIAN MR

SITI/FRRA

RETAIN THIS RECEIPT
THROUGHOUT
YOUR JOURNEY

FLIGHT	CLS	DATE	DEP	FARE-BASIS	BAG N-VAL	BEF/AFT	OPERATED BY
FRALCV LH5948	C	12NOV	0750	OK CRT	30K	/12NOV	CITYLINE
LCVFRA LH5939	C	13NOV	0900	OK CRT	30K	/12NOV	CITYLINE

Carrier Flight No./Class Date

FARE : EUR805.00 FRA LH LON446.67LH FRA446.67NUC893.34END ROE0.902230XT EUR16.

EQUI : 00VQ14.62GB25.58UB

T/F/C: EUR13.87RA
 EUR9.84DE
 EUR56.20XT

TOTAL: EUR885.91

Gate Boarding Time Seat

FUEHREN SIE DIESEN
BELEG WAEHREND
DER GESAMTEN REISE
MIT SICH
ELECTRONIC TICKET

220 6285979654

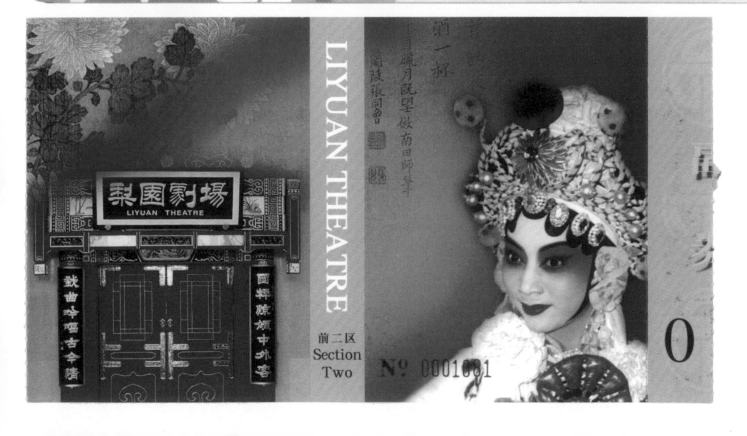

LIYUAN THEATRE

梨園劇場
LIYUAN THEATRE

前二区
Section Two

№ 0001001

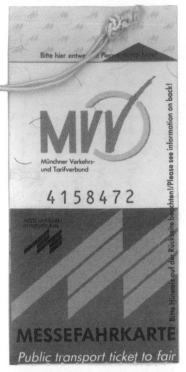

AIRLANKA

№ 30466
HKG

№ 30466
CMB

AIRLANKA
№ 30466

Baggage checked subject to tariffs, including limitation of liability therein contained. This is not the Luggage ticket (baggage check) described in article 4 of the Warsaw Convention or the Warsaw Convention as amended by the Hague Protocol, 1955

TRA -181

Bitte hier entwerten / Please come here!

MVV
Münchner Verkehrs- und Tarifverbund

4158472

MESSE MÜNCHEN INTERNATIONAL

MESSEFAHRKARTE
Public transport ticket to fair

Bitte Hinweis auf der Rückseite beachten!/Please see information on back!

Hamburger Verkehrsverbund /HVV/

Einzelkarte 2.Kl.
Nahbereich oder
Ergänzungskarte zu Zeitkarten
Holstenstraße HS502 60
25.01.00 21:29 **2.70 DM

Ausgegeben durch S-Bahn Hamburg GmbH

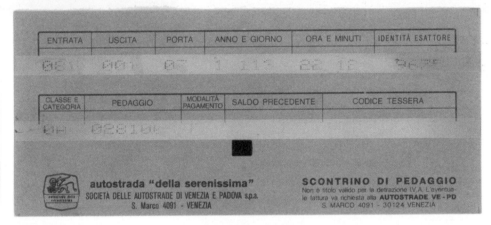

ENTRATA	USCITA	PORTA	ANNO E GIORNO	ORA E MINUTI	IDENTITÀ ESATTORE

CLASSE E CATEGORIA	PEDAGGIO	MODALITÀ PAGAMENTO	SALDO PRECEDENTE	CODICE TESSERA

autostrada "della serenissima"
SOCIETÀ DELLE AUTOSTRADE DI VENEZIA E PADOVA s.p.a.
S. Marco 4091 - VENEZIA

SCONTRINO DI PEDAGGIO
Non è titolo valido per la detrazione I.V.A. L'eventuale fattura va richiesta alla AUTOSTRADE VE - PD
S. MARCO 4091 - 30124 VENEZIA

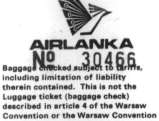

Hamburger Verkehrsverbund S

Einzelkarte 2.Kl.
Nahbereich oder
Ergänzungskarte zu Zeitkarten
Bahnhof HS502 60
05.06.99 **2.70 DM

Hamburger Verkehrsverbund S

Einzelkarte 2.Kl.
Nahbereich oder
Ergänzungskarte zu Zeitkarten
Gesundh HS502 60
09.01.00 10:04 **2.70 DM

Hamburger Verkehrsverbund /HVV/

Einzelkarte 2.Kl.
Nahbereich oder
Ergänzungskarte zu Zeitkarten
Hauptbahnhof HH505 GH
21.10.01 13:11 **2.70 DM 01

Ausgegeben durch S-Bahn Hamburg GmbH

Hamburger Verkehrsverbund /HVV/

Einzelkarte 2.Kl.
Nahbereich oder
Ergänzungskarte zu Zeitkarten
Altona HS505 60
25.01.00 14:13 **2.70 DM

Ausgegeben durch S-Bahn Hamburg GmbH

York Hotel

21, MOUNT ELIZABETH, SINGAPORE 0922.
TELEPHONE: 7370511

	DATE	SERVER	TABLE NO	NO OF PERSONS	212696
1				1 WHITROSE	
2				CHK 696 18NOV'93 21:05 GST 1	
3					
4				1 FRESHLY SQ JUICE 5.00	
5				1 BUFFET DINNER(A) 19.80	
6				TAX 4% 1.00	
7				SVC 10% 2.50	
8				TOTAL DUE 28.30	
9				VOID	
				1 B. Dinner -19.80	
10					
11				1 OPEN FOOD WS 4.50	
12				1 FROM DRINK 2.50	
13				TAX 4% 0.50	
14				SVC 10% 1.20	
15				TOTAL DUE 13.70	
16					
17					
18					
19					
20					
21					
22					
23					
24					
25					

NO TIPPING, PLEASE
10% SERVICE CHARGE & GOVT. TAX

AMOUNT PAID OR CHARGED PRINTED HERE ➡

GUEST
NAME

SIGNATURE ROOM NO. 1602

EinzelTicket
1-2 Tarifzonen Erw.
A 1,90
PS EUR
KVB VRS
84035 1107 R 007 020515 08:49

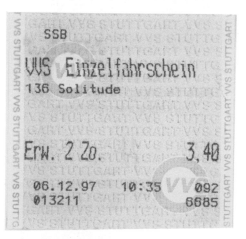

ISARCARD ***9,50EUR
260 *VB 07.04*11:38 *45042
1.-2. Ring
15.WOCHE 03
KONTROLLNR.XX 00801

SSB
VVS Einzelfahrschein
136 Solitude

Erw. 2 Zo. 3,40
06.12.97 10:35 092
013211 6685

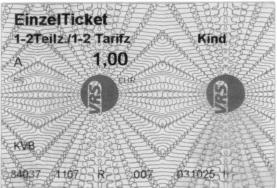

EinzelTicket
1-2Teilz./1-2 Tarifz Kind
A 1,00
PS EUR
KVB
84037 1107 R 007 031025

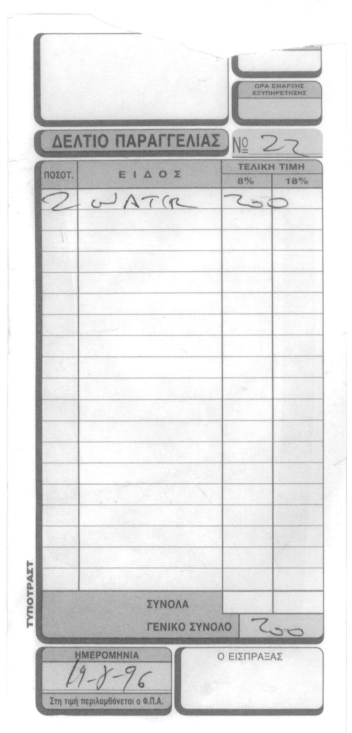

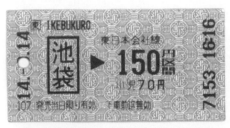

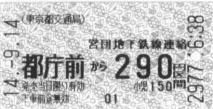

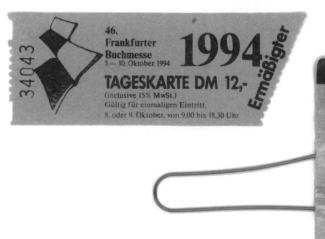

EinzelTicket

Preisstufe K Erw.

K 1,30

KVB VRS

68001 2100 HEUM 051229 13:18

EinzelTicket

Preisstufe K Erw.

K 1,30

KVB
NEUMARKT
84074 0002 4074 051228 16:57

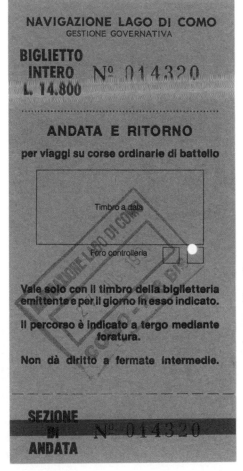

NAVIGAZIONE LAGO DI COMO
GESTIONE GOVERNATIVA

BIGLIETTO
INTERO N° 014320
L. 14.800

. .

ANDATA E RITORNO

per viaggi su corse ordinarie di battello

Timbro a data

Foro controlleria

Vale solo con il timbro della biglietteria
emittente e per il giorno in esso indicato.

Il percorso è indicato a tergo mediante
foratura.

Non dà diritto a fermate intermedie.

SEZIONE
DI N° 014320
ANDATA

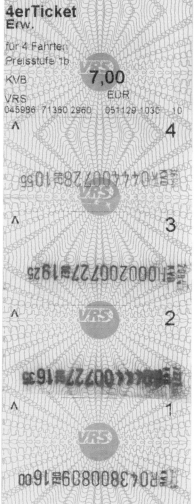

4erTicket
Erw.

für 4 Fahrten
Preisstufe 1b

KVB 7,00

VRS EUR
045996 71360 2960 051129 1030 10

PAYMENT RECEIPT

Mrs Maja Neske
Barbican Customer number:1647048

Total value: £54.00
Postal/Admin. charge: £1.00
Grand Total £55.00
Total paid by American Express £55.00
####

Booking reference: 4784324 14-09-2005 11-

Reduced booking fee online
www.barbican.org.uk

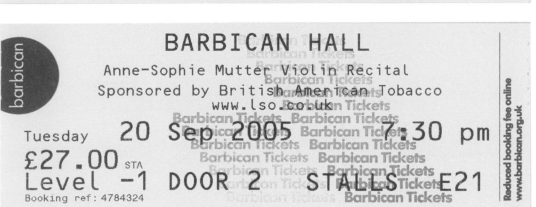

BARBICAN HALL

Anne-Sophie Mutter Violin Recital
Sponsored by British American Tobacco
www.lso.co.uk

Tuesday 20 Sep 2005 7:30 pm

£27.00 STA
Level -1 DOOR 2 STALLS E21
Booking ref: 4784324

Reduced booking fee online
www.barbican.org.uk

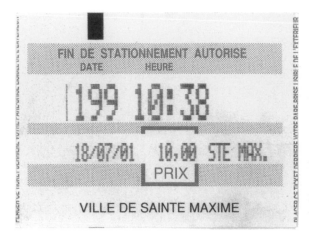

FIN DE STATIONNEMENT AUTORISE
DATE HEURE

199 10:38

18/07/01 10,00 STE MAX.

PRIX

VILLE DE SAINTE MAXIME

PRIX PAYE	SEMAINE	JOUR	FIN DU STATIONNEMENT AUTORISE
	01.00	23 MA	12:00

PLACER CE TICKET DERRIÈRE VOTRE PARE-BRISE LISIBLE DE L'EXTERIEUR

SOGEPARC

PRIX PAYÉ	SEMAINE	JOUR	FIN DU STATIONNEMENT AUTORISÉ	PRIX PAYÉ	SEMAINE	JOUR	FIN DU STATION AUTORIS
	18.00	37 ME	18:26				

PLACER CE TICKET DERRIÈRE VOTRE PARE-BRISE LISIBLE DE L'EXTÉRIEUR SOUCHE A CONSERVER

PRIX PAYÉ	SEMAINE	JOUR	FIN DU STATIONNEMENT AUTORISÉ	PRIX PAYÉ	SEMAINE	JOUR	FIN DU STATION AUTORIS
	10.00	37 ME	15:00				

PLACER CE TICKET DERRIÈRE VOTRE PARE-BRISE LISIBLE DE L'EXTÉRIEUR SOUCHE A CONSERVER

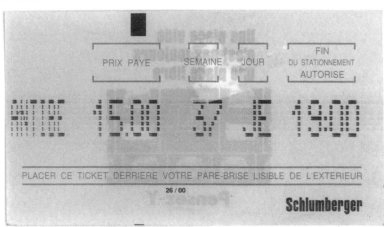

PRIX PAYE	SEMAINE	JOUR	FIN DU STATIONNEMENT AUTORISE
	15.00	37 JE	18:00

PLACER CE TICKET DERRIERE VOTRE PARE-BRISE LISIBLE DE L'EXTERIEUR

26 / 00

Schlumberger

005777 001 04154 0

Es gelten die Tarif- und Beförderungsbestimmungen der DB AG sowie innerhalb von Verkehrsverbünden/Tarifgemeinschaften deren jeweiligen Bestimmungen.

Bitte beachten Sie! Bei Ihrem Fahrschein handelt es sich um Thermopapier. Bitte vor Sonneneinstrahlung, Feuchtigkeit und Wärme schützen. Auch nicht anderen schädigenden Stoffen wie

Dopravní podnik hl. m. Prahy, akciová společnost

000481 *321300
Nepřestupní jízdenka zlevn.
povrchová doprava.....15 min
metro 4 stanice...max.30 min
mimo noční linky a lan.dráhu

PRAŽSKÁ INTEGROVANÁ DOPRAVA

4 Kč PRAHA nebo 2P

den Fahrschein ungültig. Der Fahrschein ist auf Thermopapier gedruckt. Bitte schützen Sie ihn vor direkter Sonneneinstrahlung, Feuchtigkeit, Wärme sowie vor Lösungsmitteln, Fetten o. a. schädigenden Stoffen. Wir wünschen Ihnen eine angenehme Fahrt.

S-Bahn Berlin GmbH
Invalidenstraße 19, 10115 Berlin
Tel. (0 30) 29 74 33 33
www.s-bahn-berlin.de

00821900702482

Änderungen oder Manipulationen machen den Fahrschein ungültig. Der Fahrschein ist auf Thermopapier gedruckt. Bitte schützen Sie ihn vor direkter Sonneneinstrahlung, Feuchtigkeit, Wärme sowie vor Lösungsmitteln, Fetten o. a. schädigenden Stoffen. Wir wünschen Ihnen eine angenehme Fahrt.

S-Bahn Berlin GmbH
Invalidenstraße 19, 10115 Berlin

008219 008219 008219

L NFA 01/04 L NFA 01/04 L NFA 01/04

Berlin Bahn Berlin Deutsche Bahn Gruppe

SHVV

Einzelkarte
2. Kl. Großbereich Hamburg
HADAG LANDUNGSB 0039 A 32
26.12.04 13:06 2.40 EUR

DB CIV 80

Gültigkeit: H:am 14.03.03

FAHRKARTE E/K 1/0
NORMALPREIS KL.2 1 BC
 EINFACHE FAHRT

1 Von :Babenhausen (Hess)
1 Nach:Aschaffenburg Hbf
= VIA :
1
5
8
1 187005*134 BARZAHLUNG EUR ****1,25
1 Zub R enthält MWSt 7 % EUR ××*0,08
- Würzburg 93032984 Netto EUR ***1.17
 93032984

DB

1.Geltungstag: 29.03.98 Hinfahrt Rückfahrt
Fahrschein gilt bis: frühestens:
gilt bis zum: -------- 01.04.98 --------

ICE Kl: 2 EINFACHE FAHRT BC (B)

Von :Kufstein
Nach:Frankfurt (Main) City
Über:RO* (ICE:M*MA*F)

057521-253 DM ***77,50
Zub F (MWST: ~~10, 11)
Stuttgart 35961224
 35961224

DB 18

88945851

DB 07

12495301

DB 06

12495300

Austeller Exhibitor
Entrance pass for all days

Nicht übertragbar; nur zusammen mit Personalausweis gültig. Wiedereintritt am selben Tag: Vor Verlassen des Geländes Autorisierung durch Supervisor.

Non-transferable; valid only with identification. To exit and re-enter on the same day: please contact the gate supervisor for prior approval before leaving the fairgrounds.

11.04 12.04 13.04 14.04 15.04

Ticket Code http://www.hannovermesse.de
fsox f7w zre r35

A

31 5 5 5 0044108 55

AIRLANKA

№ 56202

TRV

№ 56202

CMB

AIRLANKA

№ 56202

Baggage checked subject to tariffs,
including limitation of liability
therein contained. This is not the
Luggage ticket (baggage check)
described in article 4 of the Warsaw
Convention or the Warsaw Convention
as amended by the Hague Protocol, 1955

TRA - 183

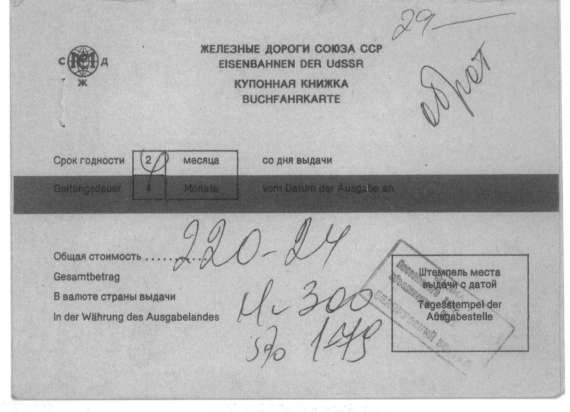

с д ж

ЖЕЛЕЗНЫЕ ДОРОГИ СОЮЗА ССР
EISENBAHNEN DER UdSSR

КУПОННАЯ КНИЖКА
BUCHFAHRKARTE

29
оброт

| Срок годности | 2 | месяца | со дня выдачи |
| Geltungsdauer | 4 | Monate | vom Datum der Ausgabe an |

Общая стоимость *220-24*

Gesamtbetrag

В валюте страны выдачи

In der Währung des Ausgabelandes *Ил 300*

5% 148

Штемпель места
выдачи с датой

Tagesstempel der
Ausgabestelle

с д ж

ЖЕЛЕЗНЫЕ ДОРОГИ СОЮЗА ССР
EISENBAHNEN DER UdSSR

КУПОННАЯ КНИЖКА
BUCHFAHRKARTE

| Срок годности | 2 | месяца | со дня выдачи |
| Geltungsdauer | | Monate | vom Datum der Ausgabe an | *110,10 5,00 250*

ВХО
„Интурист-Ленинград"
Общая стоимость Фирма „Интуртранс"
Gesamtbetrag „ *25 06 91* " г.

В валюте страны выдачи

In der Währung des Ausgabelandes

Штемпель места
выдачи с датой

Tagesstempel der
Ausgabestelle

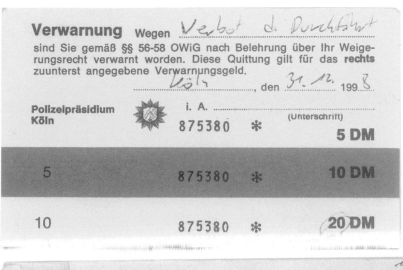

Verwarnung Wegen _Verbot d. Durchfahrt_

sind Sie gemäß §§ 56-58 OWiG nach Belehrung über Ihr Weigerungsrecht verwarnt worden. Diese Quittung gilt für das **rechts** zuunterst angegebene Verwarnungsgeld.

Köln , den _31. 12._ 199 _8_

Polizeipräsidium
Köln

i. A. _____
(Unterschrift)

875380 *

5 DM

| 5 | 875380 * | **10 DM** |
| 10 | 875380 * | **20 DM** |

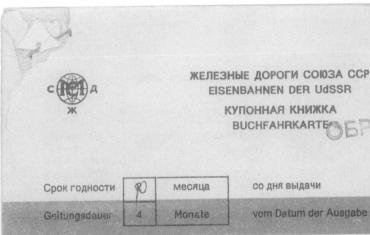

ЖЕЛЕЗНЫЕ ДОРОГИ СОЮЗА ССР
EISENBAHNEN DER UdSSR

КУПОННАЯ КНИЖКА
BUCHFAHRKARTE ОБРАТНЫЙ

Срок годности [20] месяца со дня выдачи

Geltungsdauer [4] Monate vom Datum der Ausgabe an

Общая стоимость _ROT 220-24_

Gesamtbetrag _up 300_

В валюте страны выдачи _5% 17S_

In der Währung des Ausgabelandes

| Штемпель места выдачи с датой |
| Tagesstempel der Ausgabestelle |

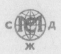

ЖЕЛЕЗНЫЕ ДОРОГИ СОЮЗА ССР
EISENBAHNEN DER UdSSR

КУПОННАЯ КНИЖКА
BUCHFAHRKARTE

Срок годности [2] месяца со дня выдачи

Geltungsdauer [4] Monate vom Datum der Ausgabe an

110,10 5.00 280

Общая стоимость

Gesamtbetrag _25 06 91_

В валюте страны выдачи

In der Währung des Ausgabelandes

| Штемпель места выдачи с датой |
| Tagesstempel der Ausgabestelle |

IBERIA IB

IB 8971119

Bultos:	Peso:
Destino To	_DEN_
Compañia Airline	Vuelo Flight
Co	_123_
Via	_JFK_
Compañia Airline	Vuelo Flight
TW	_777_
Via	_LON_
Compañia Airline	Vuelo Flight
MH	_002_

IB-756

EinzelTicket
1-2Teilz./1-2 Tarifz Kind
A 1,00
KVB VRS
84008 1111 H 007 031027 10:06

EinzelTicket
1-2 Tarifzonen Erw.
A 2,00
EUR
KVB VRS
68001 1101 HEUM 031004 12:03

EinzelTicket
1-2 Tarifzonen Erw.
A 2,00
EUR
KVB VRS
68001 1101 HEUM 031227 14:32

EinzelTicket
1-2 Teilzonen Erw.
K 1,25
EUR
KVB VRS
82329 1101 R 016 030721 20:55

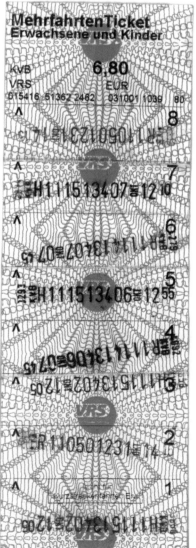

MehrfahrtenTicket
Erwachsene und Kinder
KVB 6,80
VRS EUR
015416 51362 2462 031001 1039 80
8
7
6
5
4
3
2
1

EinzelTicket
1-2Teilz./1-2 Tarifz Kind
A 1,00
KVB VRS
84050 1107 H 007 031026 13:08

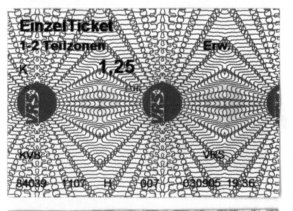

EinzelTicket
1-2 Teilzonen Erw.
K 1,25
KVB VRS
84039 1102 H 007 030905 19:36

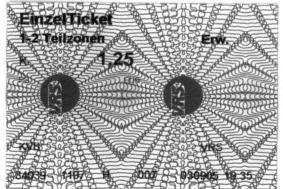

EinzelTicket
1-2 Teilzonen Erw.
K 1,25
KVB VRS
84039 1107 H 007 030905 19:35

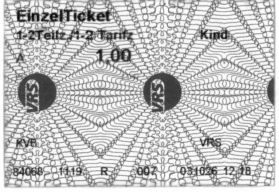

EinzelTicket
1-2Teilz./1-2 Tarifz Kind
A 1,00
KVB VRS
84068 1119 R 007 031026 12:18

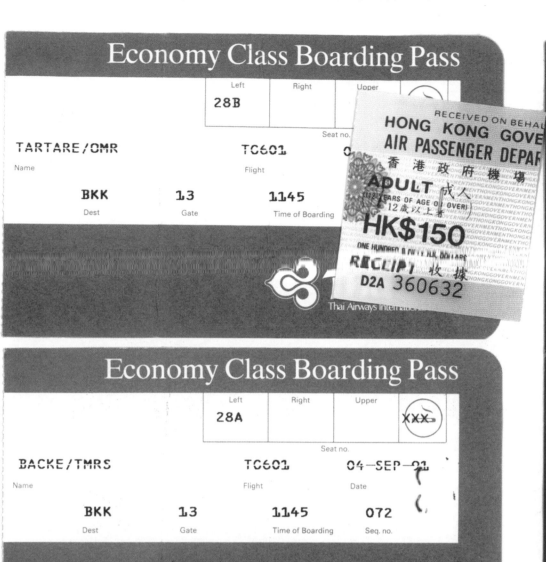

Economy Class Boarding Pass

	Left	Right	Upper
	28B		

Seat no.

TARTARE/OMR
Name

TC601
Flight

BKK
Dest

13
Gate

1145
Time of Boarding

Thai Airways International

	Reihe Row	Platz Seat
	33	B
	Rangée Fila	Siège Asiento

Via
Hintere Tür
Rear door
Porte arrière
Puerta trasera

HF

Hapag-Lloyd Flug

Sitzplatzkarte + Einsteigekarte
Seating card + Boarding pass
Carte d'accès à bord
Tarjeta de embarque 261

Warteraum

RECEIVED ON BEHAL
HONG KONG GOVE
AIR PASSENGER DEPAR
香港政府機場
ADULT 成人
(12) YEARS OF AGE O (OVER)
12歲以上者
HK$150
ONE HUNDRED & FIFTY HK DOLLARS
RECEIPT 收據
D2A 360632

Economy Class Boarding Pass

	Left	Right	Upper
	28A		XXX

Seat no.

BACKE/TMRS
Name

TC601
Flight

04-SEP-91
Date

BKK
Dest

13
Gate

1145
Time of Boarding

072
Seq. no.

Thai
Thai Airways International Limited

DB	1.Geltungstag: 21.02.98	Hinfahrt	Rückfahrt
	Fahrschein gilt bis zum: -------	gilt bis: 24.02.98	frühestens: --------

1
8
=
0
0
7
2
4

K1: 2 EINFACHE FAHRT BC(B)
Von : Frankfurt (Main)
Nach: Köln
Über: (NR/KO)

057075*215
Zub F
Dortmund 40524458

DM ***29,50
(MWST: ***3,85)

40524458

DB	1.Geltungstag: 21.02.98	Hinfahrt	Rückfahrt
	Fahrschein gilt bis zum: -------	gilt bis: --------	frühestens: 21.02.98

1
8
0
0
7
2
4

K1: X EC/IC-ZUSCHLAG (ZUG) -------
E:1 K:X

057075*215
Zub F
Dortmund 40524459

DM ****8,00
(MWST: ***1,04)

40524459

Einzel Ticket
VRS VRS
Preisstufe A 1-2 Zonen 3,30 DM
VRS
472KB1113E007 17DEZ98 16:34
25 072579 Nur gültig mit Entwerteraufdruck

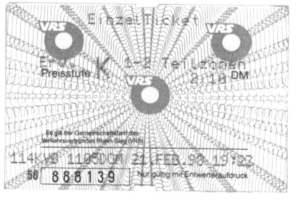

Einzel Ticket
VRS VRS
Preisstufe K 1-2 Teilzonen 2,18 DM
VRS
114KVE 11000M 21.FEB.98 13:23
50 888139 Nur gültig mit Entwerteraufdruck

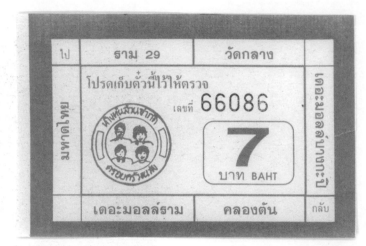

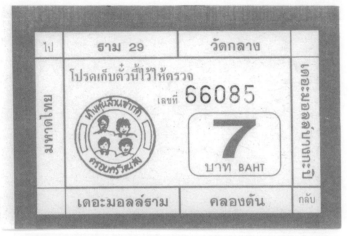

6745 *

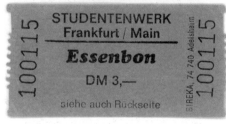

6745 *

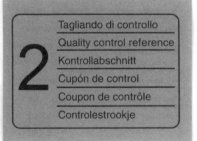

	Tagliando di controllo
	Quality control reference
2	Kontrollabschnitt
	Cupón de control
	Coupon de contrôle
	Controlestrookje

RÉPUBLIQUE FRANÇAISE

CARTE DE SÉJOUR
DE RÉSIDENT TEMPORAIRE

EE 050180

ETR 120 S-1

STUDENTENWERK
Frankfurt / Main

Essenbon

DM 3,—

siehe auch Rückseite

100115 100115 BIREKA, 74 740 Adelsheim

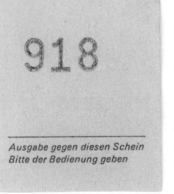

918

*Ausgabe gegen diesen Schein
Bitte der Bedienung geben*

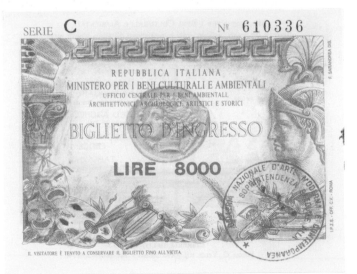

SERIE C № 610336

REPUBBLICA ITALIANA
MINISTERO PER I BENI CULTURALI E AMBIENTALI
UFFICIO CENTRALE PER I BENI AMBIENTALI,
ARCHITETTONICI, ARCHEOLOGICI, ARTISTICI E STORICI

BIGLIETTO D'INGRESSO

LIRE 8000

IL VISITATORE È TENUTO A CONSERVARE IL BIGLIETTO FINO ALL'USCITA.

Die Gartenordnung wird anerkannt.

451633

Eintrittskarte
Erwachsener
9,00 €
inkl. 10 % Baubeitrag

Zoo Berlin

Die Gartenordnung wird anerkannt.

618181

Eintrittskarte
Erwachsener
9,00 €
inkl. 10 % Baubeitrag

Erhöhung 1,00 € Zoo Berlin

16MG01 1312 555

LATO DI INSERIMENTO
INSERT THIS SIDE UP

* 70476 /B

OPERA S. MARIA DEL FIORE • FIRENZE

CERRAI

BATTISTERO

LIRE 5.000

ESENTE IVA - ART. 10.22 D.P.R. 633/72
CONSERVARE IL BIGLIETTO FINO ALL'USCITA
VISITORS MUST KEEP THE TICKET DURING THE VISIT

Thai
Thai Airways International Limited

FRA
FRANKFURT

TG 10-57-48

Thai

TG 10-57-45

FRA
FRANKFURT

Airline / Flight.

TG / 924

阳朔县水路客运管理站

综 合 服 务 管 理 处

壹 元 1.00 外

Nº 0005374

越秀公园

地址：解放北路　电话：3346494

AANVULLENDE DIENST

P 4587 (versie 0295) - 64278

ЗУБОЧИСТКИ
100 шт.

МЛХ БССР
БУДА-КОШЕЛЕВСКИЙ ЛЕСХОЗ

ЗУБОЧИСТКИ ДЕРЕВЯННЫЕ
Артикул ГМ 107-130
К-во 100 шт.
Цена 38 коп.
Дата выпуска
ТУ 56 БССР 9--81. Штамп ОТК

ГфП. Зак. 7293.--600000

SHOCON

HEAVY
CHECKED BAG

PESANTE
BAGAGLIO

HEAVY

HEAVY

BAGAGLIO
PESANTE

HEAVY
CHECKED BAG

KG

ORFEO - Kino
Hamburgerallee 45
6000 Frankfurt 90
Eintrittskarte
Preise It. Aushang
Nur für d. gelöste Vorstellg. gültig. Auf-
bewahren, auf Verlangen vorzeigen.

03.11.47

tcc
Coupon SEMAINE
193898 E
NE PAS OBLITÉRER
VALABLE A PARTIR DU LUNDI
1 9 JUIN 1989
JUSQU'AU DIMANCHE SUIVANT INCLUS
Carte blanche
N° 214777

TRAJET 052B
05 18JN 14:04

Valable pour 1 trajet
RETOUR INTERDIT
529 04A04 20FE 14:37
143112

CABIN BAGGAGE

FIRST CLASS

Philippine Airlines

DEBIT-CREDIT CARD SALES VOUCHER

Description	Number	Total
2 TICKETS	13471	£33·60S

Date: 24·JUN·05 Issuing office: Victoria 5154⊕5426S88

AMERICAN EXPRESS
**** ****** CARDHOLDER'S COPY

Expires Authorised
01/06 90

DEBIT/CREDIT CARD SALES VOUCHER N9422181867
T21093844

Qty Description	Number	Total
001 TICKET	49621	£24·00S

Date: 15·JLY·05 Issuing Office: LIVERPOOL STREET 2032⊕1899E24
Customer card number AMEX Expires 03/06
**** **** **** CARDHOLDER'S COPY

Authorised Sale Confirmed
20

Debit my card account with the total amount
Please retain for your records

Class	Ticket Type	Adult	Child	
STD	STD OPEN RETURN	ONE	NIL	RTN

Start date Number
15·JLY·05 76024 2032⊕1899E24

From	Valid Until	Price
STANSTED AIRPORT	14·AUG·05	£24·00X
To	Route	
LONDON TERMINALS	ANY PERMITTED	1120

2-PART RETURN Printed 11:20 on 15·JLY·05

Class	Ticket Type	Adult	Child	
STD	STD OPEN RETURN	ONE	NIL	OUT

Start date Number
15·JLY·05 76024 2032⊕1899E24

From	Valid Until	Price
LONDON TERMINALS	14·AUG·05	£24·00X
To	Route	
STANSTED AIRPORT	ANY PERMITTED	1120

2-PART RETURN Printed 11:20 on 15·JLY·05

P.V.P.	P.V.P.
Pts 615	Pts 560
P.V.P. 340	Pts 225
Pts 220	Pts 255
Pts 195	P.V.P. 220
Pts 60	Pts 100
Pts 135	
Pts 280	
Pts 340	
Pts 745	

HANDLER BÜRGERFEST 18·BIS 20·AUGUST·1962

LICHTLEISTE M.ABDECKUNG 58W 3519333

STÜCK € 17.90

35,-

4 015904 003428 35000

RÉUNION DES MUSÉES NATIONAUX
ENTRÉE
PLEIN TARIF
36 F
293552
MODRE FRANCE H60PT

4/160
€ 4,50

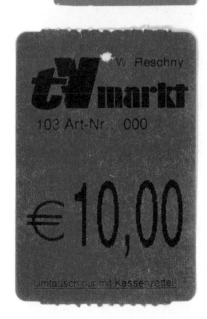

tVmarkt W. Reschny
103 Art-Nr.: 000

€ 10,00

Umtausch nur mit Kassenzettel

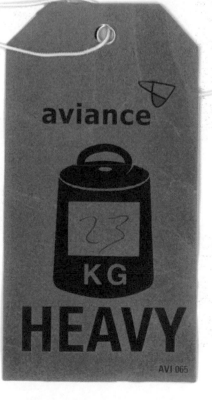

aviance

23

KG

HEAVY

AVI 065

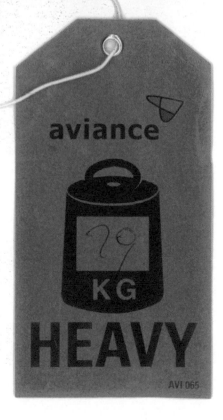

aviance

29

KG

HEAVY

AVI 065

47

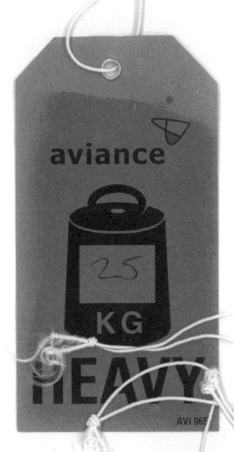

aviance

25

KG

HEAVY

AVI 065

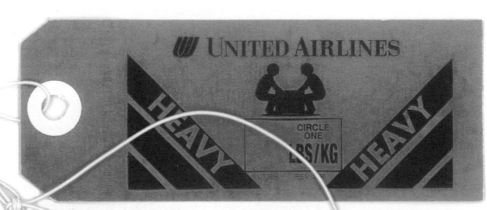

UNITED AIRLINES

HEAVY

CIRCLE
ONE
LBS/KG

UT3BH REV

HEAVY

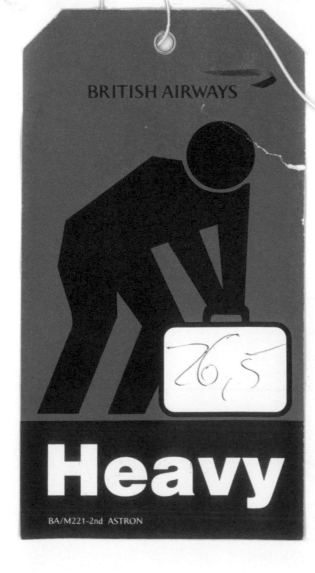

BRITISH AIRWAYS

26,5

Heavy

BA/M221-2nd ASTRON

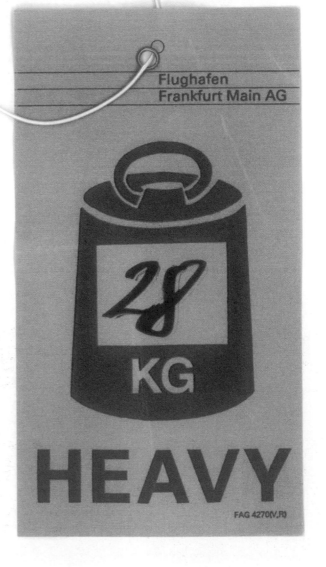

Flughafen
Frankfurt Main AG

28

KG

HEAVY

FAG 4270(V.R)

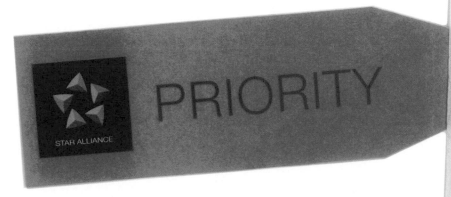

PRIORITY

STAR ALLIANCE

78056.01

262€

REDUZIERT

262 2,00

ZERBRECHLICH

Bitte nicht werfen

o k t G m b H

NICHT
BELASTEN!

SK 128 ratioform 85652 Landsham

DM ,99

Mindestens haltbar
bei: 14.17

€0,99

FRAGILE

HANDLE WITH CARE

malaysia AIRLINES

F-0185
07-82

FRAGILE

FRAGIL

Philippine Airlines

قابلــة للكسـر

FRAGILE

◆MEA CHECKED BAGGAGE

1-C14

FRAGILE

قابل للكسر

طيران الخليج
GULF AIR

GF-2068 (4/03) 3385368

FRAGILE

شكستني

IRAN AIR
The Airline of the
ISLAMIC REPUBLIC OF IRAN

۹۳۰–۱۲–۱۲

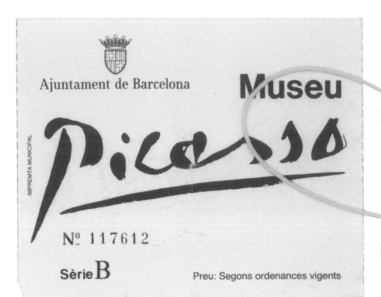

Ajuntament de Barcelona

IMPREMTA MUNICIPAL

Museu

Picasso

Nº 117612

Sèrie B Preu: Segons ordenances vigents

AÉROPORT NICE CÔTE D'AZUR
CHAMBRE DE COMMERCE ET D'INDUSTRIE NICE CÔTE D'AZUR

P1

/1049 3527/020027915/052031
7:29 29/08/03 BE 1 - P1
TVA Parc P1
 ATTENTION : PARKING LIMITÉ À 2 HEURES DE STATIONNEMENT
 AU-DELÀ : PÉNALITÉ INDIVISIBLE DE 25 €/JOUR
29/08/03 20:19

351002

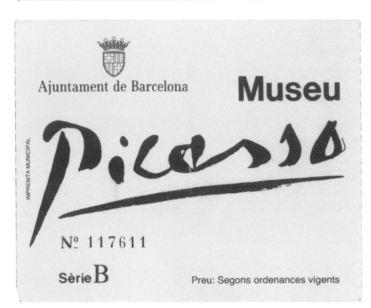

Ajuntament de Barcelona

IMPREMTA MUNICIPAL

Museu

Picasso

Nº 117611

Sèrie B Preu: Segons ordenances vigents

FIRST CLASS
Cabin Baggage in passenger's own care.

NAME *Backe*

DESTINATION

FLIGHT NO.

TRA 27

AIRLANKA

21

Eintritt Erwachsener 6,50

06.03.05

KPMG-Kunstabend

Jeden 1. Mittwoch ab 18.00 Uhr
Eintritt frei

K21

KUNSTSAMMLUNG NORDRHEIN-WESTFALEN

STADT- UND UNIVERSITÄTSBIBLIOTHEK
SENCKENBERGISCHE BIBLIOTHEK

Bockenheimer Landstraße 134-138
6000 Frankfurt am Main 1 Telefon 2 12 39-256

LESERAUSWEIS

Backe, Tanja

T 00 782 378

桂林市交通费
（91）报 销 单
人民币

含公路建设基金
含保险金
车 号

№ 0065462

桂林市交通费
（91）报 销 单
人民币

含公路建设基金
含保险金
收款人

№ 0065464

桂林市交通费
（91）报 销 单
人民币

含公路建设基金
含保险金
收款人

№ 0065465

FLT. NO.

DP. 116

01575

01577

16MG01 1151 247

LATO DI INSERIMENTO
INSERT THIS SIDE UP

＊ 716390 /A

OPERA S. MARIA DEL FIORE • FIRENZE

CERRAI - Pisa

CUPOLA

LIRE 10.000

ESENTE IVA - ART. 10.22 D.P.R. 633/72

CONSERVARE IL BIGLIETTO FINO ALL'USCITA
VISITORS MUST KEEP THE TICKET DURING THE VISIT

Bangkok
Airways
สายการบินภายในประ

271157

Rheinfähre
Königswinter GmbH

Fahrgeldquittung

DM 1.30

Im Fahrpreis ist der
ermäß. Satz der MWSt.
enthalten.
Nur am Lösungstag gültig.
Während der Fahrt aufbe-
wahren und auf Verlangen
vorzeigen. Beförderungs-
bedingungen beachten.

Druck Fronhofer, Regensburg

271155

CAAC

民航广西区局

乘机旅客班车票

贰元伍角

广西壮族自治区桂林旅游局
发票
监制章

桂〈林〉字

№ 0105714

A1 000839

DM 2,60

Erwachsene Preisstufe I

Bremen

Wir fahren Sie zum VBN-Tarif

A 066337

DM 4,70

Erwachsene Preisstufe C

Wir fahren Sie zum VBN-Tarif

上海中联商厦
工商登记：3100001001904
税务登记：310044132216911
发方税票盘联 中联
销零 04-0092569
（销货结算单）

电脑编号 0048174

户名 _____ 20○4年6月2日

品 名	规 格	数量	单位	单价	金 额								②
					万	千	百	十	元	角	分		
棉质衬衫				68.00				6	8	0	0		
合计人民币（大写） 陆拾捌元整							¥	6	8	0	0		

南京东路340号 邮编200001 电话：63515300 浦发行黄浦分行 076363-4100304269

现 金	支 票	卡	

柜号 _____ 营业员 03-31

发票未经本店盖章无效

苏州市代办铁路客运票价手续费定额发票
江苏省苏州市
地方税务局监制
发 票 联
客户收执
金 额
320503
837724748
苏地 (203111)字 N○ 0117451 年 月 日
发票专用章
（加盖发票专用章有效）

北京市出租汽车专用发票
BEIJING TAXI RECEIPT
北京市
发票联
地方税务局监制
INVOICE

发票号 1000040116
No. 11383001

监督电话：
Supervision Tel
市发展改革委：12358
Development and
Innovation Council of Beijing
市交通委员会：68351150
Communication
Council of Beijing

北京市出租汽车发票专用章

机打发票 手写无效

单 位 Section	
电 话 Tel	63741888
车 号 Taxi No	京B-C7890
证 号 Certificate No	
日 期 Date	2005-03-27
上 车 ON	13:29
下 车 OFF	13:38
单 价 Unit Price	1.20
里 程 Mileage	3.6
等 候 Wait	00:02:05
状 态 State	1
金 额 Sum	¥10.00

密 码
PASSWORD

Kızılsaray Mah. 80.Sok. No:4 Ü.K.V.D.6130048422 B.Yılı:2002 Anl.Tarihi:04.02.2002/65 ANTALYA

S

08/04/2003

Finike Döviz
TİCARET A.Ş.
MALİYE BAKANLIĞI T.C.
SERİ A
SIRA NO: 9249
160469

Kazım Özalp Cad. Büyükşehir İş Merk.
No.: 35 ANTALYA
Tel-Da (0 242) 244 45 60-61 Pbx
Ant. Kurumlar V. D. 388 015 4168
İL KODU : 07 DÖVİZ ALIM BELGESİ

MÜESSESE KODU : 1092

EURO		EUR
	200.00	
	1,740,000.00	
	348,000,000.00	
	212.71	
	348,000,000.00	

Y.UcYuzKırkSekizMilyonTL

B.Yeri : KUTLU & AVCI OFSET FORM BASKI Yusuf Mavalar T.: 241 85 20 (Pbx) Fax: 241 88 54

中国工商银行
THE INDUSTRIAL AND COMMERCIAL BANK OF CHINA

日期	时间	状态
20030302	14:46:15	000000

交易序号	交易代码	机号
095579	010000	10010647

ACCEPT

卡号
67255050*****5
SUB:

金额
WITHDRAW FOR RMB1,000.00

转入帐号 109,91€ 手续费

储户须知

1. 存款金额以本行实际收到的现金为准
 Deposits will be credited to your account after
 verification by the Bank.
2. 如对凭条有疑问请及时与银行联系
 Should you have any questions, please contact
 the Bank.
3. 此凭条只供储户存款与取款核对之用, 不作
 任何凭据
 The Customer Advice only serves as the chec-
 king ship for the Customer other than any other
 proofs of whatever nature.

工商银行自动柜员机竭诚为您提供
迅速、准确、方便、安全的优质服务!

北京市友谊公司交款单 N? 007256

19 年 8 月 17 日

编 号	品 名	单位	数量	单价	金 额
66-15	笔		2		3.00

人民币(大写) 叁元

本票不做报销凭证 售货员签章

苏州市代办铁路客票服务费定额发票

江苏省苏州市

发 票 联

金 额

№ 0117452

320503
837724748

发票专用章

客 户 收 执

PASSENGER TICKET AND BAGGAGE CHECK PASSENGER COUPON **CIEE**

DATE AND PLACE OF ISSUE 91

NAME OF PASSENGER NOT TRANSFERABLE

Tartare / O Mr

ISIC YOUTH

USIT STUDENT
REISEN GMBH
FRANKFURT

ISSUED IN CONJUNCTION WITH
7470·998·537

RESTRICTIONS/ENDORSEMENTS

VALID ON DL FLIGHTS ONLY
NON-REFUNDABLE WITHOUT REFERENCE TO ISSUING OFFICE

009175·

NOT GOOD FOR PASSAGE	CARRIER	FLIGHT NUMBER	CLASS	DATE	TIME	ALLOW KG/PCS	TICKET DESIGNATOR	STATUS	NOT VALID BEFORE	AFTER
FROM SAN FRANCISCO	DL	1988	M	25 SEP						
TO NEW YORK JFK	DL	126					UEC	X		
TO FRANKFURT			V O I D							
TO VOID			V O I D							
TO VOID										

18 AUG 92

FOR OFFICE USE ONLY (1)

BOOKING REF/PNR	BAGGAGE CHECKED UNCK'D	PCS.		UNCK. WT.	PCS.	UNCK. WT.	PCS.	UNCK. WT.	PCS.	UNCK. WT.	S/OVER PERMITTED

	CPN	AIRLINE	FORM	SERIAL NUMBER	CK

TAX

TAX

⊙ 000 7470998538 3 □

DO NOT MARK OR WRITE IN WHITE AREA ABOVE

桂林市湖滨饭店住宿

统一专用发票

桂（林）字 90（3）　№ 013959

姓名 外宾に

第二联：发票

房号	摘　要	天数	单价	金额超过万元无效	金　额	备　注
K217 2（8）	8月2日至　月　日	12	70		100	
	月　日至　月　日					
	月　日至　月　日					

合计人民币（大写）　万　仟　壹佰　　拾　　元　　角　　分

开票人签字　　　　　　　　　199 1 年 8 月 2 日

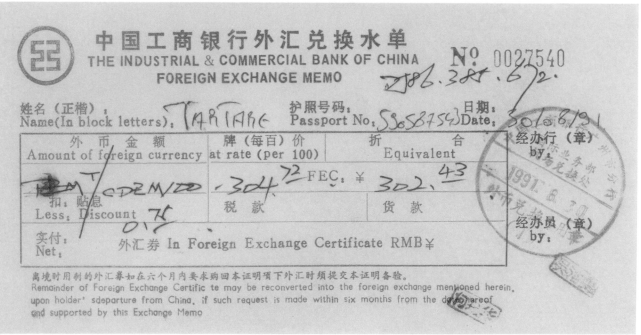

中国工商银行外汇兑换水单

THE INDUSTRIAL & COMMERCIAL BANK OF CHINA
FOREIGN EXCHANGE MEMO

№ 0027540

姓名（正楷）：
Name(In block letters)： TARTARE

护照号码： 53058754）
Passport No.

日期： 30/6/91
Date：

外币金额 Amount of foreign currency	牌（每百）价 at rate (per 100)	折　合 Equivalent
DEM/DEMV00	.304.72	FEC：¥ 302.43
扣贴息 Less：Discount 0.15	税款	货款

实付： 外汇券 In Foreign Exchange Certificate RMB¥
Net：

经办行（章）by：
1991. 6. 30
经办员（章）by：

离境时用剩的外汇券如在六个月内要求购回本证明项下外汇时须提交本证明备验。
Remainder of Foreign Exchange Certific te may be reconverted into the foreign exchange mentioned herein,
upon holder' sdeparture from China, if such request is made within six months from the date hereof
and supported by this Exchange Memo

北京市友谊公司交款单　　№ 057254

19　年 8 月 5 日

三联：交购货人收执

编　号	品　名	单位	数量	单价	金　额 千百十元角分
35-5			1		1000

人民币（大写）　￥10.00

本票不做报销凭证　　　　　　售货员签章

民航广西区局

CAAC

乘机旅客班车票

贰元伍角

桂〈林〉字

№ 0105713

RED & WHITE FLEET
Pier 41, Fisherman's Wharf
ALCATRAZ
TUESDAY SEPTEMBER 22, 1992
NO REFUNDS OR EXCHANGES
Please arrive at Pier 41
30 minutes prior to
Departure Time 1:15 PM
AZ0922

RED & WHITE FLEET
Pier 41, Fisherman's Wharf
ALCATRAZ
TUESDAY SEPTEMBER 22, 1992
NO REFUNDS OR EXCHANGES
Please arrive at Pier 41
30 minutes prior to
Departure Time 1:15 PM
AZ0922

Réservé Reserviert
Reserviert Riservato
Reserviert Riservato

00104 1042 182 A
97202 21.07
INTERLAKEN O AMSTERDAM CS

23 EXPRESSRESERVIERUNG
FäR PLATZKARTENINHABER
FREIGEBEN BITTE
21.07 182

Handled By	**TARJETA DE EMBARQUE**
IBERIA	BOARDING PASS

Control No.	Vuelo/Flight	Destino/Destination
020	LT 1281	FRANKFURT

Su puerta de embarque está indicada en los
Paneles de Información de SALIDAS y
en las pantallas de Televisión.

Su asiento/Your Seat
10 B

Your Departure Gate will be shown on
Departure Boards and Television Screens.

PEAK TRAMWAYS COMPANY LIMITED

Issued subject to Peak
Tramways Ordinance
and By-laws
NOT TRANSFERABLE
PEAK TRAMWAYS CO. LTD.

PEAK TRAMWAYS COMPANY LIMITED

| 9/14/92 - 10/10/92 | | DAILY | 10/11/92 - 11/1/92 | |
| --- | --- | --- | --- |
| Leave Pier 41 | Leave Alcatraz | Leave Pier 41 | Leave Alcatraz |
| 9:15 am | 9:40am | 9:45 am | 10:10 am |
| 9:45 | 10:10 | 10:15 | 10:40 |
| 10:15 | 10:45 | 10:45 | 11:10 |
| 10:45 | 11:15 | 11:15 | 11:45 |
| 11:15 | 11:45 | 11:45 | 12:15 pm |
| 11:45 | 12:15 pm | 12:15 pm | 12:45 |
| 12:15 pm | 12:45 | 12:45 | 1:15 |
| 12:45 | 1:15 | 1:15 | 1:45 |
| 1:15 | 1:45 | 1:45 | 2:15 |
| 1:45 | 2:15 | 2:15 | 2:45 |
| 2:15 | 2:45 | 2:45 | 3:15 |
| 2:45 | 3:15 | | 3:55 |
| 3:15 | 3:45 | | 4:35 |
| 3:45 | 4:15 | | |
| 4:15 | 4:45 | | |
| | 5:25 | | |
| | 6:05 | | |

FARES:	Round-Trip
Adult w/ Audio Tour	$ 8.50
w/o Audio	5.50
Senior (62+) w/ Audio	7.60
w/o Audio	4.60
Child (5-11) w/ Audio	4.00
w/o Audio	3.00

$2.00 service charge per ticket for charge-by-phone orders

Please allow enough time for the entire tour
(at least 2 hours).
Please wear comfortable WALKING shoes and
WARM clothing as it often gets chilly on the Island.

*Red & White Fleet is a concessionaire of the National Park
Service. Alcatraz is part of the Golden Gate National
Recreation Area (GGNRA)*

寿 № 0007972

乘座缆车（或滑道机降座缆平安保险凭证）

保 险 费：每人壹元
保险金额：每人因意外伤害身故给付人民币贰万元，附加意外伤害医疗人民币伍千元
保险期限：游客持票乘座缆车（或滑道）时起至乘座缆车（或滑道）结束时止
保险责任及索赔手续等内容保险合同专用章
(140)

中国人寿怀柔区公司

MÝVATN TOURS
JÓN ÁRNI SIGFÚSSON

TEL. 464 4196 - FAX 464 4380

ASKJA TOUR

No. 6589

北京市慕田峪
长城旅游服务公司
地方门禁卡

2005-3-27 8:00:45
售票员： 27
票类： 成人票
单价： 35.00
人数： 01
总价： 35.00

31990511010

报销凭证 0091527

中国银行
Bank of China

自动提款机客户通知书 CUSTOMER ADVICE

帐号 Account Number	7250155010 ✱✱✱✱✱	提款机分行号 ATM Branch No.	0142
请将此单放入信封 Put This Advice in Envelope SEQ: 045563		金额 Transaction Amount $1000.00 RMB	
转入帐户 Transfer to			

存款 Deposit	提款 ✱✱✱ Withdrawal	转帐 Transfer
结单/支票簿/提款单 Statement/Cheque Book/ Withdrawal Slip Request	其他服务 Other Transaction	此卡由银行保留 Card Retained
接纳 ✱✱✱ Accepted	取消 Rejected	请与银行联络 Please Contact Bank
日期及时间 SEP04 09:44 Date and Time	提款机号 05 Terminal	备考 0720 Reference

1. 存款须经本行复核后才存入您帐户，至于存入支票，本行将以代收方式处理，票款须待交换兑现后方能提用。
 Deposits will be credited to your account after verification by the Bank. Cheques although passed to your Credit are accepted for collection only and the proceeds will not be available until the cheques have been cleared.
2. 转帐请自行通知收款人，本行恕不另行通知。
 Please advise the beneficiary of transfers since the Bank will not do so.
3. 台端索取之结单，支票簿，请两天以后到开户行领取。
 Statement , Cheque Book or NPS Withdrawal Slips requested will be mailed.

168
1x Garder
€ 1.50
08/10/2004
Zeit: 15:13

50
1x Garder
€ 1.50
09/10/2004
Zeit: 10:38

UB MEDIA AG
Tel. 0812121/2 26-0 · Best.-Nr. 70-27
Post-it® Haftnotizen

Bitte
hier unterschreiben !

THR

FLIGHT NO. 724

IR 951199 T

THR TEHRAN FINAL DESTINATION

IRAN AIR
The Airline of the
ISLAMIC REPUBLIC OF IRAN

MEMBER OF IATA

IR 951199 T

THR
طهران

AUG87　　　　　　V031　　N97 04:39 31AUG87

London Buses ⊖　　**London Buses** ⊖　　**London Buses** ⊖

NOT TRANSFERABLE　　NOT TRANSFERABLE　　NOT TRANSFERABLE

ADULT　　　　　　1902　　007 £0.35 ADULT

DEUTSCHE 🏤 POST AG
148
7720　　　　　　E96 1507
3009 **003.00** 09.02.00
60325 FRANKFURT AM MAIN 17

mbH & Co.

ROYAL ACADEMY OF ARTS　　　370
Piccadilly, London W1V 0DS

SENSATION

Young British Artists from the
Saatchi Collection

Sunday　　　　　　02-Nov-1997

£7.00　　　　ADULT　　　Booking Ref
92220

87828

✦ **LanChile**

L O A D STAND BY DO NOT

87828

Form. 105 - 005 - Imp. Santiago.

Johann Wolfgang Goethe-Universität
Frankfurt am Main

SEMESTERBESCHEINIGUNG

BACKE, TANJA

geb. am **11.04.68**　　in HANAU
Matrikel-Nr. **100793**

ist im　**SOMMER-** Semester **1991**
als Student der **Universität Frankfurt** immatrikuliert.

Gültig vom **01.04.91**　　bis **30.09.91**

Stud. Beiträge in Höhe von **DM**　**60,-**
wurden entrichtet.

Diese Bescheinigung wurde maschinell erstellt und ist ohne
Unterschrift gültig. Änderungen ohne Bestätigung des Sekre-
tariats machen die Bescheinigung ungültig.

FEUERSTEIN'S
Kinder-
Sport-
Karussell
Frankfurt

FORM/MODELE
STYLE/MODELO EIFEL

4 021408 438550

ARTIKEL/ARTICLE
ARTICLE/ARTICULO 94553/000 2235907E
GRÖSSE/TAILLE
SIZE/TALLA L 236/058

PRADA
GIROCOLLO TG. L

ART.
SJM12 1132/070/SJM12-2M-051
528107 000180B26
5281050801980033
070000180888
L 198.00

belle d'inverno, più belle d'estate · schön im Winter, im Sommer noch schöner

DOLOMITI
non trasferibile - nicht übertragbar

2412 042 83800 01 494 10

STEP-Piacenza

LIGNE N°1 du Métro de Lille.

• Temps moyen entre chaque station 1 mn 20
• Bureau accueil et informations dans la station "Gares"

Gares
Rihour Caulier
République Fives
Gambetta Marbrerie
Wazemmes Hellemmes
Porte des Postes Lezennes Pont de Bois
C.H.R. - Oscar Lambret Hôtel de ville
C.H.R. B - Calmette Triolo
 Cité Scientifique
 4 Cantons

coméli

Rue de Cysoing 59650 Villeneuve d'Ascq Tél. 20.91.92.01

votre confort et votre sécurité en vol,
us ne pouvons accepter de bagages
mineux.

our comfort and safety on board,
y cabin bags are not allowed

eul bagage / dimensions 115 cm
rry-on only / size 115 cm

CABINE

AIR FRANCE

SOGENAL

Guichet
Filiale

Votre VENTE
Ihr VERKAUF

du/vom

DÉCOMPTE D'ACHAT DE BILLETS ÉTRANGERS
ANKAUFSABRECHNUNG VON AUSLANDSSORTEN

DEVISES WÄHRUNG	COURS KURS	CONTREVALEUR GEGENWERT
Den 100	3,31	331,-
		FF

1984 - Mt Fd - 10032

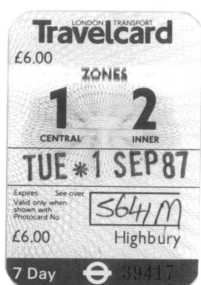

LONDON TRANSPORT
Travelcard
£6.00

ZONES
1 2
CENTRAL INNER

TUE * 1 SEP 87

Expires See over
Valid only when
shown with
Photocard No
S64 M

£6.00 Highbury

7 Day ⊖ 39417

£35.00

Rush

⊕ Lufthansa
Missed Connex Baggage

4
GEPRÜFT
FRA SO

To

LHR

Airline / Flight

LH 4728

Printed in the Fed. Rep. of Germany

BRITISH AIRWAYS EXPEDITE BAGGAGE Rush

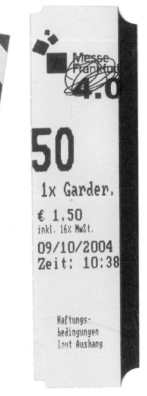

Messe
Frankfurt
4.0

50

1x Garder,

€ 1.50
inkl. 16% MwSt.

09/10/2004
Zeit: 10:38

Haftungs-
bedingungen
laut Aushang

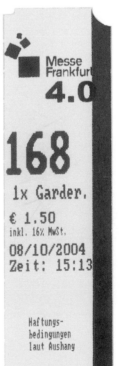

Messe
Frankfurt
4.0

168

1x Garder,

€ 1.50
inkl. 16% MwSt.

08/10/2004
Zeit: 15:13

Haftungs-
bedingungen
laut Aushang

10

Poll

Communauté Urbaine de Lille
Musée d'art moderne
à Villeneuve d'Ascq

10 Frs - TARIF REDUIT

№ 017240

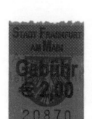

STADT FRANKFURT
AM MAIN
Gebühr
€ 2,00
20870

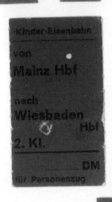

MUSEI E GALLERIE
MONUMENTI PONTIFICIE
L. 13000
226794

Kinder-Eisenbahn
von
Mainz Hbf
nach
Wiesbaden Hbf
2. Kl.
___ DM
für Personenzug

Communauté Urbaine de Lille
Musée d'art moderne
à Villeneuve d'Ascq

10 Frs - TARIF REDUIT

№ 0023690

Communauté Urbaine de Lille
Musée d'art moderne
à Villeneuve d'Ascq

10 Frs - TARIF REDUIT

№ 017239

PARKSCHEIN
zur Benützung gebührenpflichtiger Kurzparkzonen

MAGISTRAT DER
STADT WIEN **746061 VR**

Parkdauer ½ **Stunde** 6 S

Monat	Tag			Stunde		Min.
Jänner	1	11	21	0	12	0
Feber	2	12	22	1	13	
März	3	13	23	2	14	15
April	4	14	24	3	15	
Mai	5	15	25	4	16	30
Juni	6	16	26	5	17	
Juli	7	17	27	6	18	45
August	8	18	28	7	19	
September	9	19	29	8	20	
Oktober	10	20	30	9	21	
November			31	10	22	
Dezember	JAHR 19			11	23	

PAUL GERIN, WIEN II

Wertmarke 50790

Wertmarke 50789

Bier 32988

Wertmarke 50722

VENERANDA FABBRICA
DEL DUOMO DI MILANO

SALITA CON
ASCENSORE

№ 261711

25659 MUSEUM MODERNER KUNST
PALAIS LIECHTENSTEIN
EINTRITTSKARTE
Gültig für 1 Person
S 15.—
inkl. 10% USt.

05634 **Eintrittskarte**
Preis siehe Anschlag
Nicht übertragbar
Aufbewahren und auf
Verlangen vorzeigen

Minigolf
Fit und Fun
für jedermann

Name des Spielers

ohne Vorkenntnisse zu spielen

Gültig für eine Spielrunde

Feld	Pkt.-Zahl	Feld	Pkt.-Zahl
1			
2	3	10	2
3	3	11	
4	3	12	3
5		13	2
6	1	14	2
7	2	15	
8	3	16	
9	4	17	
Übertrag		18	
Gesamtpunktzahl:			

Druck: Bäckerei Leu Hamburg (OII)

Getränke

77568

Cinematheek HAAGS FILMHUIS

Wurst

17337

Sonderausspielung

Serie

Durch Punkte
sammeln größerer
Gewinn erhältlich.

Versuch's nochmal Versuch's
nochmal Versuch's nochmal
nochmal Versuch's nochmal
nochmal Versuch's nochmal
Versuch's nochmal Versuch's
nochmal Versuch's nochmal
Versuch's nochmal Versuch's
nochmal Versuch's nochmal

Leider verloren

Versuch's nochmal Versuch's

WAARDE
VALEUR
DÉCLARÉE

LA POSTE N°
DISTINGO
OBJETS SIGNALÉS

69 1.75
BLOKKER
Nu 0.85

69 1.75
BLOKKER
Nu 0.85

Spiel mit

Spiel mit

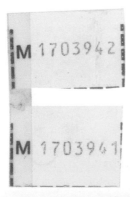

M 1703942

M 1703941

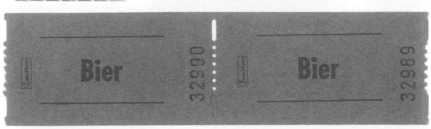

Bier 32990 Bier 32989

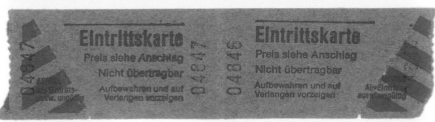

04847 Eintrittskarte 2370 Eintrittskarte 04846
 Preis siehe Anschlag Preis siehe Anschlag
 Nicht übertragbar Nicht übertragbar
 Aufbewahren und auf Aufbewahren und auf
 Verlangen vorzeigen Verlangen vorzeigen

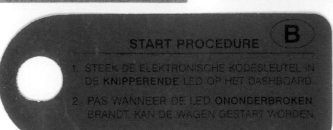

START PROCEDURE (B)

1. STEEK DE ELEKTRONISCHE KODESLEUTEL IN
 DE KNIPPERENDE LED OP HET DASHBOARD

2. PAS WANNEER DE LED ONONDERBROKEN
 BRANDT, KAN DE WAGEN GESTART WORDEN

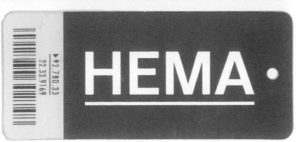

92.780.33
22.33.9169

HEMA ·

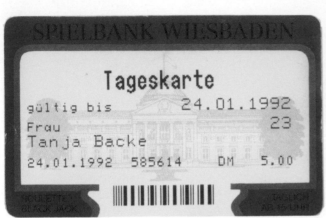

SPIELBANK WIESBADEN

Tageskarte

gültig bis 24.01.1992
Frau 23
Tanja Backe
24.01.1992 585614 DM 5.00

ROULETTE
BLACK JACK TÄGLICH
 AB 15 UHR

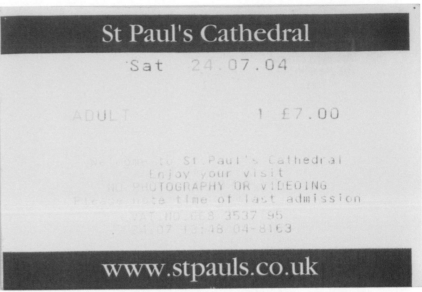

St Paul's Cathedral

Sat 24.07.04

ADULT 1 £7.00

Welcome to St.Paul's Cathedral
Enjoy your visit
NO PHOTOGRAPHY OR VIDEOING
Please note time of last admission
VAT NO. GB 3537 95
24.07 13:48 04-8163

www.stpauls.co.uk

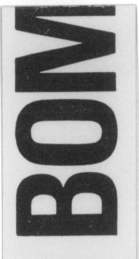

BOM

Bombay

AIR-INDIA

816373

BOM
AI - A

BOM AI - A
BOMBAY

BAGGAGE IDENTIFICATION TAG

This is not the luggage ticket (baggage check) described in
Article 4 of the Warsaw Convention, or the Warsaw
Convention as amended by the Hague Protocol 1955.

बॉम्बे
BOMBAY

BOM AI - A 816373

AIR-INDIA

ETTORE SOTTSASS
WORKS 1979 - NOW
DAUER DER AUSSTELLUNG 27.03.-27.06.2004

Erwachsene	3,00 €	Esprit Europe GmbH
Schüler, Studenten	2,00 €	Esprit-Allee · 40882 Ratingen
Kinder bis 12 Jahre	frei	t +49 (2102) 123-45900
Gruppen ab 15 Personen	20,00 €	f +49 (2102) 123-15900
Führungen auf Anfrage		e-mail sottsass@esprit.com
		www.esprit.com/sottsasss 009953 ✳

Leider verloren

PMI
PALMA DE MALLORCA

IBERIA

PMI
PALMA DE MALLORCA

0 0085572

IBERIA

N° VUELO
PESO

BCN
BARCELONA

IBERIA

BCN
BARCELONA

6329460

IBERIA

N° VUELO
PESO

MÝVATN TOURS
JÓN ÁRNI SIGFÚSSON

TEL. 464 4196 - FAX 464 4380

No. 6588

ASKJA TOUR

Einige Flecken lassen sich nicht entfernen!

Wir haben unser Bestes getan, aber einige Flecken und Verfärbungen können nicht entfernt werden, ohne die Farbe oder das Gewebe zu beschädigen.

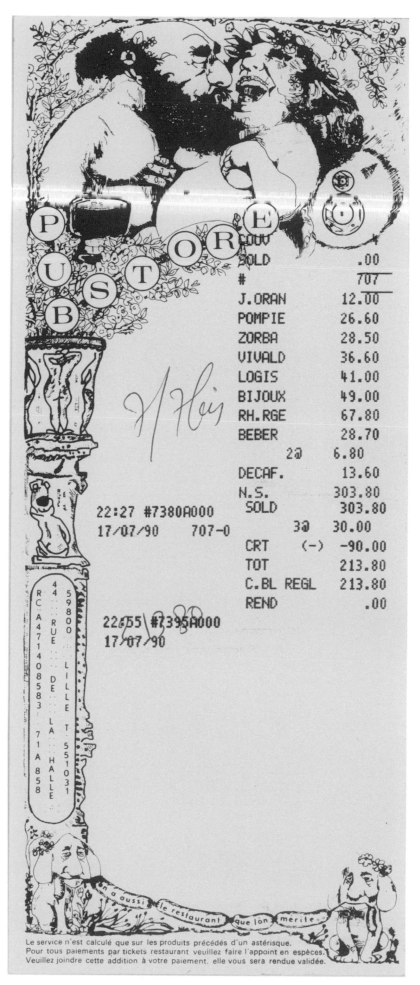

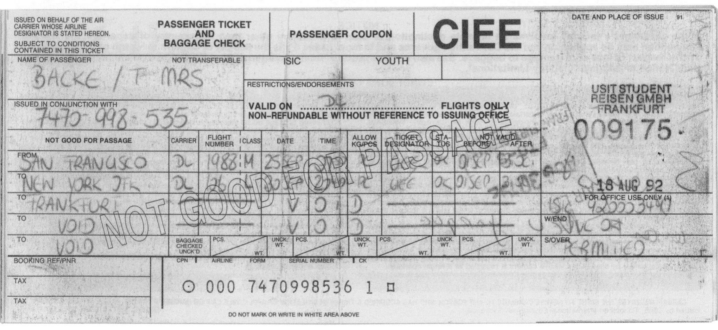

PASSENGER TICKET AND BAGGAGE CHECK — **PASSENGER COUPON** — **CIEE**

ISSUED ON BEHALF OF THE AIR CARRIER WHOSE AIRLINE DESIGNATOR IS STATED HEREON. SUBJECT TO CONDITIONS CONTAINED IN THIS TICKET

DATE AND PLACE OF ISSUE 91

NAME OF PASSENGER — NOT TRANSFERABLE: BACKE / T MRS

ISIC — YOUTH

RESTRICTIONS/ENDORSEMENTS

ISSUED IN CONJUNCTION WITH: 7470-998-536

VALID ON DL FLIGHTS ONLY
NON-REFUNDABLE WITHOUT REFERENCE TO ISSUING OFFICE

USIT STUDENT REISEN GMBH FRANKFURT

009175.

NOT GOOD FOR PASSAGE	CARRIER	FLIGHT NUMBER	CLASS	DATE	TIME	ALLOW KG/PCS	TICKET DESIGNATOR	STA-TUS	NOT VALID BEFORE	NOT VALID AFTER
FROM FRANKFURT	DL	117	L	30 AUG				OK	/	31 AUG
TO MIAMI	DL	446	M				CIEE	OK	/	31 OCT
TO LOS ANGELES			V	O	I	D		—	—	—
TO VOID			V	O	I	D		—	—	—
TO VOID										

18 AUG 92

FOR OFFICE USE ONLY (1)
ISIC 925553447
W/END TVL OK
S/OVER PERMITTED

BAGGAGE CHECKED UNCK'D — PCS. UNCK. WT. — PCS. UNCK. WT. — PCS. UNCK. WT. — PCS. UNCK. WT. — PCS. UNCK. WT.

BOOKING REF/PNR

TAX USD 18 00 US TAX PAID
TAX USD 4 00 DL TAX PAID

⊙ 000 7470998535 0 ▯

CPN — AIRLINE — FORM — SERIAL NUMBER — CK

DO NOT MARK OR WRITE IN WHITE AREA ABOVE

PASSENGER TICKET AND BAGGAGE CHECK — **PASSENGER COUPON** — **CIEE**

ISSUED ON BEHALF OF THE AIR CARRIER WHOSE AIRLINE DESIGNATOR IS STATED HEREON. SUBJECT TO CONDITIONS CONTAINED IN THIS TICKET

DATE AND PLACE OF ISSUE 91

NAME OF PASSENGER — NOT TRANSFERABLE: BACKE / T MRS

ISIC — YOUTH

RESTRICTIONS/ENDORSEMENTS

ISSUED IN CONJUNCTION WITH: 7470-998-535

VALID ON DL FLIGHTS ONLY
NON-REFUNDABLE WITHOUT REFERENCE TO ISSUING OFFICE

USIT STUDENT REISEN GMBH FRANKFURT

009175.

NOT GOOD FOR PASSAGE	CARRIER	FLIGHT NUMBER	CLASS	DATE	TIME	ALLOW KG/PCS	TICKET DESIGNATOR	STA-TUS	NOT VALID BEFORE	NOT VALID AFTER
FROM SAN FRANCISCO	DL	1988	M	25 SEP				OK	01 SEP	31 OCT
TO NEW YORK JFK	DL	26	M	26 SEP			CIEE	OK	01 SEP	31 OCT
TO FRANKFURT			V	O	I	D				
TO VOID			V	O	I	D				
TO VOID										

18 AUG 92

FOR OFFICE USE ONLY (1)
ISIC 925553440
W/END TVL OK
S/OVER PERMITTED

BAGGAGE CHECKED UNCK'D — PCS. UNCK. WT. — PCS. UNCK. WT. — PCS. UNCK. WT. — PCS. UNCK. WT. — PCS. UNCK. WT.

BOOKING REF/PNR

TAX

TAX

⊙ 000 7470998536 1 ▯

CPN — AIRLINE — FORM — SERIAL NUMBER — CK

DO NOT MARK OR WRITE IN WHITE AREA ABOVE

阳朔饭店营业（国营）

统 一 发 票

桂（朔）字 № 000399

姓名 91 年 8 月 25 日

摘	要	金	额	
				第二联 收 据

合计人民币 千 壹 百 贰 拾 元 角 分 ¥

企业盖章 — 收款人

TENGELMANN
Heilbronn

BANANEN

verpackt am: 26.11.98 mindestens haltbar bis:

DM/kg 3,99 Einwaage 00,554kg

2714004 00221.9 PREIS 2,21

Zerbrechlich
Fragile

DSK 9161 B-88 (FRA LT 3) Printed in Germany

364

Lufthansa

EXPRÈS
EXPRÈS
EXPRÈS
EXPRÈS
EXPRÈS
EXPRÈS

804375
MUSEU
DALI
FIGUERES

ENTRADA

804376
MUSEU
DALI
FIGUERES

ENTRADA

ISSUED BY / EMIS PAR	SPECIAL SERVICE TICKET BILLET DE SERVICES SPECIAUX	PASSENGER'S COUPON COUPON DU PASSAGER	AIRLINE / COMPAGNIE FORM / MODELE SERIAL NO. / NO. DE SERIE
△ DELTA AIR LINES, INC.	DATE OF ISSUE / DATE D'EMISSION	ACCT. DEPT. USE ONLY POUR LA COMPTABILITE	006:4077:193:804

SOLD SUBJECT TO TARIFF REGULATIONS
SOUMIS AUX REGLEMENTS TARIFAIRES

30 AUG 92

PASSENGER NAME / NOM DU PASSAGER NOT TRANSFERABLE / INCESSIBLE

BACHE / TRRS

□ UPGRADING DECLASSEMENT

AUG 30 92

NOT GOOD FOR PASSAGE / NON VALABLE POUR TRANSPORT CARRIER TRANSPORT.

FROM / DE TO / A FARE BASIS BASE TARIF. FARE BASIS BASE TARIF.

PLACE OF ISSUE / LIEU D'EMISSION 92

FROM / DE

SAN FRANCISCO DL

FORM / DE TO / A FARE BASIS BASE TARIF. FARE BASIS BASE TARIF.

ISSUED IN CONJUNCTION WITH TICKET NUMBER / BILLET COMPLEMENTAIRE

TO / A

NEW YORK DL

000 7470 998536

☒ OTHER AUTRE CICE

FORM OF PAYMENT / MODE DE PAIEMENT

TO / A

FRANKFURT ROUGFCE

CA APP. C. SWHURK

CHARGES / FRAIS EQUIV. AMT. PAID CONTRE VALEUR VERSEE

26.00

5234 9520 3090 5450

TAX / TAXE TOTAL USD 25.00

CPN TICKET NUMBER / NUMERO DE SERIE CK

1232 D 08-94 K

OLIVIER TARTARE

DO NOT MARK OR WRITE IN WHITE AREA ABOVE / NE RIEN INSCRIRE DANS LA PARTIE BLANCHE CI-DESSUS

ECONOMY 054
Bordkarte/Boarding Pass
Name of passenger
ECKART/OLIVIA CHD
From FRA
To CDG
LUFTHANSA
Carrier - Flight No./Class Date
LH 4194 M 04OCT
Gate | Boarding Time | Seat NONSMOKER
A26 | 1600 | 10B
ZONE 3
Pcs. | Ck.Wt. | Unck.Wt. Pcs. | Ck.Wt. | Unck.Wt.

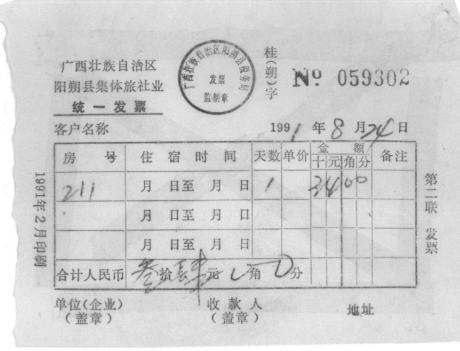

广西壮族自治区
阳朔县集体旅社业
统一发票

桂(朔)字 № 059302

客户名称 199 1 年 8 月 24 日

房号	住宿时间	天数	单价	金额 十元角分	备注
211	月 日至 月 日	1		24 00	
	月 日至 月 日				
	月 日至 月 日				

合计人民币 叁拾肆 元 L 角 0 分

单位(企业) 收款人 地址
(盖章) (盖章)

1991年2月印刷 第二联 发票

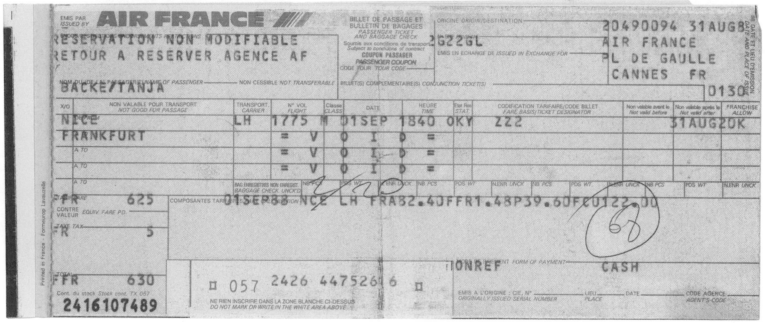

EMIS PAR / ISSUED BY **AIR FRANCE** BILLET DE PASSAGE ET / BULLETIN DE BAGAGES ORIGINE ORIGIN/DESTINATION 20490094 31AUG8
RESERVATION NON MODIFIABLE PASSENGER TICKET AND BAGGAGE CHECK 2G22GL AIR FRANCE
RETOUR A RESERVER AGENCE AF COUPON PASSAGER / PASSENGER COUPON EMIS EN ECHANGE DE / ISSUED IN EXCHANGE FOR PL DE GAULLE CANNES FR
CODE TOUR / TOUR CODE
NOM DU PASSAGER/NAME OF PASSENGER NON CESSIBLE NOT TRANSFERABLE BILLET(S) COMPLEMENTAIRE(S) CONJUNCTION TICKET(S) 0130
BACKE/TANJA

| X/O | NON VALABLE POUR TRANSPORT / NOT GOOD FOR PASSAGE | TRANSPORT. CARRIER | N° VOL FLIGHT | Classe CLASS | DATE | HEURE TIME | Etat Rés STAT | CODIFICATION TARIFAIRE/CODE BILLET FARE BASIS/TICKET DESIGNATOR | Non valable avant le Not valid before | Non valable après le Not valid after | FRANCHISE ALLOW |
|-----|-----|-----|-----|-----|-----|-----|-----|-----|-----|-----|
| | NICE | LH | 1775 | M | 01SEP | 1840 | OKY | ZZ2 | | 31AUG20K | |
| | FRANKFURT | = | V O I D = | | | | | | | | |
| | A TO | = | V O I D = | | | | | | | | |
| | A TO | = | V O I D = | | | | | | | | |

TARIF/FARE 625 COMPOSANTES TARIFAIRES/FARE CALCULATION 01SEP88 NICE LH FRA32.40FFR1.48P39.60FCU122.00
CONTRE VALEUR / EQUIV. FARE PD.
TAXE/TAX 5
FR
TOTAL 630 FORM OF PAYMENT
FFR NONREF CASH
Cont. du stock Stock cont. TX 057
2416107489 □ 057 2426 44752616 □ NE RIEN INSCRIRE DANS LA ZONE BLANCHE CI-DESSUS / DO NOT MARK OR WRITE IN THE WHITE AREA ABOVE EMIS A L'ORIGINE - CIE. N° ORIGINALLY ISSUED SERIAL NUMBER LIEU PLACE DATE CODE AGENCE AGENT'S CODE

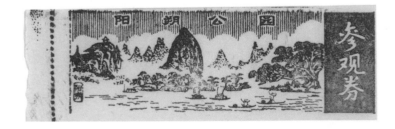

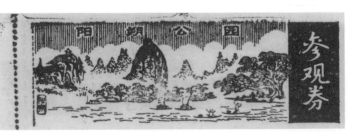

Ticket 1 — Olympic Airways (Miscellaneous Charges Order)

OLYMPIC AIRWAYS GREECE

ISSUED BY | VOID IF MUTILATED OR ALTERED | MISCELLANEOUS CHARGES ORDER | BANK EXCHANGE RATE | DATE AND PLACE OF ISSUE
VALID ONE YEAR FROM DATE OF ISSUE
SUBJECT TO TERMS AND CONDITIONS ON BACK OF PASSENGER'S COUPON | PASSENGER COUPON | EQUIVALENT AMOUNT PAID

NAME OF PASSENGER: TARTARE/O MR
(NOT TRANSFERABLE) | TAX ON MCO

TYPE OF SERVICE FOR WHICH ISSUED: UPGRADED FROM BLCA TO QICM | OTHER CHARGES

VALUE FOR EXCHANGE | AMOUNT IN LETTERS | CURRENCY: EUR | AMOUNT IN FIGURES: 1500 | TOTAL: E 1475.00 | AGENT

1 | TO | AT | ENDORSEMENT | 1 | COUPON VALUE | ISSUED IN CONNECTION WITH

RESERVATION DATA OR RESIDUAL VALUE IN LETTERS: 28G63Q

2 | TO | AT | ENDORSEMENT | 2 | COUPON VALUE | ENDORSEMENTS/RESTRICTIONS (CARBON)

RESERVATION DATA | FORM OF PAYMENT: CA 5232271000

REMARKS | ISSUED IN EXCHANGE FOR

NOT GOOD FOR PAYMENT

ORIGINAL ISSUE: HE8 | 30/3/05 | AIRLINE | FORM | SERIAL NUMBER | PLACE | DATE | AGENT'S NUMERIC CODE

⊙ 050 402134408

DO NOT MARK OR STAMP IN WHITE AREA

Ticket 2 — CIEE / Passenger Ticket and Baggage Check

ISSUED ON BEHALF OF THE AIR CARRIER WHOSE AIRLINE DESIGNATOR IS STATED HEREON.
SUBJECT TO CONDITIONS CONTAINED IN THIS TICKET

PASSENGER TICKET AND BAGGAGE CHECK | PASSENGER COUPON | CIEE

ISIC | YOUTH

NAME OF PASSENGER: Tartare /O Mr NOT TRANSFERABLE

RESTRICTIONS/ENDORSEMENTS
VALID ON DL FLIGHTS ONLY
NON-REFUNDABLE WITHOUT REFERENCE TO ISSUING OFFICE

ISSUED IN CONJUNCTION WITH: 7470-998-538

DATE AND PLACE OF ISSUE: 91
USIT STUDENT REISEN GMBH FRANKFURT
009175·
18 AUG 92
FOR OFFICE USE ONLY (1)
ISIC 920135744

NOT GOOD FOR PASSAGE	CARRIER	FLIGHT NUMBER	CLASS	DATE	TIME	ALLOW KG/PCS	TICKET DESIGNATOR	STATUS	NOT VALID BEFORE	VALID AFTER
FROM FRANKFURT	DL	117	L	30 AUG				OK	—	3 AUG
TO MIAMI	DL	446				PC	CIEE	OK	—	31 OCT
TO LOS ANGELES		VOID								
TO VOID		VOID								
TO VOID										

NOT GOOD FOR PASSAGE

W/END TVL OK
S/OVER PERMITTED

BOOKING REF/PNR | CPN | AIRLINE | FORM | SERIAL NUMBER | CK
TAX USD 8 00 US TAX PAID
⊙ 000 7470998537 2 ▯
TAX 160 4 00 DL TAX PAID

DO NOT MARK OR WRITE IN WHITE AREA ABOVE

Ticket 3 — Delta Air Lines Inc. (Special Service Ticket)

△ DELTA AIR LINES, INC.

ISSUED BY / EMIS PAR
SOLD SUBJECT TO TARIFF REGULATIONS / SOUMIS AUX REGLEMENTS TARIFAIRES

SPECIAL SERVICE TICKET / BILLET DE SERVICES SPECIAUX | PASSENGER'S COUPON / COUPON DU PASSAGER

AIRLINE / COMPAGNIE | FORM / MODELE | SERIAL NO. / NO. DE SERIE
006 : 4077 : 193 : 805

DATE OF ISSUE / DATE D'EMISSION: 30 AUG 92

ACCT. DEPT. USE ONLY / POUR LA COMPTABILITE

PASSENGER NAME / NOM DU PASSAGER: TARTARE /O MR NOT TRANSFERABLE / INCESSIBLE

DELTA AIR LINES
AUG 30 92

☐ UPGRADING DECLASSEMENT

NOT GOOD FOR PASSAGE / NON VALABLE POUR TRANSPORT	CARRIER TRANSPORT.
FROM / DE: SAN FRANCISCO	DL
TO / A: NEW YORK	DL
TO / A: FRANKFURT	

FROM / DE | FARE BASIS BASE TARIF. | TO / A | FARE BASIS BASE TARIF.

☒ OTHER AUTRE CIEE REBUSFEE

PLACE OF ISSUE / LIEU D'EMISSION: 92

ISSUED IN CONJUNCTION WITH TICKET NUMBER / BILLET COMPLEMENTAIRE: 000 7470 99 85 38

FORM OF PAYMENT / MODE DE PAIEMENT: CA Appr. C AAVNM7
5234 9520 3090 5450

CHARGES / FRAIS: 2500 | EQUIV. AMT. PAID CONTRE VALEUR VERSEE | CPN | TICKET NUMBER / NUMERO DE SERIE | CK: 1232 D | 08-94 K
OLIVIER TARTARE

TAX / TAXE | TOTAL USD 2500

DO NOT MARK OR WRITE IN WHITE AREA ABOVE / NE RIEN INSCRIRE DANS LA PARTIE BLANCHE CI-DESSUS

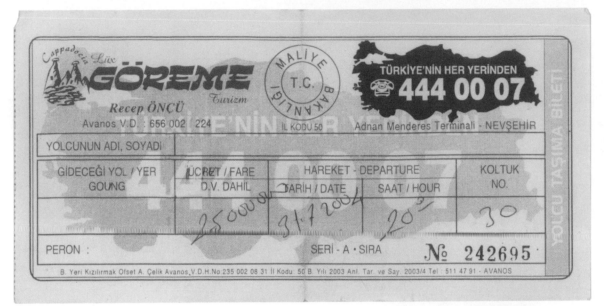

GÖREME
Cappadocia Lüx Turizm
Recep ÖNCÜ
Avanos V.D. : 656 002 224

MALİYE BAKANLIĞI T.C.
İL KODU 50

TÜRKİYE'NİN HER YERİNDEN
☎ 444 00 07
Adnan Menderes Terminali - NEVŞEHİR

YOLCU TAŞIMA BİLETİ

YOLCUNUN ADI, SOYADI				
GİDECEĞİ YOL / YER GOUNG	ÜCRET / FARE D.V. DAHİL	HAREKET - DEPARTURE		KOLTUK NO.
		TARİH / DATE	SAAT / HOUR	
	25 000 00	31.7.2004	20³⁰	30
PERON :		SERİ - A · SIRA		№ 242695

B. Yeri Kızılırmak Ofset A. Çelik Avanos V.D.H.No:235 002 08 31 İl Kodu: 50 B. Yılı 2003 Anl. Tar. ve Say. 2003/4 Tel : 511 47 91 - AVANOS

Musées de la Ville de Paris
ENTRÉE GRATUITE
les musées
ENTRÉE GRATUITE
451965
B.E.T. 35238

S.T.U.C.
CANNES
MOORE PARAGON - ARGENT

CARTE 6 VOYAGES
PLEIN TARIF
VALABLE 1 ZONE
NE PAS PLIER

12R29 13358
14R28 12153
14R28 19358
09R28 13658
08R28 21107
12R27 17402

S.T.U.C.
CANNES
MOORE PARAGON - ARGENT

CARTE 6 VOYAGES
PLEIN TARIF
VALABLE 2 ZONES
NE PAS PLIER

24R28 28034
13R23 12458
10R30 15072
17R14 13149

Einzelfahrkarte
2,00 € / 2 Zonen
6 Zonen Kind
Ergänzungskarte für Zeitkarten.
Bitte sofort bei Fahrtantritt entwerten.
0131381
Es gelten die Tarifbestimmungen und Beförderungsbedingungen.
0170 BBL 116 480 17-08 Hier entwerten

Einzelfahrkarte
2,00 € / 2 Zonen
6 Zonen Kind
Ergänzungskarte für Zeitkarten.
Bitte sofort bei Fahrtantritt entwerten.
0124153
Es gelten die Tarifbestimmungen und Beförderungsbedingungen.

InterCity Hotel
BERLIN
ZIMMERAUSWEIS · ROOM-PASS

Name *Backe*
Zimmer Nr. *144*
Preis *83,-*

Am Ostbahnhof 5 · Telefon 030/2 93 68-0
STEIGENBERGER
HOTEL GROUP

FAHRAUSWEIS NR. *168065*
Ankunft *22.12*
Abreise *23.12*
Benutzungsbedingungen siehe Rückseite
VBB Gültig im Tarifbereich Berlin ABC

InterCity Hotel
BERLIN
ZIMMERAUSWEIS · ROOM-PASS

Name *Backe*
Zimmer Nr. *144*
Preis *83,-*

Am Ostbahnhof 5 · Telefon 030/2 93 68-0
STEIGENBERGER
HOTEL GROUP

FAHRAUSWEIS NR. *168066*
Ankunft *22.12*
Abreise *23.12*
Benutzungsbedingungen siehe Rückseite
VBB Gültig im Tarifbereich Berlin ABC

Union Bank
Union Bank

*All transactions are subject to Bank verification and collection.

DATE	TIME	MACHINE
09/11/92	05:01PM	104-A

MACHINE LOCATION

JAPAN CENTER
SAN FRANCISCO CA

CUSTOMER IDENTIFICATION NUMBER

*TRANSACTION DESCRIPTION

BUSINESS DATE: 09/14/92
0481
WITHDRAW $200.00
FROM CHECKING

Ultimate

Thank You

Member FDIC

Form 2900 (Rev. 2/89)

Hier in den Entwerter einführen

BVG 621B 1125 So31 Bhf. 2

FAHRSCHEIN
NORMALTARIF
 AB
CM1332 3.90 DM

02.09.99 BVG

Tarif für Berlin und Umland. Ausgegeben durch BVG. Gültig nach den geltenden Beförderungsbedingungen. Bitte bei Fahrtantritt sofort entwerten; nach Entwertung nicht übertragbar. Bitte Rückseite beachten.
BVG · Potsdamer Straße 188 · 10783 Berlin · Tel. 2560

RF 97 34073832

BILLET
CLAUDEL
PT 35.00 24/03
20:40 5227162
8014880 242043

BILLET
CLAUDEL
PT 35.00 24/03
20:40 5227112
8014881 242043

サービスチケット

本券6枚にて500円分の

* お支払1,010円以下1枚、2,000円以下2枚　ご飲食にご利用出来ます
 1,000円増毎に1枚増進呈　　　　　　　　　　（お土産も可）
* 配布期間　平成15年11月末日まで
* おつりはお出し出来ません（現金との引換は出来ません）

寿しのむさし

有効期限
平成15年12月20日まで

本店	上堀川店	紫明通店	京都駅八条口アスティロード店
河原町三条上ル	堀川通北山上ル	紫明通堀川東入	
TEL 222-0634	TEL 493-4891	TEL 441-6340	TEL 662-0634

Lucent Danstheater

Voorstelling
5295 BALLETT FRANKFURT

| Datum | | Tijd |
| zo 25 Mei 1997 | | 20.15 uur |

| Prijs | Soort | Kaartnr. | Factuurnr. |
| 35.00 | Normaal | 5295079? | |

| Registratienr. | Klantnr. | Naam |
| 064983 | 109041 | Studio Dumber Telefonische res. |

Spuiplein, Den Haag
Telefoon 070-3604930

Na aanvang van de voorstelling geen toegang
Gekochte plaatsbewijzen worden niet geruild of teruggenomen

ZAAL RECHTS

| Rij | Stoel |
| U | 11 |

25 Mei 1997 20.15

5295

Plaatsbewijs

PARKEERTIJD EINDIGT

DATUM	TIJD
VR	12:41 10:52
18/04/03	2,00EUR ZEESTR

3708 BETAALD

TMC
TAXAMETER CENTRALE B.V.

Schlumberger

PARKEERTIJD EINDIGT

DATUM	TIJD
ZA	14:22 11:52
08/04/00	5,00 JAVASTR.

2623 BETAALD

TMC
TAXAMETER CENTRALE B.V.

Schlumberger

2	*Go dols*	E/CASA 650
2	*Pau*	E/CASA 650
		PAN/OLI 125
	Gamela	PAN/OLI 125
1	*Empes*	OOLAS 050
1	*To Espala*	1.ESPMN 5.25
		BEBIDA 375
1	*Tinto*	BEBIDA 375
1	*vino*	BEBIDA 650
1	*Blanco*	BEBIDA 150
1	*agua*	BEBIDA 150
1		BEBIDA 175
2	*Campillo*	BEBIDA 175

EFECTI 4.475
19 APR '96 #0062 CAJ1

ED 15204

DXB
MH B 003836
malaysia
DXB
DUBAI
SEQ. NO. 801
36

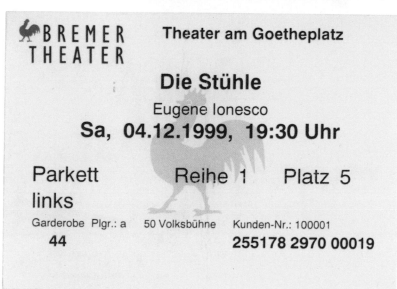

BREMER THEATER Theater am Goetheplatz

Die Stühle

Eugene Ionesco
Sa, 04.12.1999, 19:30 Uhr

Parkett Reihe 1 Platz 5
links

Garderobe Plgr.: a 50 Volksbühne Kunden-Nr.: 100001
44 **255178 2970 00019**

PARKEERTIJD EINDIGT
DATUM TIJD
VR 21:44 19:44
20/08/99 5,00 STRANDWG
BETAALD

PARKEERTIJD EINDIGT
DATUM TIJD
VR 12:38 11:38
20/08/99 2,00 JAVASTR.
2624 BETAALD
TMC
TAXAMETER CENTRALE B.V. Schlumberger

PARKEERTIJD EINDIGT
DATUM TIJD
232 17:39 16:51
20/08/99 2,50 WILHL.KD
BETAALD

PARKEERTIJD EINDIGT
DATUM TIJD
ZA 12:19 10:49
02/05/98 3,00 JAVASTR.
BETAALD
TMC
TAXAMETER CENTRALE B.V. Schlumberger

PARKEERTIJD EINDIGT 2194
DATUM TIJD
ZA 13:34 11:34
21/08/99 6,00 HOOIKADE
BETAALD

Leg deze zijde leesbaar achter uw voorruit.
This side must be clearly legible in your windscreen.
Placez ce côté de façon lisible derrière votre pare-brise.
Legen Sie diese Seite lesbar hinter die Windschutzscheibe.

PARKEERTIJD EINDIGT
DATUM TIJD
232 15:04 13:53
20/08/99 2,50 MUSMPARK
BETAALD

PARKEERTIJD EINDIGT
DATUM TIJD
VR 10:49 09:19
09/04/99 3,00 SCHEEPST
BETAALD
TMC
TAXAMETER CENTRALE B.V. Schlumberger

PARKEERTIJD EINDIGT
DATUM TIJD
ZO 12:45 11:46
22/08/99 3,00 TOERNOOI
3822 BETAALD
TMC
TAXAMETER CENTRALE B.V. Schlumberger

50,- DM	2785696 *	**60,- DM**
40,- DM	2785696 *	**50,- DM**
30,- DM	2785696 *	**40,- DM**
20,- DM	2785696 *	**30,- DM**
10,- DM	2785696 ¥	**20,- DM**
5,- DM	2785696 *	**10,- DM**

Bescheinigung 2785696 * **5,- DM**

Wegen _Geschwindigkeitsüberschreitung 16 km/h_
wurden Sie nach Belehrung über Ihr Weigerungsrecht mit Ihrem Einverständnis
gem. §§ 56–58 OWiG verwarnt. Diese Bescheinigung gilt zugleich als Quittung für
das **rechts oben** angegebene Verwarnungsgeld.

OF, 22.11. 2000

VD, OF
(Dienststelle) (Unterschrift)

Quittung für Einstellgebühr
Im aufgedruckten Betrag ist die ges. MwSt. enthalten.

03.12.98 11:28 P1 /02 082857
7.00 DM

city-parking GmbH Zentrale Hauptverwaltung:
Alpenstraße 21, 86004 Augsburg
Telefon 08 21 / 57 70 15

VIELEN DANK UND GUTE FAHRT !!!
THANKS AND HAVE A GOOD TRIP !!!

Kein Ausfahrt-Ticket!

PARKEERTIJD EINDIGT
DATUM TIJD

VR 15:46 12:59

24/09/04 3,90EUR KLOMBSTR

2980 BETAALD

TMC TAXAMETER CENTRALE B.V.

| 5,- EUR | 3693947 * | **10,- EUR** |

Bescheinigung 3693947 * **5,- EUR**

Wegen _StVO_
wurden Sie nach Belehrung über Ihr Weigerungsrecht mit Ihrem Einverständnis
gem. §§ 56–58 OWiG verwarnt. Diese Bescheinigung gilt zugleich als Quittung für das
rechts oben angegebene Verwarnungsgeld.

Datum _21.06.04_

D 6 20
(Dienststelle) (Unterschrift)

PARKEERTIJD EINDIGT
DATUM TIJD

VR 12:44 11:44

24/09/04 1,10EUR ZIEKEN

4020 BETAALD

Leg deze zijde leesbaar achter uw voorruit.
This side must be clearly legible in your windscreen.
Placez ce côté de façon lisible derrière votre pare-brise.
Legen Sie diese Seite lesbar hinter die Windschutzscheibe.

WETTANNAHME RENNEN-NR. VERANSTALTER DATUM TICKET-NR. EINSATZ DM GEWINN DM
FRA12 6 FRA12 21/ 9/97 197 420 10*

SIEG * PLATZ ZWEIER MIT

| RENNEN | WETTART | EINSATZ | PFERDE |

NUR EINSEITIG BESCHRIFTEN!

P 5 8 DM 5*

Für die Wette sind ausschließlich die Vorschriften für den Wettbetrieb in ihrer jeweils gültigen Fassung maßgebend. Der Wetter erkennt diese durch Abgabe seines Wettscheines als verbindlich an. Maßgebend ist der maschinelle Ausdruck auf der Wettkarte, der im Computer gespeichert ist: Gewinnauszahlung nur gegen Rückgabe des Wettscheines. Ein Anspruch auf Gewinnauszahlung erlischt nach 30 Tagen.

est. FRANCE TELECOM- **59036 LILLE CEDEX**

MR TARTARE OLIVIER

2705 3852 0303 7139 5214 0155 62635

COMPTE

EINTRITTS-KARTE

zur Fürstengruft

50 Pfennig

C INT **85** FR **100** USA **38**

Bitte warten Sie auf Ihren Aufruf

Zentrales Bürgeramt

1. Stock

66

BOSCH Do. 29.11.01 10:17

2366 101 824

Maillinger Str. 11×13 40
VB 931
Hier ENTWERTEN

EINZELFAHRT
KURZSTRECKE

MVV

***1.80 DM**

Bitte Hinweise auf der Rückseite beachten!

VB 3394692

MVV

Hier ENTWERTEN

EINZELFAHRT
KURZSTRECKE

MVV 01

***2.00 DM**

Bitte Hinweise auf der Rückseite beachten!

VB 1008265

MVV

Hier ENTWERTEN

EINZELFAHRT
KURZSTRECKE

MVV 01

***1.80 DM**

Bitte Hinweise auf der Rückseite beachten!

VB 4940036

MVV

Hier ENTWERTEN

**Fahrkarte für 1 Einzelfahrt
1 Zone**

4,00 DM

Bitte Hinweise auf der Rückseite beachten!

VD 2787076

MVV

R000019 26.11.18 16

EINZELFAHRT
1 ZONE

MVV 01

***3,60 DM**

Bitte Hinweise auf der Rückseite beachten!

VB 1201081

MVV

Hier in den Entwerter einführen

•7 12 55 S o46 Alex-platz

TBU-Tageskarte
Regeltarif
Alexanderplatz BC
AL 3 7.50 DM

16.11.97 S
S-Bahn Berlin GmbH

Tarif für Berlin und Umland. Ausgegeben durch S-Bahn Berlin. Gültig
nach den geltenden Beförderungsbedingungen. Bitte bei Fahrtantritt
sofort entwerten; nach Entwertung nicht übertragbar.
Bitte Rückseite beachten.
S-Bahn Berlin GmbH · Invalidenstr. 130/131 · 10115 Berlin

RF 97 42676095

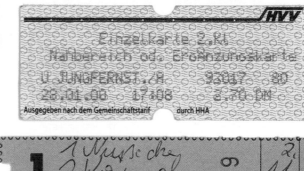

/HVV

Einzelkarte 2.Kl
Nahbereich od. Ergänzungskarte
U JUNGFERNST./A 93017 80
23.01.00 17:08 2.70 DM

Ausgegeben nach dem Gemeinschaftstarif durch HHA

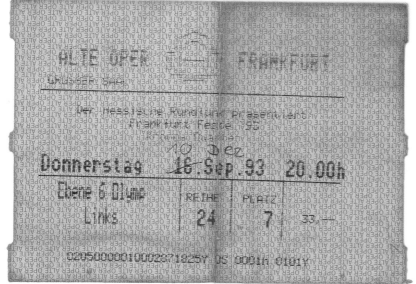

ALTE OPER FRANKFURT
Grosser Saal

Der Hessische Rundfunk präsentiert
Frankfurt Feste '93

10. Dez
Donnerstag 16.Sep.93 20.00h

Ebene 6 Blung REIHE PLATZ
Links 24 7 33,-

0205000000100023718257 05 0001H 0101Y

1
1 Muscheln 29 2,40
2 Punsch 11,60
2 Küsch 6,40
1 Teilch 2,80
1 Limo 26,00 2,80

```
80    01381116-2        Besondere Angaben        EL    Frankfurt
      01381116-61       Indications spéciales           (Main)Hbf.
                                                        18.07.94
Zahlungsart                                             110700077
Mode de palement  BARZAHLUNG                            Ausgabestempel
800034475009

           Wir haben für Sie reserviert / Nous vous avons réservé / We have reserved

   1 Sitzplatz im ICE
   BERLIN ZOO    --> FRANKFURT M

   Abfahrt / Départ / Departure      22.07          17:48                    697

                                                  Platznummern / Numéros des places / Place numbers

   Abteil / Compartiment / Compartment  Kl.           Fenster
      Großraumwagen                     Cl.           Fenetre
   1 Nichtraucher                       2     3       45

Ermäß.                      Grund                     VA / TA    DM
Réduct.  D = 100%    = %    Motif   1 Gratis                     ********  888
         = %    = %
```

```
80    01381115-1        Besondere Angaben        EL    Frankfurt
      01381115-71       Indications spéciales           (Main)Hbf
                                                        18.07.94
Zahlungsart                                             110700077
Mode de palement  BARZAHLUNG                            Ausgabestempel
800035062542

           Wir haben für Sie reserviert / Nous vous avons réservé / We have reserved

   1 Sitzplatz im ICE
   FRANKFURT M    --> BERLIN ZOO

   Abfahrt / Départ / Departure      19.07          15:18                    594

                                                  Platznummern / Numéros des places / Place numbers

   Abteil / Compartiment / Compartment  Kl.           Mitte
      Großraumwagen                     Cl.           Milieu
   1 Nichtraucher                       2     9       48

Ermäß.                      Grund                     VA / TA    DM
Réduct.  D = 100%    = %    Motif   1 Gratis                     ********  888
         = %    = %
```

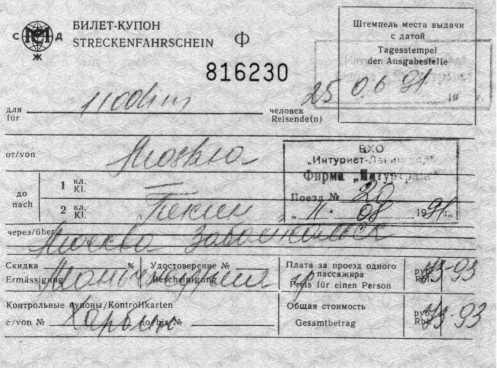

```
             БИЛЕТ-КУПОН
             STRECKENFAHRSCHEIN    Ф          Штемпель места выдачи
                                                      с датой
                    816230                       Tagesstempel
                                               der Ausgabestelle

для  _____  человек       25 06 91
für                           Reisende(n)

от/von        Москва          ВХО
        1  кл.                „Интурист-Ленинград"
           Kl.                Фирма „Интуртранс"
до                           Поезд №  20
nach    2  кл.   Пекин          11  08  1991
           Kl.

через/über   Москва Забайкальск

Скидка        %  Удостоверение №        Плата за проезд одного   руб  93
Ermässigung      Bescheinigung             пассажира            Rbl
                                        Preis für einen Person

Контрольные купоны/Kontrollkarten      Общая стоимость          руб  93
с/von №            по/bis №              Gesamtbetrag           Rbl
```

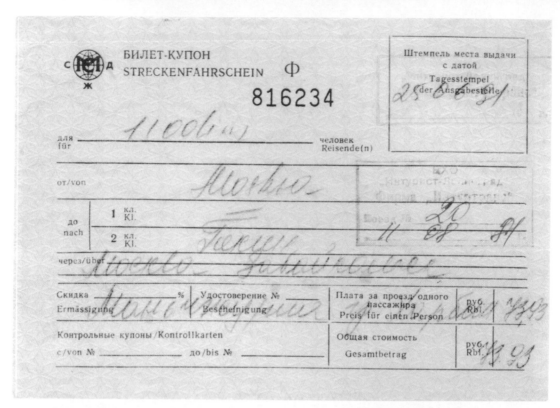

БИЛЕТ-КУПОН
STRECKENFAHRSCHEIN Ф

816234

Штемпель места выдачи
с датой
Tagesstempel
der Ausgabestelle

для
für _____ человек
Reisende(n)

от/von

до 1 кл.
nach Kl.

 2 кл.
 Kl.

через/über

Скидка _____% Удостоверение №
Ermässigung Bescheinigung

Плата за проезд одного
пассажира
Preis für einen Person

руб.
Rbl.

Контрольные купоны/Kontrollkarten

с/von № _____ до/bis № _____

Общая стоимость
Gesamtbetrag

руб.
Rbl.

BURG RONNEBURG
1254 erste urkundliche Erwähnung.
Seit 1476 in Ysenburger Besitz.

Die Ronneburg um 1900 *gez. Arch. W. Landgrebe, Offenbach a. M.*

☐ Herr ☐ Frau ☐ Frl. ☐ Firma

36115
Bücher bei Dausien
Buchhandlung
Werner Dausien
Tel. 0 61 81/2 23 16
Salzstr. 18
6450 Hanau/Main

Verlag

Straße

KNO-K&V

PLZ Ort

Datum BS-Nr. = 7 Stellen/ISBN = 10 Stellen Anzahl ☐ Expl. an
 Kunden

Bestellzeichen Reihen-Bezeichnung Band-Nr.

☐ Abholer
☐ schriftlich
☐ telefon. benachrichtigt

Bücherzettel Autor
bei Abholung Tel. _____
bitte mitbringen Titel/Reihe
Termin- und Preis-
angaben sind ☐ senden ☐ Rechn.
unverbindlich ☐ Anzahlung

Melde-Nr. Ausgabe DM DM _____ erh.

Bemerkungen Zeichen

80

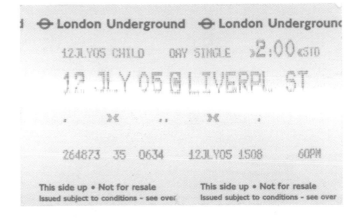

London Underground London Underground

12JLY05 CHILD DAY SINGLE »2:00«STD

12 JLY 05 @ LIVERPL ST

264873 35 0634 12JLY05 1508 60PM

This side up • Not for resale This side up • Not for resale
Issued subject to conditions – see over Issued subject to conditions – see over

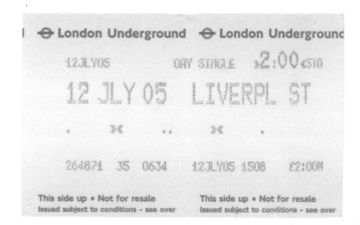

London Underground London Underground London U

25JLY04 01DAY TRAVELCARD STD

25 JLY 04 »123456«

DAY TRAVELCARD==, .OFF-PEAK

107851 35 0741 25JLY04 0927 £5:40C

ot for resale This side up • Not for resale This side up • Not
conditions – see over Issued subject to conditions – see over

London Underground London Underground

12JLY05 DAY SINGLE »2:00«STD

12 JLY 05 LIVERPL ST

264871 35 0634 12JLY05 1508 £2:00M

This side up • Not for resale This side up • Not for resale
Issued subject to conditions – see over Issued subject to conditions – see over

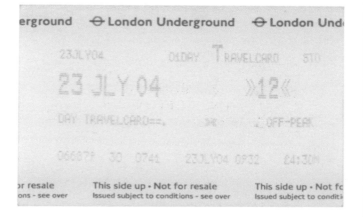

London Underground London Underground London Und

23JLY04 01DAY TRAVELCARD STD

23 JLY 04 »12«

DAY TRAVELCARD==, OFF-PEAK

06687P 30 0741 23JLY04 0932 £4:30M

or resale This side up • Not for resale This side up • Not fo
ons – see over Issued subject to conditions – see over Issued subject to conditi

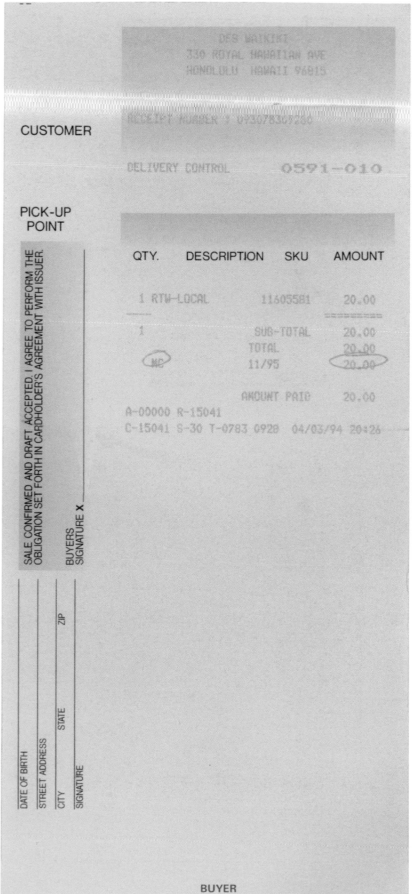

DFS WAIKIKI
330 ROYAL HAWAIIAN AVE
HONOLULU HAWAII 96815

CUSTOMER

RECEIPT NUMBER 7 073078307280

DELIVERY CONTROL 0591-010

PICK-UP
POINT

QTY.	DESCRIPTION	SKU	AMOUNT
1 RTW-LOCAL		11605581	20.00
1	SUB-TOTAL		20.00
	TOTAL		20.00
MC	11/95		20.00
	AMOUNT PAID		20.00

A-00000 R-15041
C-15041 S-30 T-0783 0920 04/03/94 20:26

SALE CONFIRMED AND DRAFT ACCEPTED. I AGREE TO PERFORM THE
OBLIGATION SET FORTH IN CARDHOLDER'S AGREEMENT WITH ISSUER.

BUYERS
SIGNATURE X

DATE OF BIRTH
STREET ADDRESS
CITY STATE ZIP
SIGNATURE

BUYER

Abzuholen am _____

Postzustellung _____

STADT FRANKFURT AM MAIN

Der Magistrat
Standesamt

☐ Bezirk Mitte / ☐ Bezirk Höchst

___/___/___ obenstehenden Betrag erhalten.

34.12/2001-10.433 Graphia Huß

FÖRDERKREIS
BURG RONNEBURG E.V.

Burg Ronneburg · D-6451 Ronneburg
Telefon 0 60 48/32 90/33 07/71 80
Telefax 0 60 48/33 85

GRUPPEN

4796

BURG RONNEBURG

1254 erste urkundliche Erwähnung.
Seit 1476 in Ysenburger Besitz.

Die Ronneburg um 1900

gez. Arch. W. Landgrebe, Offenbach a. M.

Nº 227635

SHJ

الشارقة

SHARJAH

SHJ

Nº 227635

الشارقة

Baggage identification tag issued by:
GULF AIR Nº 227635
Baggage checked subject to tariffs including limitations
of liability therein contained.
This is not the luggage ticket (baggage check) described
in Article 4 of the Warsaw Convention or the Warsaw
Convention as amended by the Hague Protocol 1955.

SHARJAH

GSD-7565 S/C 0339584461

Tahoe City Inn
Registration Card
916-581-3333

Unit No. _____ 18

Date In _____ 9/14/92

Total Days _____ 1

09330

NAME _____ Tanja Brske

STREET _____

CITY _____ STATE _____ ZIP _____

CAR
LICENSE NO. _____ STATE _____ CA

MAKE
CAR _____ Dodg COLOR _____ White NUMBER
PERSONS _____ 2

DRIVER'S LIC. NO. _____ 411505569L

Mon	X
Tue	
Wed	
Thur	
Fri	
Sat	
Sun	

RATE TOTAL TAX HOW PD: MC

$ 50.93 $ 50.93 $ 4.07 PAID $ 55.00

NOTICE TO GUESTS: ADVANCE PAYMENT REQUESTED

This property is privately owned and the management reserves the right to refuse service to anyone and will not be responsible for accidents or injury to guests or for loss of money, jewelry, or valuables of any kind.

Do you wish to have a "home-away-from-home-entertainment-center" in your home? If so, please read and sign the following:

By contracting with the management of the Tahoe City Inn the above room has become my home for the duration of my stay here.

I, being an Adult, over the age of 18 years wish to exercise my absolute right as a citizen to satisfy my intellectual and emotional needs in the privacy of my own home.

Accordingly, pursuant to my request, I hereby acknowledge receipt of instructions which, if I choose to employ them, will activate the "home-away-from-home-entertainment-center," which is a fixture in my temporary quarters.

I understand that by employing the device I may, if I choose to, enjoy Adult exotic films in the privacy of my temporary home. I further understand that I shall not aid, assert or allow any person under the age of 18 years to view the materials or films that I may choose to view in my own home nor trust these materials on my unwilling adult members of the General Public.

SIGNATURE _____

Datum _____

537 *

Name
u. Adr. _____

Mo	Di	Mi	Do	Fr	Sa	€4,40

In diesem Betrag ist die gesetzliche MWSt. enthalten.
o. Kn m. Gü o. Gü m. Schn o. Schn
verschwitzt verfärbt versengt verschmutzt defekt Risiko Kunde

BAYERISCHE VERWALTUNG
DER STAATL. SCHLÖSSER, GÄRTEN UND SEEN

63388 Fronhofer, Regensburg

Schatzkammer
in der Residenz München

Eintrittskarte DM 2.50

84 Auf Verlangen bitte vorzeigen 63388 84

BRASSERIE

VICTOR HUGO

S.A.R.L. au capital de 830 000 F

5, Place Carnot — 69002 LYON

(Angle Place Carnot - Rue Victor Hugo)

R.C. B 313955270 LYON ☎ **78 37 37 24** C.C.P. LYON 1135-12 F

LE BAR

RESTAURANT

de la PRESQU'ILE

OUVERT 7/7

de 6 h. à 1 h.

*

SERVICE

RESTAURANT

de 8 h. à MINUIT

*

L'ETE, SA TERRASSE

PLACE CARNOT

(DEJEUNER, DINER)

*

Nous acceptons les cartes

Diner's Club
Euro-Card
American Express
Carte bleue
Tous Chèques ou
Tickets Restaurants

12/05/90		0314M0000	08
MENUAM			147,00
P JOUR			*40,00
VIN			*23,00
BOI CH	2X	6,50	*13,00
TOTAL			*141,00

Pour tout paiement par chèque ou
C.C.P., nous prions notre aimable
clientèle de bien vouloir présenter
carte d'identité ou passeport au
serveur.

MERCI Service compris 15 % perçu directement par le personnel

AR UDARA NGURAH RAI BALI P.T. (PERSERO

№ 652569

PASSENGER RECEIPT **2**

PSC
INTERNATIONAL
Rp. 14.000 ,-
Please Retain and Show on Demand

AR UDARA NGURAH RAI BALI P.T. (PERSERO

№ 652577

PASSENGER RECEIPT **2**

PSC
INTERNATIONAL
Rp. 14.000 ,-
Please Retain and Show on Demand

FÖRDERKREIS
BURG RONNEBURG E.V.

Burg Ronneburg · D-6451 Ronneburg
Telefon 06048/3290/3307/7180
Telefax 06048/3385

GRUPPEN

4797

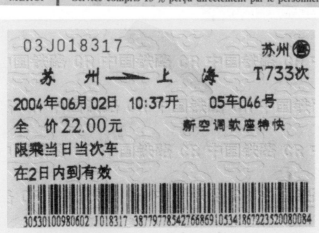

03J018317 苏州 🉑

苏 州 ➜ 上 海 T733次

2004年06月02日 10:37开 05车046号

全 价22.00元 新空调软座特快

限乘当日当次车

在2日内到有效

30530100980602 J018317 38779778542766869105341867223520080084

U.S. POSTAGE
PAID
SAN JOSE,CA
95117
OCT 19.'05
AMOUNT

UNITED STATES
POSTAL SERVICE

0000 00106 $7.55
00051517-11

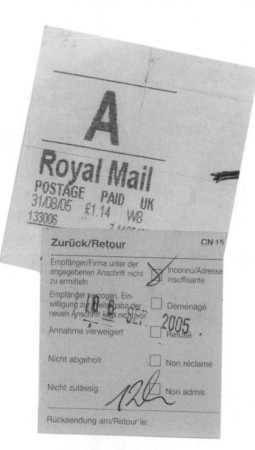

No. 15831

DIN IN ☐
TAKE OUT ☐

TAKEN TIME :

TIME OUT :

BAAK
PIZZA CHICKEN SANDWICHES
باك
البـديل العـربي الأفـضل

Name :	Telephone :	
Floor :	Flat:	Mobile :
Street :		
Building :	Code #	

SPECIAL DISHES

LAZAGNA ☐ SPAGHETTI ☐ BROSTED N ☐ ML ☐

STARTERS & SIDE ORDERS

SALAD BAR S ☐ L ☐ GARLIC BREAD N ☐ CZ ☐
MINESTRONE ☐ O.RINGS ☐ P.WDGIES ☐ F.FRIES N ☐ L ☐

SPECIAL BAAK

SUPREME SAN ☐ ML ☐ CHEESE SAN ☐ ML ☐ BAAK
CHK.STEAK SAN ☐ ML ☐ CHK.BURGER SAN ☐ ML ☐ SAN ☐ ML ☐

KIDS MEAL

CHK.BURGER ☐ HAMBURGER ☐
CHK.TENDERS ☐ ☐

BEVERAGES

SOFT DRINKS S ☐ M ☐ L ☐ COFFEE ☐ TEA ☐
CANS ☐ WATER ☐ ESPRESSO ☐ CAPPUCCINO ☐

PROMOTIONS

☐ ☐
☐ ☐

PIZZA

QTY	SIZE	TYPE	ITEM	SALAMI	PEPPERONI	BEEF	SHRIMPPS	CHICKEN	ONIONS	GREEN PEPER	HOT PEPER	MUSHROOM	OLIVE	TOMATOES	ANCHOVIES	CORN	CHEESE
			SUP														
			VEG														
			CHIK														
			SEA														
			SPICY														
			MEAT														
			MRG														

15831

BAAK
PIZZA CHICKEN SANDWICHES
باك
البـديل العـربي الأفـضل

لاستفساراتكم يرجي الإتصال بالمكتب الرئيسي على هاتف رقم

4734837- 4738375

PVG . /HVV

Einzelkarte € 2,40

2. Kl. Großbereich Hamburg
oder zwei Ringe

21.08.2005 11:28 115 Alst 39 A
Schulterblatt

7101 1160 BVG 7 0074 Gute Fahrt!

BEWONERSVERGUNNING

Gebiedscode: Geldig tot en met:

08 **30-09-04**

TG brichon/naam: Geldig in:

FB-FR-73 **Archipelbuurt**

Geldig met ingang van: Volgnummer:

01-04-04 **109636**

Opmerkingen:

Niet geldig Javastraat, Bankastraat tussen Burg.
Patijnlaan en Atjehstraat

P PARKEREN

A 604981

Vorgezählt:

Nachgezählt:

1000
Deutsche Mark
In 20 Banknoten zu 50 DM
Ohne Gewähr,
daher beim Empfang zu zählen

Best.Nr. 34030
171189

KAUFHOF

Reservierung Abschnitt
 für Kunde

Nr. Abteilung

154281 *140*

Filial-
Nr. Bezeichnung

0,4,8 *Schuhe (Lager)*

Ihre Kaufhof-Filiale reserviert für
Sie Ware in o.a. Abteilung bis zu
nebenstehenden Datum. ➤ *19.07.05*
Es gilt der Preis am Abholtag!

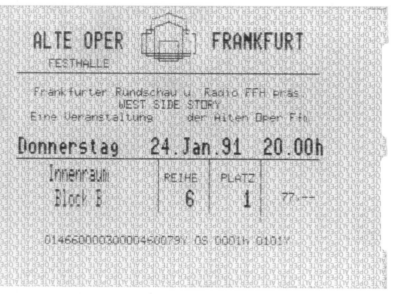

ALTE OPER FRANKFURT

FESTHALLE

Frankfurter Rundschau u. Radio FFH präs.
WEST SIDE STORY
Eine Veranstaltung der Alten Oper Ffm

Donnerstag 24.Jan.91 20.00h

Innenraum	REIHE	PLATZ	
Block B	6	1	77.--

0146600003000046079V 0S 0001W 0101Y

TACHES INDELEBILES

———————

Nous avons apporté tous nos soins et
notre art dans le traitement de votre vêtement,
mais le résultat n'est pas parfait.

Nous avons jugé préférable d'arrêter le
traitement qui risquerait de détériorer le tissu.

Dévoués à vos ordres.

BLANPRESS

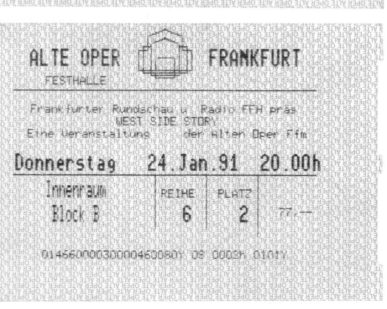

ALTE OPER FRANKFURT

FESTHALLE

Frankfurter Rundschau u. Radio FFH präs.
WEST SIDE STORY
Eine Veranstaltung der Alten Oper Ffm

Donnerstag 24.Jan.91 20.00h

Innenraum	REIHE	PLATZ	
Block B	6	2	77.--

0146600003000046080Y 0S 0003H 0101Y

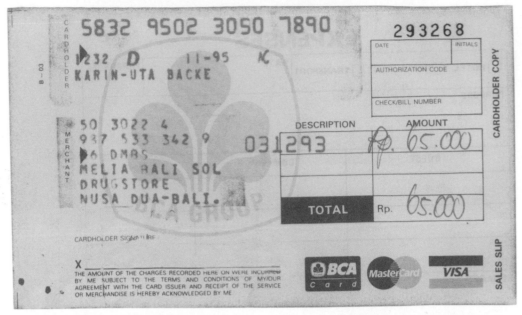

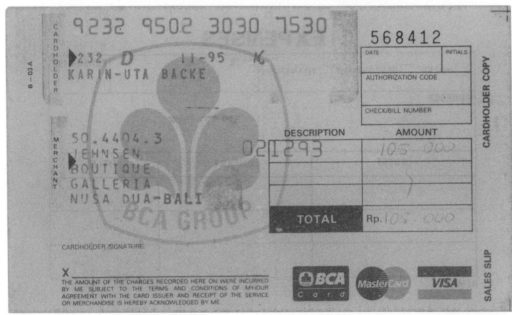

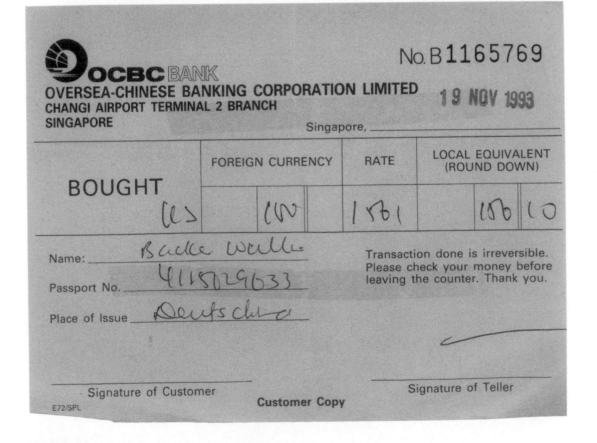

MoschMosch

ZWISCHENRECHNUNG

1 x Picooul 0,2 à 3,50		3,50
1 x Apollinaris à 2,00		2,00
1 x Gyoza Gemüse à 2,50		2,50
1 x 2,50 Wantans Gemüse		2,50
1 x 8,50 Glasnudelsuppe		8,50
1 x Seelenruhe à 9,00		9,00
Gesamt:		28,00
Nettoumsatz	24,	
Umsatz 16% inkl.	28,00	
MwSt 16%	3,86	
22.1.2004		

المغسلة الأتوماتيكية السعودية
Saudi Automatic Laundry

الرياض، ت : ٤٦٤٩٣٣٧ / ٤٩٥٨٩٧٦ - جدة ت، فاكس : ١٤٥٩ X ٦٦٤١١١١
Riyadh, Tel : 4958976 / 4649337 - Jeddah Tel&Fax : 6641111 x 1459
Riyadh, Fax : 4631579 INVOICE No. **19426**

Name : _____ إسم
Date : _____ Delivery Date : _____

السطيف الجاف Dry Cleaning	الكمية Qnty.	المدقق Check	المدقق Pack	سعر الوحدة Unit Price	الإجمالي Total
Suit-2pcs, 3pcs بدلة					
Uniform 2pcs زي عسكري					
Jacket/Coat جاكت / كوت					
Trousers بنطلون	1				
Shirt/Silk قميص / قميص حرير					
Thobe Wool ثوب صوف					
Sweater/Sp سويتر					
Tie/Scarf ايشارب					
Dress-Lo/Sp 2pcs فستان					
Skirt-Lo/Sp تنورة					
Blouse/Sp بلوزة					
Besht بشت					
Abaya عباية					
Blanket/Quilt-S/D بطانية					

غسيل وكوي Laundry	Starch+1SR L☐ M☐ H☐	Pressing PO☐ FP☐ SC☐	Packing F☐ H☐ B☐		
Trousers بنطلون					
Shirt قميص	1				
Thobe White ثوب أبيض					
Ghutra غترة					
Pajama 2 Pcs بجامة ٢ قطعة					
Shorts شورت					
Underpants سروال قصير					
Vest فانلة داخلية					
Socks جوارب					
Bedsheet-S/D شرشف					
Pillowcase كيس مخدة					
Hand Face Towel منشفة يد					
Bath Towel منشفة وجه					
T-Cloth-S/M/L مفرش طاولة					
Napkin منديل					

خدمات أخرى Other Services	REPAIR ☐ DARN ☐ ZIP ☐ ALT ☐				
Pressing كوي فقط					
Curtain ستائر					
Carpet سجاد					
Hand Wash * غسيل يدوي					

STAIN ☐ TORN ☐ DIS ☐ DAM ☐ TOTAL الإجمالي

خدمة في نفس اليوم ٢٥٪ زيادة السعر / * غسيل يدوي ٥٠٪ زيادة
Sameday Express 25% Extra / Special * Handwash 50% Extra 1

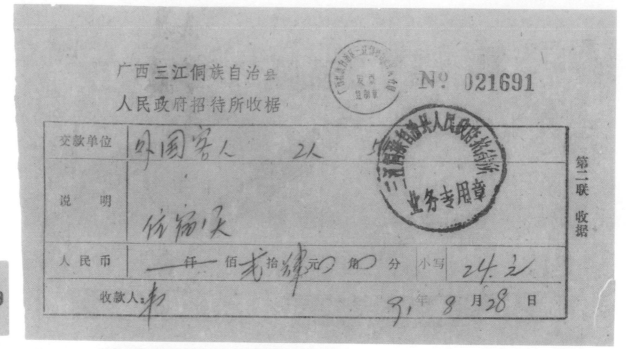

广西三江侗族自治县
人民政府招待所收据

No. 021691

第二联 收据

交款单位 外国客人 2人

说 明 住宿1天

人民币 小写 24.2

收款人 81年 8月28日

399

PARKING
LES TAMARIS
Plage de Pampelonne

La Direction décline toute responsa-
bilité de vol, d'accident et d'incendie
survenant pendant la durée du parking.
Les droits perçus, n'étant pas du gar-
diennage, mais des droits de station-
nement.

No 014881

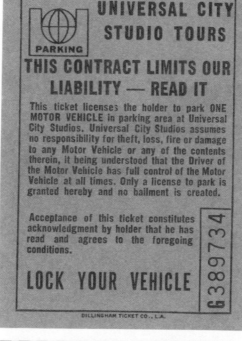

UNIVERSAL CITY
STUDIO TOURS

PARKING

THIS CONTRACT LIMITS OUR
LIABILITY — READ IT

This ticket licenses the holder to park ONE
MOTOR VEHICLE in parking area at Universal
City Studios. Universal City Studios assumes
no responsibility for theft, loss, fire or damage
to any Motor Vehicle or any of the contents
therein, it being understood that the Driver of
the Motor Vehicle has full control of the Motor
Vehicle at all times. Only a license to park is
granted hereby and no bailment is created.

Acceptance of this ticket constitutes
acknowledgment by holder that he has
read and agrees to the foregoing
conditions.

G389734

LOCK YOUR VEHICLE

DILLINGHAM TICKET CO., L.A.

RECEIPT OF LEFT BAGGAGE
BANGKOK AIRPORT

Date : 30 DEC 1991

Received the sum of twenty baht
for 1 piece of left baggage per day.

SER. A
No 599685

NO. OF PIECES 1 | BAHT 20

Vorgezählt:

1000
Deutsche Mark
in 10 Banknoten zu 100 DM
Ohne Gewähr,
daher beim Empfang zu zählen

Nachgezählt:

ORFIX - 34041
171219

COMMERZBANK
AKTIENGESELLSCHAFT

Vorgezählt:

1000
Deutsche Mark
in 10 Banknoten zu 100 DM
Ohne Gewähr,
daher beim Empfang zu zählen

Nachgezählt:

Best.Nr. 34041
171219000

```
        THE MARINA SAFEWAY
   NOBODY DOES IT BETTER FOR LESS

 0.13LB @ 3.39 /LB
WT    SALAD BAR              .44
      SMOKD SALMON          4.49
      RED RADS 529           .55
      H LETTUC 432           .99
 0.41LB @ .39 /LB
WT    CARROTS 356            .16
 0.24LB @ .59 /LB
WT    SQUASH  552            .14
      KRFT DRESSNG          1.19
      LG LEMON 187           .55
      TAX                    .00

      BALANCE DUE           8.51

      CREDIT                8.51

      CHANGE                 .00

 9/17/92 17:43 0711 08 0149 178
```

WERKSTATT KINO
mal seh'n e.V.
Adlerflychtstraße 6 Hhs.

Eintrittskarte

Preis laut Aushang
Nur a. Lösungstag gültig
Aufbewahren und auf
Verlangen vorzeigen!

013234
Fronhofer, Regensburg

WERKSTATT KINO
mal seh'n e.V.
Adlerflychtstraße 6 Hhs.

Eintrittskarte

Preis laut Aushang
Nur a. Lösungstag gültig
Aufbewahren und auf
Verlangen vorzeigen!

013236
Fronhofer, Regensburg

BAYERISCHE VERWALTUNG
DER STAATL. SCHLÖSSER, GÄRTEN UND SEEN

Altes Residenztheater
Cuvilliés-Theater

Eintrittskarte

DM -.50

11909 79 Fronhofer, Regensburg 11909

BAYERISCHE VERWALTUNG
DER STAATL. SCHLÖSSER, GÄRTEN UND SEEN

Altes Residenztheater
Cuvilliés-Theater

Eintrittskarte DM -.50

11910 79 Fronhofer, Regensburg 11910

WERKSTATT KINO
mal seh'n e.V.
Adlerflychtstraße 6 Hhs.

Eintrittskarte

Preis laut Aushang
Nur a. Lösungstag gültig
Aufbewahren und auf
Verlangen vorzeigen!

024652
Fronhofer, Regensburg

MART... IZING
TEXTILPFLEGE
SCHWEIZERSTRASSE 66
...... FRANKFURT
TELEFON: 069/612094

ABH. MONTAG
KNOPF FEHLT
SAKKO 5.40
 282 AS 0.00
TEILE 1
TOTAL 5-40
NACHKAS×5-40
10:13 BED·A
 A 25-06-2004
2541 A 1

194107

Rheinfähre
Königswinter GmbH

Fahrgeldquittung

DM 3.90

Im Fahrpreis ist der
ermäß. Satz der MWSt.
enthalten.
Nur am Lösungstag gültig.
Während der Fahrt aufbe-
wahren und auf Verlangen
vorzeigen. Beförderungs-
bedingungen beachten.

Druck: Fronhofer, Regensburg

194107

COIN - BERBER

BOUZIDI IDRISSI FACTURE

67 Talaa Kebira , Hadadin

Fès Medina № 00 492

Tèl : 63 69 46

 Fès le _____

Mr _____

Quantite	Designation	Prix U.	TOTAL
1	Kilimeberber		1150 dh

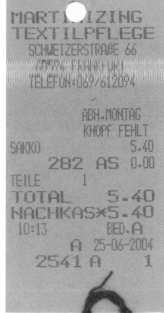

FOTO-FUCHS
Hammerstr. 2
63450 HANAU/M.
Tel. 2 37 68

Ausführung gemäß
gleichzeitiger
Anweisung mit gleicher
Nummer erbeten

Diesen Anhänger bitte
am Gegenstand lassen

Reparatur
Reklamation

052375 *

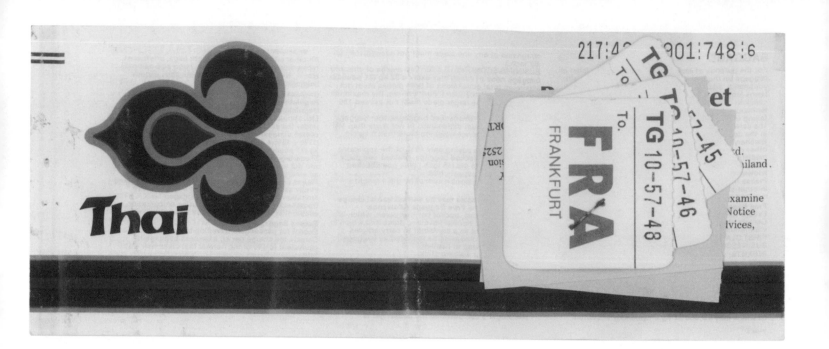

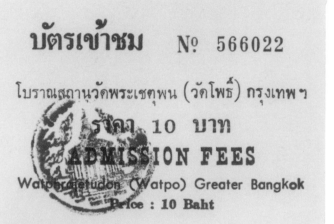

บัตรเข้าชม № 566022

โบราณสถานวัดพระเชตุพน (วัดโพธิ์) กรุงเทพฯ

ราคา 10 บาท

ADMISSION FEES

Watphraetudon (Watpo) Greater Bangkok

Price : 10 Baht

PRIORITY

TRA 274A

SINGAPORE AIRLINES

USAir

standby

46769

Münchner Stadtmuseum

Eintritt

—,50 DM

Auf Verlangen vorzei

284

285

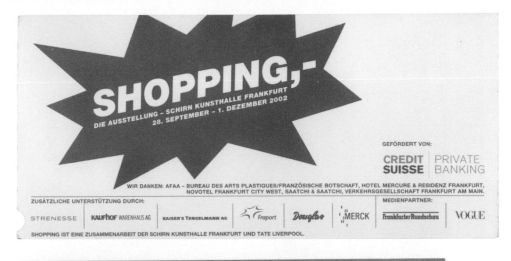

SHOPPING,-

DIE AUSSTELLUNG – SCHIRN KUNSTHALLE FRANKFURT
28. SEPTEMBER – 1. DEZEMBER 2002

GEFÖRDERT VON:

CREDIT SUISSE | PRIVATE BANKING

WIR DANKEN: AFAA – BUREAU DES ARTS PLASTIQUES/FRANZÖSISCHE BOTSCHAFT, HOTEL MERCURE & RESIDENZ FRANKFURT, NOVOTEL FRANKFURT CITY WEST, SAATCHI & SAATCHI, VERKEHRSGESELLSCHAFT FRANKFURT AM MAIN.

ZUSÄTZLICHE UNTERSTÜTZUNG DURCH:

MEDIENPARTNER:

STRENESSE | **KAUFHOF** WARENHAUS AG | KAISER'S TENGELMANN AG | Fraport | Douglas | MERCK | Frankfurter Rundschau | VOGUE

SHOPPING IST EINE ZUSAMMENARBEIT DER SCHIRN KUNSTHALLE FRANKFURT UND TATE LIVERPOOL.

Zoo/Aquarium
Tierpark Berlin

0,50 €

zur Deckung zusätzlicher
Zuschuss-Kürzungen 2004

089807

Zoo/Aquarium
Tierpark Berlin

0,50 €

zur Deckung zusätzlicher
Zuschuss-Kürzungen 2004

089806

170 **170**

Preis

Eintrittskarte

Bitte aufbewahren,
auf Verlangen vorzeigen!

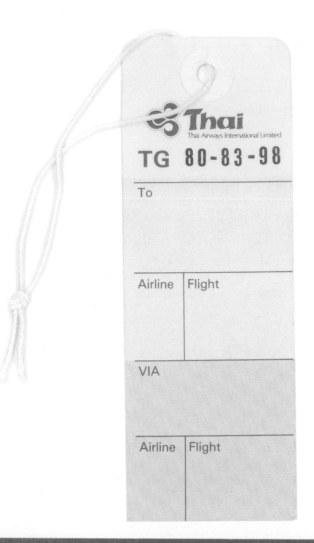

FRAGILE

8 **Thai**
Thai Airways International Public Company Limited

THAI 1627

TG 80-83-98

To

Airline | Flight

VIA

Airline | Flight

8 **Thai**
Thai Airways International Limited

PAINTINGS
MALEREI
JULIAN 1978-2003
SCHNABEL

AFTER OPENING PARTY

ZEIT TIME 28. JANUAR 2004, AB 22 UHR AT 10 P.M.
ORT VENUE SCHIRN CAFÉ
MIT WITH DJ DANIEL HAAKSMAN

Approved Cabin Baggage germ

name:

flight-no.: date:

Wallraf
Richartz
Museum/
Museum
Ludwig

Stadt Köln

Wallraf
Richartz
Museum/
Museum
Ludwig

Stadt Köln

H. Sch.
Serie 3420

Kombinieren Sie die
Sternzeichen

Versuch's nochmal Versuch's
nochmal Versuch's nochmal
Versuch's nochmal Versuch's
nochmal Versuch's nochmal
Versuch's nochmal Versuch's
nochmal Versuch's nochmal
Versuch's nochmal Versuch's

Leider verloren

Versuch's nochmal Versuch's

EUROPÄISCHE GEMEIN...

BUNDESREPUBLIK
DEUTSCHLAND

REISEPASS

Rechnung **5804** *

Datum 5.11.98 3 Hemden Preis

Name Torza

Adresse

Betrag dankend erhalten. [einschl. MWSt.]

BAYERISCHE VERWALTUNG
DER STAATL. SCHLÖSSER, GÄRTEN UND SEEN
Residenzmuseum München
Eintrittskarte DM 1.50
Auf Verlangen bitte vorzeigen

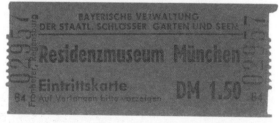

Ex POS **BGI** 2411705 **BWIA** **BGI**
BARBADOS International **BARBADOS**
 TRINIDAD & TOBAGO
 AIRWAYS

PAX NAME Mrs Babe

BWIA **FRAGILE**
ACCEPTED FOR TRANSPORTATION AT THE PASSENGER'S RISK

Datum _____
 265 *
Name
u. Adr. 2.1.05

Mo Di Mi Do Fr Sa € 4,90
In diesem Betrag ist die gesetzliche MWSt. enthalten.
m. Kn o. Kn m. Gü o. Gü m. Schn o. Schn
verschwitzt verfärbt versengt verschmutzt defekt Risiko Kunde

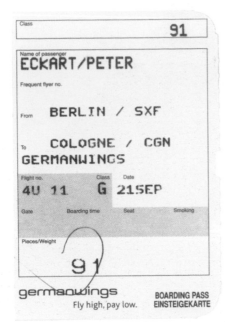

Class 91

Name of passenger
ECKART/PETER

Frequent flyer no.

From **BERLIN / SXF**

To **COLOGNE / CGN**
GERMANWINGS

Flight no.	Class	Date
4U 11	G	21SEP

Gate Boarding time Seat Smoking

Pieces/Weight

91

germanwings
Fly high, pay low.

BOARDING PASS
EINSTEIGEKARTE

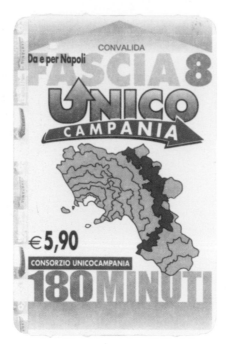

CONVALIDA
Da e per Napoli
FASCIA 8
UNICO
CAMPANIA

€5,90
CONSORZIO UNICOCAMPANIA
180MINUTI

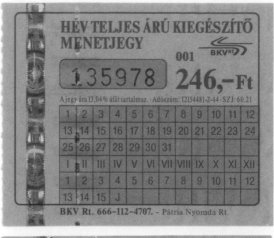

HÉV TELJES ÁRÚ KIEGÉSZÍTŐ
MENETJEGY 001 BKV RT

135978 246,-Ft

A jegy ára 13,04 % áfát tartalmaz. Adószám: 12154481-2-44 · SZJ: 60.21

BKV Rt. 666-112-4707. - Pátria Nyomda Rt.

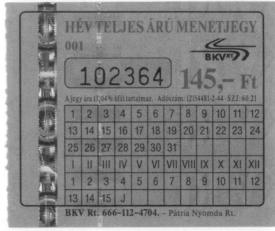

HÉV TELJES ÁRÚ MENETJEGY
001 BKV RT

102364 145,-Ft

A jegy ára 13,04 % áfát tartalmaz. Adószám: 12154481-2-44 · SZJ: 60.21

BKV Rt. 666-112-4704. - Pátria Nyomda Rt.

126384 SCHIRN
KUNSTHALLE
FRANKFURT

089741 SCHIRN
KUNSTHALLE
FRANKFURT

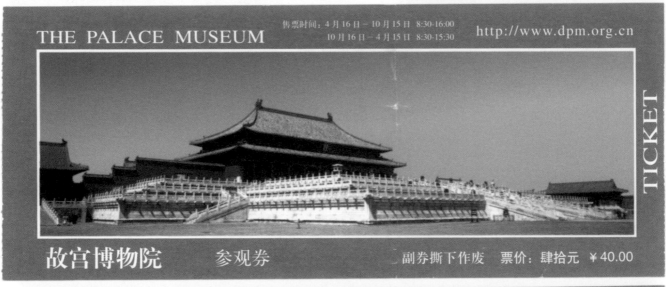

THE PALACE MUSEUM

售票时间：4月16日－10月15日 8:30-16:00
10月16日－4月15日 8:30-15:30

http://www.dpm.org.cn

TICKET

故宫博物院 参观券 副券撕下作废 票价：肆拾元 ￥40.00

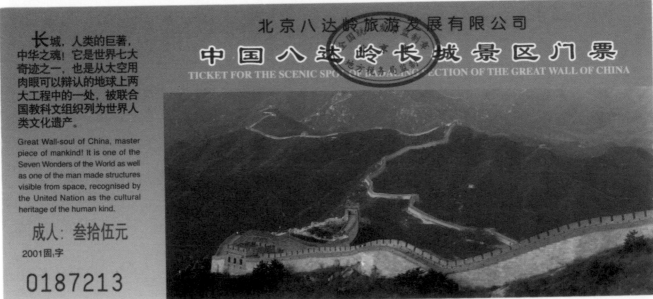

长城，人类的巨著，中华之魂！它是世界七大奇迹之一，也是从太空用肉眼可以辩认的地球上两大工程中的一处，被联合国教科文组织列为世界人类文化遗产。

Great Wall-soul of China, master piece of mankind! It is one of the Seven Wonders of the World as well as one of the man made structures visible from space, recognised by the United Nation as the cultural heritage of the human kind.

成人：叁拾伍元

2001固,字

0187213

北京八达岭旅游发展有限公司
中国八达岭长城景区门票
TICKET FOR THE SCENIC SPOT OF BADALING SECTION OF THE GREAT WALL OF CHINA

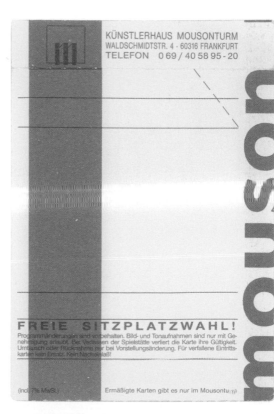

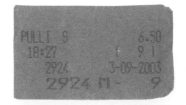

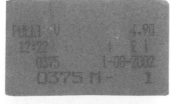

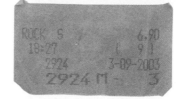

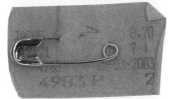

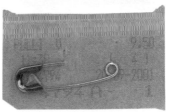

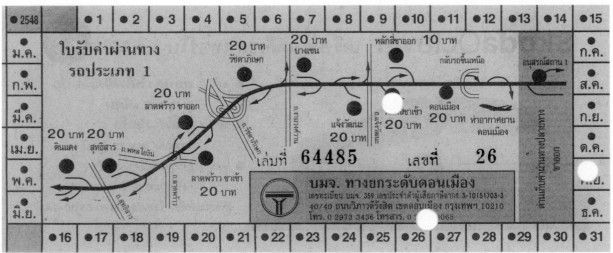

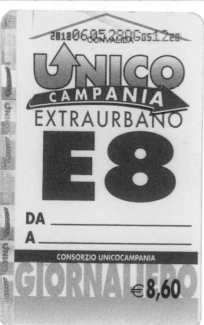

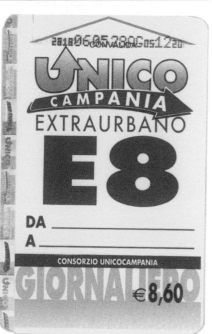

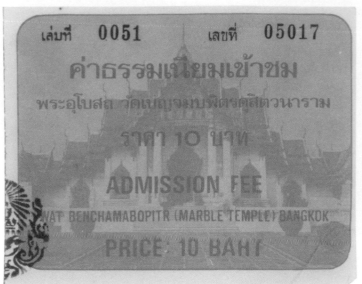

เล่มที่ 0051 เลขที่ 05017

ค่าธรรมเนียมเข้าชม

พระอุโบสถ วัดเบญจมบพิตรดุสิตวนาราม

ราคา ๑๐ บาท

ADMISSION FEE

WAT BENCHAMABOPITR (MARBLE TEMPLE) BANGKOK

PRICE: 10 BAHT

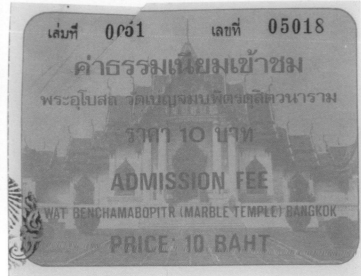

เล่มที่ 0051 เลขที่ 05018

ค่าธรรมเนียมเข้าชม

พระอุโบสถ วัดเบญจมบพิตรดุสิตวนาราม

ราคา ๑๐ บาท

ADMISSION FEE

WAT BENCHAMABOPITR (MARBLE TEMPLE) BANGKOK

PRICE: 10 BAHT

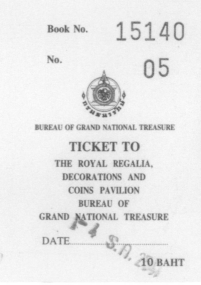

N⁰ 14 N⁰ 14

บัตรอนุญาตเข้าชม

ศาลาเครื่องราชอิสริยยศ เครื่องราชอิสริยาภรณ์

และเหรียญกษาปณ์ไทย

THE ENTRANCE TICKET TO

THE ROYAL THAI DECORATIONS AND COINS PAVILION

วันที่ _____

เล่มที่ 26040 เล่มที่ 26040 ๑๐ บาท

Messe Düsseldorf
IGEDO COMPANY
NORD OG

456

1xGarderobe

€ 1.50
inkl. MwSt.
18/11/2005
Zeit: 12:07

456

GW-Ticket 09461-9001

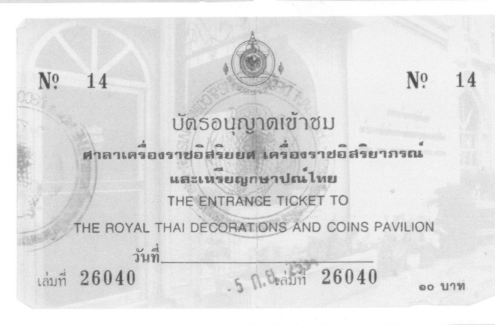

Book No. 15140 Book No. 15140

No. 05 No. 05

BUREAU OF GRAND NATIONAL TREASURE BUREAU OF GRAND NATIONAL TREASURE

TICKET TO TICKET TO

THE ROYAL REGALIA, DECORATIONS AND COINS PAVILION BUREAU OF GRAND NATIONAL TREASURE THE ROYAL REGALIA, DECORATIONS AND COINS PAVILION BUREAU OF GRAND NATIONAL TREASURE

DATE _____ DATE _____

10 BAHT 10 BAHT

TRF/7540

Baggage identification tag issued by
GULF AIR N⁰ 483796 ABU DHABI
Baggage checked subject to tariffs including limitations
of liability therein contained.
This is not the luggage ticket (baggage check) described
in Article 4 of the Warsaw Convention or the Warsaw
Convention as amended by the Hague Protocol 1955.

Messe Düsseldorf
IGEDO COMPANY
NORD OG

121

Koffer

€ 2.00
inkl. MwSt.
18/11/2005
Zeit: 12:07

121

GW-Ticket 09461-9001

```
**********************
*  A U C H A N  *
CENTRE COMMERCIAL V2*
**********************

TEL. 20.91.92.88
        BONJOUR !!

   ELIANE    CAISS. 439

POMELOS FILET              15.90
SILHOUETTE UHT - 6L        22.50
MOUCHOIRS DUVELINE         14.90
POMELOS FILET              15.90
ORANGE 3 KILO              22.90
CHOU FLEUR                  5.00
SILHOUETTE 20% CAND.        7.90
MAIS DOUXJARDINE 1/2       13.50
BARRE RAISINS CEREA.       10.25
PETIT NOVA 30% 12X60       12.50
PETIT NOVA 30% 12X60       12.50
SILHOT NAT 0% YOPLA.        7.20
SILHOT NAT 0% YOPLA.        7.20
817122
NON ALIMENTAIRE             7.95
GEL DOUCHE ITHAQUE          6.50
POMME GOLDEN                8.80
emmental suisse           14.24
Y.NATURE CHAMBOURCY        15.90
ANANAS                     15.90
ANANAS                     15.90
PIMENTS ROUGES STORA        6.95
PIMENTS ROUGES STORA        6.95
MOUSSE A RASER BRUT        11.20
PIMENTS ROUGES STORA        6.95
DEMI CANDEREL 100           9.50
VELOUTE POIS JAMBON         3.65
SOUPE PASSEE 9 LEGU.        4.60
SOUPE PASSEE LEGUMES        5.90
POULE AU POT KNORR 4        4.95
MATINO MOULU LAVAZZA       22.95
APRES SHAMPOOING PRE        9.45
MAIS DOUXJARDINE 1/2       13.50
CORNICHONS GUERET           5.50
WEETABIX 430 G             12.50
VITAGERMINE MIX FRU.       16.00
WASA SEIGLE BLOND           5.95
WASA FIBRES 250G            6.80
WASA CEREALE DOREE          7.30
WEETABIX 430 G             12.50
WASA FIBRES 250G            6.80
      2 QTE    F17.10
EAU VICHY ST YORRE        34.20

TOTAL             467.44

NO   2274890689188922
CARTE          ACHATS      467.44
               TRACE    010597
  2711         CAISS. 439
SIGNATURE*

CARTE              467.44
ART. 42
MERCI DE VOTRE VISITE

2711
0019 4236-0019 2765 20:09  30/ 6/90/ SAM
```

— Ouvert Toute l'année —

La Houle 35260 CANCALE
2, Quai Thomas Tél. 02.99.89.90.94

SIRET 381 258 508 00013

```
*TABLE 301

COUVERTS   3

2 ASSIETTE FR/MER CARTE    198.00
1 POISSON ENFANT            45.00
1 MUSCADET                  75.00
1 1/2 EAU GAZEUSE           18.00
1 ORANGINA                  15.00
2 CAFE                      30.00
2 CALVADOS VIEILLE RESERVE  80.00
                          --------
S/TOTAL                    461.00

DONT TVA 20.60 %            78.74
```

TOTAL 461.00

OUVERT TOUTE L'ANNEE

JEU 20 AOU 98 SERV.2

MERCI DE VOTRE VISITE - THANK YOU WELCOME - DANKESCHÖEN

Acceptons le règlement des sommes dues par chèque libellé à notre nom, en notre qualité
de membre d'un centre de gestion agréé par l'administration fiscale.

IMP. GUIBERT - TÉL. 02 96 72 65 11

```
***EUROMARCHE***  A Shopping Pleasure
OPEN 24 HOURS A DAY  - Tel: 482-5657

051-M & M MINIS TU        2.00
270-NIVEA SHAMPOO          8.95
****           BAL         10.95
    Cash                  100.00
    CHANGE                 89.05
19/03/05 22:17 0001111 0147 679
Thank You For Shopping With Us!!!
Item Exchange In 2 Days NO CASH REFUND
```

```
LE NAUTIC
VIEUX PORT
SAINT-RAPHAEL

CREME      11.00
SIROP      10.00
TOTAL
          21.00
0# 68M20-08'88
```

```
MAG. DER STADT
6050 OFFENBACH
ÄMTER 31 U 32

23.06.88

31-FLM      5.00

TOTAL       5.00

1
1261A      15:45
```

Kempinski Hotel
Beijing Lufthansa Center
BEIJING
凯宾斯基饭店
北京燕莎中心有限公司

Bill 帐单

2106759

<< KEMPI G.GALLERY >>

Honzen

Dragon Palace

Kempi Deli

Rendez-vous

Paulaner Bräuhaus

Seasons Café

Trattoria La Gondola

Room Service

Jade Ballroom

```
1781 KEMPI CASH#2

TBL 1/1      CHK 992     GST 1
     28MAR'05  7:32

1 OPEN COFFEE          19.00
1 OPEN BREAD           10.00
CASH RMB              100.00
SUBTOTAL               28.00
PAYMENT                28.00
CHANGE DUE             72.00
----1781 CLOSED 28MAR  7:33-----
```

Please Print Name 打印姓名	Room No. 房号
	550
Guest Signature 客人签名	!

```
RESTAURACJA DWORC.
KAMIRO S.C.
70-035 SZCZECIN
UL.KOLUMBA 2
A.MIERZEJEWSKI
NIP 852-000-08-26
    22/12/04
    OFPAR:067791

PRODUKCJ  *4.50 B
PRODUKCJ  *3.50 B
PRODUKCJ  *3.00 B

SUMA B    *11.00
PTU 7%    *0.72
KW.PTU    *0.72

RAZEM     *11.00
GOT6W     *11.00

   3 LICZSP

0016  #645 A 14:19
7E DL 98097202
```

```
ELF BELGIE  NV
AUTOBAAN E 19
MINDERHOUT  .N
TEL 03.3145581

43.77L
LOODVRIJ 1177
MARS SNK    27
VISA F 1204.00

111189/1244P12
*** DANK U ***
* TOT ZIENS  *
```

```
RUDY HADISUWARNO
MANDARIN HOTEL
JAKARTA

19-11-93 #542550

#125
DP02      17.050
SUBTL     17.050
CASH      17.050

ITEM       1
2CL  8005 19:19
```

```
上海书城南东店

收款员:54    累计积分:
地址:南京东路345号  电话:63221557

陆家嘴夜色(明信片)    2.00*100%    5

总价:    10.00    总册数:5
折让:   -0.000    实价:    10.00
现金:    10.00    礼券:
IC卡:             找零:    0.000
支票:             会员等级:
06/02/04  17:22:40
940354535245
请妥善保存单据，凡有质量问题凭单退换。谢
谢光临
```

FURET DU NORD

NOUVEAUX HORAIRES

du LUNDI AU SAMEDI

9h30 a 19h30

15-03-93 N0014

FOLIO 4
71 F33.50 ←
FOLIO 6
71 F43.00 ←
POCHE F47.00
LDP LP8
71 F32.00
 F155.50
REMISE 5% S7.77
LITT F87.50
SousTL F235.23

CB F235.25
 5ARTC
0022N 014NC11:18TM

731 - Papir

Cis. dokladu 93679
Herlitz 22% 50,00
Herlitz 22% 37,00
zbozi 22% 7,00
zbozi 22% 48,00
 12* 4,00
zbozi 22% 6,00
 7,05
1001 4% 14,04
 2* 7,00
Herlitz 22% 15,00
zbozi 22% 40,00
 4* 10,00
zbozi 22% 45,00
 9* 5,00
zbozi 22% 20,00
 4* 5,00
CELKEM 37 282,00
HOTOVE 282,00

VRATIT 0,00
DPH 22,0% 48,40
Zaklad dane 219,60
DPH 5,0% 0,70
Zaklad dane 13,30
Obslouzil(a) Vas 1053
Pokladni misto c.7313
Dekujeme za navstevu.

98470 17313 1053
0 22.11.96 09.52

RTE.NURIA SOC.COOPERATIV
C.I.F. F-41670126
Avda.de MALAGA,1
SEVILLA

08/10/95 001#6734
A-01 CLERK01 GLU#0012

 COPIA *

SALDO 0
 2x 100
PAN 200
 2x 600
ENSALADA 1200
 2x 225
REFRESCOS 450
 2x 150
CAFE 300
SUBTOTAL 2150
 7.00%
I.V.A 151
IMPORTE 2301

 M A T C H
 532. MARCQ
 TEL: 20 06 83 32

MATCH VOUS REMERCIE
DE VOTRE VISITE

1010 18-03-94 N110011

RIZ LONG GRAIN 7.30
CHAMP.CHARLES 73.80
 ST MORET LEGE 10.00
BOURSIN AIL 9.35
CREME FRAICHE 4.50
CAMEMBERT COEU 9.30
Y.NATURE X 4 2.70
LAITUE 4.90
 40 FILTRES N2 2.50
FILET CABILLAU 19.34
BANANE 11.80
GAMA ECO 10.65
CITRONS 9.50
POIRES 4.80
EAU SOURCE MON 1.60
POMMES 4.75
ORANGES 4.35
 CHAVROUX 45% 11.20
 BRESSE BLEU 13.90
FROMAGE FRAIS 4.45
SOUPE POISSON 19.90
CAROTTE KG 4.90
POT AU FEU 10.90
POMME TERRE 5K 6.50
 2 X2.70
BAGUETTE 250G 5.40
SOUS TOT 263.39
TOTAL 263.39

RECU 300.00
RENDU 36.61

01028 25ARTI 19:59TM

ANTONIO ESCOBEDO
GOMEZ
AV. REVOLUCION 732
ZONA CENTRO

---- RFC----
EOGA201224085
04/09/1992
R.F.NO 055333
HORA/ 19:15

CURIOS %10 #2298

TOTIVA #209
TOTVTA #2298

EFVO. #2298

1 TOTART

001
STX -- NCR0000433
CXP

LE CAFE GLACIER

DIVERS 18.00
DIVERS 18.00
DIVERS 46.00
DIVERS 46.00
 NUL
DIVERS 46.00
DIVERS 35.00
DIVERS 9.00
DIVERS 9.00
TOTAL =

21/11/96 21:31 000#0370
0001CLERK001 CLU#0040

*UCET *

*P*SALDO *0.00
 2 x 29.00
SVETLE P.05
 *58.00
MINERAL.MATT
 *21.00
 2 x 10.00
COUVERT
 *20.00
KURE.-ROZMAR
 *159.00
HRANOLKY
 *20.00
JARNI SALAT
 *39.00
SOPS.SALAT
 *39.00
SLIVOVICE
 *69.00
MEZISOUCET *425.00
S DANI 22% *425.00
DPH 22% *76.64
NETO 1 *348.36

HOTOVE *425.00

BUNDESAUTOBAHNTANKSTELLE

A
054
...45

Welkom
NS Internationaal

034

Internat./plaatshesp/info
10:02 1/0 1997

WELKOM
OP UW POSTKANTOOR

211

Alle handelingen

12:42 2/5 1000 321M

Welcome

082

Service

12:15 11/12 2000 0000

Welcome

079

Service

12:04 11/12 2000 0374

WELKOM
A
207

.12

Welcome

080

Service

12:04 11/12 2000 0313

Deze toets is
buiten gebruik

Maak een
andere keuze

Button 4
18:32 1/3 1997 615

Welkom
NS Internationaal

c411

binnen 1 uur
12:58 16/12 2000

Welkom
NS Internationaal

B208

1e klas
12:58 16/12 2000

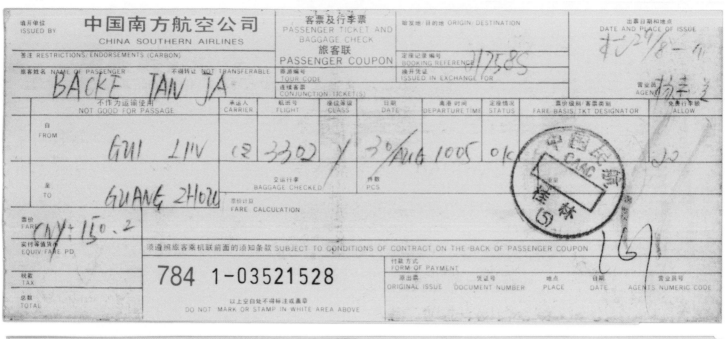

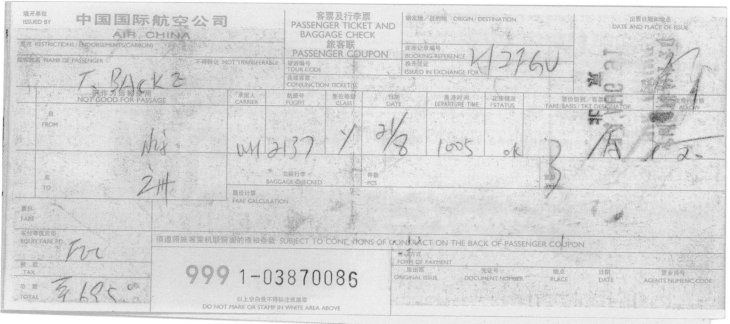

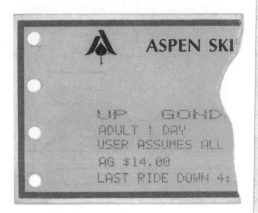

ASPEN SKI

UP GOND
ADULT 1 DAY
USER ASSUMES ALL
AG $14.00
LAST RIDE DOWN 4:

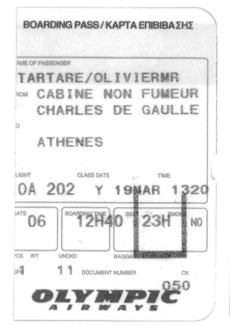

BOARDING PASS / ΚΑΡΤΑ ΕΠΙΒΙΒΑΣΗΣ

NAME OF PASSENGER
TARTARE/OLIVIERMR
FROM CABINE NON FUMEUR
CHARLES DE GAULLE
TO ATHENES

FLIGHT	CLASS	DATE	TIME
OA 202	Y	19MAR	1320

GATE	BOARDING TIME	SEAT	SMOKE
06	12H40	23H	NO

| PCS | WT | UNCKD | BAGGAGE | |
| 1 | 11 | | DOCUMENT NUMBER | CK |

OLYMPIC AIRWAYS 050

DEUTSCHE VERKEHRS-KREDIT-BANK
AKTIENGESELLSCHAFT
ZWEIGNIEDERLASSUNG KARLSRUHE
13- 2 3. AUG. 1989 -5
BLZ: 660 103 00

VISA

4970009502099023 8911

MR OLIVIER TARTARE

Tr.- Nr. 4400 30

Vu.- Nr. 4556920133
DVKB
BISMARCKALLEE 3
7800 FREIBURG

Gen.- Nr. 56629 Betrag: 100,00 DMK

08 23 09:43

X--------------------------------

Nord
NC 06274

Meliá Bali Sol
★★★★★ GL
Nusa Dua. Bali. Indonesia. Tel. (0361) 71510 Tlx 35237 Fax. 71360.

FOREIGN CURRENCY EXCHANGE VOUCHER
№ 145100

NAME	ROOM	3106
	DATE	29-11-93
	RATE	2027
US DOLLAR – CASH	US	71
US DOLLAR – T/C		
	TOTAL	Rp 143.917
CASHIER	RECEIVED	
	GUEST SIGNATURE	

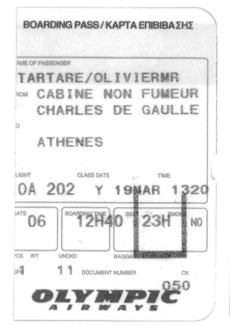

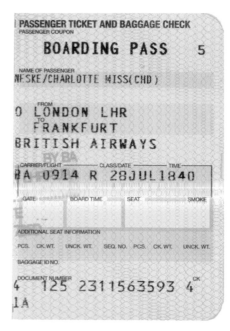

PASSENGER TICKET AND BAGGAGE CHECK
PASSENGER COUPON

BOARDING PASS 5

NAME OF PASSENGER
NESKE/CHARLOTTE MISS(CHD)

FROM
O LONDON LHR
TO
FRANKFURT
BRITISH AIRWAYS
BY BA

CARRIER/FLIGHT CLASS/DATE TIME
BA 0914 R 28JUL1840

GATE BOARD TIME SEAT. SMOKE

ADDITIONAL SEAT INFORMATION

PCS. CK.WT. UNCK. WT. SEQ. NO. PCS. CK. WT. UNCK. WT.

BAGGAGE ID NO.

DOCUMENT NUMBER
4 125 2311563593 4 CK
1A

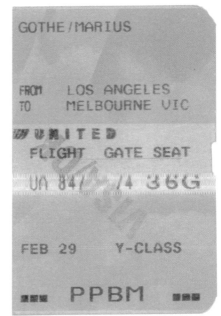

GOTHE/MARIUS

FROM LOS ANGELES
TO MELBOURNE VIC

UNITED

FLIGHT GATE SEAT
UA 847 74 36G

FEB 29 Y-CLASS

PPBM

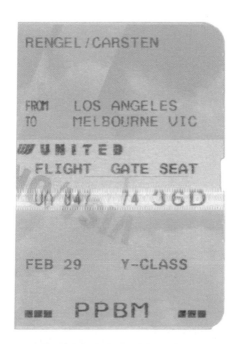

RENGEL/CARSTEN

FROM LOS ANGELES
TO MELBOURNE VIC

UNITED

FLIGHT GATE SEAT
UA 847 74 36D

FEB 29 Y-CLASS

PPBM

INFANT
Boarding Pass

Name
SPAMER/MAXBENJAMININ

From
To COPENHAGEN
 BRUSSELS

Carrier Flight Class Date Time
SN 2264 Y 15DEC2010

Gate	Boarding Time	Seat	Smoke
	1940	NO SEAT	

Pcs Wt

ECONOMY
Boarding Pass

Name
SPAMER/ANDREASMR

From
To COPENHAGEN
 BRUSSELS

Carrier Flight Class Date Time
SN 2264 Y 15DEC2010

Gate	Boarding Time	Seat	Smoke
A	1940	10A	NO

Pcs Wt
2 37 0015

ECONOMY
Boarding Pass

Name
SPAMER/ANDREASMR

From
To BRUSSELS
 FRANKFURT

Carrier Flight Class Date Time
SN 2619 Y 15DEC2210

Gate	Boarding Time	Seat	Smoke
C02	2140	18E	NO

Pcs Wt
2 37 0006

BOARDING PASS
PALUBNÍ VSTUPENKA

NAME OF PASSENGER / JMÉNO CESTUJÍCÍHO
ECKART

FROM / Z
PRAGUE
TO / DO
COLOGNE

FLIGHT / LET CLASS / TŘÍDA DATE / DATUM TIME / ČAS
J 773 Y 07MAR 1230

GATE VYCHOD	BOARDING TIME ČAS NÁSTUPU	SEAT SEDADLO	SMOKE KUŘÁCI
08	1200	N/A	

PCS WT UNCKD BAGGAGE ID NUMBER
CPN 4 0 DOCUMENT NUMBER CK

RA Menzies

ECONOMY
Boarding pass

Name
SPAMER/ANDREASMR

From FRANKFURT
To BRUSSELS

Flight Class Date Time
Gate Boarding

SN 2620 Y 11DEC 0800
 Time

D21 0730 15C NO

2 33

The *Qualiflyer* Group
0075

ECONOMY
Boarding Pass

Name
NAEGELESPAMER/ISABEL

From
To BRUSSELS
 FRANKFURT

Carrier Flight Class Date Time
SN 2619 Y 15DEC2210

Gate	Boarding Time	Seat	Smoke
C02	2140	18F	NO

Pcs Wt
PLD 0005

AUTOROUTES DU SUD DE LA FRANCE
Direction Régionale d'Exploitation de NIORT
B.P. 11 - GRANZAY-GRIPT - 79360 BEAUVOIR-SUR-NIORT

km PARCOURUS		GARE ENTREE	
CAT FISCALE	ANNÉE	GARE SORTIE	
			CLASSE PÉAGE

0 260 89 202 01 84 1 94,0

JOUR TARIF

CERTIFICAT DE PASSAGE
1513239

WELCOME
TO THE
UNITED STATES

DEPARTMENT OF THE TREASURY
UNITED STATES CUSTOMS SERVICE

CUSTOMS DECLARATION

FORM APPROVED
OMB NO. 1515-0041

Each arriving traveler or head of family must provide the following information (only **ONE** written declaration per family is required):

1. Name: ————————————————————
 Last First Middle Initial

2. Number of family members traveling with you ——————————

3. Date of Birth: ——/——/—— 4. Airline/Flight: ————
 Month Day Year

5. U.S. Address: ————————————————————

————————————————————————————

		YES	NO
6.	I am a U.S. Citizen If No, Country: ——————————————	☐	☐
7.	I reside permanently in the U.S. If No, Expected Length of Stay: —————————	☐	☐

8. The purpose of my trip is or was
 ☐ BUSINESS ☐ PLEASURE

		YES	NO
9.	I am/we are bringing fruits, plants, meats, food, soil, birds, snails, other live animals, farm products, or I/we have been on a farm or ranch outside the U.S.	☐	☐
10.	I am/we are carrying currency or monetary instruments over $10,000 U.S. or foreign equivalent.	☐	☐

11. The total value of all goods I/we purchased or acquired abroad and am/are bringing to the U.S. is (see instructions under Merchandise on reverse side; visitors should report value of gifts only):
 $ ————————————
 U.S. Dollars

SIGN ON REVERSE SIDE AFTER YOU READ WARNING.
(Do not write below this line.)

INSPECTOR'S NAME	STAMP AREA
BADGE NO.	

Paperwork Reduction Act Notice: The Paperwork Reduction Act of 1980 says we must tell you why we are collecting this information, how we will use it and whether you have to give it to us. We ask for this information to carry out the Customs, Agriculture, and Currency laws of the United States. We need it to ensure that travelers are complying with these laws and to allow us to figure and collect the right amount of duties and taxes. Your response is mandatory

Customs Form 6059B (102584)

Deutsche Bundesbahn [DB]

DARMSTADT HBF 1799 6027
(von (Ausgabestelle) FAA-Nr. lfd. Nr.

25059A 13 2 05 EHP *3 30
Datum Uhrzeit Kl Zone Tarif DM

(Tarif siehe Rückseite)

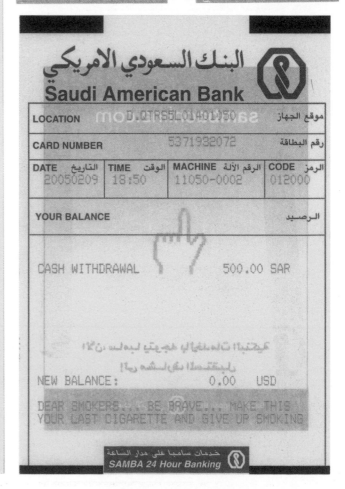

البنك السعودي الامريكي
Saudi American Bank

LOCATION	MO.QTR55L014011/30	موقع الجهاز
CARD NUMBER	5371932072	رقم البطاقة

DATE التاريخ	TIME الوقت	MACHINE الرقم الآلة	CODE الرمز
20050209	18:50	11050-0002	012000

YOUR BALANCE الرصيد

CASH WITHDRAWAL 500.00 SAR

NEW BALANCE: 0.00 USD

DEAR SMOKERS... BE BRAVE... MAKE THIS YOUR LAST CIGARETTE AND GIVE UP SMOKING

خدمات سامبا على مدار الساعة
SAMBA 24 Hour Banking

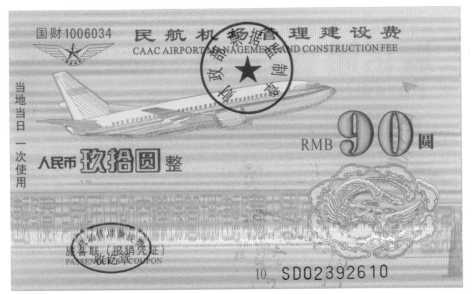

国财 1006034
民航机场管理建设费
CAAC AIRPORT MANAGEMENT AND CONSTRUCTION FEE

当地当日一次使用

人民市 玖拾圆 整

RMB **90** 圆

旅客联（报销凭证）
PASSENGER'S COUPON

10. SD02392610

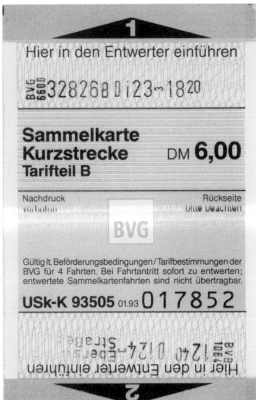

▲ **1**
Hier in den Entwerter einführen

BVG 6600 **328268** Di23ー18²⁰

Sammelkarte
Kurzstrecke DM **6,00**
Tarifteil B

Nachdruck Rückseite
verboten bitte beachten

BVG

Gültig lt. Beförderungsbedingungen / Tarifbestimmungen der
BVG für 4 Fahrten. Bei Fahrtantritt sofort zu entwerten;
entwertete Sammelkartenfahrten sind nicht übertragbar.

USk-K 93505 01.93 **017852**

Hier in den Entwerter einführen
BVG 6604 **12⁴⁰** Di24ーEbers-Straße

▼ **2**

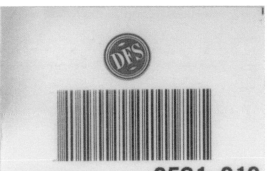

DFS

DELIVERY CONTROL NUMBER
デリバリー番号 **0591-010**

DEPARTURE DATE
ホノルル出発日 **04/10/94**
(月・日・年)

FLIGHT NUMBER **CP 00034**
航空便名
 HNL/0

PLEASE PRINT YOUR NAME.
お名前をローマ字でご記入ください。

NAME-LAST (姓)	BACKE
NAME-FIRST (名)	√
JAPAN BOUND ONLY (日本でのご連絡先)	PHONE NO.:

お買物をする前に「ホノルル出発日」、「航空便名」に誤りの
ないことを確認してください。記載事項に誤り、または変
更があった場合、必ず下記の電話番号にご連絡いただくか、
直接当店受付までお申し出ください。尚、出発当日の変更
についてはホノルル空港店にご連絡ください。ご連絡がな
い場合、品物がお手許に届かないことがあります。

ご来店の際は、このカードを必ずご持参ください。このカ
ードについている領収書の品物は全て「ホノルル空港渡し」
です。

デューティ・フリー・ショッパーズ

● ホノルル市ロイヤル・ハワイアン通り330 電話：931-2655
 営業時間：午前9時〜午後11時まで(年中無休)

● ホノルル空港店：国際空港メイン・ロビー 電話：837-3145

譲渡禁止

(裏面もご覧ください)

DUTY FREE SHOPPERS

■ WAIKIKI SHOP
 330 Royal Hawaiian Avenue Phone: 931-2655
 Store Hours: 9AM–11PM (Daily)

■ AIRPORT SHOP
 Honolulu International Airport Main Lobby
 Phone: 837-3145

* SEE BACK FOR ADDITIONAL INFORMATION *

HOSE S 6.50
12:26 (4)
0880 17-08-2005
0880 K - 2

CINEMA-THEATER Programminformation:
 Telefon 28 31 78
6000 Frankfurt 1 Kartenreservierung:
Roßmarkt Telefon 28 29 33

GOOD MORNING VIETNAM OF E.A.

Kino	Reihe	Sitz	Datum	Uhrzeit	Preis	Nr.
Cines			14.09.88	20H15	07.00	1

Aufbewahren und auf Verlangen vorzeigen. Gilt nur für die gelöste Vorstellung. **087016**

TURM-PALAST 6000 Frankfurt 1 Programminformation:
 Bleichstraße 55 Telefon 28 31 78
Am Eschenheimer Turm Am Eschenheimer Turm
 Kartenreservierung:
 Telefon 28 17 87

Kino	Reihe	Sitz	Datum	Uhrzeit	Preis	Nr.
4			20.04.91	22h45	09.00	27

Bis zum Schluß der Vorstellung aufbewahren und auf Verlangen vorzeigen.
Gilt nur für die gelöste Vorstellung. **817197**

METRO IM SCHWAN
Frankfurt, Steinweg 12, Tel. 28 40 30

NUTS

Kino	Reihe	Sitz	Datum	Uhrzeit	Preis	Nr.
1			08.05.88	20H30	10,00	16

Aufbewahren und auf Verlangen vorzeigen. Gilt nur für die gelöste Vorstellung. **235125**

DB Deutsche Bahn Besondere Angaben

Klasse	Tarif			Ermäß.	Grund
2	*ICE* HIN- UND RUECKFAHRT			50,0%	BC(J)
				XX Erwachsene(r)	XX Kind(er)

1. Geltungstag | Zur Hinfahrt gültig bis einschließlich | Zur Rückfahrt | Rückfahrt frühestens am

19.07.94 18.08.94 18.08.94 19.07.94 Reserv. H: 0 R: 0

von Frankfurt(Main) über (ICE:F*B)

nach Berlin Stadtbahn

012459064 MWST D: **158,00 15,0% = **20,61 ZA DM
01245906-62 XX **158,00 ∞∞∞

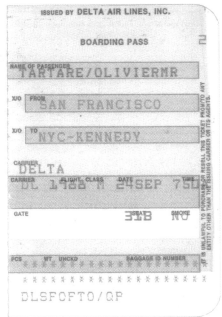

ISSUED BY DELTA AIR LINES, INC.

BOARDING PASS 2

NAME OF PASSENGER
TARTARE/OLIVIERMR

X/O FROM SAN FRANCISCO

X/O TO NYC-KENNEDY

CARRIER DELTA
CARRIER FLIGHT CLASS DATE TIME
DL 1425 M 24SEP 750

GATE SEAT B SMOKE NO

PCS WT. UNCKD BAGGAGE ID NUMBER
* * * * * * * * * * * * * * *

DLSFOFTO/QP

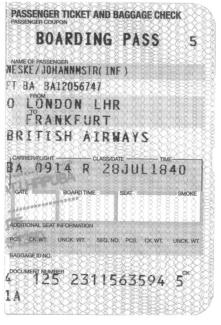

PASSENGER TICKET AND BAGGAGE CHECK
PASSENGER COUPON

BOARDING PASS 5

NAME OF PASSENGER
NESKE/JOHANNMSTR(INF)
FT BA BA12056747
O LONDON LHR
TO FRANKFURT
BRITISH AIRWAYS

CARRIER/FLIGHT CLASS/DATE TIME
BA 0914 R 28JUL1840

GATE BOARD TIME SEAT. SMOKE

ADDITIONAL SEAT INFORMATION
PCS. CK.WT. UNCK.WT. SEQ.NO. PCS. CK.WT. UNCK.WT.

BAGGAGE ID NO.

DOCUMENT NUMBER CK
4 125 2311563594 5
1A

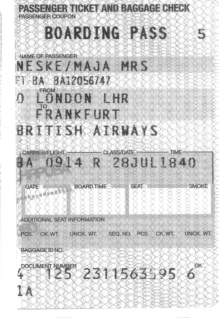

PASSENGER TICKET AND BAGGAGE CHECK
PASSENGER COUPON

BOARDING PASS 5

NAME OF PASSENGER
NESKE/MAJA MRS
FT BA BA12056747
O LONDON LHR
TO FRANKFURT
BRITISH AIRWAYS

CARRIER/FLIGHT CLASS/DATE TIME
BA 0914 R 28JUL1840

GATE BOARD TIME SEAT. SMOKE

ADDITIONAL SEAT INFORMATION
PCS. CK.WT. UNCK.WT. SEQ.NO. PCS. CK.WT. UNCK.WT.

BAGGAGE ID NO.

DOCUMENT NUMBER CK
4 125 2311563595 6
1A

15224941113.02.03.51
EinzelTicket **DB**

A 1,80 ERW
Preisstufe Preis

Nur gültig mit Entwerteraufdruck ▶

ES GELTEN DIE BESTIMMUNGEN DES
VERBUNDTARIFS RHEIN-RUHR

Düsseldorf Hbf

ISSUED
UNITED AIRLINES

BOARDING PASS

NAME OF PASSENGER
GOTHE/MARIUS
FREQUENT FLIER NUMBER

FROM SYDNEY

TO SAN FRANCISCO

CARRIER UNITED
CARRIER FLIGHT CLASS DATE TIME
UA 862C 28MAR 1200N

BOARDING 1115A

GATE 60
EXIT 16G SMOKE NO

SEAT

PCS WT UNCKD BAGGAGE ID NUMBER
* * * * * * * * * * * * * * * * * *

VIKING LINE
TAL-HEL 24.07 0815

ROSELLA

ADULT

A=10+20 W=90
Alcohol Wine
B=110
Beer
7904 4664 2700 0216
HE zi01 0318 04 42 00

L.G.E. Textilpflege GmbH
MARTINIZING-Reinigung
Schweizer Straße 66
Tel. 61 20 94
60594 Frankfurt 70

6315 ✳

Name	*Burghit*					
Adresse						
TAG	Mo	Di	Mi	Do	Fr	Sa
STUNDE	7 8	9 10	11 12	13 14	15 16	17 18
Anzug / Kostüm						
Hose						
Rock						
Jackett S - Str						
Mantel						
Popeline-Mantel						
Kleid						
Pulli / Pullover				7.		
1 Bluse				7.50		
DATUM		TOTAL	23.00			

◆ ALPHA-CHEM-Auszeichnung „M"

STADTWERKE FRANKFURT AM MAIN

00173127 160 10⁰⁰ R- 02.20

Standort	Tag	Uhrzeit	Preis

Nicht übertragbar. Es gelten die Gemeinsamen Beförderungsbedingungen und Tarifbestimmungen. Fahrscheine sind nach Beendigung der Fahrt bis nach Verlassen des Haltestellenbereichs aufzubewahren.

Autoroutes
du Sud
du la France

CERTIFICAT DE PASSAGE

Direction régionale
d'exploitation d'Agen

A62 échangeur
F-47520 Le Passage

0 042 89 225 59 56 1 016,0

	JOUR		TARIF
ANNEE			CLASSE PEAGE
km PARCOURUS			GARE SORTIE
CODE FISCAL		GARE ENTREE	X

Le code fiscal doit être apposé sur le véhicule à l'emplacement défini par le Décret N° 71.105. du 3-2-71

33447 LUMEN

3699079

GREAT WESTERN GW

Card Number	Transaction	
	WITHDRAW	
Amount	Date	Time
$40.00	09/16/92	08:21 PM
From	To	Location
CHK		SF/MARINA

KEEP THIS RECEIPT. - SEQ# 153750

OUR GREAT CHECKING ACCOUNTS GIVE YOU
GREAT VALUE - ASK US HOW

All deposits are subject to verification prior to being available for withdrawal. The balance shown on this record may not reflect unprocessed transactions.
RBF 1899

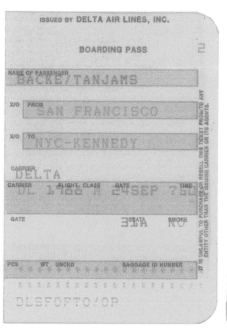

ISSUED BY DELTA AIR LINES, INC.

BOARDING PASS

NAME OF PASSENGER
BACKE/TANJAMS

X/O FROM
SAN FRANCISCO

X/O TO
NYC-KENNEDY

CARRIER
DELTA

CARRIER	FLIGHT	CLASS	DATE	TIME
DL 1188	M	24SEP	750	

GATE	SEAT	SMOKE
	3 VIE	NO

PCS WT UNCKD BAGGAGE ID NUMBER

DLSFOPTO/QP

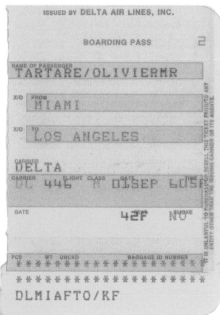

ISSUED BY DELTA AIR LINES, INC.

BOARDING PASS

NAME OF PASSENGER
TARTARE/OLIVIERMR

X/O FROM
MIAMI

X/O TO
LOS ANGELES

CARRIER
DELTA

CARRIER	FLIGHT	CLASS	DATE	TIME
DL 446	M	01SEP	605P	

GATE	SEAT	SMOKE
	42F	NO

PCS WT UNCKD BAGGAGE ID NUMBER

DLMIAFTO/KF

By signing this receipt or by accepting these Cheques, I accept the terms of the Purchase Agreement and agree to sign these Cheques immediately.

En signant ce reçu ou en prenant possession de ces chèques, je déclare accepter les conditions du contrat d'achat figurant au verso et m'engage à signer ces chèques immédiatement.

Durch Unterzeichnung dieser Quittung bzw. die Entgegennahme dieser Cheques anerkenne ich die Kaufbedingungen.

Note: Immediately sign each of your Cheques in the upper left corner. Under the terms of the Agreement you are not protected in case of loss or theft until your Cheques are so signed.

A noter: Signez immédiatement chaque Chèque dans be coin supérieur gauche, ainsi que le stipulent les conditions de vente. Vous n'avez aucun recours en cas de perte ou de vol si vos Chèques ne sont pas signés de cette façon.

Achtung: Bitte sofort jeden Ihrer Cheques in der oberen linken Ecke unterzeichnen. Nach den Kaufbedingungen sind Sie im Falle von Verlust oder Diebstahl erst dann geschützt, wenn Sie Ihre Cheques so unterzeichnet haben.

Customer's Record of Purchase
Relevé d'achat destiné au client
Kaufbestätigung des Kunden

RD110-952-871

CONTENT • CONTENU • INHALT
American Express Travelers Cheques

3 × US$100	US$300

Plus: Charges • Frais • Gebühren

Important
Wichtig

AMERICAN
EXPRESS
®

Carry Separately From Cheques
Conservez cette liste séparément de vos chèques
Halten Sie diesen Abschnitt getrennt von Cheques

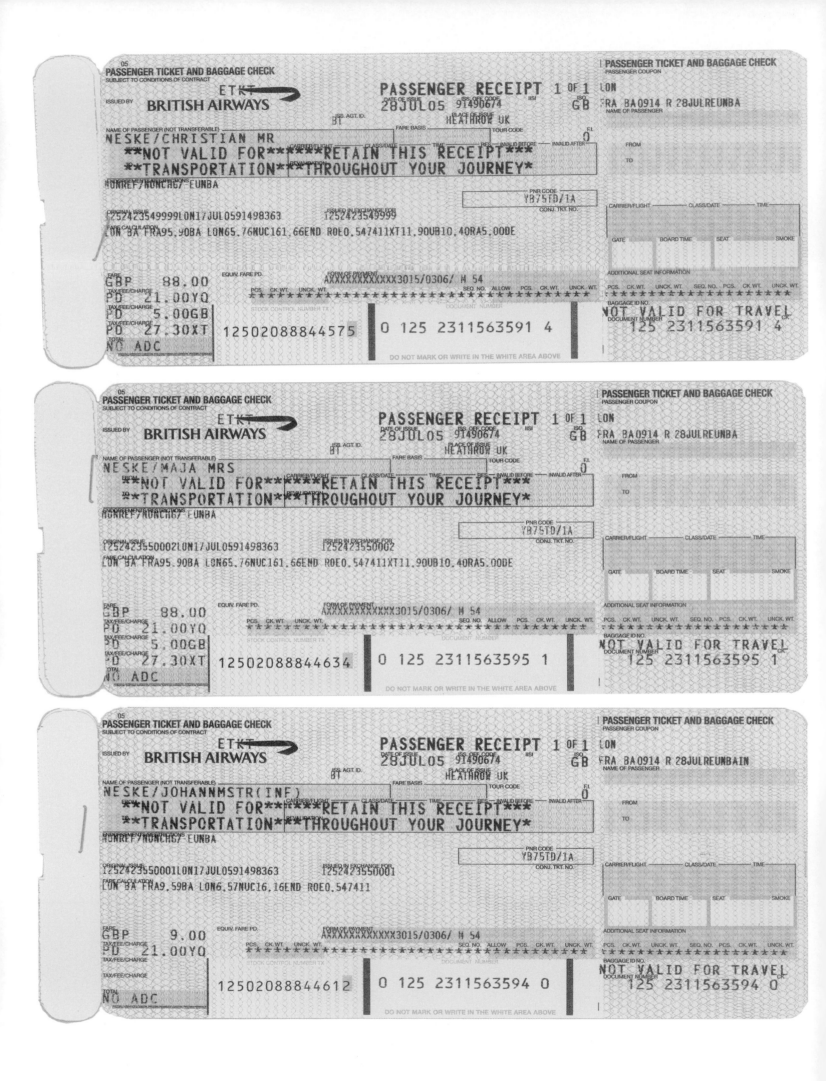

110

Ab Entwertung 120 min gültig

S 22⁵⁵ Mo 26 Oranien burger

VBB Einzelfahrausweis
Regeltarif

B1 Berlin AB
 ***2,00 EUR

Gemeinsamer Tarif der im Verkehrsverbund Berlin-
Brandenburg (VBB) zusammenwirkenden Verkehrsunter-
nehmen. Gültig nach den geltenden Beförderungsbedingungen

S-ORS 1 3/4
050627 22:49 51 00139738

Vor Fahrtantritt entwerten

S 10⁴⁰ Do 03 Fried-

VBB Kurzstrecke Berlin
Regeltarif

B0 ***1,20 EUR

Gemeinsamer Tarif der im Verkehrsverbund Berlin-
Brandenburg (VBB) zusammenwirkenden Verkehrsunter-
nehmen. Gültig nach den geltenden Beförderungsbedingungen

S-FR 3 1/1
050120 10:33 51 00141000

Ab Entwertung 120 min gültig

S 22⁵⁵ Mo 26 Oranien burger

VBB Einzelfahrausweis
Regeltarif

B1 Berlin AB
 ***2,00 EUR

Gemeinsamer Tarif der im Verkehrsverbund Berlin-
Brandenburg (VBB) zusammenwirkenden Verkehrsunter-
nehmen. Gültig nach den geltenden Beförderungsbedingungen

S-ORS 1 2/4
050627 22:49 51 00139737

| Die Bahn DB REISEPLAN | | DATUM: So 31.07.05 | Dauer: 1:54 |
| VON: Haan | | NACH Frankfurt(Main)Hbf | |

BAHNHOF/HALTESTELLE	UHR	GLEIS	ZUG
Haan	ab 18:04	7	RB 11227
Köln Hbf	an 18:35	8	
Köln Hbf	ab 18:43	4	ICE 17
Frankfurt(Main)Hbf	an 19:58	17	

162008319 31.07.05 10:45 **Angaben ohne Gewähr**

ENTRÉE A
GRANDS APPARTEMENTS
GALERIE DES GLACES
ENTREE TARIF REDUIT
05-10-98 35,00FF

CHÂTEAU DE VERSAILLES

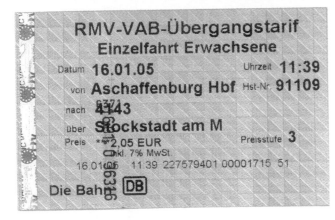

RMV-VAB-Übergangstarif
Einzelfahrt Erwachsene

Datum **16.01.05** Uhrzeit **11:39**

von **Aschaffenburg Hbf** Hst-Nr. **91109**

nach **4143**

über **Stockstadt am M**

Preis **2,05 EUR** Preisstufe **3**
 inkl. 7% MwSt.

16 01 05 11:39 227579401 00001715 51

Die Bahn DB

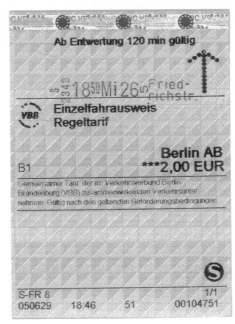

Ab Entwertung 120 min gültig

S 18⁵⁰ Mi 26 Fried- richstr.

VBB Einzelfahrausweis
Regeltarif

B1 Berlin AB
 ***2,00 EUR

Gemeinsamer Tarif der im Verkehrsverbund Berlin-
Brandenburg (VBB) zusammenwirkenden Verkehrsunter-
nehmen. Gültig nach den geltenden Beförderungsbedingungen

S-FR 8 1/1
050629 18:46 51 00104751

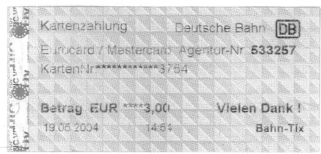

Kartenzahlung Deutsche Bahn DB

Eurocard / Mastercard Agentur-Nr. **533257**

KartenNr.***********3754

Betrag EUR ****3,00 Vielen Dank !

19.05.2004 14:54 Bahn-Tix

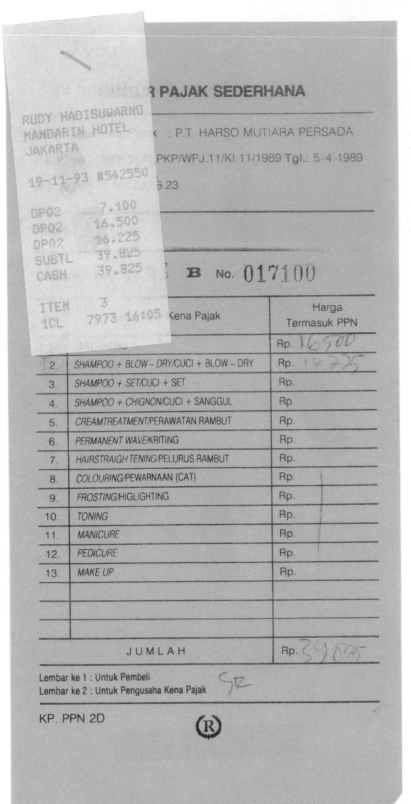

RUDY HADISUWARNO
MANDARIN HOTEL
JAKARTA

19-11-93 #542550

DP02 7.100
DP02 16.500
DP02 16.225
SUBTL 39.825
CASH 39.825

ITEM 3
1CL 7973 16:05

R PAJAK SEDERHANA

k : P.T. HARSO MUTIARA PERSADA

PKP/WPJ.11/KI.11/1989 Tgl.: 5-4-1989

6.23

B No. 017100

		Kena Pajak	Harga Termasuk PPN
			Rp. 16500
2.	SHAMPOO + BLOW – DRY/CUCI + BLOW – DRY		Rp. 16225
3.	SHAMPOO + SET/CUCI + SET		Rp.
4.	SHAMPOO + CHIGNON/CUCI + SANGGUL		Rp.
5.	CREAMTREATMENT/PERAWATAN RAMBUT		Rp.
6.	PERMANENT WAVE/KRITING		Rp.
7.	HAIRSTRAIGH TENING/PELURUS RAMBUT		Rp.
8.	COLOURING/PEWARNAAN (CAT)		Rp.
9.	FROSTING/HIGLIGHTING		Rp.
10.	TONING		Rp.
11.	MANICURE		Rp.
12.	PEDICURE		Rp.
13.	MAKE UP		Rp.
	JUMLAH		Rp. 39825

Lembar ke 1 : Untuk Pembeli
Lembar ke 2 : Untuk Pengusaha Kena Pajak

KP. PPN 2D

®

CARDMEMBER COPY

Diners Club International®

ESTABLISHMENT
ZARA - LIAT TOWERS
#02-02/#03-02
LIAT TOWERS SZ38881
TERMINAL NO. 71305882
ESTAB NO. 168168171809

MASTER
5335550235005700
NADINE WEINHEIMER

TRAN
TYPE SALE EXPIRY DATE
BATCH 05/07
NO. 000308 TRACE
DATE/ 020978
TIME MAR 20 04 17:47
REF. NO. APP
408017470223 CODE 046044

TOTAL $59.70

Redeem Your Club Rewards
points for FREE gifts, Free
shopping and dining vouchers,
or even free air tickets!

I CONFIRM INCURRING THE CHARGES HEREIN AND WILL OBSERVE MY
AGREEMENT WITH DINERS CARD ISSUERS.

CARDMEMBER SIGNATURE

X

Topiint Computer Supplies Tel: (65) 6477 4568 (ISO 9002)

البنك السعودي الامريكي
Saudi American Bank

LOCATION	D.DTRSSL01401050	موقع الجهاز	
CARD NUMBER		رقم البطاقة	
DATE التاريخ	TIME الوقت	MACHINE الرقم الآلة	CODE الرمز
YOUR BALANCE		الرصيد	

خدمات سامبا على مدار الساعة
SAMBA 24 Hour Banking ®

express ⊗ Heathrow express ⊗ Heathrow expr

EXP not for resale not for resale

ADULT 27 . MAY . 05 137243 050033

HEATHROWEXP VALID 3 DAYS

PADDINGTON HEX ONLY 0835

on request Conditions of carriage available on request Conditions of carriage available

utes every 15 minutes takes 15 min

METROPOLE 3
ONE FINE DAY
27-04-97 18:45
NORMAAL 15.00
 (002)
PATHÉ
Cinemas
1-1621579

Aktiengesellschaft
REEDEREI NORDEN-FRISIA
Norderney
FAHRKARTE JST 4Tg
Norddeich --> Juist
4Tages Rückf. Erw.
DM 40.00 incl. LSt DM 2.62
30.07.99 09.38 00107 N2-3302

PROBEBÜHNE I
STATION 11.2
SAAS FEE
24.03.00
Freitag 24:00 Uhr

FREIE PLATZWAHL

Programmänderungen sind vorbehalten. Bild- und Tonaufnahmen sind nur mit
Genehmigung erlaubt. Bei Verlassen der Spielstätte verliert die Karte ihre
Gültigkeit. Umtausch oder Rücknahme nur bei Vorstellungsänderung. Für ver-
fallene Eintrittskarten kein Ersatz. Kein Nacheinlaß!

5.00 DM
(incl. 7% MwSt.)
 461
m Künstlerhaus MOUSONTURM
 Waldschmidtstraße 4 · 60316 Frankfurt
 Telefon 069 / 40 58 95 - 20

METROPOLE 3
ONE FINE DAY
27-04-97 18:45
NORMAAL 15.00
 (001)
PATHÉ
Cinemas
1-1621578

Aktiengesellschaft
REEDEREI NORDEN-FRISIA
Norderney
FAHRKARTE JST 4Tg
Norddeich --> Juist
4Tages Rückf. Erw.
DM 40.00 incl. LSt DM 2.62
30.07.99 09.38 00108 N2-3302

PROBEBÜHNE I
STATION 11.2
SAAS FEE
24.03.00
Freitag 24:00 Uhr

FREIE PLATZWAHL

Programmänderungen sind vorbehalten. Bild- und Tonaufnahmen sind nur mit
Genehmigung erlaubt. Bei Verlassen der Spielstätte verliert die Karte ihre
Gültigkeit. Umtausch oder Rücknahme nur bei Vorstellungsänderung. Für ver-
fallene Eintrittskarten kein Ersatz. Kein Nacheinlaß!

5.00 DM
(incl. 7% MwSt.)
 460
m Künstlerhaus MOUSONTURM
 Waldschmidtstraße 4 · 60316 Frankfurt
 Telefon 069 / 40 58 95 - 20

Eldorado
FILMTHEATER
Frankfurt am Main
Schäfergasse 29 Tel.281348

FTB LISELOTTE JAEGER FRANKFURT/MAIN
Nur für die gelöste Vorstellung gültig.

Heaven
24.02.2002 18:15 Uhr
Parkett
6,70EUR
020 552 181 501 001 009 22
Beckerbillett Hamburg (050) 501935

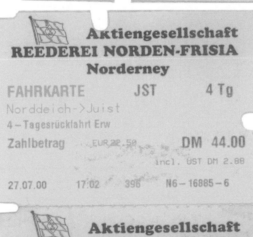

Aktiengesellschaft
REEDEREI NORDEN-FRISIA
Norderney
FAHRKARTE JST 4 Tg
Norddeich->Juist
4-Tagesrückfahrt Erw
Zahlbetrag EUR 22.50 DM 44.00
 incl. UST DM 2.88
27.07.00 17:02 396 N6-16885-6

Eldorado
FILMTHEATER
Frankfurt am Main
Schäfergasse 29 Tel.281348

FTB LISELOTTE JAEGER FRANKFURT/MAIN
Nur für die gelöste Vorstellung gültig.

Heaven
24.02.2002 18:15 Uhr
Parkett
6,70EUR
020 552 181 501 001 009 11
Beckerbillett Hamburg (050) 501934

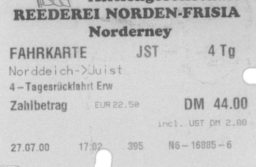

Aktiengesellschaft
REEDEREI NORDEN-FRISIA
Norderney
FAHRKARTE JST 4 Tg
Norddeich->Juist
4-Tagesrückfahrt Erw
Zahlbetrag EUR 22.50 DM 44.00
 incl. UST DM 2.88
27.07.00 17:02 395 N6-16885-6

FECHA FIN DE ESTACIONAMIENTO AUTORIZADO FECHA FIN ESTAC. AUTORIZ.

08/06/05 19:51 08/06 19:51 0,40EUR

0,40EUR 0703 19:16 19:16 0703

PRECIO / PRICE

EXCMO. AYUNTAMIENTO
DE CHICLANA DE LA
FRONTERA O.R.A. CONSERVE ESTE RESGUARDO
 KEEP THIS RECEIPT

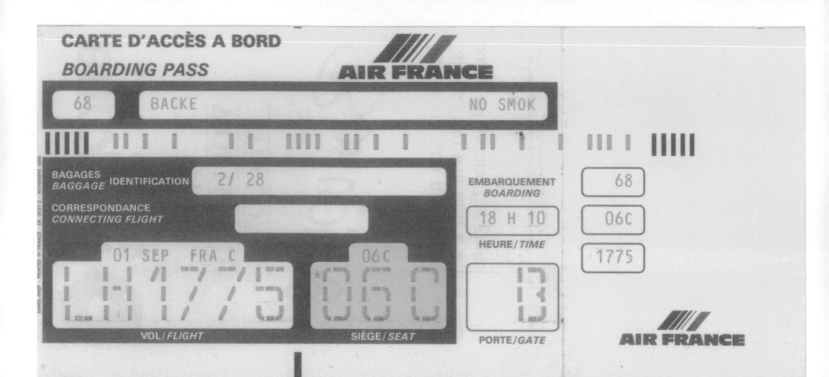

CARTE D'ACCÈS A BORD
BOARDING PASS
AIR FRANCE

| 68 | BACKE | NO SMOK |

| BAGAGES / BAGGAGE | IDENTIFICATION | 2/ 28 |

CORRESPONDANCE
CONNECTING FLIGHT

01 SEP FRA C

LH1775 *060*

VOL / FLIGHT SIÈGE / SEAT

EMBARQUEMENT
BOARDING

18 H 10
HEURE / TIME

06C

B

PORTE / GATE

68
06C
1775

AIR FRANCE

| MIT LUFTPOST PAR AVION | MIT LUFTPOST PAR AVION | MIT LUFTPOST PAR AVION | MIT LUFTPOST PAR AVION | MIT LUFTPOST PAR AVION |

BANK OF THE WEST

```
09/21/92  12:29  S1A26778

5232950030005453-0

580 GREEN STREET        778

RECORD NO.            3283
WITHDRAWAL $       200.00
FR CK0000000000000000000

LEDGER BAL $          0.00
AVAIL BAL  $          0.00
```

ALL TRANSACTIONS SUBJECT TO PROOF
AND VERIFICATION BY BANK OF THE WEST

T.L.V.
FONDUE - 83400 HYERES - Tél. 04 94 58 21 81
R FONDUE - PORQUEROLLES
Billet à conserver pendant toute la durée du voyage. A présenter à toute réquisition.

(Résidence Secondaire) Validité 2004

TARIF SPÉCIAL 10 EUROS 10 € 50

NOM N° 006690
N° de la carte..................

TPM incluse
- Le transporteur se réserve le droit de modifier l'itinéraire ou d'annuler le voyage.
- Dans le cas où la responsabilité du transporteur serait engagée, elle le serait exclusivement aux clauses et conditions des dispositions législatives concernant les transporteurs maritimes de voyageurs (Loi du 18 juin 1966 et textes subséquents). Le Tribunal de Commerce de Toulon étant seul compétent.
- En particulier, les enfants accompagnés bénéficiant de la gratuité du transport sont soumis aux conditions ci-dessus.

 T.L.V.
TOUR FONDUE - 83400 HYERES - Tél. 04 94 58 21 81
TOUR FONDUE - PORQUEROLLES
Billet à conserver pendant toute la durée du voyage. A présenter à toute réquisition.

(Résidence Secondaire) Validité 2004

TARIF SPÉCIAL 10 EUROS 10 € 50

NOM N° 006691
N° de la carte..................

TPM incluse
- Le transporteur se réserve le droit de réserve l'itinéraire ou d'annuler le voyage.
- Dans le cas où la responsabilité du transporteur serait engagée, elle le serait exclusive clauses et conditions des dispositions législatives concernant les transporteurs maritimes de v (Loi du 18 juin 1966 et textes subséquents). Le Tribunal de Commerce de Toulon étant seul c
- En particulier, les enfants accompagnés bénéficiant de la gratuité du transport sont son conditions ci-dessus.

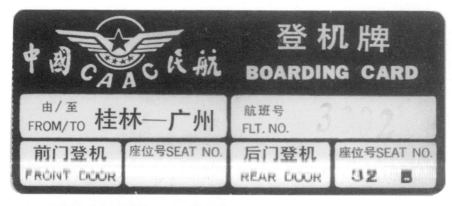

中國 C A A C 民航　登机牌

BOARDING CARD

由/至 FROM/TO　桂林—广州　航班号 FLT. NO. 3__2__

前门登机 FRONT DOOR　座位号SEAT NO.　后门登机 REAR DOOR　座位号SEAT NO. 02 B

SKIEZ 365 JOURS PAR AN

3500
3016
2100
1550

0101 867　35F 41 486 01

TIGNES ENF. 01.1

DROIT DE TIMBRE PAYE SUR ETAT - AUTORISATION DU 16 JUIN 1942

AIR FRANCE

DK oct. 85 - 3186-0

FRANCFORT

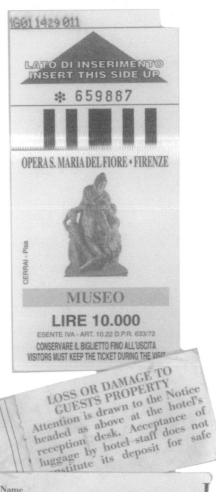

1G01 1429 011

LATO DI INSERIMENTO
INSERT THIS SIDE UP

✱ 659887

OPERA S. MARIA DEL FIORE • FIRENZE

CERRAI - Pisa

MUSEO

LIRE 10.000

ESENTE IVA - ART. 10.22 D.P.R. 633/72

CONSERVARE IL BIGLIETTO FINO ALL'USCITA
VISITORS MUST KEEP THE TICKET DURING THE VISIT

LOSS OR DAMAGE TO
GUESTS PROPERTY
Attention is drawn to the Notice
headed as above at the hotel's
reception desk. Acceptance of
luggage by hotel staff does not
constitute its deposit for safe

ROOM
NUMBER

**ROOM
NUMBER**

Name _____
Deposited on _____
Collection Date _____

Nº 327838

Hilton

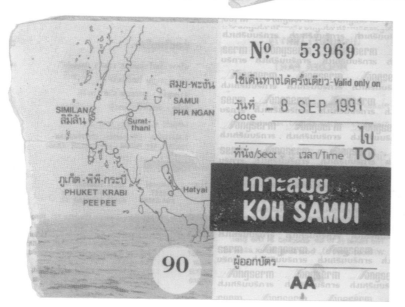

SIMILAN
สิมิลัน

Surat-
thani

ภูเก็ต-พีพี-กระบี่
PHUKET KRABI
PEE PEE

Hatyai

สมุย-พะงัน
SAMUI
PHA NGAN

Nº 53969

ใช้เดินทางได้ครั้งเดียว-Valid only on

วันที่
date - 8 SEP 1991

ที่นั่ง/Seat　เวลา/Time　ไป TO

เกาะสมุย
KOH SAMUI

ผู้ออกบัตร _____

AA

90

sabena S

SN
Z

swissair +

VIAGGI NEI LUOGHI VESUVIANI
IN CIRCUMVESUVIANA

TOO-TO-TRAIN

Assessorato al Turismo
Assessorato ai Trasporti
REGIONE CAMPANIA

Corso Garibaldi 387 Napoli 80142
C.F. e P.IVA 07608220633
CIRCUMVESUVIANA s.r.l.

SKIEZ 365 JOURS PAR AN
3500
3016
2100
1550

2312 067 200F 41 659 07

TIGNES ENF.
29 D

DROIT DE TIMBRE PAYE SUR ETAT - AUTORISATION DU 16 JUIN 1942

RUWAN KALA

Kandyan Arts & Crafts. Silver Jewellery
& Brasswere

79, Galle Road,
Aluthgama.

8/12/200

M

Qty.	Description	Rate	Rs.	Cts.
1	Budda		6000	00
			6000/=	
	501			

Kempinski Hotel
Beijing Lufthansa Center

BEIJING

凯宾斯基饭店
北京燕莎中心有限公司

MCHA 623

Room Pass

房　卡

Name 姓名

Room 房间
550

Kempinski
HOTELS & RESORTS

باسكن ﹰ٣١ روبنز

ص. ب ١٤٠١ . الدمام ٣١٤٣١
هاتف: ٨٣٤٣٤١٠ / ٨٣٣٢٥٤٨ – فاكس: ٨٣٥٠٠١٩

من أهم واجباتنا في باسكن روبنز إرضاء العميل لذا فإن
ملاحظاتكم على جوانب الخدمة المختلفة تهمنا كثيراً
وستساعدنا على تقديم خدمة أفضل. نرجو كتابة الاسم
والعنوان بشكل واضح في المساحة المخصصة لذلك وشكراً

موقع المحل: _____

التاريخ: _____ الوقت _____

رقم البائع الذي قام بخدمتك _____

ضعيفة	لا بأس	جيدة	ممتازة	
☐	☒	☐	☐	١) مستوى الخدمة
☐	☐	☒	☐	٢) معاملة الموظف
☐	☐	☒	☐	٣) نظافة المحل
☐	☐	☒	☐	٤) جودة البضاعة

٥) هل قدم عينة للتنوق؟ ☐ نعم ☒ لا

٦) ملاحظات _____

الاسم: _____
العنوان: _____

中國 CAAC 民航 登机牌 BOARDING CARD

由/至 FROM/TO	桂林—广州	航班号 FLT. NO.	3302
前门登机 FRONT DOOR	座位号SEAT NO.	后门登机 REAR DOOR	座位号SEAT NO. 32—A.

STANDBY

SINGAPORE AIRLINES

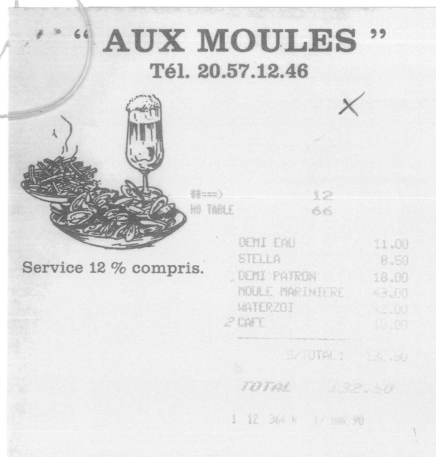

" AUX MOULES "
Tél. 20.57.12.46

Service 12 % compris.

X

样===)		12
NO TABLE		66
DEMI EAU		11.00
STELLA		8.50
DEMI PATRON		18.00
MOULE MARINIERE		43.00
WATERZOI		42.00
2 CAFE		10.00
	S/TOTAL:	132.50
	TOTAL	132.50

1 12 364 H 17 MAR 90

S.A. FRITERIE MODERNE - 34, rue de Béthune - LILLE
S.A. au capital de 250.000 F - R.C. Lille B 318 722 295

*Nous vous remercions
de votre visite*

Pour tout paiement par chèque, veuillez présenter une pièce d'identité.

BOARDING PASS / ΚΑΡΤΑ ΕΠΙΒΙΒΑΣΗΣ

NAME OF PASSENGER
TARTARE/OLIVIERMR
FROM NON SMOKING CABIN
ATHENS
TO
HERAKLION

FLIGHT	CLASS	DATE	TIME
OA 518	Y	19MAR	0000

GATE	BOARDING TIME	SEAT	SMOKE
	21H40	21F	NO

PCS	WT	UNCKD	BAGGAGE
CF1	11	DOCUMENT NUMBER	CK

137

OLYMPIC
AIRWAYS

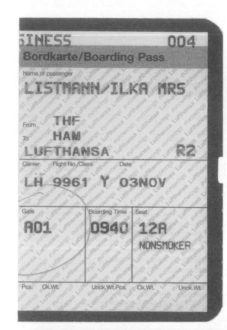

SINESS 004
Bordkarte/Boarding Pass
Name of passenger
LISTMANN/ILKA MRS
From THF
To HAM
LUFTHANSA R2
Carrier Flight No./Class Date
LH 9961 Y 03NOV

Gate	Boarding Time	Seat
A01	0940	12A NONSMOKER

Pcs. Ck.Wt. Unck.Wt.Pcs. Ck.Wt. Unck.Wt.

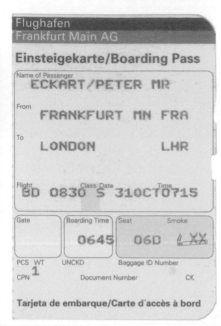

Flughafen Frankfurt Main AG

Einsteigekarte/Boarding Pass
Name of Passenger
ECKART/PETER MR
From FRANKFURT MN FRA
To LONDON LHR
Flight BD 0830 S 31OCT0715

Gate	Boarding Time	Seat	Smoke
	0645	06D	XX

PCS WT UNCKD Baggage ID Number
CPN 1
Document Number CK

Tarjeta de embarque/Carte d'accès à bord

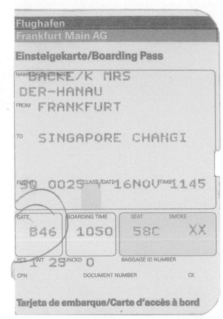

Flughafen Frankfurt Main AG

Einsteigekarte/Boarding Pass
NAME OF PASSENGER
BACKE/K MRS
DER-HANAU
FROM FRANKFURT
TO SINGAPORE CHANGI
FLIGHT SQ 0025 Y 16NOV 1145

GATE	BOARDING TIME	SEAT	SMOKE
B46	1050	58C	XX

PCS 1 WT 25 UNCKD 0
CPN
DOCUMENT NUMBER CK

Tarjeta de embarque/Carte d'accès à bord

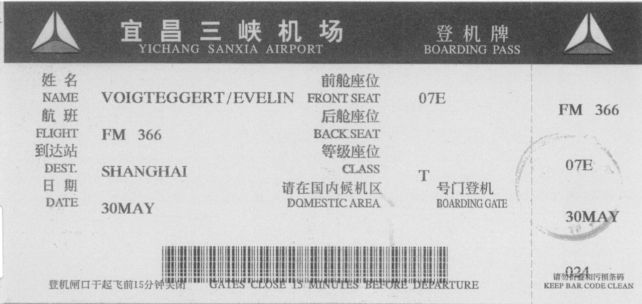

宜昌三峡机场
YICHANG SANXIA AIRPORT
登机牌
BOARDING PASS

姓名 NAME VOIGTEGGERT/EVELIN
前舱座位 FRONT SEAT 07E
FM 366

航班 FLIGHT FM 366
后舱座位 BACK SEAT

到达站 DEST. SHANGHAI
等级座位 CLASS T
07E

日期 DATE 30MAY
请在国内候机区 DOMESTIC AREA
号门登机 BOARDING GATE
30MAY

024

登机闸口于起飞前15分钟关闭 GATES CLOSE 15 MINUTES BEFORE DEPARTURE
请勿折登机和污损条码 KEEP BAR CODE CLEAN

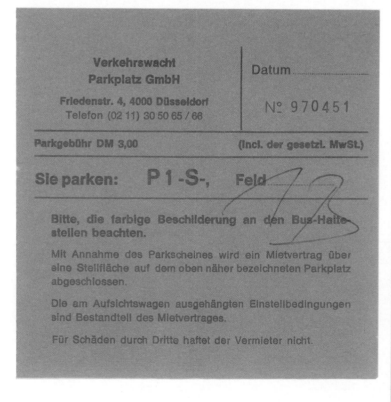

Verkehrswacht Parkplatz GmbH

Datum

Friedenstr. 4, 4000 Düsseldorf
Telefon (02 11) 30 50 65 / 66

№ 970451

Parkgebühr DM 3,00 (Incl. der gesetzl. MwSt.)

Sie parken: P 1-S-, Feld

Bitte, die farbige Beschilderung an den Bus-Halte-stellen beachten.

Mit Annahme des Parkscheines wird ein Mietvertrag über eine Stellfläche auf dem oben näher bezeichneten Parkplatz abgeschlossen.

Die am Aufsichtswagen ausgehängten Einstellbedingungen sind Bestandteil des Mietvertrages.

Für Schäden durch Dritte haftet der Vermieter nicht.

Gültig für die Wertmarkenarten 5 oder 6 bis 3/94 W 0 9 5 7 2

Gültig für die Tarifzonen | Wertmarkenart

Gelb
Grün
X

Kalender-monat alle Tage 5
Kalender-woche Mo-So 6

Preisstufe
2 1

1 4 6 8 5 Karten-Nummer ► W 0 9 5 7 2

Karten-Nummer bitte auf der **Zuschlagwertmarke** eintragen und die Zuschlagwertmarke hier einstecken.

DEUTSCHE BUNDESBAHN
-5621-2600942
02 FEB 94
W 0 9 5 7 2
Karten-Nr.

MUSÉE
du MUR de L'ATLANTIQUE

le 1er Musée privé

installé dans un blockhaus allemand 39/45
batterie TODT

AUDINGHEN (Cap Gris-Nez) 62179

Entrée : 7 F.

No 012133

Enfant

Imprimerie Decousser Frères - Calais

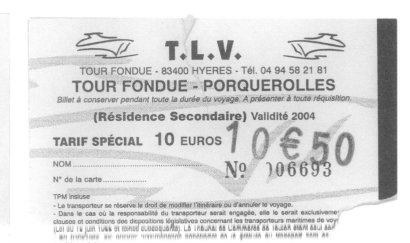

T.L.V.

TOUR FONDUE - 83400 HYERES - Tél. 04 94 58 21 81
TOUR FONDUE - PORQUEROLLES

Billet à conserver pendant toute la durée du voyage. A présenter à toute réquisition.

(Résidence Secondaire) Validité 2004

TARIF SPÉCIAL 10 EUROS 10 € 50

NOM ..

N° de la carte

No 006693

TPM incluse

- Le transporteur se réserve le droit de modifier l'itinéraire ou d'annuler le voyage.
- Dans le cas où la responsabilité du transporteur serait engagée, elle le serait exclusivement
clauses et conditions des dispositions législatives concernant les transporteurs maritimes de voy
conditions ci-dessus.

FECHA	FIN DE ESTACIONAMIENTO AUTORIZADO	FECHA	FIN ESTAC. AUTORIZ.

14/06/05 18:06 |14/06 18:06 1,40EUR|

1,40EUR 0201 11:17 11:17 0201

PRECIO / PRICE

EXCMO. AYUNTAMIENTO
DE CHICLANA DE LA
FRONTERA **O.R.A.** CONSERVE ESTE RESGUARDO
KEEP THIS RECEIPT

EXP HEX SINGLE SGL

ADULT 28.JLY.05 013442 050129

PADDINGTON VALID 3 DAYS £14.00X

HEATHROWEXP HEX ONLY 1644

t for resale Conditions of carriage available on request

CASA - MUSEU GAUDÍ

CARRETERA DEL CARMEL - PARK GÜELL

08024 BARCELONA

ENTRADA: 4 - EUROS

176560

DONATIU D'HOMENATGE A
L'ARQUITECTE ANTONI GAUDÍ,
DESTINAT A LA CONSTRUCCIÓ
DEL TEMPLE DE LA SAGRADA
FAMÍLIA:

lton

**ROOM
NUMBER**

Name

Deposited on

Collection Date

No 253907

**PLEASE READ
CONDITIONS
ON REVERSE**

No 253907

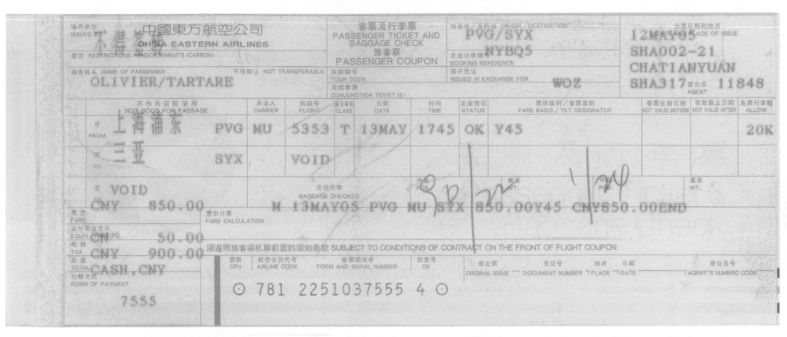

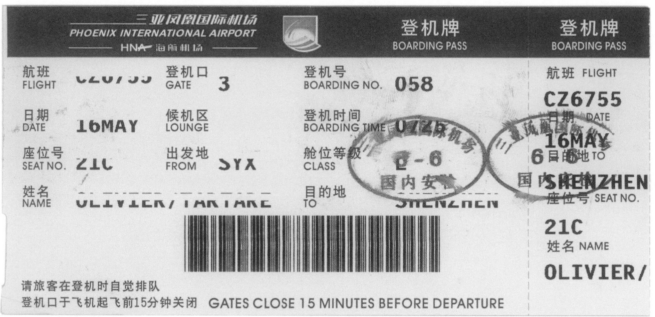

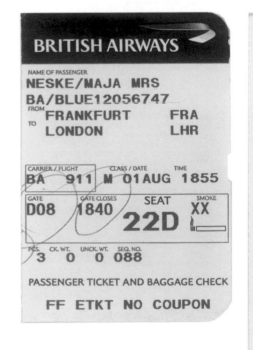

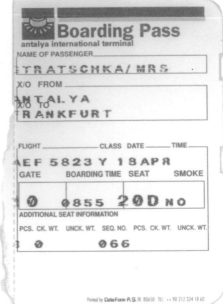

Boarding Pass
antalya international terminal
NAME OF PASSENGER
ETRATSCHKA/MRS
X/O FROM
ANTALYA
X/O TO
FRANKFURT

FLIGHT	CLASS	DATE	TIME
AEF 5823	Y	18APR	

GATE	BOARDING TIME	SEAT	SMOKE
0	0855	20D	NO

ADDITIONAL SEAT INFORMATION

PCS. CK. WT.	UNCK. WT.	SEQ. NO.	PCS. CK. WT.	UNCK. WT.
0		066		

Printed by DataForm A.S. IR. 80650 TEL: ++ 90 212 324 18 60

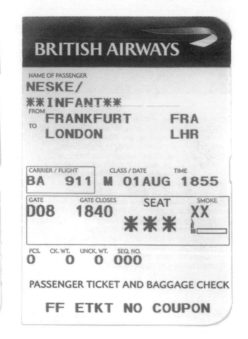

BRITISH AIRWAYS
NAME OF PASSENGER
NESKE/
INFANT
FROM
FRANKFURT FRA
TO
LONDON LHR

CARRIER / FLIGHT	CLASS / DATE	TIME
BA 911	M 01AUG	1855

GATE	GATE CLOSES	SEAT	SMOKE
D08	1840	***	XX

PCS.	CK. WT.	UNCK. WT.	SEQ. NO.
0	0	0	000

PASSENGER TICKET AND BAGGAGE CHECK

FF ETKT NO COUPON

046

Conceived and designed by
Marks Barfield Architects

BRITISH AIRWAYS
London eye

Bangkok Airways
BOARDING PASS
เที่ยวบิน FLT. NO.
DP. 116
เลขที่นั่ง FLT. NO.
NO-SMOKING
7 C

เล่มที่ 2488

เลขที่ 24397

SAMUI AIRPORT
MAINTENANCE FEES
ค่าบำรุงรักษา สนามบินสมุย

100.00 บาท Baht

เลขที่นั่ง FLT. NO.
NO-SMOKING
7 D

中国南方航空
CHINA SOUTHERN
顾客服务 950333
呼叫中心
网上订票 HTTP://WWW.CS-AIR.COM

登机牌
BOARDING
PASS

姓 名 NAME	VOIGTEGGERT/EVELINM
航班号 FLIGHT	CZ3951
日 期 DATE	24MAY04
登机时间 BD TIME	1910

到达站 DEST	桂林GUILIN
序 号 BD NO	138
座位号 SEAT	13C
登机口 GATE	15
舱 位	G

航班号 FLIGHT	CZ3951
座位号 SEAT	13C
日 期 DATE	24MAY
序 号 BD NO	138

重要提示：
航班起飞前10分
GATES CLOSED 10 MINU

BVG
6136 14 10 Fr 16 ∞ Kleiste
Park 5

Tageskarte

Tarif für Berlin und Umland.
Ausgegeben durch BVG.

Gültig nach den geltenden
Beförderungsbedingungen.

7,80 DM

Bitte bei Fahrtantritt sofort
entwerten; nach Entwertung
nicht übertragbar.

AB

Bitte Rückseite beachten.

TA 9801 076379

上海磁浮交通发展有限公司
SMT Shanghai Maglev Transportation Development Co.,Ltd.

上海磁浮列车
Shanghai Maglev Train

轨道交通2号线 龙阳路车站 上海磁浮列车示范运营线 浦东机场 磁浮列车引导标识

$13.00

Adult

JAN 28 2005 9:17 AM

Good For 1 Admission

Empire State Building
Observatory
esbnyc.com

TABLE MOUNTAIN ROTAIR

ENJOY THE RIDE!! !!!!

17 12.01

歴史と伝統の饗宴

世界文化遺産 二条城
築城400年祭

入城・入場共通当日券
大人 1,100円

発行:元離宮二条城「築城400年祭」実行委員会
有効期間:平成15年9月13日〜同年11月16日
入城・入場:午前9時〜午後4時
※本券は払い戻し・再発行はできません。
※再入城・再入場はできません。

中国 广州

中山纪念堂
Sun yat-sen Memorial Hall 票价壹元

PRIORITY
PRIORITAIRE

PRIORITY
PRIORITAIRE

RMV

Es gelten die Gemeinsamen Beförderungsbedingungen und Tarifbestimmungen

Kurzstrecke Erwachsene ermäßigt

Datum 11.01.03 Uhrzeit 14:55
von Ffm-Höhenstraße Hst.-Nr. 50517
- nach 97 Autom.-Nr. 1662
Tarifgebiet
über

Preis 1,25 € Preisstufe 3
inkl. 7% MwSt.

VGF VerkehrsGesellschaft
 Frankfurt am Main

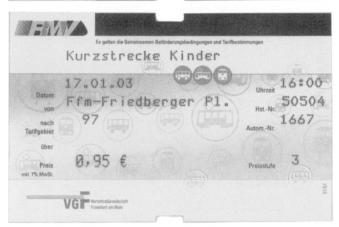

RMV

Es gelten die Gemeinsamen Beförderungsbedingungen und Tarifbestimmungen

Kurzstrecke Kinder

Datum 17.01.03 Uhrzeit 16:00
von Ffm-Friedberger Pl. Hst.-Nr. 50504
nach 97 Autom.-Nr. 1667
Tarifgebiet
über

Preis 0,95 € Preisstufe 3
inkl. 7% MwSt.

VGF VerkehrsGesellschaft
 Frankfurt am Main

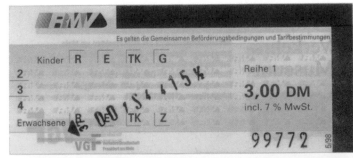

RMV

Es gelten die Gemeinsamen Beförderungsbedingungen und Tarifbestimmungen

Kinder R E TK G

2
3 Reihe 1
4 3,00 DM
Erwachsene R E TK Z incl. 7 % MwSt.

0015 15

99772 5/98

VGF VerkehrsGesellschaft
 Frankfurt am Main

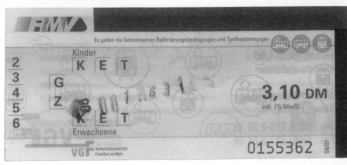

RMV

Es gelten die Gemeinsamen Beförderungsbedingungen und Tarifbestimmungen

Kinder K E T

2
3
4 G 3,10 DM
5 Z inkl. 7% MwSt.
6 K E T
Erwachsene

0155362 04/01

VGF VerkehrsGesellschaft
 Frankfurt am Main

Ein Oberhemd
wie Sie es wünschen!
Auch Ihre übrige Wäsche liefert mit Sorgfalt gewaschen Ihre Wäscherei

WELCOME
TO THE
UNITED STATES

DEPARTMENT OF THE TREASURY
UNITED STATES CUSTOMS SERVICE

CUSTOMS DECLARATION

FORM APPROVED
OMB NO. 1515-0041

Each arriving traveler or head of family must provide the following information (only **ONE** written declaration per family is required):

1. Name: ---
 Last First Middle Initial

2. Number of family members traveling with you -----------------------

3. Date of Birth _____ / _____ / 19___ 4. Airline/Flight: _____
 Month Day Year

5. U.S. Address: --
 --

6. I am a U.S. Citizen YES ☐ NO ☐
 If No,
 Country: -----------------------------

7. I reside permanently in the U.S. YES ☐ NO ☐
 If No,
 Expected Length of Stay: --------------

8. The purpose of my trip is or was
 ☐ BUSINESS ☐ PLEASURE

9. I am/we are bringing fruits, plants, meats, food, soil, YES ☐ NO ☐
 birds, snails, other live animals, farm products, or
 I/we have been on a farm or ranch outside the U.S.

10. I am/we are carrying currency or monetary YES ☐ NO ☐
 instruments over $10,000 U.S. or foreign
 equivalent.

11. The total value of all goods I/we purchased
 or acquired abroad and am/are bringing
 to the U.S. is (see instructions under
 Merchandise on reverse side; visitors
 should report value of gifts only): $ _____
 U.S. Dollars

SIGN ON REVERSE SIDE AFTER YOU READ WARNING.
(Do not write below this line.)

INSPECTOR'S NAME | STAMP AREA

BADGE NO.

Paperwork Reduction Act Notice: The Paperwork Reduction Act of 1980 says we must tell you why we are collecting this information, how we will use it and whether you have to give it to us. We ask for this information to carry out the Customs, Agriculture, and Currency laws of the United States. We need it to ensure that travelers are complying with these laws and to allow us to figure and collect the right amount of duties and taxes. Your response is mandatory

Customs Form 6059B (102584)

MUSÉE
du MUR de L'ATLANTIQUE
le 1er Musée privé
installé dans un blockhaus allemand 39/45
batterie TODT
AUDINGHEN (Cap Gris-Nez) 62179

Entrée : 7 F.
Enfant N⁰ 012134

Imprimerie Decousser Frères - Calais

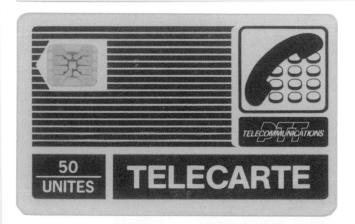

50 UNITES TELECARTE
TELECOMMUNICATIONS PTT

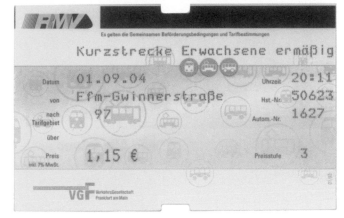

RMV
Es gelten die Gemeinsamen Beförderungsbedingungen und Tarifbestimmungen

Kurzstrecke Erwachsene ermäßig

Datum	01.09.04	Uhrzeit	20:11
von	Ffm-Gwinnerstraße	Hst.-Nr.	50623
nach	97	Autom.-Nr.	1627
Tarifgebiet			
über			
Preis inkl. 7% MwSt.	1,15 €	Preisstufe	3

VGF Verkehrsgesellschaft Frankfurt am Main

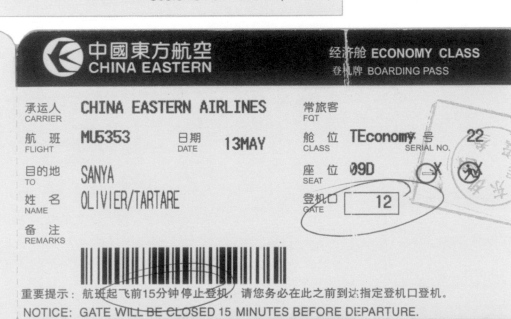

中國東方航空
CHINA EASTERN 经济舱 ECONOMY CLASS
 登机牌 BOARDING PASS

承运人 CARRIER	CHINA EASTERN AIRLINES	常旅客 FQT					
航班 FLIGHT	MU5353	日期 DATE	13MAY	舱位 CLASS	TEconomy	序号 SERIAL NO.	22
目的地 TO	SANYA			座位 SEAT	09D		
姓名 NAME	OLIVIER/TARTARE			登机口 GATE	12		
备注 REMARKS							

航班/目的地/座位/序号

重要提示：航班起飞前15分钟停止登机，请您务必在此之前到达指定登机口登机。
NOTICE: GATE WILL BE CLOSED 15 MINUTES BEFORE DEPARTURE.

125

umwelt-neutral

Die von uns verwendete Verpackungsfolie ist aus Polyethylen und verbrennt in Müllverbrennungsanlagen ohne Rückstände zu Wasserdampf und Kohlendioxyd, ist grundwasserneutral und recyclingfähig.

Frankfurter Allgemeine
ZEITUNG FÜR DEUTSCHLAND

20

81 81 01

COUPON

TRINK - KUR

Gesundtrinken an Deutschlands einziger Glaubersalztherme

3 x täglich Ihrer Gesundheit zu Liebe

Bitte abgeben an der Brunnenausgabe/Wandelhalle. Sie erhalten Ihr persönliches Trinkglas

Bereithaltung – Aufbewahrung – Reinigung

EUROTRAIN

CIV D **BIJ**

AMEROPA
DER REISEVERANSTALTER DER BAHN

Teilnehmerausweis Carte de participant Participant's card	Name und Vorname Nom et prénom Name and first name	BACKE, TANJA

| Alter / Age / Age | Jahre / ans / years | Geburtstag
Date de naissance
Date of birth | 11.4.68 |

☒ Jugendlicher unter 26 Jahren
Jeune de moins de 26 ans
Juveniles under 26 years

☐ Begleiter
nur zulässig im DB-Binnenverkehr

Gültig / Valable / Valid **2** Monate ab / mois à partir du / months from **31. Dez. 1988**

Fahrausweis ohne Kundenfahrplan ungültig
Ce billet n'est pas valable sans fiche-horaire
Ticket not available without passenger's time-table

Bei Fahrausweisen des DB-Binnenverkehrs
Gültigkeit: Hin- u. Rückfahrt 1 Monat, einfache Fahrt 4 Tage

Preis / Prix / Price **DM 58.–46,–**

Meliá Bali Sol
***** GL
Nusa Dua. Bali. Indonesia. Tel. (0361) 71510 Tlx 35237 Fax. 71360.

FOREIGN CURRENCY EXCHANGE VOUCHER
№ 145405

		ROOM	1332
NAME		DATE	3-12-93
		RATE	2027.
US DOLLAR–CASH			
US DOLLAR–(T/C)	05	100	
			^
		TOTAL	Rp 202.700.
CASHIER		RECEIVED	
		GUEST SIGNATURE	

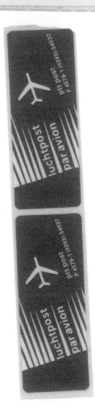

DZ129-192-155

CONTENT • CONTENU • INHALT
American Express Travelers Cheques

5 × US$20 | US$100

Plus: Charges • Frais • Gebühren

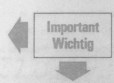

Important
Wichtig

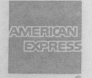

Carry Separately From Cheques
Conservez cette liste séparément de vos chèques
Halten Sie diesen Abschnitt getrennt von Cheques

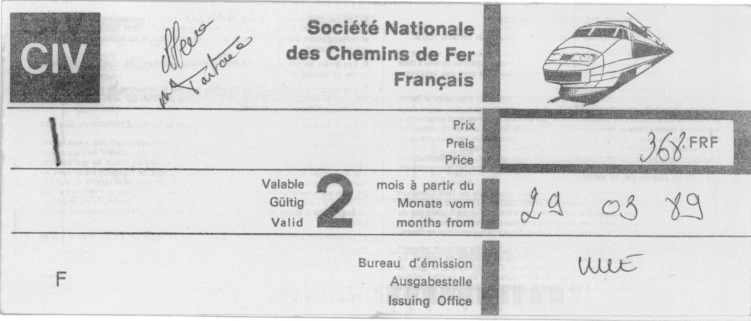

CIV

Société Nationale des Chemins de Fer Français

| | Prix / Preis / Price | 368 FRF |

Valable / Gültig / Valid **2** mois à partir du / Monate vom / months from — 29 03 89

F — Bureau d'émission / Ausgabestelle / Issuing Office — MME

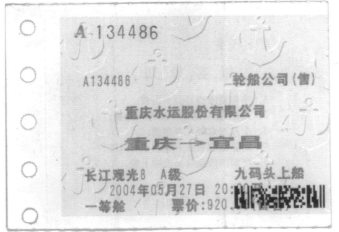

A-134486
A134486 轮船公司(售)
重庆水运股份有限公司
重庆→宜昌
长江观光8 A级 九码头上船
2004年05月27日 20:00
一等舱 票价:920

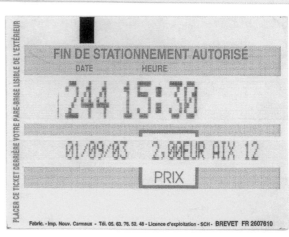

FIN DE STATIONNEMENT AUTORISÉ
DATE HEURE
244 15:30

01/09/03 2,00EUR AIX 12

PRIX

Fabrle. - Imp. Nouv. Carmaux - Tél. 05. 63. 76. 52. 48 - Licence d'exploitation -SCH - BREVET FR 2607610

KOTVA
165.00

3 X 0254 0 165.00 *

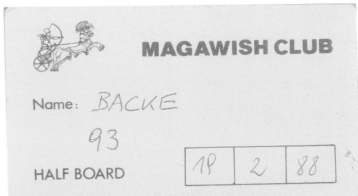

MAGAWISH CLUB

Name: BACKE

93

HALF BOARD | 18 | 2 | 88 |

```
AFSCHEURCOUPON
JULIANASTRAAT
08/04/04    16:16
```

```
No.
Kompression in bar
Compression value in bar
Pression    en bar    Dat.
45  7   9   11  13  15  17

Zyl.
1/2
3
4/5
6
7
8
3.5                          17.5
Best. Nr. 5 1341 248 00-4
DSGM          MADE IN GERMANY
MOTOMETER
```

Westerland (S) – Essen Hbf
Köln Hbf – Frankfurt (M)
04.06 00827 007 066

Budapesti Közlekedési Rt.
1072 Budapest, Akácfa utca 15.

 BKV RT

Budavári Sikló menetjegy

Ára: 600 Ft (hegymenet)

A jegy ára 13,04% áfát tartalmaz.
Adószám: 12154481244 SZJ: 60.21

272669

Pátria Nyomda R. – BKV Rt. 666-112-4120

HO - Gaststätte	„Thomas Müntzer" Keller
6100 Meiningen	
Telefon 2344	

Ihr Verzehr	Mark
Dunkel 1	4,—
Soft 1	1,45
Steak 1	7,60
Bratkart 1	6,85
	19,90

Unterschrift V 11/10 SeG 2/89

NAME TOUR : _____

ROOM NO. : 3/06

✦ Meliá Bali Sol
★★★★★ GL

Nusa Dua, Bali, Indonesia. PO. Box 1048 Tuban
Tel. (0361) 71510 Tlx. 35257 Fax. 71360
◆ Grupo Sol

```
26.01.94 Ausstellung

11H00          SEHEN / LESEN

DM 06,00       Ermässigt

004800

0# 41          CCS 06592/2020 D-5568 Daun
```
Nur für die gelöste Vorstellung

Naam/voorletters Name/initials	_____
Straat Street	_____
Plaats City	_____
Land Country/State	_____
Telefoon Telephone	_____

KLM

CREW BAGGAGE

Form No. 9-28-358

PIA

Destination

PIA 59-14-10

Flight number PK	Weight

Baggage identification tag

Destination

PIA 59-14-10

CREW BAGGAGE

MAHRUĠ MILL-PUBLIC TRANSPORT ASSOCIATION

$\frac{\text{Ċ}}{39}$ 567889

8 ċ

Jekk ma turix il-biljett terġa' thallas.
If ticket is not shown on demand, fare must be paid again

PRINTEX - MALTA

MAHRUĠ MILL-PUBLIC TRANSPORT ASSOCIATION

$\frac{\text{Ċ}}{40}$ 534225

8 ċ

Jekk ma turix il-biljett terġa' thallas
If ticket is not shown on demand, fare must be paid again

PRINTEX - MALTA

MINI

TUESDAY

23

AUG 05

148069

CONTROL NUMBER

NOT FOR SALE

KEEP

THIS TRANSFER/ FARE RECEIPT AS PROOF OF PAYMENT

7 8 9 10	USE FOR TRAVEL IN ANY DIRECTION UNTIL TIME INDICATED	:00 :30
11 12 1 2		:00 :30
3 4 5 6		:00 :30
7 8 9 10		:00 :30

OPDRACHT VOOR FOTO VAN DIA

1 DIA PER ZAKJE

DIA INLEVEREN IN EEN

DIARAAMPJE VAN 5 x 5 CM

HEMA

MAHRUĠ MILL-PUBLIC TRANSPORT ASSOCIATION

$\frac{\text{Ċ}}{13}$ 569548

8 ċ

Jekk ma turix il-biljett terġa' thallas
If ticket is not shown on demand, fare must be paid again

PRINTEX - MALTA

MAHRUĠ MILL-PUBLIC TRANSPORT ASSOCIATION

$\frac{\text{Ċ}}{40}$ 534212

8 ċ

Jekk ma turix il-biljett terġa' thallas
If ticket is not shown on demand, fare must be paid again

PRINTEX - MALTA

Preisstufe I DM **2.50**

G7 000399

Salle
Séminaire

andré

BAR · RESTAURANT · LA ROCHELLE

Réceptions
Cocktails
Réunions

5, rue
Saint-Jean

Tél.
46.41.28.24

sur le port

SAL

Surface mail
Air
Lifted

From
The Netherlands

P 4583-1 ptt post

ExpressReservierung – Bitte
für Platzkarteninhaber
freigeben

13.04 00724 018 074

GOVERNMENT OF INDIA
DEPARTURE (EMBARKATION) CARD
FOR FOREIGN NATIONALS

BUREAU OF IMMIGRATION
सत्यमेव जयते
INDIA

1a. Name **(as in passport)** Leave one box blank after every part of the name/initial

1b. Sex
(put "✓" in box)
☐ MALE
☐ FEMALE

2. Nationality

3. Passport Number

4. Date of Birth (DD/MM/YY)

5a. Date of departure (DD/MM/YY) **5b.** Flight Number **5c.** Port of destination

6a. Arrival date in India (DD/MM/YY) **6b.** Port of arrival in India

Signature of passenger

IMMIGRATION STAMP(DEPARTURE)

D04 1463201

WISH YOU A HAPPY JOURNEY

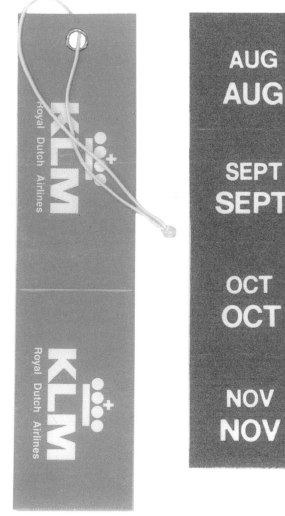

KLM
Royal Dutch Airlines

KLM
Royal Dutch Airlines

AUG
AUG

SEPT
SEPT

OCT
OCT

NOV
NOV

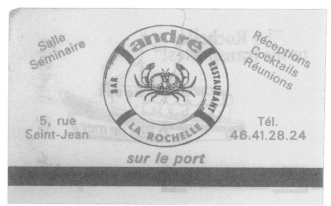

Salle
Séminaire

andré

BAR · RESTAURANT · LA ROCHELLE

Réceptions
Cocktails
Réunions

5, rue
Saint-Jean

Tél.
46.41.28.24

sur le port

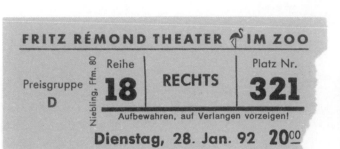

FRITZ RÉMOND THEATER IM ZOO

| Preisgruppe D | Reihe **18** | **RECHTS** | Platz Nr. **321** |

Niebling, Ffm. 80

Aufbewahren, auf Verlangen vorzeigen!

Dienstag, 28. Jan. 92 20⁰⁰

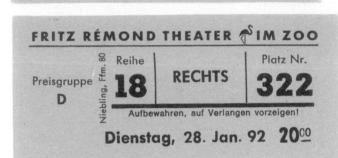

FRITZ RÉMOND THEATER IM ZOO

| Preisgruppe D | Reihe **18** | **RECHTS** | Platz Nr. **322** |

Niebling, Ffm. 80

Aufbewahren, auf Verlangen vorzeigen!

Dienstag, 28. Jan. 92 20⁰⁰

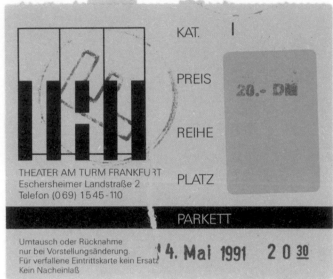

KAT. I

PREIS

REIHE

PLATZ

20.- DM

THEATER AM TURM FRANKFURT
Eschersheimer Landstraße 2
Telefon (069) 1545-110

PARKETT

Umtausch oder Rücknahme
nur bei Vorstellungsänderung.
Für verfallene Eintrittskarte kein Ersatz
Kein Nacheinlaß

14. Mai 1991 20 30

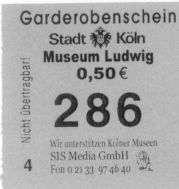

Garderobenschein
Stadt Köln
Museum Ludwig
0,50 €
Nicht übertragbar!

286

Wir unterstützen Kölner Museen
SIS Media GmbH
Fon 0 21 33 97 46 40

4

Garderobenschein
Stadt Köln
Museum Ludwig
0,50 €
Nicht übertragbar!

287

Wir unterstützen Kölner Museen
SIS Media GmbH
Fon 0 21 33 97 46 40

4

Garderobenschein
Stadt Köln
Museum Ludwig
0,50 €
Nicht übertragbar!

307

Wir unterstützen Kölner Museen
SIS Media GmbH
Fon 0 21 33 97 46 40

4

Flecken Ahten

La Tempête/Der Sturm

Regie: Peter Brook
Theater Am Turm — Coproduktion

THEATER AM TURM
Frankfurt am Main
Eschersheimer Landstraße 2
Tel. (0 69) 15 45 - 110

15,- DM

B

Kategorie Preis

Reihe Platz

Kein Sitzplatzanspruch

Kongreßhalle Frankfurt/Messegelände
Mittwoch, den 8. Mai 1991, 20.00 Uhr

La Tempête/Der Sturm

Regie: Peter Brook
Theater Am Turm — Coproduktion

THEATER AM TURM
Frankfurt am Main
Eschersheimer Landstraße 2
Tel. (0 69) 15 45 - 110

15,- DM

B

Kategorie Preis

Reihe Platz

Kein Sitzplatzanspruch

Kongreßhalle Frankfurt/Messegelände
Mittwoch, den 8. Mai 1991, 20.00 Uhr

STADT FRANKFURT
AM MAIN
Gebühr
€ 5,00
15709

3112506

S.T.U.C.
CANNES

18 56022

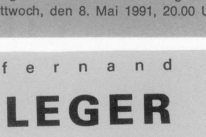

f e r n a n d

LEGER

Musée d'art moderne Villeneuve d'Ascq

Philippine Airlines

MABUHAY CLASS

Philippine Airlines

26	31	THU	MAR
26	31	THU	MAR
27	SUN	FRI	APR
27	SUN	FRI	APR
28	MON	SAT	MAY
28	MON	SAT	MAY
29	TUES	JAN	JUN
29	TUES	JAN	JUN
30	WED	FEB	JUL
30	WED	FEB	JUL

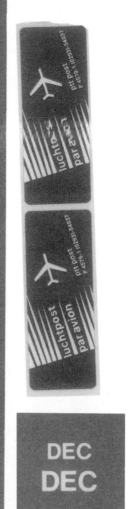

DEC
DEC

Meliá Bali Sol
★★★★★ GL
Nusa Dua. Bali. Indonesia. Tel. (0361) 71510 Tlx 35237 Fax. 71360.

FOREIGN CURRENCY EXCHANGE VOUCHER

Nº 145011

NAME			ROOM	3106
			DATE	28/11/93
			RATE	2027
US DOLLAR-CASH	US	66		133 782
US DOLLAR-T/C				
			TOTAL	133.782
CASHIER		RECEIVED		
		GUEST SIGNATURE		

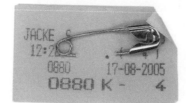

JACKE S
12:28
0880 17-08-2005
0880 K - 4

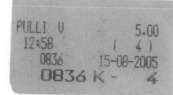

PULLI V 5.00
12:58 (4)
0836 15-08-2005
0836 K - 4

HOSE S
12:58 (4)
0836 15-08-2005
0836 K - 3

Frankfurt (M) - Berlin

15.05 00694 Wagen 2 013

T-SHIRT 2.60
(4)
0836 15-08-2005
0836 K - 2

24005 ✱

Palácio Nacional da Pena
Sintra

€ 1.49 300$00

№ 147027

Bilhete só válido para transporte
interno de acesso ao palácio

MARIA IDALINA SANTOS LOPES
Contribuinte nº 161 595 979
Av. Biarritz, 5-B - Monte Estoril
2765-399 ESTORIL • Tel. 21 466 2608 (Valor do IVA incluído)

Palácio Nacional da Pena
Sintra

€ 1,49 300$00

№ 147028

Bilhete só válido para transporte
interno de acesso ao palácio

MARIA IDALINA SANTOS LOPES
Contribuinte nº 161 595 979
Av. Biarritz, 5-B - Monte Estoril
2765-399 ESTORIL • Tel. 21 466 2608 (Valor do IVA incluído)

287 KEINE HAFTUNG
gegen diesen Abschnitt
3

307 KEINE HAFTUNG
gegen diesen Abschnitt
1

Ayuntamiento de Jerez

11:50

Alcázar de Jerez
Conjunto Monumental
INSTITUTO DE CULTURA
P-1100042-I
C/ANCHA, 3 11404 JEREZ
Nº de entrada: ALCAZAR-AC1-4936-188526
Fecha de entrada: 10/06/2005 11:50:40

Nº	Categoría	Precio	Importe
2	VISITA ALC C.O. REDUCID	2,65	5,30
Importe Total:			**5,30 €**

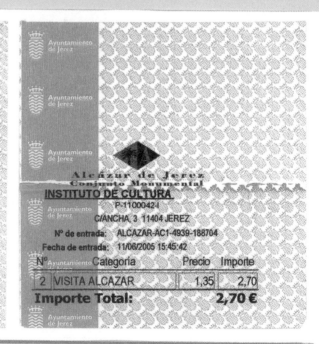

Ayuntamiento de Jerez

Alcázar de Jerez
Conjunto Monumental
INSTITUTO DE CULTURA
P-1100042-I
C/ANCHA, 3 11404 JEREZ
Nº de entrada: ALCAZAR-AC1-4939-188704
Fecha de entrada: 11/06/2005 15:45:42

Nº	Categoría	Precio	Importe
2	VISITA ALCAZAR	1,35	2,70
Importe Total:			**2,70 €**

luchtpost
par avion
ptt post
P 4579-1 (02931-64037

Frankfurt (M) - Berlin

15.05 00694 Wagen 2 011

CONVALIDA

UNICO NAPOLI

CONSORZIO UNICOCAMPANIA

90 MINUTI € 1,00

VALIDO IL
FINO ALLE

29/08/05
ORE 24.00

698-34869

658

Ausgabe gegen diesen Schein
Bitte der Bedienung geben

658

330

Preis

T-Rex: Back to the Cretaceous 3D 12:30 PM
Science Mall open from: 10:00 AM

02/10/2005 110105574
Child 2 Event

3211431302382

Make the most of your day by arriving 10mins prior to the start
of our shows, workshops, IMAX screenings and Tower Experience.

T-Rex: Back to the Cretaceous 3D 12:30 PM
Science Mall open from: 10:00 AM

02/10/2005 110105574
Adult 2 Event

8766986856832

Make the most of your day by arriving 10mins prior to the start
of our shows, workshops, IMAX screenings and Tower Experience.

苏州市天平票证印刷有限公司·2003·2·(1-2万)

全国重点文物保护单位

双塔及罗汉院正殿遗址
游览券
每券：捌元

苏
地(203021) № 0014709

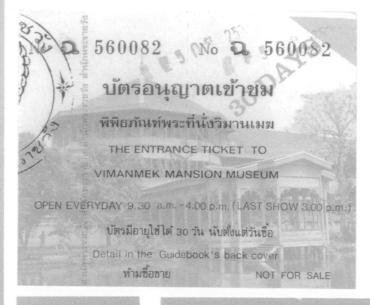

560082 № Q 560082

บัตรอนุญาตเข้าชม

พิพิธภัณฑ์พระที่นั่งวิมานเมฆ

THE ENTRANCE TICKET TO

VIMANMEK MANSION MUSEUM

OPEN EVERYDAY 9.30 a.m. - 4.00 p.m. (LAST SHOW 3.00 p.m.)

บัตรมีอายุใช้ได้ 30 วัน นับตั้งแต่วันซื้อ

Detail in the Guidebook's back cover

ห้ามซื้อขาย NOT FOR SALE

286	307	307
KEINE HAFTUNG gegen diesen Abschnitt	KEINE HAFTUNG gegen diesen Abschnitt	KEINE HAFTUNG gegen diesen Abschnitt
2	2	3

重庆蓝天印制厂印制 2002.12
100份／本印 10000 本从 0000001 至 1000000 号止

重庆机场客车票
Chong Qing Air Port Bus Ticket

专线

全国统一发票监制章
重庆市 (13)
地方税务局监制

人民币：壹拾伍元整
RMB: 15YUAN
(2003) 交客定

№ 0919894

车号：　座号：

年 月 日 时 分

中国·重庆 巫山小三峡游览券
THE LESSER THREE GORGES OF WU... TICKET

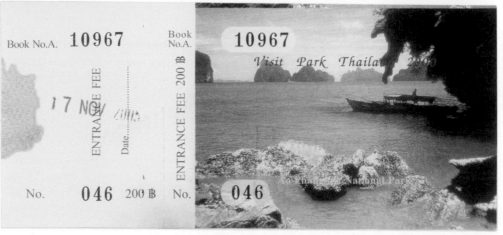

Book No.A. 10967

Book No.A. 10967

Visit Park Thailand 2000

ENTRANCE FEE

17 NOV 2003

Date

No. 046 200 ฿

ENTRANCE FEE 200 ฿

No. 046

MABUHAY CLASS

Philippine Airlines

INDIAN ART HANDICRAFT BAZAR

45, Shaheed Bhagat Singh Place (Complex), Gole Market, New Delhi-110001 (INDIA)
Phone : 23366802, 23366803 ● Telefax : 91-11-23366801 E-mail : itb@vsnl.com

06/03/2005

1 Saree Rs. 1000

Rs. 1,000/-

AIR FRANCE
AF 30 98 76
LIVRAISON CLAIM

FRANCFORT

BY AIR MAIL
par avion
Royal Mail

luchtpost par avion ptt post P 4579-1 (0293)-54037

luchtpost par avion ptt post P 4579-1 (0293)-54037

60 x 120

Gestione Governativa
Navigazione Laghi
Maggiore - Garda - Como

Lago di Como

P. IVA 00802050153

№ 155714

Corsa Semplice Tariffa Ordinaria

Como	Bellagio
Cernobbio	Menaggio
Bleviò	Varenna
Moltrasio	Bellaño
Torno	Acquaseria
Urio	Dervio
Carate	Pianello
Faggeto L.	Dongo
Pognana	Gravedona
Careno	Domaso
Nesso	Piona
Argegno	Colico
Sala	Limonta
Isola C.	Vassena
Lezzeno	Onno
Lenno	Mandello
Tremezzo	Abbadia L.
Cadenabbia	Lecco

Tratta 2

COD.: C.S./T.O.2

timbro e data di validità

NAVIGAZIONE LAGO DI COMO

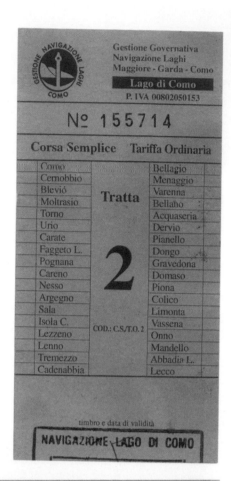

🏛 Kunst- und Ausstellungshalle der Bundesrepublik Deutschland

MOMI'S JEWERLY
Indonesian Opal – Silver
Shopping arcade Hotel Santika
Jl. Jenderal Sudirman 19
Telp. 61910 Fax. (0274) 61910
Yogyakarta - Indonesia

01951 Tgl. 24 - 11 - 93

Banyak nya	Nama Barang	Harga	Jumlah
1	En - 64		$ 12
1	K19 - 23	$	119
		$	131
		–	11
		$	120
	ME		

Barang yang sudah dibeli tidak dapat di tukar/dikembalikan

Tanda Terima, Jumlah Rp.

中国国际航空公司
AIR CHINA

客票及行李票
PASSENGER TICKET AND
BAGGAGE CHECK
旅客联
PASSENGER COUPON

O. TARFAVZ

CARRIER	FLIGHT	CLASS	DATE	DEPARTURE TIME	STATUS	FARE BASIS	ALLOW
WN	2137	Y	21/8	1005	OK		

999 1 - 03870085

VILLE DE
LA MADELEINE

LE PERSONNEL DE LA PISCINE
EST HEUREUX DE VOUS ACCUEILLIR

Gerhard Richter
Eintritt Erwachsener 6.50

12.02.05

KPMG-Kunstabend

Jeden 1. Mittwoch ab 18.00 Uhr
Eintritt frei

20

K20

KUNSTSAMMLUNG NORDRHEIN-WESTFALEN

CHEST
WAIST
SEAT
20 CM

BODY MEASUREMENTS IN C M

CHEST	88
WAIST	70
SEAT	96

38

HENNES & MAURITZ

Eintrittskarte

Museum Ludwig
Sonderausstellung

Stadt ✦ Köln 474360

PHOTO ERM. 8358 11.11.93 6.00 3

Nur gültig für den einmaligen Besuch

287

KEINE HAFTUNG
vor diesem Abschnitt

ETH
Eilat
אילת

arkia
ארקיע

arkia israeli airlines ltd.
ארקיע קוי תעופה ישראליים בע"מ

IZ 216518

Flight

CMB № 151001

AIRLANKA
COLOMBO

CMB

UL № 151001

Gozo Channel Co. Ltd.

CMAR № 297675 M

MGARR CIRKEWWA SERVICE
ADULT RETURN Lm1.00

NOT VALID
FOR TRAVEL

Abholung gegen diesen Beleg und Barzahlung!

H. D. K. M.
schw./braun
farbig/weiß
½ – 1 Paar
Fertig: Mo Di Mi Do Fr Sa Lg.-Nr. 64

0337

138913672415 04/12/2004 07:53
CHARLEROI SUD 65P Ⓑ
TARIF SENIORS 65 ANS ET PLUS
Valable pour un voyage ALLER ET RETOUR

le : 04/12/2004

De : ZONE CHARLEROI
A : ZONE BRUXELLES

DU LUNDI AU VENDREDI: DEPART A PARTIR DE 9H01.
Les samedis, dimanches et jours fériés légaux: pas de restriction horaire.
Ce tarif n'est pas d'application durant certaines périodes.
Voyageur(s) : 1
INTERRUPTION DE VOYAGE ET SURCLASSEMENT NON AUTORISES - NON REMBOURSABLE
Nos Conditions générales de transport sont d'application. Info dans nos gares.

2e CLASSE Ref 75740543 ***3.00EUR

© CIT 1996 77.106.001 / 18

Eine Rundfahrt auf dem
STARNBERGERSEE
ist die schönste Erholung!

STAATL. SEENSCHIFFAHRT
Ruf Starnberg (0 81 51) 1 20 23

051102
Eintrittskarte
Preis siehe Anschlag
Nicht übertragbar
Aufbewahren und auf
Verlangen vorzeigen

17462
Münchner Stadtmuseum
Eintritt
1,50 DM
Auf Verlangen vorzeigen

53724
Eintrittskarte
Preis siehe Anschlag
Nicht übertragbar
Aufbewahren und auf
Verlangen vorzeigen

12 MID	11 PM
10 PM	9 PM
8 PM	7 PM
6 PM	5 PM
4 PM	3 PM
2 PM	1 PM
12 PM	11 AM
10 AM	9 AM
8 AM	7 AM
6 AM	

NEW YORK CITY TRANSIT AUTHORITY

M6

002121

SEP
1992 **26**

Transfer to ONE of the routes listed below
ONLY at the bus stop nearest the intersection
of the M6 and the

	At	Toward
M22	Vesey St	FDR Dr-Grand St
M9	Vesey St	Union Square
M9	Barclay St	Battery Park City
B51	City Hall	Downtown Brooklyn
M15	City Hall	126 St-2 Av
M101	City Hall	193 St-Amsterdam Av
M102	City Hall	147 St-Powell Blvd
M22	Chambers St	World Trade Center
M21	Houston St	Either Direction
M13	W 8 St/W 9 St	Either Direction
M14	W 14 St	Either Direction
M23	W 23 St	Either Direction
M4	W 32 St	Fort Tryon Park
Q32	W 32 St	Jackson Heights
M4	W 34 St	32 St-Penn Station
Q32	W 34 St	32 St-Penn Station
M16	W 34 St	Either Direction
M34	W 34 St	Either Direction
M42	W 42 St	Either Direction
M104	W 42 St	Either Direction
M27	W 49 St/W 50 St	Either Direction
M50	W 49 St/W 50 St	Either Direction
M30	W 57 St	Either Direction
M57	W 57 St	Either Direction
M58	W 57 St	Either Direction
M5	Central Pk South	178 St-Broadway
M7	Central Pk South	147 St-Powell Blvd

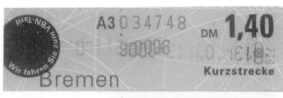

A3 034748 DM **1,40**
900006
Bremen **Kurzstrecke**

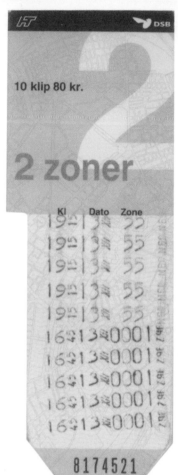

HT · DSB
10 klip 80 kr.

2 zoner

Kl	Dato	Zone
19	13	55
19	13	55
19	13	55
19	13	55
19	13	55
16	13	0001
16	13	0001
16	13	0001
16	13	0001
16	13	0001

8174521

Aktiengesellschaft
REEDEREI NORDEN-FRISIA
26506 Norddeich – ☎ 0 49 31/98 70

Frisia-Großgaragen
Zubringerdienst
DM 2,00 incl. MWSt. ermäß. Satz

28326

– nicht übertragbar –

Aktiengesellschaft
REEDEREI NORDEN-FRISIA
26506 Norddeich – ☎ 0 49 31/98 70

Frisia-Großgaragen
Zubringerdienst
DM 2,00 incl. MWSt. ermäß. Satz

80850

– nicht übertragbar –

TRANSFER FARE RECEIPT
ADULT $3.00

00490

MUNI · RAILWAY

SEP. 10, 1992
THURSDAY

VALID UNTIL TIME INDICATED

7		0
8	**$3.00**	
9		
10		30
11		0
12		
1		
2		30
3		
4		
5		
6		

MVV 01 MÜNCHNER VERKEHRS-
UND TARIFVERBUND

Streifenkarte

15.00 DM

ERWACHSENE

Bitte Hinweise auf der Rückseite beachten!

VB **5604307**

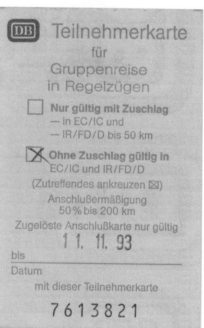

DB **Teilnehmerkarte**
für
Gruppenreise
in Regelzügen

☐ **Nur gültig mit Zuschlag**
– in EC/IC und
– IR/FD/D bis 50 km

☒ **Ohne Zuschlag gültig in**
EC/IC und IR/FD/D
(Zutreffendes ankreuzen ☒)
Anschlußermäßigung
50% bis 200 km
Zugelöste Anschlußkarte nur gültig
1 1. 11. 93
bis
Datum
mit dieser Teilnehmerkarte

7613821

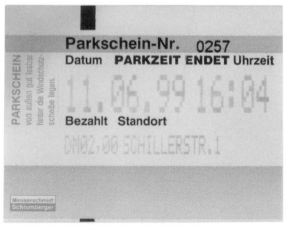

Parkschein-Nr. 0257

Datum **PARKZEIT ENDET** Uhrzeit

11.06.99 16:04

Bezahlt Standort

DM02,00 SCHILLERSTR.1

PARKSCHEIN von außen gut lesbar hinter die Windschutz-scheibe legen.

Messerschmidt
Schlumberger

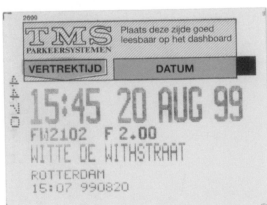

2699
TMS
PARKEERSYSTEMEN

Plaats deze zijde goed
leesbaar op het dashboard

VERTREKTIJD **DATUM**

15:45 20 AUG 99

FM2102 F 2.00
WITTE DE WITHSTRAAT
ROTTERDAM
15:07 990820

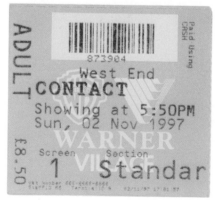

Paid Using CASH

873904

West End
CONTACT
Showing at 5:50PM
Sun, 02 Nov 1997
£8.50
ADULT
Screen Section
1 Standar
WARNER VILLAGE

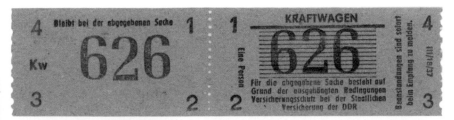

4 | Bleibt bei der abgegebenen Sache | 1 | 1 | **KRAFTWAGEN** | 4
Kw | **626** | Eine Person | **626** | Für die abgegebene Sache besteht auf Grund der ausgehängten Bedingungen Versicherungsschutz bei der Staatlichen Versicherung der DDR | Beanstandungen sind sofort beim Empfang zu melden.
3 | | 2 | 2 | | 3

Eintrittskarte
Preis siehe Anschlag
Nicht übertragbar
Aufbewahren und auf Verlangen vorzeigen

RATP SNCF
SECTION URBAINE
Ⓜ Ⓜ Ⓜ Ⓣ
00073299 1606 C1

Wissenschaftsstadt
Darmstadt
Ordnungsamt

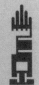

Sehr geehrte Verkehrsteilnehmerin,
Sehr geehrter Verkehrsteilnehmer,

Ihnen wird eine Verkehrsordnungswidrigkeit zur Last gelegt. Der Tatbestand wurde im Rahmen eines automatisierten Verfahrens festgehalten. Sie werden in Kürze über alles Weitere informiert. Aus technischen Gründen können Anfragen bis dahin leider nicht beantwortet werden.
Bitte sehen Sie aus diesem Grund auch von Vorsprachen ab.

Hochachtungsvoll
Ordnungsamt

Dear Motorist,

You have been charged with a traffic offense. The evidence involved has been obtained using automatically operating equipment. You will receive further information on the charge in the near future. We regret that we will be unable to respond to any questions that you may have before that time. We thus also request that you refrain from seeking a personal audience until you have received further notice.

Yours respectfully,
Office of the City Clerk

Chère conductrice, cher conducteur,

Ceci est une contravention. Votre inculpation a été enregistrée en informatique. Vous recevrez sous peu de plus amples détails. Pour des raisons techniques, nous vous prions de bien vouloir attendre nos instructions et donc de ne pas nous contacter avant.

Veuillez agréer, chère conductrice, cher conducteur, nos salutations distinguées.
Les services de l'ordre

Gentile Signora, Gentile Signore,

è stato accertato, tramite un procedimento automatico, che Lei ha commesso un' infrazione contro il Codice della Strada. Le comunicheremo, il piu' presto possibile, ulteriori paricolari. Nel frattempo ci è impossibile, per ragioni tecniche, rispondere ad eventuali domande e La preghiamo pertanto di astenersi dal telefonare o dal presentarsi di persona ai nostri uffici.

Distinti saluti

32/36G4 – 09/98

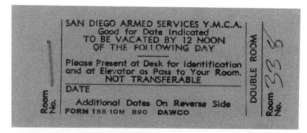

SAN DIEGO ARMED SERVICES Y.M.C.A.
Good for Date Indicated
TO BE VACATED BY 12 NOON
OF THE FOLLOWING DAY

Please Present at Desk for Identification and at Elevator as Pass to Your Room.
NOT TRANSFERABLE

DATE

Additional Dates On Reverse Side
FORM 158 10M 890 DAWCO

Room No. | DOUBLE ROOM Room No. 335

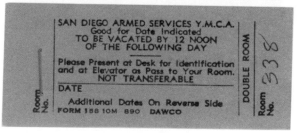

SAN DIEGO ARMED SERVICES Y.M.C.A.
Good for Date Indicated
TO BE VACATED BY 12 NOON
OF THE FOLLOWING DAY

Please Present at Desk for Identification and at Elevator as Pass to Your Room.
NOT TRANSFERABLE

DATE

Additional Dates On Reverse Side
FORM 158 10M 890 DAWCO

Room No. | DOUBLE ROOM Room No. 336

Elysee 2
Knight Moves
09.02.92 (79) 17h30
Eintritt DM 12.00
REIHE 04
✳✳✳✳✳✳✳
Wir sind eines der stärksten Center—
Nur für die gelöste Vorstellung gültig

Aktiengesellschaft
REEDEREI NORDEN-FRISIA
26506 Norddeich – ☎ 0 49 31/98 70

Frisia-Großgaragen
Zubringerdienst
DM 2,00 incl. MWSt. ermäß. Satz

82514

–nicht übertragbar–

Aktiengesellschaft
REEDEREI NORDEN-FRISIA
26506 Norddeich – ☎ 0 49 31/98 70

Frisia-Großgaragen
Zubringerdienst
DM 2,00 incl. MWSt. ermäß. Satz

28332

–nicht übertragbar–

Eintritts'karte
Preis siehe Anschlag
Nicht übertragbar

Aufbewahren und auf Verlangen vorzeigen.

94494

PARKSCHEIN von außen gut lesbar hinter die Windschutzscheibe legen.

Parkschein-Nr. 0458
Datum PARKZEIT ENDET Uhrzeit

27.01.99 18:54

Bezahlt Standort
05.00 Appellhofplatz

Messerschmidt
Schlumberger

AnytimeTeller
TRANSACTION RECEIPT
5235950330005420 WITHDRAW

YOUR IDENTIFICATION TRANSACTION CODE
 $200.00 09/06/92 08:56AM
AMOUNT DATE TIME

CHKING ST BARBARA MAIN
FROM ACCOUNT TO ACCOUNT LOCATION

RETAIN STATEMENT FOR YOUR RECORDS
PRESENT BALANCE AVAILABLE BALANCE DAILY LIMIT

All deposits and payments subject to
verification. Please retain receipt for
your records. HomeFedBank FSB
EP-012 (7/90)
 DD09-34089-0

QUEENS PARK RANGERS

QPR V BIRMINGHAM CITY

NATIONWIDE LGE DIV ONE 1997/98

SOUTH AFRICA ROAD

SAT 01 NOV 1997 03:00PM KICK OFF

Enter Via Turnstile Block 4&7
ADULT/CONC KIOSK

BLOCK	ROW	SEAT	PRICE
E	W	132	£20.00

24 HOUR - MATCH & TICKET INFORMATION LINE 0181-740-0503
PLANS & CONDITIONS ON REVERSE TO BE RETAINED

SOUTH AFRICA ROAD KIOSK

ERICSSON

CUSTOMER COPY

ESTABLISHMENT NAME
I. PAPARAZZI
MIAMI BEACH, FLORIDA
000995210858950 02

DATE APPROVAL CODE
AUG 31, 92 AAMSBX

CUSTOMER NAME
TARTARE
5330930030305433
M.C. 94/08

TRANSACTION TYPE
SALE

RECORD OF CHARGE #	TERMINAL #
594598	50010340

DESCRIPTION OF PURCHASES/SERVICES
FOOD AND BEVERAGE

BASE AMOUNT $3.69

TIP AMOUNT

TOTAL

CUSTOMER SIGN HERE
X

Cardholder acknowledges receipt of goods and/or services in the
amount of the Total shown hereon and agrees to perform the obli-
gations set forth in the Cardholder's agreement with the issuer.
CD 6725 PRINTED IN USA 8/92

SPIELBANK BAD HOMBURG
Mutter von Monte Carlo

Tageskarte 16.07.99

Herr Peter Eckart

DM 5.00 21.48 1163

Bitte nicht knicken!
Wiedervorlage der Karte beschleunigt die Einlaßformalitäten!

INFANT
Boarding Pass

AMER/MAXBENJAMININ

BRUSSELS
FRANKFURT

Flight	Class	Date	Time
2619	Y	15DEC	2210

ate	Boarding Time	Seat	Smoke
2	2140	NO SEAT	

Wt

FREQUENZEN [Hz]
AUDIOVISUELLE RÄUME
9. FEBRUAR – 28. APRIL 2002

UNTERSTÜTZT VON:
 ZUMTOBEL STAFF
 DAS LICHT

MEDIENPARTNER:
Frankfurter Rundschau JOURNAL 2 DE:BUG WIRE

ZUSÄTZLICHE UNTERSTÜTZUNG VON:
MESSE FRANKFURT, MUSIKMESSE PROLIGHT+SOUND, WOM – WORLD OF MUSIC, RADIO X, FUNDEMENTAL STUDIOS,
DAS WERK, PUBLICIS, THE BRITISH COUNCIL, DCA, FRAME, ÖSTERREICH, BUNDESKANZLERAMT – KUNSTSEKTION

Cia. Caminho Aéreo Pão de Açúcar
Rio de Janeiro - Brasil

Bondinho

Um carioca a serviço do
turismo desde 1912

A Brazilian service since 1912

É proibido alimentar ou tocar os animais silvestres
Don't feed, touch or play with the wild animals

A4 № 205603

Sträusschen

Rosenmontagszug

KKG Nippeser Bürgerwehr 1903 e.V.

Telefon (0 61 81) 2 92-25 25
Telefax (0 61 81) 2 92-27 89
24-Stunden-Störungsdienst:
Telefon (0 61 81) 22 32

KREISWERKE HANAU

Klar, wir machen es.

Unterbrechung
der Trinkwasserversorgung

am Do. 10. 2. 05

von ca. 10:00 bis ca. 12:00 Uhr

Sehr geehrte Kundin,
sehr geehrter Kunde,

wegen dringend notwendiger Arbeiten an unserem Trinkwasser-
versorgungsnetz sind wir gezwungen, die Wasserlieferung zu
unterbrechen.
Bitte teilen Sie Ihren Verbrauch so ein, dass Sie in der angegebenen
Zeit auf die Wasserentnahme verzichten können, und vergessen
Sie nicht, Ihre Wasserhähne geschlossen zu halten.
Wir werden uns bemühen, die Arbeiten in der angegebenen Zeit
auszuführen und bitten für die Versorgungsunterbrechung um Ihr
Verständnis.

Mit freundlichem Gruß
Kreiswerke Hanau GmbH

● **Bitte beachten Sie:**

● Bevorraten Sie sich mit Ihrem zu erwartenden Wasserbedarf.
● Halten Sie alle Entnahmestellen geschlossen.
● Öffnen Sie zuerst die in Ihrem Haus am höchsten gelegene
 Zapfstelle, um möglicherweise vorhandene Luft entweichen zu lassen.
● Betätigen Sie auf keinen Fall zuerst einen Druckspüler.

P. H.
Serie 1492

P. H.
Serie 1492

Versuch's nochmal Versuch's
nochmal Versuch's nochmal
Versuch's nochmal Versuch's
nochmal Versuch's nochmal
Versuch's nochmal Versuch's
nochmal Versuch's nochmal
Versuch's nochmal Versuch's
nochmal Versuch's nochmal

Leider verloren

Versuch's nochmal Versuch's

Versuch's nochmal Versuch's
nochmal Versuch's nochmal
Versuch's nochmal Versuch's
nochmal Versuch's nochmal
Versuch's nochmal Versuch's
nochmal Versuch's nochmal
Versuch's nochmal Versuch's
nochmal Versuch's nochmal

Leider verloren

Versuch's nochmal Versuch's

SCIENCE DIVISION
THE THAI RED CROSS SOCIETY

SNAKE FARM

BANGKOK, THAILAND

DATE.........7. SEP. 1991

BK. 159

NO. 15850

ADMISSION 70 BAHT

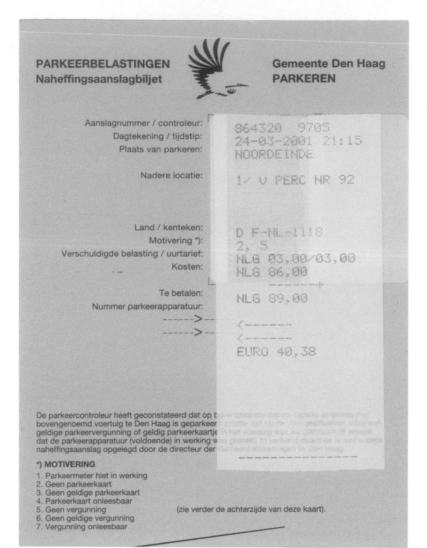

Aanslagnummer / controleur:
Dagtekening / tijdstip:
Plaats van parkeren:

Nadere locatie:

864320 9705
24-03-2001 21:15
NOORDEINDE

1/ V PERC NR 92

Land / kenteken:
Motivering *):
Verschuldigde belasting / uurtarief:
Kosten:

D F-NL-1118
2, 5
NLG 03,00/03,00
NLG 86,00

Te betalen:
Nummer parkeerapparatuur:

NLG 89,00

------>------
------>------

<--------
<--------

EURO 40,38

De parkeercontroleur heeft geconstateerd dat op bovenstaande datum, tijdstip en plaats het bovengenoemd voertuig te Den Haag is geparkeerd zonder dat op de voorgeschreven wijze een geldige parkeervergunning of geldig parkeerkaartje in het voertuig was aangebracht of zonder dat de parkeerapparatuur (voldoende) in werking was gesteld. In verband daarmee is aan u deze naheffingsaanslag opgelegd door de directeur der Gemeentebelastingen te Den Haag.

***) MOTIVERING**
1. Parkeermeter hiet in werking
2. Geen parkeerkaart
3. Geen geldige parkeerkaart
4. Parkeerkaart onleesbaar
5. Geen vergunning
6. Geen geldige vergunning
7. Vergunning onleesbaar

(zie verder de achterzijde van deze kaart).

114 cm

6 ans

G

CORSAIRE CARREAUX

3 393043 541485

فَنَادِق ابو نواس
ABOU NAWAS
H O T E L S

CONVALIDA

UNICO NAPOLI

CONSORZIO UNICOCAMPANIA

90 MINUTI

€ 1,00

baby-walz

01142.890.54.03

19106860

94173 06786

00 404

2er Pack Body 1/2 Arm

Gr. EUR
62 11,90

01142.890.54.03

SCIENCE DIVISION
THE THAI RED CROSS SOCIETY

SNAKE FARM
BANGKOK, THAILAND
−7 SEP 1991
DATE..........................

BK. 150

ADMISSION **70** BAHT NO. 15849

Straßenverkehrsamt Offenbach a. M.
– Verkehrsüberwachungsdienst –

attag/Datum Tatzeit
23 06 88 von: 15 45 bis:

Kennzeichen Fabrikat
4U-PN 445 BMW

atort: **Offenbach/M.**
Belguer Ch 76-80 D

Zuwiderhandlung:

☒ siehe Rückseite unter Nummer ➝ 0015

☐

ehr geehrter Verkehrsteilnehmer!

nnen wird eine Verkehrsordnungswidrigkeit zur Last gelegt. Sie werden
eshalb in der nächsten Zeit von der zuständigen Verwaltungsbehörde
veitere Mitteilung erhalten.

**itte sehen Sie aus diesem Grunde von Vorsprachen bei einer
olizeidienststelle ab;** Zahlungen können dort nicht entgegengenommen
verden.

ochachtungsvoll
tadt Offenbach a. M.
er Oberbürgermeister
traßenverkehrsamt
Verkehrsüberwachungsdienst –

P. H.
Serie 1492

Versuch's nochmal Versuch's
nochmal Versuch's nochmal
Versuch's nochmal Versuch's
nochmal Versuch's nochmal
Versuch's nochmal Versuch's
nochmal Versuch's nochmal
Versuch's nochmal Versuch's
nochmal Versuch's nochmal

Leider verloren

Versuch's nochmal Versuch's

266

Preis

TRANSFER FARE RECEIPT
ADULT $3.00

MUNI RAILWAY 00489

SEP. 10, 1992
THURSDAY

VALID UNTIL TIME INDICATED

7	0
8	
9	
10	30

$3.00

11	0
12	
1	
2	30

3
4
5
6

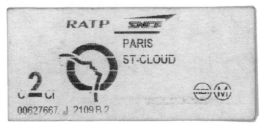

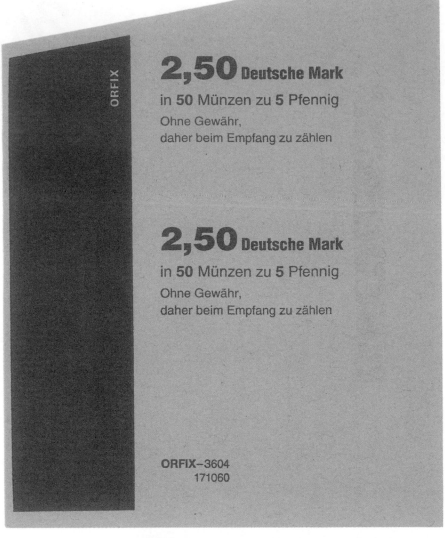

2,50 Deutsche Mark

in **50** Münzen zu **5** Pfennig

Ohne Gewähr,
daher beim Empfang zu zählen

2,50 Deutsche Mark

in **50** Münzen zu **5** Pfennig

Ohne Gewähr,
daher beim Empfang zu zählen

ORFIX–3604
171060

ORFIX

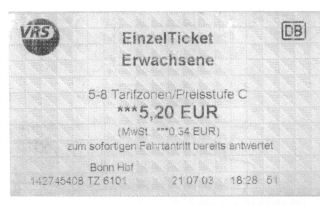

VRS

EinzelTicket
Erwachsene

DB

5-8 Tarifzonen/Preisstufe C
***5,20 EUR
(MwSt. ***0.34 EUR)
zum sofortigen Fahrtantritt bereits entwertet

Bonn Hbf
142745408 TZ 6101 21.07.03 18:28 51

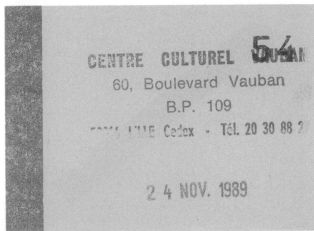

CENTRE CULTUREL VAUBAN

60, Boulevard Vauban

B.P. 109

59011 LILLE Cedex - Tél. 20 30 88 2

2 4 NOV. 1989

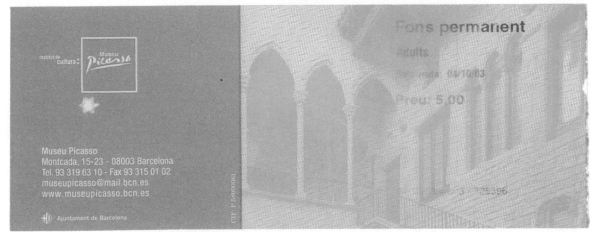

Institut de
Cultura : Museu Picasso

Museu Picasso
Montcada, 15-23 - 08003 Barcelona
Tel. 93 319 63 10 - Fax 93 315 01 02
museupicasso@mail.bcn.es
www.museupicasso.bcn.es

Ajuntament de Barcelona

Fons permanent

Adults

Preu: 5,00

Meliá Bali Sol
★★★★★ GL

3106 DIAL 4 FOR SERVICE

PRESSING / PLANCHADO
OPEN 7 DAYS A WEEK / ABIERTO 7 DIAS A LA SEMANA

Room No. No. de Habitacion	3106	Name Nombre		**LAUNDRY MARK**
Date Fecha		Time Hora	No. of Guest	

☐ **REGULAR / NORMAL :**
To return by 6 pm same day, regular charge. Latest collection 15 pm otherwise to return on the next day. Si se entrega antes de las 15 horas sera devuelto el mismo dia sobre las 19 horas. Si es entregado despues de las 15 horas le sera devuelto al dia siguiente. Siendo este el cargo normal.

☐ **EXPRESS / URGENTE :**
Will be ready within 1 hour subject to 100% surcharge. Latest collection 10 am - 3 pm.
Estara listo en 1 horas con un 100% de recargo. Las horas de recogida seran hasta las 15 horas.

Guest Count Contado Por el Cliente	Hotel Count Contado Por Hotel	Gentlemen / Caballeros	Unit Price US$ Precios Por Unidad en US$	Amount US$ Total en US$
		Dress Shirt / Camisa	1.30	
		Suit 2 pieces / Traje 2 piezas	2.95	
		Trousers / Pantalones	1.55	
		Safari Suit / Traje Safari	2.80	
		Jacket / Chaqueta	1.80	
		Sweater / Sueter	1.40	
		Necktie / Corbata	0.75	
		Scarf / Pañuelo	0.70	
		Shorts / Pantalones Cortos	1.00	2.
		Overall / Conjunto	2.60	
		Sarong	1.30	

		Ladies / Señoras		
		Blouse / Blusa	1.30	1.3
		Skirt / Falda	1.40	
		Suit 2 pieces / Conjunto 2 piezas	2.80	71.3
		Slacks / Pantalones	1.60	
		Shorts / Pantalones Cortos	1.00	RP 6.93
		Dress / Vestido	2.60	
		Jacket / Chaqueta	1.80	15.5 10.75
		Sweater / Sueter	1.40	
3P 7		Scarf / Pañuelo	0.70	RP 8.00

Checked by : _____			**TOTAL**	

Prices Subject to Service & Tax 15%

Special Instructions
Instrucciones Especiales

Conditions :

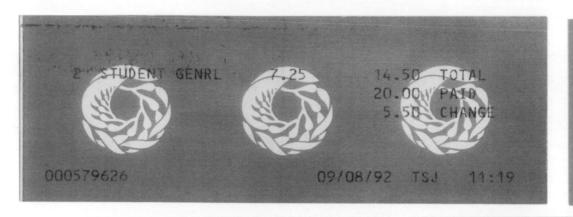

2 STUDENT GENRL 7.25 14.50 TOTAL
 20.00 PAID
 5.50 CHANGE

000579626 09/08/92 TSJ 11:19

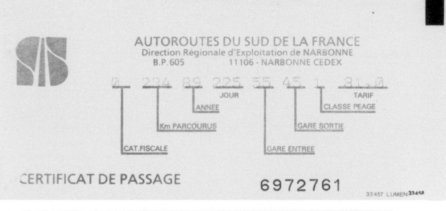

By signing this receipt or by accepting these Cheques, I accept the terms of the Purchase Agreement and agree to sign these Cheques immediately.

En signant ce reçu qu en prenant possession de ces chèques, je déclare accepter les conditions du contrat d'achat figurant au verso et m'engage à signer ces chèques immédiatement.

Durch Unterzeichnung dieser Quittung bzw. die Entgegennahme dieser Cheques anerkenne ich die Kaufsbedingungen.

Note: Immediately sign each of your Cheques in the upper left corner. Under the terms of the Agreement you are not protected in case of loss or theft until your Cheques are so signed.

A noter: Signez immédiatement chaque chèque dans le coin supérieur gauche, ainsi que le stipulent les conditions de vente. Vous n'avez aucun recours en cas de perte ou de vol si vos Chèques ne sont pas signés de cette façon.

Achtung: Bitte sofort jeden Ihrer Cheques in der oberen linken Ecke unterzeichnen. Nach den Kaufsbedingungen sind Sie im Falle von Verlust oder Diebstahl erst dann geschützt, wenn Sie Ihre Cheques so unterzeichnet haben.

Customer's Record of Purchase
Relevé d'achat destiné au client
Kaufbestätigung des Kunden

HF103-683-507

CONTENT • CONTENU • INHALT
American Express Travelers Cheques

3 x US$50 US$150

Plus: Charges • Frais • Gebühren

Important Wichtig

AMERICAN EXPRESS

Carry Separately From Cheques
Conservez cette liste séparément de vos chèques
Halten Sie diesen Abschnitt getrennt von Cheques

EURO TUNNEL

BILLET D'ENTRÉE POUR LA VISITE
DE LA MAQUETTE EUROTUNNEL
AU CENTRE D'INFORMATION DE SANGATTE

VALABLE POUR 1 ADULTE

Nᵒ 067413 10 FF

EURO TUNNEL

BILLET D'ENTRÉE POUR LA VISITE
DE LA MAQUETTE EUROTUNNEL
AU CENTRE D'INFORMATION DE SANGATTE

VALABLE POUR 1 ADULTE

Nᵒ 067414 10 FF

AUTOROUTES DU SUD DE LA FRANCE
Direction Régionale d'Exploitation de NARBONNE
B.P. 605 11106 - NARBONNE CEDEX

JOUR TARIF
ANNEE CLASSE PEAGE
Km PARCOURUS GARE SORTIE
CAT.FISCALE GARE ENTREE

CERTIFICAT DE PASSAGE 6972761

33457 LUMEN 33450

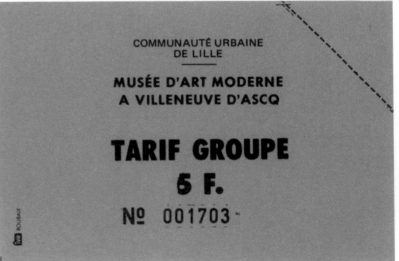

COMMUNAUTÉ URBAINE
DE LILLE

MUSÉE D'ART MODERNE
A VILLENEUVE D'ASCQ

TARIF GROUPE

5 F.

Nᵒ 001703

CEZANNE

Gemälde · Meisterwerke aus vier Jahrzehnten

KUNSTHALLE TÜBINGEN
16. Januar bis 2. Mai 1993

2 1. MRZ. 1993

Eintrittskarte DM 12,–

Gültig für einmaligen Eintritt

A № 06770

Pfänder

Adlerwarte Pfänder
Pfänder Bergstation, 6911 Lochau, Tel. 0663/053040

Flugvorführung № 18271

ART COLOGNE 1993

27. Internationaler Kunstmarkt Köln · 11. bis 17. November 1993

SONDERTAGESKARTE

STK DM 10,– incl. 15 % MwSt.
Berechtigt nur zum einmaligen Besuch der Art Cologne.

Sonderpreis für Schüler, Studenten, Auszubildende, Bundeswehrgrund-
und Ersatzdienstleistende, Schwerbehinderte und Rentner gegen Vorlage
des Ausweises.

Innerhalb des Messegeländes hat unsere Hausordnung Gültigkeit.
Diese Karte ist nicht übertragbar.

00095

| M | F | 11 | 12 | 13 | 14 | 15 | 16 | 17 |

f e r n a n d

LEGER

Musée d'art moderne Villeneuve d'Ascq

ZAAL 2	ZAAL 2
TIERRA	TIERRA
20-06-97 21:45	20-06-97 21:45
KORTING W bf 11.00	NORMAAL W bf 13.50
(001)	(001)
1-0123337	1-0123336

ZAAL 2	ZAAL 3
I SHOT ANDY WAR	DOWN BY LAW
19-04-97 21:45	09-07-97 19:15
KORTING W bf 11.00	KORTING bf 8.50
(001)	(001)
1-0112547	1-0126692

```
         BETAALAUTOMAAT
14/09/96                          15:42:07
KASSANR      380701 REFERENTIE  11399

TOTAAL FL                         129,90
TLV: 5468551505067468000
PASNR              EXP.DATUM       9907
EUROCARD NEDERLAND    TRANSNR    3G1027

HANDTEKENING

_____

      U HEEFT BETAALD TOT ZIENS
```

CARDNET

[クレジットカード売上票]
（データギャザ専用）
加盟店名 ホテルニューオータニマクハリ
043-297-7777
カード会社　　　　　DC
端末番号　　49661-510-49338
会員番号　 5525545261035017

伝票番号	有効期限	取引内容
04379	06/12	売上
支払区分	分割回数	取扱区分
一括		110
商品区分	処理通番	
	631724	

ご利用日　 2004/11/14 08:37:26
承認番号　　　　　　 641338

金　　額　　　　　　¥7,429
税その他　　　　　　　　¥0
合計金額　　　　　　¥7,429

品名・型式他	数量

035713E PK LH GOTHE MAR
ご案内
ご利用ありがとうございました。
またのご来店を
お待ちしております。
＊2a996620000＊

売場	係員

お客様控

自由席特急券
LTD.EXP.（NON-RESERVED）
京　都　→　関西空港
KYOTO　　　KANSAI AIRPORT

10月 5日から 2日間有効
1回限り有効
¥1・150

15.10.-5　京都駅W22発行
00322-02 (4-)　　C36

自由席特急券
LTD.EXP.（NON-RESERVED）
京　都　→　関西空港
KYOTO　　　KANSAI AIRPORT

10月 5日から 2日間有効
1回限り有効
¥1・150

15.10.-5　京都駅W22発行
00322-01 (4-)　　C36

Europa Palast
Schweigen der Lämm
03.05.91 <63> 23H15
Eintritt　　 DM 11.00
REIHE　13
Wir sind für Sie
Spitze
Nur für die gelöste Vorstellung gültig

Elysee 2
Knight Moves
09.02.92 <78> 17h30
Eintritt　 DM 12.00
REIHE　04
Unser THX-System
ist einfach Spitze
Nur für die gelöste Vorstellung gültig

関西国際空港 SALES SLIP	DUTY FREE SHOP **KANSAI** *Airport*	関西国際空港株式会社 TEL: 0724-55-2340

FLT.No.	()
NAME		

CODE	I T E M	QTY	AMOUNTS
	FOODS	3	1500

関空 4

⑧お客様控

DATE 03.10.05 U$　　14.00　　　¥1,500
BILL-NO.112-0012 / 031005 CLERK

CR CARD CO.		ACCT.NO.		VALUE	
CLASS CODE	APRV.CODE		TRANS NO.	CR	STATUS

€2 ⊘
6.7.2005
1 6. GIU. 2005

S. APOLLINARE IN CLASSE
NOVAMUSA S.r.l.
Via Acireale Zir
98125 MESSINA
Part. IVA 0184635082

Bitte unterschreiben und an

ums (GFS) zurück

weiterleiten!

UB MEDIA AG
Tel. 0812/21/226-0 · Best.-Nr. 70-12
Post-it® Haftnotizen

Einzelfahrt Kind

DATUM 02.10.97		UHRZEIT 23:19	
LINIE 034		RICHTUNG R	
VON DA.-Mathildenplatz	HST.-NR. 40144		
NACH TARIFGEBIET 4080	MODUL-NR. 02740		
ÜBER ohne Umweg	GER.-NR. 01252		
PREIS DM2,00	03	LFD.NR. 011	
PREISST.			

INCL.7% MW.ST.
HEAG Verkehrs-GmbH

Sec. 199C

Securair Ltd. (HKG)

Flt No. _____ Date _____

Seat No. _____ Time _____

Pax _____

Destination _____

Description of Article _____

No. of Items _____

Security carton to be collected

From _____

At _____

Passenger Copy № 77822

Your property should be claimed from the airline by which you
are travelling within 7 days after which it may be disposed of.

台端需在七天之内從所乘搭之航空公司辦事處領回有關
物品，逾時自誤。

Datum	Kennzeichen
29.10. 2003	I-PE 861
	Fahrzeugtyp
	Renault

Tatort / Straße

Sehr geehrte Verkehrsteilnehmerin,

Sehr geehrter Verkehrsteilnehmer,

Ihnen wird eine Verkehrsordnungswidrigkeit zur Last gelegt.
Sie werden deshalb in der nächsten Zeit von der zuständigen
Verwaltungsbehörde weitere Nachricht erhalten.
Bitte sehen Sie aus diesem Grund von einer Vorsprache bei
einer Polizeidienststelle ab.

PSA Nr.: 853

```
19:02          08/07/95        :
AUTH CODE:144504

WIMBLEDON SHOP
WIMBLEDON LONDONSW19
02423854.0527    2625200

MASTERCARD
5232030230007830
1195

THANKYOU
£27.00  SIGN BELOW

PLEASE DEBIT MY ACCOUNT AS SHOWN
```

LANCASTER HALL HOTEL

**35 CRAVEN TERRACE
LONDON W2 3EL**

TEL: 020 7723 9276 FAX: 020 7706 2870

NAME 406

ROOM No.

DEP. DATE 14/07/05

**KEEP THIS CARD CAREFULLY. YOU WILL
NEED IT TO OBTAIN YOUR ROOM KEY.**

Bitte unterschreiben und an

uns (GFS) zurück

weiterleiten!

UB MEDIA AG
Tel. 0812/126-0 · Best.-Nr. 70-12
Post-It® Haftnotizen

TRASPORTI
VELOCI
MARITTIMI

BIGLIETTO PASSEGGERI

Nave

Amalfi 1 08/09/05 18.49 - A1001630.48
Linea: Corsa del:
AMSA 08-09-05 **19:10**
Amalfi
Salerno
Ordinario Nave
Quantità: 1
Importo € 4,00 Cassa

COPIA PER IL PASSEGGERO

TRASPORTI
VELOCI
MARITTIMI

BIGLIETTO PASSEGGERI

Nave

Positanc 08/09/05 11.24 - PO006090070
Linea: Corsa del:
POAM 08-09-05 **12:00**
Positano
Amalfi
Ordinario Nave
Quantità: 1
Importo € 5,00 Cassa

COPIA PER IL PASSEGGERO

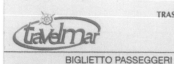

TRASPORTI
VELOCI
MARITTIMI

BIGLIETTO PASSEGGERI

Nave

Concordia 1 08/09/05 09.38 - C1005640069
Linea: Corsa del:
SAPO 08-09-05 **09:40**
Salerno
Positano
Ordinario Nave
Quantità: 1
Importo € 6,00 Cassa

COPIA PER IL PASSEGGERO

C制 自由席特急券
LTD. EXP. (NON-RESERVED)
京 都 → 関 西 空 港
KYOTO KANSAI AIRPORT

SEP. 4 (VALID 2 DAYS)
Valid for only one trip
¥1,150

17.-9.-2 京都駅W2発行
50530-02 (4-)R313C25

自由席特急券
LTD. EXP. (NON-RESERVED)
関 西 空 港 → 京 都
KANSAI AIRPORT KYOTO

SEP. 1 (VALID 2 DAYS)
Valid for only one trip
¥1,150

17.-9.-1 関西空港駅W3発行
60433-01 (4-) C36 経1

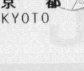
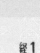

TRASPORTI
VELOCI
MARITTIMI

BIGLIETTO PASSEGGERI

Nave

Positanc 08/09/05 11.24 - PO006090069
Linea: Corsa del:
POAM 08-09-05 **12:00**
Positano
Amalfi
Ordinario Nave
Quantità: 1
Importo € 5,00 Cassa

COPIA PER IL PASSEGGERO

C制 自由席特急券
LTD. EXP. (NON-RESERVED)
京 都 関 西 空 港
KYOTO → KANSAI AIRPORT

SEP. 4 (VALID 2 DAYS)
Valid for only one trip
¥1,150

17.-9.-2 京都駅W2発行
50530-01 (4-)R313C25

自由席特急券
LTD. EXP. (NON-RESERVED)
関 西 空 港 → 京 都
KANSAI AIRPORT KYOTO

SEP. 1 (VALID 2 DAYS)
Valid for only one trip
¥1,150

17.-9.-1 関西空港駅W3発行
60433-02 (4-) C36 経1

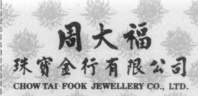

周大福
珠寶金行有限公司
CHOW TAI FOOK JEWELLERY CO., LTD.

HK$100
港幣壹佰元
現金代用券

廣東省港澳航運公司
KWANGTUNG PROVINCE H.K./MACÁU NAVIGATION CO.,
總代理：珠江船務有限公司
H.K. Agents: Chu Kong Shipping Co., Ltd.

廣州—香港客票 № 11174
KWANGCHOW/HONG KONG SERVICE TICKET

持票人
Ticket Holder: _____ 性別 男/女 証件號碼 Travel Document No. _____

1991年 8 月31日
16- I

開航日期 Sailing Date: _____

開航時間 Sailing Time: P.M 2:00 座 號 Cabin No. _____

票價 FARE 兌換券FEC¥ : 83.00

另加收

堤圍防護費：港幣10元
堤圍防護費專用章

售票章：

注　意：1. 本票依照后列條件發出
IMPORTANT : (1) Issue subject to conditions overleaf.
　　　　　2. 旅客須在開航前一小時到達碼頭（廣州河南洲頭咀港澳碼頭）
　　　　　(2) Passengers should embark one hour before sailing.

第四聯　廣州 至 香港
Kwangchow → Hong Kong
E8102

HK$100
港幣壹佰元
現金代用券

廣東省港澳航運公司
KWANGTUNG PROVINCE H.K./MACÁU NAVIGATION CO.,
總代理：珠江船務有限公司
H.K. Agents: Chu Kong Shipping Co., Ltd.

廣州—香港客票 № 11173
KWANGCHOW/HONG KONG SERVICE TICKET

性別 男/女 証件號碼
Ticket Holder: _____ Sex: 男/女 Travel Document No. _____

1991年 8 月31日
16J

開航日期 Sailing Date: _____

開航時間 Sailing Time: P.M 2:00 座 號 Cabin No. _____

票價 FARE 兌換券FEC¥ : 83.00

另加收

堤圍防護費：港幣10元
堤圍防護費專用章

售票章：

注　意：1. 本票依照后列條件發出
IMPORTANT : (1) Issue subject to conditions overleaf.
　　　　　2. 旅客須在開航前一小時到達碼頭（廣州河南洲頭咀港澳碼頭）
　　　　　(2) Passengers should embark one hour before sailing.

YOSEMITE
NATIONAL PARK SERVICE
KEEP YOUR RECEIPT
VALID THRU DATE BELOW

ENTRANCE 5.00

CASH $5.00

#ENT 1

ADD1 5
9595 13:19 9/18/92

100 JAHRE SAALBURG

STUDENTENWERK FRANKFURT AM MAIN
-Anstalt des öffentlichen Rec

Eintrittskarte für einen
kostenlosen Besuch des
Römerkastells Saalburg

№ 1561 N

Deve ser obliterado no 1.° viagem.
Conserve este bilhete.
It must be validated on the first
journey and be retained for inspection.

Stagecoach PORTUGAL

ANVERS U- -O

2 1

RATP

3104C 3104

RATP SNCF

SECTION URBAINE

CHL. H

C2CL
00280195D

CHATELE U- UO

2

RATP

D 0108

CHL 65 01122

ND221 S 8010

SINGAPORE AIRLINES

Sydney SQ 192803

Bagcage checked subject to tariffs, including
limitations of Liability there-in contained.

This is not the Luggage ticket (baggage check)
described in Article 4 of the Warsaw Convention or
The Warsaw Convention as amended by The Hague
Protocol, 1955.

Sydney
192803

SYD

B - 180953 Ordnungsnummer: 1001

500

Deutsche Post AG Nicht übertragbar!

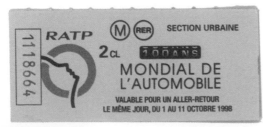

RATP M RER SECTION URBAINE

1118664

2CL 100ANS

MONDIAL DE
L'AUTOMOBILE

VALABLE POUR UN ALLER-RETOUR
LE MÊME JOUR, DU 1 AU 11 OCTOBRE 1998

Steak Steak

09019 09018

09060

PULLI U
12:39
512
.5179.11 - 2

JACKE S 8.70
11
2005
5432 N - 1

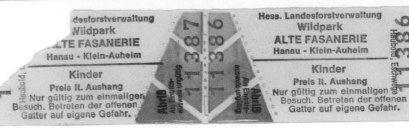

desforstverwaltung
Wildpark
ALTE FASANERIE
Hanau - Klein-Auheim

Kinder
Preis lt. Aushang
Nur gültig zum einmaligen
Besuch. Betreten der offenen
Gatter auf eigene Gefahr.

11387 11386

Hess. Landesforstverwaltung
Wildpark
ALTE FASANERIE
Hanau - Klein-Auheim

Kinder
Preis lt. Aushang
Nur gültig zum einmaligen
Besuch. Betreten der offenen
Gatter auf eigene Gefahr.

Ca__ Credit Memo

RESORT INNS LIMITED
AYURVEDA WALAUWA
WARAHENA - BENTOTA

MEDICINE Date: 13.12.2004

Name : MRS. KLARA KLETZKA

Waiter No: Room No: 5 103

Qty.	PARTICULARS	Rs	cts
	Ayurveda Medicine	1200	00
	1200/=		
	Nº 01152		
	Service Charge	—	
	G S T 12.5%	—	
	Total	1200	00

.................................
Guests

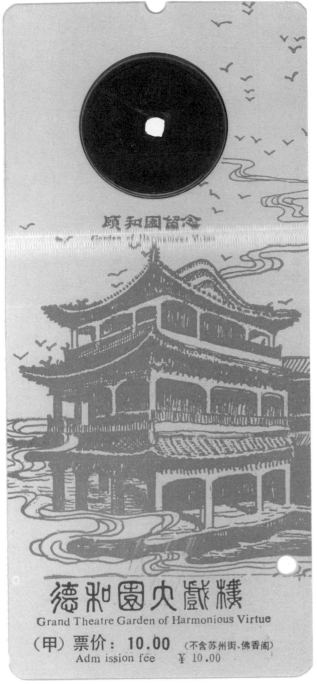

頤和園留念
Garden of Harmonious Virtue

德和園大戲樓
Grand Theatre Garden of Harmonious Virtue

（甲）票价：10.00 （不含苏州街、佛香阁）
Adm ission fee ￥ 10.00

GIFTUN IVLLAGE
BUS
Date : / / 19

رقم ٩.٢٣..

GIFTUN IVLLAGE
BUS
Date : / / 19

رقم ٧.٢٣..

JAZZ CLUB REDUT

Datum	- 6 -03- 2005	Číslo
Hodina/Cena	21*30 200,-	18

PRAHA 1, NÁRODNÍ TŘÍDA č. 20 — TEL. 224 933 48

JAZZ CLUB REDUT

Datum	- 6 -03- 2005	Číslo
Hodina/Cena	21*30 200,-	19

PRAHA 1, NÁRODNÍ TŘÍDA č. 20 — TEL. 224 933

JAZZ CLUB REDUT

Datum	- 6 -03- 2005	Číslo

message

Meliá Bali Sol
★★★★★ GL.

Nusa Dua, Bali, Indonesia. PO. Box 1048 Tuban
Tel. (0361) 71510 Tlx. 35237 Fax. 71360

Grupo Sol

Mr. / Mrs. / Miss _Jacke_

Date _11.12.91_ Time _7:00_ AM/PM

Room No. _107_

During your absence

Mr. / Mrs. / Miss _____

of _____

phone _____

☐ Telephone ☐ came to see you

☒ Please return the call

Message:

Mohn English School

AM/PM

Message Delivered Operator Receptionist

ΣΕΙΡΑ No 1

ΚΟΙΝΟΠΡΑΞΙΑ ΙΔΙΟΚΤΗΤΩΝ
ΤΟΥΡΙΣΤΙΚΩΝ ΣΚΑΦΩΝ
ΝΑΟΥΣΑΣ - ΠΑΡΟΥ

Α.Φ.Μ. 097385539 - Δ.Ο.Υ. ΠΑΡΟΥ
COOPERATION TOURIST OF NAOUSA

ΕΠΙΒΑΤΗΣ

№ 35481

26 ΣΕΠ. 2004

MONASTIRI

Ημερ/νία / Date _____

ΜΕΤ' ΕΠΙΣΤΡΟΦΗΣ	ΝΑΥΛΟΣ: 2,87
GO AND RETURN	Φ.Π.Α.: 0,18
	Ν.Α.Τ.: 0,19
	Λ.ΤΑΜΕΙΟ: 0,16
	ΕΚΟΕΜΝ: 0,10
	ΣΥΝΟΛΟ: €3,50

→

Date: _15/07/0_ **5910**

NOM: _M^me Bacquet_

L	Ma	Me	J	V	S	D
Service : Eco ○ Soigné ○ Hte Qualité ○						

PANTALON	
COSTUMETAILLEUR	
VESTE	
JUPE	
MANTEAUIMPER	
ROBE	
PULLCORSAGE	
CRAVATEFOULARD	
BLOUSON	
COUVERT.DUVET	
CHEMISECHEMISIER	

T3V / 2000 - Modèle réservé

RESERVES :
Coloris instable ○
Tache indélébile ○
Etiquetage Com- ○ Prix article si supérieur au
position insuffisant ○ barème de remboursement
Autres réserves ○

082713

**Großmarkt
Frankfurt am Main**

Parkschein P K W
von außen
gut lesbar
hinter die
Windschutzscheibe
legen

Preis € 1,50
einschl. 16% MwSt.
Ohne jede Haftung
der Marktbetriebe

HauboldESCHWEGE

Garderobenschein
Gilt nur für eine Person

4 R **0574** 322

AXA COLONIA

AXA Colonia Versicherung AG · Colonia-Allee 10–20, 51067 Köln

Der Umfang der Versicherung ist durch den Aushang
an der Garderobenannahme bestimmt.

Garderobenschein
Gilt nur für eine Person

4 R **0575** 321

AXA COLONIA

AXA Colonia Versicherung AG · Colonia-Allee 10–20, 51067 Köln

Der Umfang der Versicherung ist durch den Aushang
an der Garderobenannahme bestimmt.

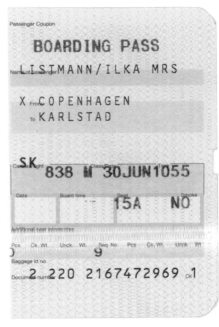

Passenger Coupon

BOARDING PASS

Name of passenger LISTMANN/ILKA MRS

X From COPENHAGEN

To KARLSTAD

S.K 838 M 30JUN1055

Gate | Board time | 15A | Smoke NO

Additional seat information

Pcs | Ck. Wt. | Unck. Wt. | Seq No | Pcs | Ck. Wt. | Unck. Wt.
9

Baggage ID Nr.

2 220 2167472969 1
Document number

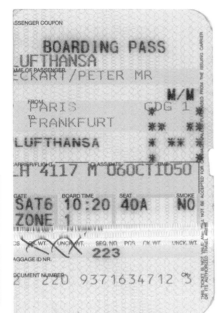

Passenger Coupon

BOARDING PASS

LUFTHANSA

Name of passenger ECKART/PETER MR

M/M

FROM PARIS CDG 1

TO FRANKFURT

LUFTHANSA

Carrier/Flight LH 4117 M 06OCT1050

GATE SAT6 BOARD TIME 10:20 SEAT 40A SMOKE NO
ZONE 1

Seq No Pos Ck. Wt. Unck. Wt.
223

Baggage ID Nr.

2 220 9371634712 3
Document Number

VILLE de LILLE

MUSÉE D'HISTOIRE NATURELLE

DROIT D'ENTRÉE

N° 061850 **ADULTE**

PRINCIPALE

VILLE de LILLE

MUSÉE D'HISTOIRE NATURELLE

DROIT D'ENTRÉE

N° 043359 **ADULTE**

PRINCIPALE

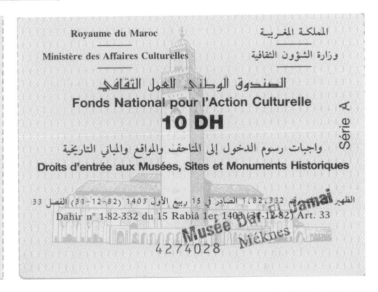

Royaume du Maroc المملكة المغربية

Ministère des Affaires Culturelles وزارة الشؤون الثقافية

الصندوق الوطني للعمل الثقافي

Fonds National pour l'Action Culturelle

10 DH 1999

واجبات رسوم الدخول إلى المتاحف والمواقع والمباني التاريخية

Droits d'entrée aux Musées, Sites et Monuments Historiques

الظهير الشريف رقم 1.82.332 الصادر في 15 ربيع الأول 1403 (31-12-82) الفصل 33

Dahir n° 1-82-332 du 15 Rabiâ 1er 1403 (31-12-82) Art. 33

4252669

Série A

Koubat Assoufara Méknes

Royaume du Maroc المملكة المغربية

Ministère des Affaires Culturelles وزارة الشؤون الثقافية

الصندوق الوطني للعمل الثقافي

Fonds National pour l'Action Culturelle

10 DH

واجبات رسوم الدخول إلى المتاحف والمواقع والمباني التاريخية

Droits d'entrée aux Musées, Sites et Monuments Historiques

الظهير الشريف رقم 1.82.332 الصادر في 15 ربيع الأول 1403 (31-12-82) الفصل 33

Dahir n° 1-82-332 du 15 Rabiâ 1er 1403 (31-12-82) Art. 33

4274028

Série A

Musée Dar El Jamai Méknes

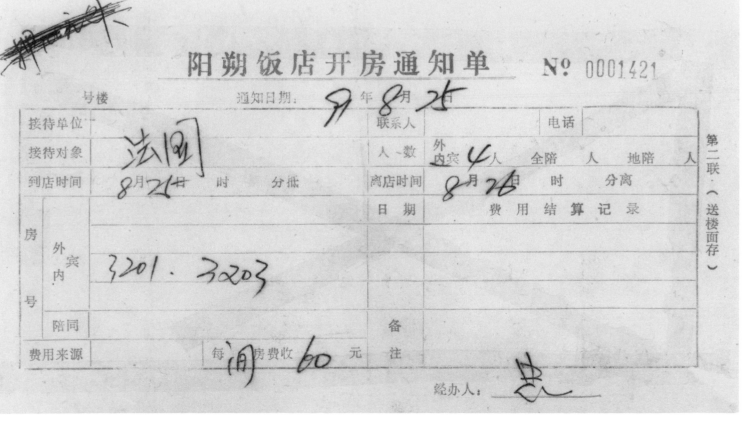

阳朔饭店开房通知单 N° 0001421

号楼 | 通知日期 91 年 8 月 25 日

接待单位		联系人		电话	
接待对象 法国		人数 外内宾 4 人	全陪 人	地陪 人	
到店时间 8月21日 时 分抵		离店时间 8月26日 时 分离			
房 外宾 内 号 3201·3203	日 期	费用结算记录			
陪同		备注			
费用来源	每(间)房费收 60 元	注 经办人			

第二联·（送楼面存）

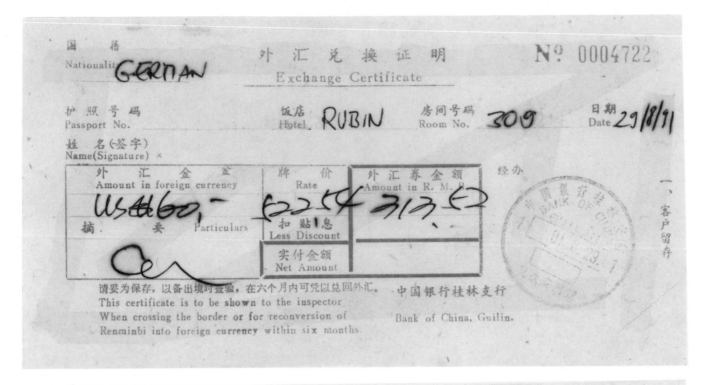

国籍 Nationality GERMAN 外汇兑换证明 Exchange Certificate №. 0004722

护照号码 Passport No.

饭店 Hotel RUBIN 房间号码 Room No. 309 日期 Date 29/8/91

姓名(签字) Name(Signature) ×

外汇金额 Amount in foreign currency	牌价 Rate	外汇券金额 Amount in R. M. B.	经办
US$460,-	522.54	213.52	
摘要 Particulars	扣贴息 Less Discount		
	实付金额 Net Amount		

请妥为保存,以备出境时查验,在六个月内可凭以兑回外汇。
This certificate is to be shown to the inspector
When crossing the border or for reconversion of
Renminbi into foreign currency within six months.

中国银行桂林支行
Bank of China, Guilin.

一、客户留存

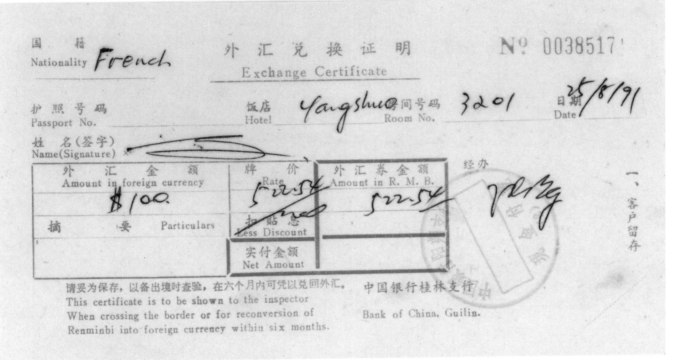

国籍 Nationality French 外汇兑换证明 Exchange Certificate №. 0038517

护照号码 Passport No.

饭店 Hotel Yangshuo 房间号码 Room No. 3201 日期 Date 25/8/91

姓名(签字) Name(Signature) ×

外汇金额 Amount in foreign currency	牌价 Rate	外汇券金额 Amount in R. M. B.	经办
$100	522.54	522.54	
摘要 Particulars	扣贴息 Less Discount		
	实付金额 Net Amount		

请妥为保存,以备出境时查验,在六个月内可凭以兑回外汇。
This certificate is to be shown to the inspector
When crossing the border or for reconversion of
Renminbi into foreign currency within six months.

中国银行桂林支行
Bank of China, Guilin.

一、客户留存

Royaume du Maroc المملكة المغربية
Ministère des Affaires Culturelles وزارة الشؤون الثقافية

الصندوق الوطني للعمل الثقافي
Fonds National pour l'Action Culturelle
10 DH
واجبات رسوم الدخول إلى المتاحف والمواقع والمباني التاريخية
Droits d'entrée aux Musées, Sites et Monuments Historiques

Série A

الظهير الشريف رقم 1.82.332 الصادر في 15 ربيع الأول 1403 (31-12-82) الفصل 33
Dahir n° 1-82-332 du 15 Rabiâ 1er 1403 (31-12-82) Art. 33

4252668

Royaume du Maroc المملكة المغربية
Ministère des Affaires Culturelles وزارة الشؤون الثقافية

الصندوق الوطني للعمل الثقافي
Fonds National pour l'Action Culturelle
10 DH
واجبات رسوم الدخول إلى المتاحف والمواقع والمباني التاريخية
Droits d'entrée aux Musées, Sites et Monuments Historiques

Série A

الظهير الشريف رقم 1.82.332 الصادر في 15 ربيع الأول 1403 (31-12-82) الفصل 33
Dahir n° 1-82-332 du 15 Rabiâ 1er 1403 (31-12-82) Art. 33

4278318

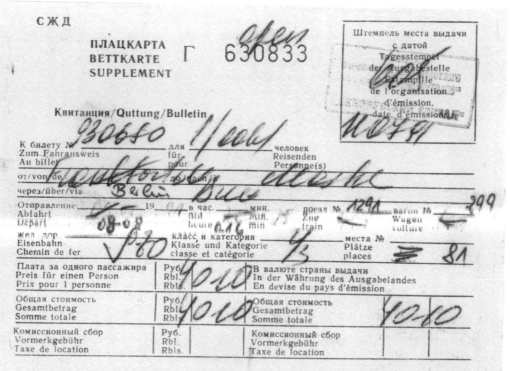

СЖД

ПЛАЦКАРТА
BETTKARTE Г *ofen* 630833
SUPPLEMENT

Штемпель места выдачи
с датой
Tagesstempel
der Ausgabestelle
Estampille
de l'organisation
d'émission,
date d'émission

Квитанция/Quittung/Bulletin

К билету № *930680* *1/eall* человек
Zum Fahrausweis für Reisenden
Au billet pour Personne(s)

от/von/de *Frankforts* по/nach/à *Maske*
через/über/via *Berlin Bus*

Отправление ___ 19 *94* в час. ___ мин. ___ поезд № *1291* ваген № ___ *299*
Abfahrt *08-08* heure *0.76* min Zug train Wagen voiture
Départ

жел. дор. *80* класс и категория *4/3* места № *81*
Eisenbahn Klasse und Kategorie Plätze places
Chemin de fer classe et catégorie

Плата за одного пассажира Preis für einen Person Prix pour 1 personne	Руб. Rbl. Rbls.	*40.10*	В валюте страны выдачи In der Währung des Ausgabelandes En devise du pays d'émission	
Общая стоимость Gesamtbetrag Somme totale	Руб. Rbl. Rbls.	*40.10*	Общая стоимость Gesamtbetrag Somme totale	*40-10*
Комиссионный сбор Vormerkgebühr Taxe de location	Руб. Rbl. Rbls.		Комиссионный сбор Vormerkgebühr Taxe de location	

T.C. KÜLTÜR VE TURİZM BAKANLIĞI

FİYATI: 10.000.000. TL.
(Fiyata KDV ve Kurum Payları Dahildir)

Ziyaret Süresince saklanacak • Be kept during the visit

BERGAMA MÜZESİ
GİRİŞ BİLETİ № 040349

REPTILIENZOO № 62257

Eintrittskarte
Erwachsene

Gilt nur für einmaligen Eintritt.
Eltern haften für ihre Kinder.

SCHEIDEGG

Hess. Landesforstverwaltung
Wildpark
ALTE FASANERIE
Hanau - Klein-Auheim
Kinder
Preis lt. Aushang
gültig zum einmaligen
ch. Betreten der offenen
auf eigene Gefahr.

Hess. Landesforstverwaltung
Wildpark
ALTE FASANERIE
Hanau - Klein-Auheim
Kinder
Preis lt. Aushang
Nur gültig zum einmaligen
Besuch. Betreten der offenen
Gatter auf eigene Gefahr.

22146 22145 22145 Abriß

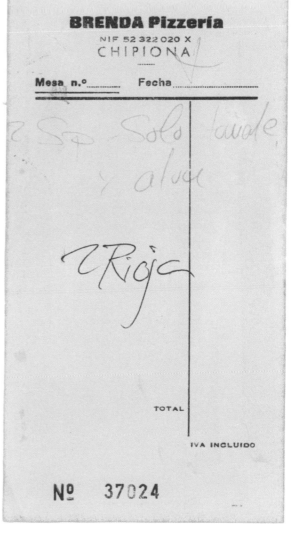

BRENDA Pizzería
NIF 52 322 020 X
CHIPIONA

Mesa n.º _____ Fecha _____

8 Sp. Solo tavole
y aloe

Rioja

TOTAL

IVA INCLUIDO

№ 37024

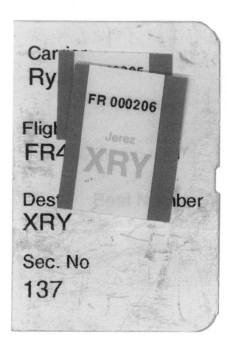

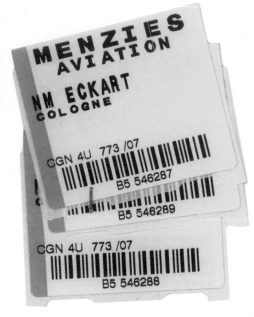

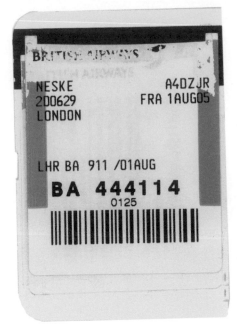

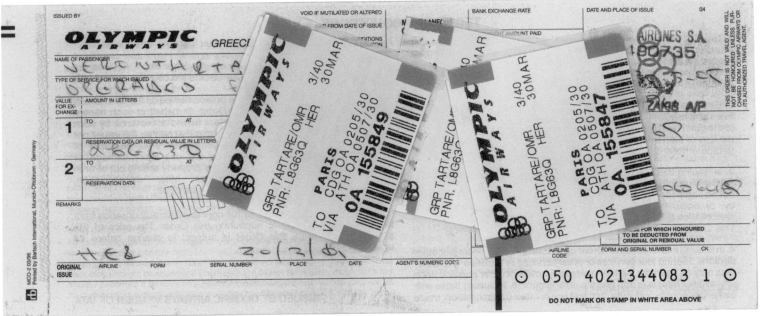

076819 Beckerbillett Hamburg (042)

Aufbewahren und auf Verlangen vorzeigen. Nur für die gelöste Vorstellung gültig.

20:30 ACHTUNG !! im BERGER
07.05 Die Geschichte der Qiuju DF
 39 PARKETT 12.00 DM

VILLE de LILLE

MUSEE D'HISTOIRE NATURELLE

DROIT D'ENTREE

№ 043358 ADULTE

TFS TENERIFFA ✈AERO LLOYD | AEF 01 79 02 Flight

Bitte unterschreiben und an Ihr
Finanzamt weiterleiten!

UB MEDIA Verlag
Tel. 0 60 85 / - 01 · Bes.-Nr. 70-23
Post-it™ Haft-Notizen

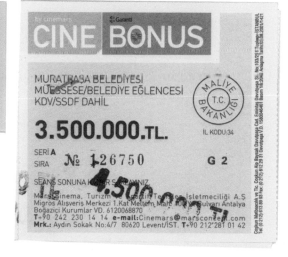

CINE BONUS Garanti

MURATPAŞA BELEDİYESİ
MÜESSESE/BELEDİYE EĞLENCESİ
KDV/SSDF DAHİL MALİYE
 T.C.
 BAKANLIĞI
3.500.000.TL. İL KODU:34

SERİ A SIRA № 126750 G 2

SEANS SONUNA KADAR SAKLAYINIZ

Marss Sinema, Turizm ve Tic. Eğitim Teseri İşletmeciliği A.Ş
Migros Alışveriş Merkezi 1.Kat Meltem Mah. 304 Y.Bulvarı Antalya
Boğaziçi Kurumlar VD. 6120068870
T+90 242 230 14 14 e-mail:Cinemars@marsconcept.com
Mrk.: Aydın Sokak No:4/7 80620 Levent/İST. T+90 212'281 01 42

KVS VRM
Einzelfahrschein

gültig 05.05.05 15:07

von 101 Koblenz-City
nach 106 KO-Arenberg
über 000 ohne Umweg

Preisstufe 2 € 1,95
Linie 008 H 16255 003 BAR

Gute Fahrt!

KVS VRM
Einzelfahrschein

gültig 05.05.05 15:07

von 101 Koblenz-City
nach 106 KO-Arenberg
über 000 ohne Umweg

Preisstufe 2 € 1,95
Linie 008 H 16255 004 BAR

Nachschlagewerke dtv 5981

Reihe

dtv Lexikon
in Kassette

Autor · Titel

3-423-05981-8	1
ISBN	Aufl.
Deutscher Taschenbuch Verlag 8 München 40 · Postfach 400 422	11377
Verlag	Verkehrs-Nr.

komplett 120,— DM
Einzelband 5,80 DM

Preis: DM

TASCHENBUCH-
LAUFKARTE

Ergänzen
Mindestlager
Fortsetzung
Erhöht um

dtv

SK 322312

SAS
SCANDINAVIAN AIRLINES

To CPH
Airline Flight
SK 1592
Via

Airline Flight

Via

Airline Flight

Via

Airline Flight

HOTEL GUTENBERG **

31, rue des Serruriers - F 67000 STRASBOURG

Téléphone 88.32.17.15

Fax 88 75 76 67

R.C. Strasbourg 58 B 348
C.C.P. Strasbourg 1273 98 L
S.A. au Capital de 300.000 F

M. TARTARE / Backe 2 Pers. Appart. N° 23

Date	N°	Code	Montants
	* 2	****	0.23
	* 1	**	165.00
	* 2	***	54.00
	* 2	***	15.40
	CH B	**	234.40 T
29 FEV 2 9430	*	**	234.40 PB

1	Appartement
2	Petit Déjeuner
3	Bar
4	Téléphone
5 à 7	Divers

Avez-vous déposé
votre clé?

Have you left
your key?

↑ Bitte hier entwerten ↑
Please validate your ticket

2345 Fr 39 Stadt
Mi.u.0

Kurzstrecke
Regeltarif

Nachdruck verboten

Berlin
BO 1,20 EUR
240904 2331 06350

Gemeinsamer Tarif der im Verkehrsverbund Berlin-Brandenburg
zusammenwirkenden Verkehrsunternehmen (VBB-Tarif).
Gültig nach den geltenden Beförderungsbedingungen.
BVG · Potsdamer Straße 188 · 10783 Berlin · Tel. 2560.

L101103
(0112009)

13566 1452 BVG

Royaume du Maroc المملكة المغربية

Ministère des Affaires Culturelles وزارة الشؤون الثقافية

الصندوق الوطني للعمل الثقافي

Fonds National pour l'Action Culturelle

10 DH

واجبات رسوم الدخول إلى المتاحف والمواقع والمباني التاريخية

Droits d'entrée aux Musées, Sites et Monuments Historiques

الظهير الشريف رقم 1-82-332 الصادر في 15 ربيع الأول 1403 (31-12-82) الفصل 33

Dahir n° 1-82-332 du 15 Rabiâ 1er 1403 (31-12-82) Art. 33

Série A

01 MAI 1999

4278317

164

hilton international · malta

DRY CLEANING LIST

DIAL 5 FOR IMMEDIATE PICK-UP SERVICE

Name Room No.

Date To be returned on

Special Instructions ...

Notice: Please list the quantity of each article in left-hand column.

Unless itemized list is sent, our count must be accepted.

FOR LAUNDRY PLEASE TURN OVER

MARK				TOTAL CHARGE: £M		

CLEAN & PRESS	£M	c	OFFICE USE	GENTLEMEN	PRESS ONLY	£M	c
	£M2	20		3 Piece Suit		£M1	00
	£M2	00		Suites		£M0	90
	£M1	00		Jackets		£M0	50
	£M0	90		Trousers		£M0	50
	£M2	10		Tuxedo		£M0	90
	£M2	00		Rain coats		£M0	90
	£M2	00		Overcoats		£M0	90
	£M0	50		Scarves		£M0	20
	£M0	50		Ties		£M0	20
	£M0	80		Pullovers & Cards		£M0	40
	£M0	95		Shirts (Silk or Wool)		£M0	45
	£M0	70		Shorts		£M0	35
				LADIES			
	£M1	80		Suits		£M0	90
	£M0	90		Jackets		£M0	55
	£M0	80		Skirts		£M0	50
	£M1	80		Skirts (Pleated)		£M0	90
	£M1	50		Dresses		£M0	75
	£M3	00		Dresses (Evening)		£M1	55
	£M2	60		Dresses (Cocktail)		£M1	40
	£M0	80		Blouses		£M0	40
	£M0	80		Jumpers — Cards		£M0	40
	£M0	90		Slacks		£M0	60
	£M2	00		Raincoats & Coats		£M1	00
	£M0	45		Scarves		£M0	25
	£M0	50		Gloves		£M0	25
	£M1	50		Robes		£M0	75
	£M0	70		Shorts		£M0	35
				CHILDREN			
	£M1	00		Suits		£M0	50
	£M0	70		Jackets		£M0	35
	£M0	60		Trousers		£M0	30
	£M0	70		Dresses		£M0	35
	£M0	60		Skirts		£M0	30
	£M0	50		Blouses		£M0	25
	£M0	50		Cards & Jumpers		£M0	25
	£M0	75		Coats		£M0	40

NOTICE: Normal Service.
 Orders received after 10.00 a.m. will be returned the following day.
 There are no Dry Cleaning Services on Sundays and Public Holidays.

 Express Service.
 Orders received before 9.00 a.m. will be returned the same day at no extra charge.
 Orders received between 9.00 a.m. and 10.00 a.m. will have a 50% additional charge to the listed price.

NOTE: An additional charge of £M0.10 will be levied for clothing inspection and minor repairs.

NOTICE: In case of damage or loss, the hotel will be responsible only for a maximum

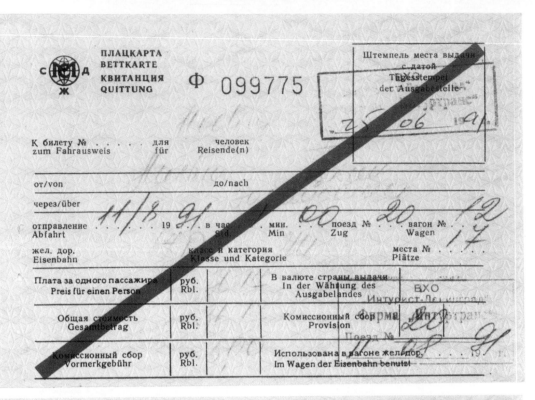

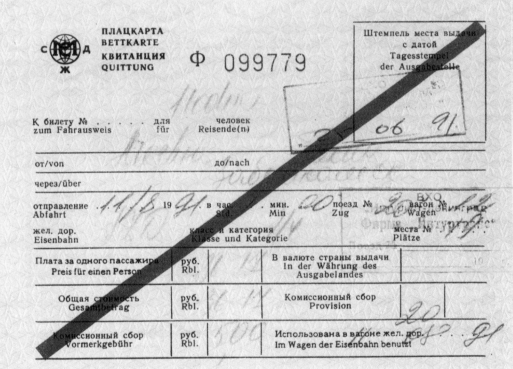

การรถไฟแห่งประเทศไทย
STATE RAILWAY OF THAILAND
ตั๋วโดยสารรถไฟ

A3591 – 74813

P9

			ต้นทาง / ORIGIN	ปลายทาง / DESTINATION
RAPID			BANGKOK	HUA HIN

ขบวน TRAIN	วันเดินทาง DEPARTURE DATE	เวลารถออก DEP. TIME	เวลาถึง ARR.TIME	ชั้น – ประเภทตู้ CLASS – COACH TYPE	คันที่ – เลขที่นั่ง CAR – SEAT NO.		ราคาตั๋ว PRICE
171	15NOV05	13:00	16:59	2 ASC40	15	16	212

ADULT
01-01

2023-307-00177-02/02 328102 BKK 15 NOV 05 10:53

✳ โปรดตรวจสอบรายการในตั๋วให้ถูกต้อง หากผิดพลาดให้แจ้งผู้ออกตั๋วทันที

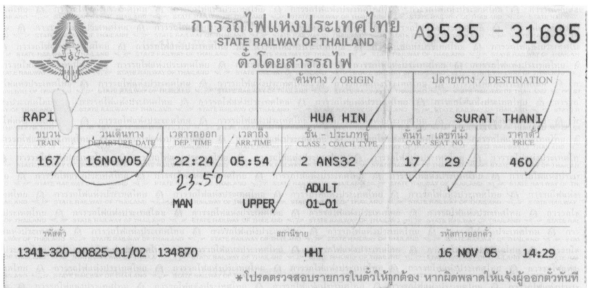

การรถไฟแห่งประเทศไทย
STATE RAILWAY OF THAILAND
ตั๋วโดยสารรถไฟ

A3535 – 31685

			ต้นทาง / ORIGIN	ปลายทาง / DESTINATION
RAPI			HUA HIN	SURAT THANI

ขบวน TRAIN	วันเดินทาง DEPARTURE DATE	เวลารถออก DEP. TIME	เวลาถึง ARR.TIME	ชั้น – ประเภทตู้ CLASS – COACH TYPE	คันที่ – เลขที่นั่ง CAR – SEAT NO.		ราคาตั๋ว PRICE
167	16NOV05	22:24	05:54	2 ANS32	17	29	460

23.50

MAN UPPER ADULT
 01-01

รหัสตั๋ว	สถานีขาย	รหัสการออกตั๋ว
1341-320-00825-01/02 134870	HHI	16 NOV 05 14:29

✳ โปรดตรวจสอบรายการในตั๋วให้ถูกต้อง หากผิดพลาดให้แจ้งผู้ออกตั๋วทันที

LC944782075US

United States Postal Service
Customs Declaration
May be opened officially

CN 22
See Instructions on Reverse
Do not duplicate without USPS approval.

Cut ☐ Gift ☐ Commercial sample Cut
☐ Documents ☑ Other

Quantity and detailed description of contents (1)	Weight (2) lb. oz.	Value (3) (US $)
BOOK		20 –

For commercial items only if known, HS tariff number (4) and country of origin of goods (5)	Total Weight (6)	Total Value (7) (US $)

I, the undersigned, whose name and address are given on the item, certify that the particulars given in this declaration are correct and that this item does not contain any dangerous article or articles prohibited by legislation or by postal or customs regulations.
Date and sender's signature (8)

PS Form **2976**, January 2004

ISCH3000045 16:46:27
CONVALIDA

UNICO ISCHIA

ORARIO
90 NOVANIA MINUTI

◻ REGIONE CAMPANIA
ASSESSORATO AI TRASPORTI € 1,20

SERIE B № 1430274

595
270

Preis

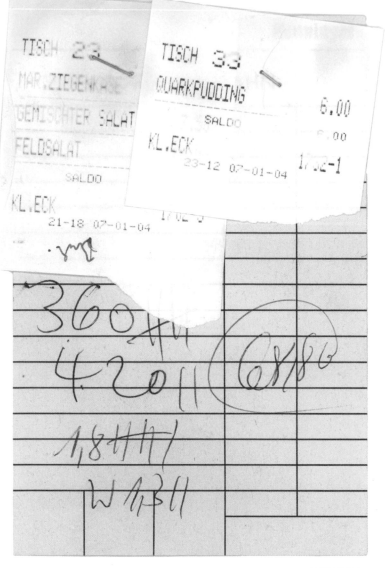

TISCH 23
MAR.ZIEGENKÄSE
GEMISCHTER SALAT
FELDSALAT
SALDO
KL.ECK
21-18 07-01-04

TISCH 33
QUARKPUDDING 6.00
SALDO 6.00
KL.ECK 1.02-1
23-12 07-01-04

360
4.20
6.86
1,84
W

TRANSCHEL
CITY-REINIGUNG
Hospitalstrasse 2
63450 Hanau
Telefon: 06181-24501

Rechnung

NK/KUNDE: #143

17 x 1,25 EU
HEMD 21,25 EU

Saldo 21,25 EU
MWST 2,93 EU
12:10 05.08.2005 6202

Saldo 21,25 EU
MWST 2,93 EU
EURO 21,25 EU
DM 41,56 DM
Bar 21,30 EU
Zurück 0,05 EU
16:57 17.08.2005 10

Es Bediente Sie Frau Stumkat
Vielen Dank!
Beehren Sie uns bald wieder

NK/KUNDE: #407
REINIGUNG DIVERS ** 3,50
12:03 08.03.2005 Frau Kraus
28309-5/12

PULLI V 4.90
10:50 (1)
2954 2-12-2003
2954 K - 1

NK/KUNDE: #407
REINIGUNG DIVERS ** 3,50
12:03 08.03.2005 Frau Kraus
28309-10/12

KLEIDERKUR
BERGERSTRAßE 53
TELEFON:433231

WÄSCHE 0.00
TEILE 1
NACHKASS0.00
11:30 BED.M
M 5-03-2004
2232 M 1

PULLI V 4.90
10:49 (, 7)
2952 2-12-2003
2952 K - 5

NK/KUNDE: #407
REINIGUNG DIVERS ** 3,50
12:03 08.03.2005 Frau Kraus
28309-7/12

NK/KUNDE: #407
REINIGUNG DIVERS ** 3,50
12:03 08.03.2005 Frau Kraus
28309-4/12

NK/KUNDE: #407
REINIGUNG DIVERS ** 3,50
12:03 08.03.2005 Frau Kraus
28309-9/12

JACKE V 7.90
18:53 (2)
7904 14-07-2004
7904 M - 1

NK/KUNDE: #407 Baco
REINIGUNG DIVERS * * 3,50
12:03 08.03.2005 Frau Kraus
28309-6/12

Steak 09601

00235 STUDENTENWERK
Frankfurt / Main
Essenbon
DM 3,—
siehe auch Rückseite
00235

Ville du Cateau - Cambrésis
MUSÉE HENRI MATISSE

Entrée plein tarif A

N° 13109

A présenter à
toutes réquisitions

KSTATT KINO
l seh'n e.V.
ychtstraße 6 Hhs.
intrittskarte
laut Aushang
Lösungslos völlig
vorzeigen!
06744

08
ensburg
BAYERISCHE VERWALTUNG
DER STAATL. SCHLÖSSER, GÄRTEN UND SEEN
LINDERHOF
ittskarte
n bitte vorzeigen
DM 2.50
GROTTE KIOSK 79
80908

Ville du Cateau - Cambrésis
MUSÉE HENRI MATISSE

Entrée plein tarif A

N° 13108

A présenter à
toutes réquisitions

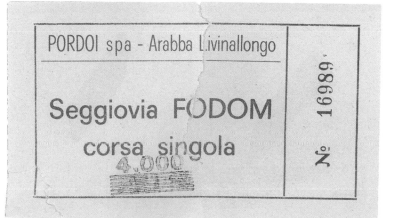

PORDOI spa - Arabba Livinallongo

Seggiovia FODOM

corsa singola

4.000

N° 16989

Hochschule für Gestaltung
Offenbach am Main

Studenten-Ausweis Nr.

Der Inhaber dieses Ausweises gehört der Hochschule
an. Alle Behörden und Dienststellen werden gebeten,
ihm Rat und Hilfe zu gewähren. Nur gültig für die
umseitig abgestempelten Semester.

Beim Abgang von der Hochschule ist der Ausweis dem Sekretariat
zurückzugeben.

Der Polizeipräsident in Berlin ▥ Berlin

Sehr geehrte Verkehrsteilnehmerin! Sehr geehrter Verkehrsteilnehmer!

Im Rahmen der polizeilichen Verkehrsüberwachung wurde eine Verkehrsordnungs-
widrigkeit festgestellt, die dem Führer bzw. Halter des Fahrzeuges mit dem Kennzei-
chen

vorzuwerfen ist. Diese Mitteilung ist nur ein erster Hinweis.

Die weitere Bearbeitung erfolgt unter Einsatz der automatischen Datenverarbeitung
beim Landespolizeiverwaltungsamt, Referat Verkehrsordnungswidrigkeiten und
Bußgeldeinziehung.

Sie (ggf. der Halter) werden von dort in Kürze einen Bescheid mit Einzelheiten zum
Tatvorwurf erhalten. Sie haben dann Gelegenheit, sich zu dem Sachverhalt zu
äußern.

Datum	Uhrzeit
31.8.13	14.35

Wichtiger Hinweis:

Mit dem o. a. Bescheid wird Ihnen ein Aktenzeichen mitgeteilt. Ohne Nennung dieses
Aktenzeichens ist die Bearbeitung von Rücksprachen, telefonischen Anfragen,
schriftlichen Äußerungen und Zahlungen nicht möglich. Bitte warten Sie daher den
Eingang des Bescheides ab. Rechtliche Nachteile entstehen Ihnen dadurch nicht.

**Ihre Polizei bittet Sie um mehr Aufmerksamkeit und zu beden-
ken, dass die Sicherheit aller Verkehrsteilnehmer vom richtigen
Verhalten jedes einzelnen abhängt. Auch Sie können nur gefahr-
los am immer dichter werdenden Straßenverkehr teilnehmen,
wenn jeder die Verkehrsvorschriften beachtet.**

Pol 801 MDE BOWI-Hinweiszettel (6.00)

AVIACO

Nº CONTROL / Boarding nº	VUELO / Flight
	DE 5603
	DUS

Autocares
VILLALONGA
C. I. F. B 07727332
Linea: Palma - P. Pollença

Nº 011084

Pollença - Pto. Pollença o vice.

Precio incluido el I. V. A. y S. O. V. 85 ptas.

Fecha

Conserve el billete a petición de cualquier empleado

Autocares
VILLALONGA
C. I. F. B 07727332
Linea: Palma - P. Pollença

Nº 011083

Pollença - Pto. Pollença o vice.

Precio incluido el I. V. A. y S. O. V. 85 ptas.

Fecha

Conserve el billete a petición de cualquier empleado

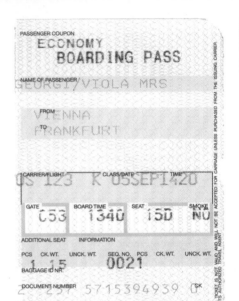

PASSENGER COUPON

ECONOMY
BOARDING PASS

NAME OF PASSENGER
GEORGI/VIOLA MRS

FROM
VIENNA
TO
FRANKFURT

CARRIER/FLIGHT	CLASS/DATE	TIME
OS 123 K	05SEP	1420

GATE	BOARD TIME	SEAT	SMOKE
C53	1340	15D	NO

ADDITIONAL SEAT INFORMATION

PCS	CK.WT.	UNCK. WT.	SEQ. NO.	PCS	CK.WT.	UNCK. WT.
1	15		0021			

BAGGAGE ID NR.

DOCUMENT NUMBER 2 257 5715394939 CK

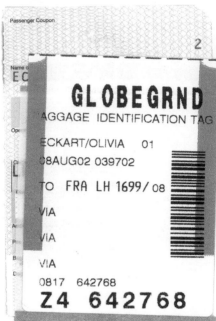

Passenger Coupon

2

Name o
EC

Op

GLOBEGRND
BAGGAGE IDENTIFICATION TAG
ECKART/OLIVIA 01
08AUG02 039702
TO FRA LH 1699 / 08
VIA
VIA
VIA
0817 642768
Z4 642768

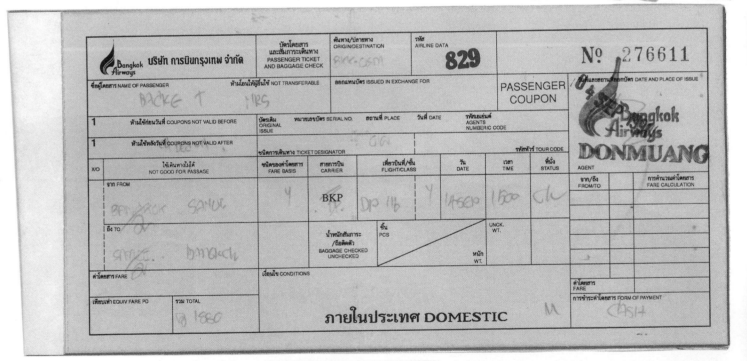

	บริษัท การบินกรุงเทพ จำกัด Bangkok Airways	บัตรโดยสาร และสัมภาระการเดินทาง PASSENGER TICKET AND BAGGAGE CHECK	ต้นทาง/ปลายทาง ORIGIN/DESTINATION BKK-USM	รหัส AIRLINE DATA 829		Nº 276611
ชื่อผู้โดยสาร NAME OF PASSENGER BACKE T MRS		ห้ามโอนให้ผู้อื่นใช้ NOT TRANSFERABLE	ออกแทนบัตร ISSUED IN EXCHANGE FOR		PASSENGER COUPON	ชื่อที่และสถานที่ออกบัตร DATE AND PLACE OF ISSUE 04 SEP Bangkok Airways DONMUANG

1	ห้ามใช้ก่อนวันที่ COUPONS NOT VALID BEFORE	บัตรเดิม ORIGINAL ISSUE	หมายเลขบัตร SERIAL NO.	สถานที่ PLACE	วันที่ DATE	รหัสเอเย่นต์ AGENTS NUMBERIC CODE	
1	ห้ามใช้หลังวันที่ COUPONS NOT VALID AFTER					รหัสทัวร์ TOUR CODE	AGENT

X/O	ใช้เดินทางไม่ได้ NOT GOOD FOR PASSAGE	ชนิดของค่าโดยสาร FARE BASIS	สายการบิน CARRIER	เที่ยวบินที่/ชั้น FLIGHT/CLASS	วัน DATE	เวลา TIME	ที่นั่ง STATUS		จาก/ถึง FROM/TO	การคำนวณค่าโดยสาร FARE CALCULATION
จาก FROM BANGKOK SAMUE		Y	BKP	DP 116 Y	14SEP	1500	CK			
ถึง TO SAMUI BANGKOK		น้ำหนักสัมภาระ /ยึดติดตัว BAGGAGE CHECKED UNCHECKED	PCS			UNCK. WT. หนัก WT.				

| ค่าโดยสาร FARE | | เงื่อนไข CONDITIONS | | | | | | | ค่าโดยสาร FARE | |
| เทียบเท่า EQUIV FARE PD | รวม TOTAL B 1880 | **ภายในประเทศ DOMESTIC** | | | | | M | | การชำระค่าโดยสาร FORM OF PAYMENT CASH | |

200

Elbestr. 31
6000...

*Ausgabe gegen diesen Schein
Bitte der Bedienung geben*

Inteiro Ida
Inicio de viagem até 18:09

SINTRA
LISB.ROSSIO

3 Zonas Esc. 210$00
IVA 5% Cont. nr. 500498601
61101 00102 326866 3012011609
CONSERVE ATÉ SAIR DA ESTAÇÃO

Inteiro Ida
Inicio de viagem até 13:05

LISBOA ROSSIO
SINTRA

3 Zonas Esc. 210$00
IVA 5% Cont. nr. 500498601
59006 01801 545915 3012011105
CONSERVE ATÉ SAIR DA ESTAÇÃO

NK/KUNDE: #210 Backe
WASCHE 2,00
15:36 07.03.2005 Frau Transchel
28250-2/6

NK/KUNDE: #407 Backe
REINIGUNG DIVERS * * 3,00
12:03 08.03.2005 Frau Kraus
28309-12/12

NK/KUNDE: #407 Backe
REINIGUNG DIVERS * * 3,50
12:03 08.03.2005 Frau Kraus
28309-11/12

NK/KUNDE: #407 Backe
REINIGUNG DIVERS * * .3,50
12:03 08.03.2005 Frau Kraus
28309-1/12

NK/KUNDE: #407 Backe
REINIGUNG DIVERS * * 3,50
12:03 08.03.2005 Frau Kraus
28309-3/12

NK/KUNDE: #407 Backe
REINIGUNG DIVERS * * 3,50
12:03 08.03.2005 Frau Kraus
28309-8/12

HOSE 11,70 EU
2 x 5,50 EU
BAUMWOLLHOSE * * 11,00 EU

Saldo 22,70 EU
MWST 3,13 EU
 EURO 22,70 EU
 DM 44,40 DM
Bar 22,70 EU 20948
12:15 04.11.2004

Es Bediente Sie Frau Transchel
Vielen Dank!

PULLI V 4.90
10:49 (7)
2952 2-12-2003
2952 K - 6

Köln Messe

ART COLOGNE 1999

PRESSE
TAGESKARTE **T**

Gültig nur am 06.11.99

Name: Matthias Dietz

Redaktion:
Editorship: Lichtbericht

BNP Banque Nationale de Paris
 B.P.F.
Payez contre ce chèque non endossable sauf au profit d'un établissement bancaire ou assimilé :

A

PAYABLE siège n° compte n° clé R.I.B. A
85, RUE NATIONALE 50515 09299929 51 le
59800 LILLE MLLE TANJA BACKE
 26 PLACE SEBASTOPOL
téléphone 59000 LILLE
compensable a 20 42 74 74
LILLE
chèque n° 6 342 290

⑈6342290⑈0590100040068⑈0515509299191⑈

Einzelfahrausweis
Regeltarif

Berlin AB
B1 **2,00 EUR**
200604 1448 06321

Gemeinsamer Tarif der im Verkehrsverbund Berlin-Brandenburg
zusammenwirkenden Verkehrsunternehmen (VBB-Tarif).
Gültig nach den geltenden Beförderungsbedingungen.
BVG · Potsdamer Straße 188 · 10783 Berlin · Tel. 25 60.
L 101103 (01/2003)

11333 0810 BVG

Kurzstrecke
Regeltarif

Berlin
B0 **1,20 EUR**
040604 0854 06323

Gemeinsamer Tarif der im Verkehrsverbund Berlin-Brandenburg
zusammenwirkenden Verkehrsunternehmen (VBB-Tarif).
Gültig nach den geltenden Beförderungsbedingungen.
BVG · Potsdamer Straße 188 · 10783 Berlin · Tel. 25 60.
L 101103 (01/2003)

10858 2099 BVG

11977907 BVG

Kurzstrecke
Ermaessigungstarif
Berlin BOE 1.00 EUR
25.06.04 18:25
05302 B

Gemeinsamer Tarif der im Verkehrsverbund Berlin-Brandenburg zusammenwirkenden
Verkehrsunternehmen (VBB-Tarif). Gültig nach den geltenden Beförderungsbedingungen.
BVG · Potsdamer Straße 188 · 10783 Berlin · Tel. 25 60.
Zum sofortigen Fahrtantritt.
L 102003 (01/2003)

09726335 BVG

Kurzstrecke
Regeltarif

Berlin
B0 **1,20 EUR**
210604 1506 0206340

Gemeinsamer Tarif der im Verkehrsverbund Berlin-Brandenburg
zusammenwirkenden Verkehrsunternehmen (VBB-Tarif).
Gültig nach den geltenden Beförderungsbedingungen.
BVG · Potsdamer Straße 188 · 10783 Berlin · Tel. 25 60.
L 101103 (01/2003)

11110 2096 BVG

05224A Mi 21-2340
Kurzstrecke
Regeltarif

Berlin
B0 **1,20 EUR**
170504 0845 06323

Gemeinsamer Tarif der im Verkehrsverbund Berlin-Brandenburg
zusammenwirkenden Verkehrsunternehmen (VBB-Tarif).
Gültig nach den geltenden Beförderungsbedingungen.
BVG · Potsdamer Straße 188 · 10783 Berlin · Tel. 25 60.
L 101103 (01/2003)

10858 2479 BVG

Kurzstrecke
Regeltarif
Berlin B0 1.20 EUR
20.09.04 12:23
00117 A

Gemeinsamer Tarif der im Verkehrsverbund Berlin-Brandenburg zusammenwirkenden
Verkehrsunternehmen (VBB-Tarif). Gültig nach den geltenden Beförderungsbedingungen.
BVG · Potsdamer Straße 188 · 10783 Berlin · Tel. 25 60.
Zum sofortigen Fahrtantritt.
L 102003 (01/2004)

11915528 BVG

Kurzstrecke
Regeltarif
Berlin B0 1.20 EUR
20.09.04 13:14
05333 A

Gemeinsamer Tarif der im Verkehrsverbund Berlin-Brandenburg zusammenwirkenden
Verkehrsunternehmen (VBB-Tarif). Gültig nach den geltenden Beförderungsbedingungen.
BVG · Potsdamer Straße 188 · 10783 Berlin · Tel. 25 60.
Zum sofortigen Fahrtantritt.
L 102003 (01/2004)

10564305 BVG

Kurzstrecke
Regeltarif
Berlin B0 1.20 EUR
20.09.04 13:14
05333 A

Gemeinsamer Tarif der im Verkehrsverbund Berlin-Brandenburg zusammenwirkenden
Verkehrsunternehmen (VBB-Tarif). Gültig nach den geltenden Beförderungsbedingungen.
BVG · Potsdamer Straße 188 · 10783 Berlin · Tel. 25 60.
Zum sofortigen Fahrtantritt.
L 102003 (01/2004)

10564304 BVG

Einzelfahrausweis
Regeltarif
Berlin AB B1 2.00 EUR
23.09.04 09:48
01305 B

Gemeinsamer Tarif der im Verkehrsverbund Berlin-Brandenburg zusammenwirkenden
Verkehrsunternehmen (VBB-Tarif). Gültig nach den geltenden Beförderungsbedingungen.
BVG · Potsdamer Straße 188 · 10783 Berlin · Tel. 25 60.
Zum sofortigen Fahrtantritt.
L 102003 (01/2003)

09630775 BVG

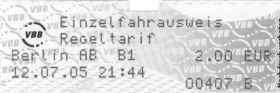

Einzelfahrausweis
Regeltarif
Berlin AB B1 2.00 EUR
12.07.05 21:44
00407 B

Gemeinsamer Tarif der im Verkehrsverbund Berlin-Brandenburg zusammenwirkenden
Verkehrsunternehmen (VBB-Tarif). Gültig nach den geltenden Beförderungsbedingungen.
BVG · Potsdamer Straße 188 · 10783 Berlin · Tel. 25 60.
Zum sofortigen Fahrtantritt.
L 102003 (02/2004)

18551543 BVG

Kurzstrecke
Regeltarif
Berlin B0 1.20 EUR
20.09.04 10:00
05206 B

Gemeinsamer Tarif der im Verkehrsverbund Berlin-Brandenburg zusammenwirkenden
Verkehrsunternehmen (VBB-Tarif). Gültig nach den geltenden Beförderungsbedingungen.
BVG · Potsdamer Straße 188 · 10783 Berlin · Tel. 25 60.
Zum sofortigen Fahrtantritt.
L 102003 (01/2004)

11977906 BVG

Agatha Christie's

TEN LITTLE INDIANS

Five Pfennig Playhouse
Old Argonher Kaserne, Hanau

043 *

5 November 1982
2000 hrs

Kontrollschein Control note Fiche de contrôle Kontrole-bon

LEITZ

Geprüftes Qualitätsprodukt Produit de qualité contrôlée
Tested quality product Getest kwaliteitsproduct

25. 5. 99 Nr. No

Bei Beanstandungen bitte En cas de réclamations prière
Kontrollzettel mit zurücksenden. de nous retourner cette fiche.
In case of complaint please Bij reclame's kontrole-bon
return this slip. bijsluiten.

GASTENBEWIJS
GUEST VOUCHER

kode 11

AANKOMST ARRIVAL –

VERTREK DEPARTURE 07 JUNI 1996

* Dit bewijs is geen betalingsbewijs!
* This voucher is not proof of payment!

Lufthansa
BAGGAGE IDENTIFICATION TAG

02
24JUL00 074487
TO FRA LH 313
VIA
VIA
VIA

LH 340394

STADT FRANKFURT
AM MAIN
Gebühr
€ 10,00
19741

长城是公元前七世纪开始修
筑的。东起山海关，西至嘉峪
关。全长六千多公里。它是世
界上七大奇迹之一。在月球上
用肉眼可辨认的地球两项重
大工程，其中一项就是中国的
长城。

The Great Wall had been
built since seven Century
BC, starting west of Shan
HaiGuan Pass and ending
east of Jia Yu Guan Pass. It
is about 6000 kilometes.
Long the Great Wall is one
of the seven wonders in the
world and one of the visible
constructions from the
moon by human eyes.

NO:
092986
副

tVmarkt

W. Reschny

093Art-Nr.: 000

€ 5,00

Umtausch nur mit Kassenzettel!

Aus kontrolliertem Anbau

Handelsklasse I
Herkunft: BRD

ELSTAR

65/75 06.10

2,0 Kg

Obsthof
Helga und Johann Lührs

Am Deich 62 a
D-21723 Hollern-Twielenfleth
Tel: 0 41 41 / 93 98 - 0

Eintrittskarten-
Gutschein

Admission ticket
voucher

Bon pour une
carte d'entrée

International Gartenfachmesse Köln
22.–24. September 1985

International Garden Trade Fair
Cologne
22nd–24th September 1985

Salon international du jardinage
Cologne
22–24 septembre 1985

toom-Markt GmbH
Louisenstraße 115
6380 Bad Homburg v.d.H.
Telefon 06172/123-0

Firma — firm — firme

Name — name — nom

Straße, Nr. oder Postfach
Street, no. or P. O. Box
rue, no. ou bôite postale
PLZ, Ort
Postal code, town
code postal, ville

Land — country — pays

Bitte Firmenanschrift/Company address/
Adresse de votre firme

20105 *

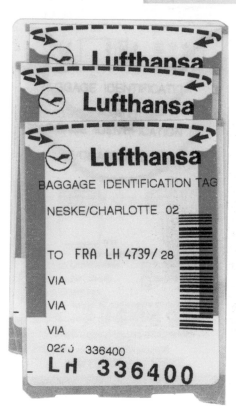

Lufthansa

Lufthansa

Lufthansa

BAGGAGE IDENTIFICATION TAG

NESKE/CHARLOTTE 02

TO FRA LH 4739/28

VIA

VIA

VIA

0220 336400

LH 336400

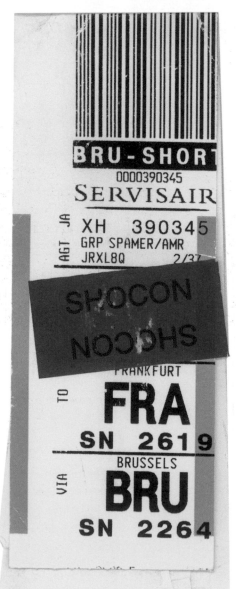

BRU-SHORT

0000390345

SERVISAIR

AGT JA XH 390345

GRP SPAMER/AMR

JRXL8Q 2/37

SHOCON

FRANKFURT

TO FRA

SN 2619

BRUSSELS

VIA BRU

SN 2264

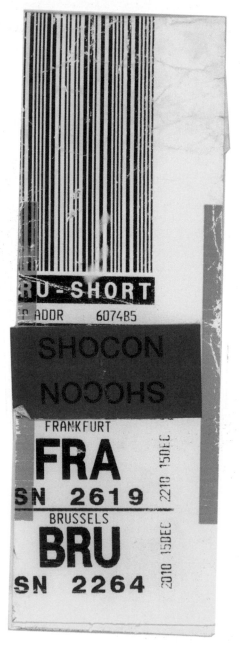

BRU-SHORT

ADDR 607485

SHOCON

FRANKFURT

FRA

SN 2619

BRUSSELS

BRU

SN 2264

Priority Baggage

British Midland

10777

13 € * 5. Lange Nacht der Kölner Museen * 6.11.2004 * 19-3 Uhr

T··Mobile·

CAMEL

Krombacher

Weihenstephan

Stadt Köln

0220 530615
LH 530615 BN 178

ECKART/PETER MR 01

TO **RUH**

LH 632 / 07

VIA

VIA

VIA

0220LH530615 LH632/07OCT

XH 300491

FLIGHT: HLX 7631

DESTINATIONS MANAGEMENT GmbH

KÄRNTEN

KLAGENFURT AIRPORT · A-9020 KLAGENFURT

HAM

XH300491

XH 426404

FLIGHT: - LX 8631

DESTINATIONS MANAGEMENT GmbH

KÄRNTEN

KLAGENFURT AIRPORT · A-9020 KLAGENFURT

TXL

XH 426404

RATP 25 1 25 22 (BUS)
CE TICKET DOIT
ETRE OBLITERE
AUSSITOT APRES
L'ACHAT
001F 38302

RATP 16 (BUS)
CE TICKET DOIT
ETRE OBLITERE
AUSSITOT APRES
L'ACHAT
005H 66593

RATP 24 1 25 22 (BUS)
CE TICKET DOIT
ETRE OBLITERE
AUSSITOT APRES
L'ACHAT
001F 38302

RATP 22 1 25 22 (BUS)
CE TICKET DOIT
ETRE OBLITERE
AUSSITOT APRES
L'ACHAT
001F 38302

LIVE ANIMALS

contents: _____

UNITED AIRLINES

LA 079 PRINTED IN U.S.A.

MUSEU HISTÓRICO DO EXÉRCITO
E FORTE DE COPACABANA

R$ 2,00

VISITAÇÃO RESTRITA

№ 4751 RIO DE JANEIRO - BRASIL
Seja bem - vindo!

07 07 07

Aufbewahren und auf Verlangen vorzeigen. Nur für die gelöste Vorstellung gültig.

21:00 ACHTUNG !! im **BERGER**
18.07 Abgeschminkt mit Vorfilm
 65 PARKETT 12.00 DM

Aufbewahren und auf Verlangen vorzeigen. Nur für die gelöste Vorstellung gültig.

21:00 ACHTUNG !! im **BERGER**
18.07 Abgeschminkt mit Vorfilm
 66 PARKETT 12.00 DM

Made by MEM-O-MATIC ® Europ.Pat.Nr.234486

Wir bitten um Geduld bis Ihr Aufruf erfolgt!

A06 DANKE!

Fax 04551 - 929 18 · D-23795 Bad Segeberg

SNCF **TRANSALPINO** B.I.G.E. PRIX · PREIS · PRICE 268 F **BIJ**

CA

CARTE DE PARTICIPANT
TEILNEHMERTKARTE
PARTICIPANT'S CARD

NOM et prénom
NAME und Vorname BACKE TANJA
SURNAME and christian name

Valable
Gultig **2** mois à partir de
Available Monate vom 08/01/88 an
 months from af

Age ans Date de naissance
Alter Jahre Geburtstag
Age 19 years Date of birth 11/04/68

Carte d'identité ou Passeport n°
Identitätskarte oder Reisepass n° G 5684114
Identity card or Passport Nr

CE BILLET N'EST PAS VALABLE
SANS FICHE HORAIRE

OHNE KUNDENFAHRPLAN
UNGÜLTIG

NOT AVAILABLE WITHOUT
PASSENGER'S TIME TABLE

Jeune de moins de 26 ans
Jugendlicher unter 26 Jahren
Young person under 26

TRANSALPINO

Aufbewahren und auf Verlangen vorzeigen. Nur für die gelöste Vorstellung gültig.

20:30 ACHTUNG !! im **BERGER**
07.05 Die Geschichte der Qiuju DF
 38 PARKETT 12.00 DM

SQ 21 43 08

Claim at Aircraft Side

Special Delivery SINGAPORE AIRLINES **Special Delivery**
 Baggage Identification Tag Only

SQ 21 43 08

N° 1560 N

Deve ser obliterado no 1.º viagem.
Conserve este bilhete.
It must be validated on the first
journey and be retained for inspection.

Stagecoach

PALMENGARTEN PalmenGarten
Pflanzen, Leben, Kultur

EINZEL ERWACHSENE 06.05.03 15:53
FUR 3.50

STADT FRANKFURT AM MAIN

Name

Straße

690019 PLZ/Wohnort

DAS KURHAUS
WIESBADEN

Sonntag,
18. Dez. 1994
19.00 Uhr

Kurbetriebe der Landeshauptstadt Wiesbaden

— Friedrich von Thiersch Saal —

Hotel NASSAUER HOF Wiesbaden Die Ernte vom Lahl

Wohltätigkeitskonzert
" . . . ihnen leuchtet kein Licht"

Schirmherrin: I. D. Tatiana
Fürstin von Metternich-Winneburg

Sektempfang: 18.30 Uhr · Beginn: 19 Uhr

| Parkett Links | Reihe 26 | Sitz 729 |

Haubold, Eschwege

Kontroll-Abriß Sonntag, 18. Dez. 1994
19.00 Uhr

Dn 40.—

| Parkett Links | Reihe 26 | Sitz 729 |

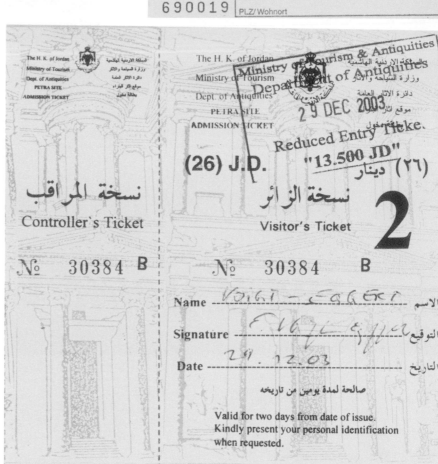

The H. K. of Jordan
Ministry of Tourism
Dept. of Antiquities
PETRA SITE
ADMISSION TICKET

The H. K. of Jordan
Ministry of Tourism
Dept. of Antiquities
PETRA SITE
ADMISSION TICKET

Ministry of Tourism & Antiquities
Department of Antiquities

29 DEC 2003

Reduced Entry Ticket

"13.500 JD"

(26) J.D.

Controller's Ticket

N° 30384 B

Visitor's Ticket 2

N° 30384 B

Name VOIGT - EGBERT

Signature EVGLEYY

Date 29.12.03

Valid for two days from date of issue.
Kindly present your personal identification
when requested.

بطاقة دخول الطائرة

10 F

| Nom | Siège | Dest |

TUNINTER Vol N°/Class Date
012

Porte Seq. N°
43

CARTE D'ACCES A BORD
BOARDING CARD

01/29/05 03:00P 0063

MAY BE USED ONLY BY PASSENGER TO WHOM ISSUED
Exceptions may apply subject to applicable tariffs and conditions of use.

This ticket valid for a single ride
- On all subway lines
- On all local buses (transfer to
 second local bus may be
 obtained on request)
- Within 2 hours of time of
 issuance shown above

This ticket not valid for
- Subway-bus and bus-subway
 transfers
- Express bus
- Local/express bus transfer
- Add value transaction
Keep dry. Do not fold.

B-9-04-09876543

In the event of a malfunction,
pay fare and note
- Date and time
- Location/number of MetroCard
 Vending Machine or station
 booth where purchased, and
- Station entry location or
 bus route, direction, and
 bus number

Contact
MetroCard Customer Service
370 Jay Street, Brooklyn, New York 11201
Tel. (212) 638-7622 (Mon-Fri, 7 am-11 pm)
(Sat-Sun, 9 am-5 pm)

PALMENGARTEN PalmenGarten
Pflanzen, Leben, Kultur

EINZEL ERWACHSENE 03.02.00 15:29
DM 7.00

STADT FRANKFURT AM MAIN

Name

Straße

0802755 PLZ/Wohnort

全国重点文物保护单位

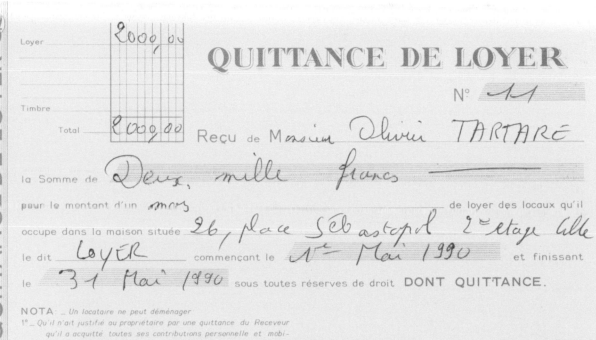

QUITTANCE DE LOYER

Loyer	2000,00
Timbre	
Total	2000,00

Nº **11**

Reçu de Monsieur *Olivier TARTARE*

la Somme de *Deux mille francs*

pour le montant d'un *mois* de loyer des locaux qu'il

occupe dans la maison située *26, place Sébastopol 2ème étage Lille*

le dit *LOYER* commençant le *1er Mai 1990* et finissant

le *31 Mai 1990* sous toutes réserves de droit DONT QUITTANCE.

NOTA _ Un locataire ne peut déménager :

1º _ Qu'il n'ait justifié au propriétaire par une quittance du Receveur
qu'il a acquitté toutes ses contributions personnelle et mobi-
lière de l'année courante.

2º _ Qu'il n'ait donné ou reçu congé par écrit dans les délais prescrits

3º _ Qu'il n'ait fait faire toutes les réparations locatives à sa charge
suivant l'usage ou d'après l'état des lieux s'il en existe un

Dieser Abschnitt ist vom
Empfänger abzutrennen
Abs.:

WWK Vers a.G.
Marsstr. 42
8000 München 2

DM
--1250,00-------

Rechnung vom/Nr.

PV

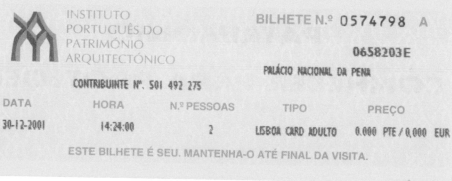

INSTITUTO
PORTUGUÊS DO
PATRIMÓNIO
ARQUITECTÓNICO

BILHETE N.º 0574798 A

0658203E

PALÁCIO NACIONAL DA PENA

CONTRIBUINTE N.º 501 492 275

| DATA | HORA | N.º PESSOAS | TIPO | PREÇO |
| 30-12-2001 | 14:24:00 | 2 | LISBOA CARD ADULTO | 0.000 PTE / 0,000 EUR |

ESTE BILHETE É SEU. MANTENHA-O ATÉ FINAL DA VISITA.

Dieser Abschnitt ist vom
Empfänger abzutrennen
Abs.:

WWK Verss.a.G.
Marsstr. 42
8 München 2

DM
--10.000,00---

Rechnung vom/Nr.

PV

STADT FRANKFURT AM MAIN

ZOO FRANKFURT
Ein Platz für Tiere und Menschen

Erwachsene EUR 8,00 080605

Druck & System: Beckerbillett Hamburg (043) Auf Verlangen vorzeigen. 613982

SINGAPORE AIRLINES

Economy Class Boarding Pass

FLIGHT	DESTN	BOARDING	GATE
SQ 326	FRA	2130	
DATE	CLASS	SEAT	
03DEC	Y	36F	

NAME

BACKE YMR

THROUGH CHECK-IN EX DPS

**WIENER
STADTHALLE –
KIBA**

Büro: Wiener Verkehrsverein
in der Opernpassage

Wien hat immer Saison

NAME:

UNTERSCHRIFT:

K. BST.		WÄHRUNGS-NR.	
A ←		8 ·	

| 0 - Div.
1 - US $
2 - can $
3 - £ stg.
4 - bfrs
5 - bfrs
6 - FF
7 - hfl
8 - DM
9 - Lit.
10 - dkr
11 - nkr
12 - skr
13 - Fmk
14 - Esc
15 - Ptas
16 - Yen
17 - Dinar kl
18 - Dinar gr
19 - Drachm
20 - Forint kl.
21 - Forint gr
22 - Kcs.
23 - Aust £
24 - Lewa
25 - Lei | WIR KAUFEN AN |
| | 100·00 E |
| MENGE / WIR VERKAUFEN |
| |
| PREIS / KURS |
| 694·0000 = |
| KURSWERT |
| 694·00 ◊ |

K. BST K-Valuten-Ankauf T-Theater Karten E-Eurosch S-Sonstiges R-Reisesch H-Zimmervverm F-Rundfahrten	PROVISION + GROSCHENAG.
	9·00 P

ÖS-GEGENWERT:	685·00 A

Datum 220588		Scheck
R Beleg Nr. 106		Karten

NAME

ROOM

GROUP

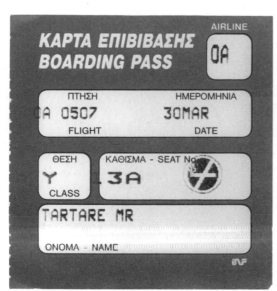

KAPTA ENIBIBAΣHΣ
BOARDING PASS

AIRLINE
OA

ΠΤΗΣΗ	HMEPOMHNIA
OA 0507	30MAR
FLIGHT	DATE

ΘEΣH	ΚΑΘΙΣΜΑ - SEAT No
Y	3A
CLASS	

TARTARE MR

ONOMA - NAME

iNF

MUSEU HISTÓRICO DO EXÉRCITO
E FORTE DE COPACABANA

R$ 2,00

VISITAÇÃO RESTRITA

№ 3825

RIO DE JANEIRO - BRASIL
Seja bem - vindo!

Championships
imbledon 1995

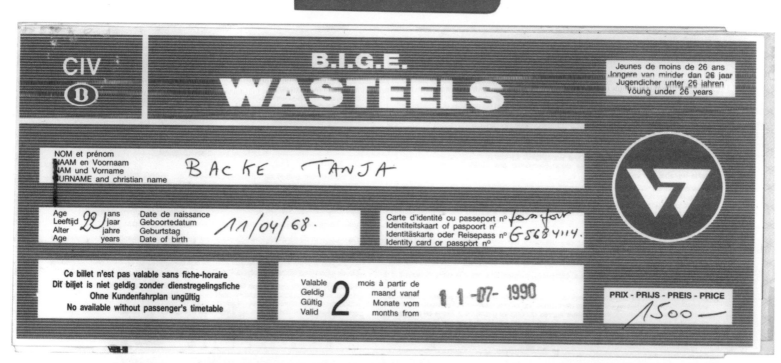

CIV
Ⓑ

B.I.G.E.
WASTEELS

Jeunes de moins de 26 ans
Jongere van minder dan 26 jaar
Jugendicher unter 26 jahren
Young under 26 years

V7

NOM et prénom
NAAM en Voornaam
NAM und Vorname
SURNAME and christian name

BACKE TANJA

| Age
Leeftijd
Alter
Age | 22 ans
jaar
jahre
years | Date de naissance
Geboortedatum
Geburtstag
Date of birth | 11/04/68. | Carte d'identité ou passeport n°
Identiteitskaart of paspoort n°
Identitäskarte oder Reisepass n°
Identity card or passport n° | G568414. |

Ce billet n'est pas valable sans fiche-horaire
Dit biljet is niet geldig zonder dienstregelingsfiche
Ohne Kundenfahrplan ungültig
No available without passenger's timetable

| Valable
Geldig
Gültig
Valid | 2 | mois à partir de
maand vanaf
Monate vom
months from | 1 1 -07- 1990 |

PRIX - PRIJS - PREIS - PRICE
1500—

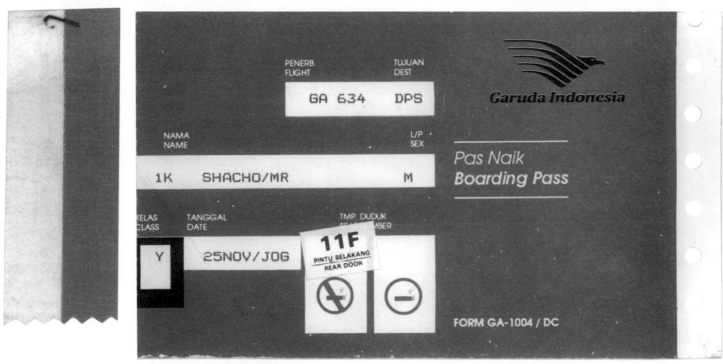

PENERB. FLIGHT	TUJUAN DEST	
GA 634	DPS	*Garuda Indonesia*

NAMA NAME		L/P SEX
1K SHACHO/MR		M

Pas Naik
Boarding Pass

KELAS CLASS	TANGGAL DATE	TMP. DUDUK SEAT NUMBER
Y	25NOV/JOG	**11F** PINTU BELAKANG REAR DOOR

FORM GA-1004 / DC

BUNDESREPUBLIK DEUTSCHLAND

FEDERAL REPUBLIC OF GERMANY
REPUBLIQUE FEDERALE D'ALLEMAGNE

REISEPASS

PASSPORT
PASSEPORT

Der Inhaber dieses Passes ist Deutscher
The bearer of this passport is a German
Le titulaire du présent passeport est ressortissant allemand

№. H 4594057

Dieser Paß enthält 32 Seiten / This passport contains 32 pages / Ce passeport contient 32 pages

BUNDESREPUBLIK DEUTSCHLAND

FEDERAL REPUBLIC OF GERMANY
REPUBLIQUE FEDERALE D'ALLEMAGNE

REISEPASS

PASSPORT
PASSEPORT

Der Inhaber dieses Passes ist Deutscher
The bearer of this passport is a German
Le titulaire du présent passeport est ressortissant allemand

Ungültig Ungültig Ungültig Ungültig

18. April 1991 2 2 00

2160 *

Economy Class Boarding Pass

FLIGHT	SQ 0152	DESTN. CGK	CLASS Y	BOARDING TIME 0700

DATE 19NOV	SEAT 045H 🚭	GATE F85	

NAME BACKE KMRS

REMARKS

Museos de La Atalaya

002406

Fundación Andrés de Ribera
Teléf.: 956 182 100
Fax 956 313 153

C/ Cervantes, 3
11403 Jerez de la Frontera (Cádiz)
E-mail: info@elmisteriodejerez.org

Economy Class Boarding Pass

FLIGHT	DESTN	BOARDING	GATE
SQ 326	FRA	2130	
DATE	CLASS	SEAT	
03DEC	Y	36B	

NAME

BACKE KMRS

THROUGH CHECK-IN EX DPS

Ticket 1

80	042429892	Besondere Angaben		EL	Frankfurt

04242989-21

Indications spéciales

BIJ EUROTRAIN

(Main) Süd
110650061 34
26.11.93 00

Gültigkeit/Validité 26.11.93 - 25.01.94

Zahlungsart
Mode de paiement

Ausgabestempel

Cachet d'émission

von/de/from	Hinfahrt/Aller/Outward	Kl. Cl.	von/de/from	Rückfahrt/Retour/Return
FORBACH(FR)			XXXXX	
nach/à/to XXXXX		1	nach/à/to XXXXX	
nach/à/to LILLE FLANDRES		2	nach/à/to XXXXX	

via FORBACH*METZ*HIRSON*****

Ermäß. Réduct.	=	%	=	%	Grund Motif BIJ		DM ***61,00	88 88
	=	%	=	%				

Ticket 2

88	Nº 50681063	Bijzondere aanwijzingen Indications spéciales Besondere Angaben		EL	Uitgiftestempel

Geldigheid/Validité/Gültigkeit 05.01.89 04.03.89

017371

Ausgabestempel

BRU.-CENTR.
05.01.89
1436 3673

Cachet d'émission

Wijze van betaling
Mode de paiement
Zahlungsart

van/de/von	HEENREIS/ALLER/HINFAHRT	KL. CL.	van/de/von	TERUGREIS/RETOUR/RÜCKFAHRT
BRUSSEL/BRUXELLES (AGGLO.)			*****	
naar/à/nach *****		1	naar/à/nach *****	
naar/à/nach FRANKFURT (MAIN)		2	naar/à/nach *****	

via AACHEN*KOE*1071*****3411

Verm. Réduct. Ermäss.	%	%	Reden Motif Grund		BEF ****1800	B

Ticket 3

80	182695936	Besondere Angaben		EL	Frankfurt

18269593-65

Indications spéciales

(Main)Hbf
25.07.91
110700021

Zahlungsart
Mode de paiement BARZAHLUNG

Ausgabestempel

Cachet d'émission

800033751811

Wir haben für Sie reserviert / Nous vous avons réservé / We have reserved

4 Sitzplätze mit EC/IC-Zuschlag / avec supplement
FRANKFURT M --> BERLIN HBF

Abfahrt/Départ/Departure	30	7.08	🕐 14:02	🚆 174

Platznummern / Numéros des places / Place numbers

Abteil / Compartiment / Compartment	Kl. Cl.		Fenster Mitte Fenetre Milieu
Großraumwagen **4 Nichtraucher**	2	30	**35 36 37 34**

Ermäß. Réduct.	=	%	=	%	Grund Motif		VA/TA	DM ***24,00	888
	=	%	=	%					

** TELEBANCO 4B **

REF. 0024.6894.00

FECHA HORA OPERACION DEPO/AUT
21/04/96 16:57 46 0417970

EC 672550 010318811510/0 280 96/12

IMPORTE
RETIRADO ******25.000,00 PTS

GRACIAS POR SU VISITA

** TELEBANCO 4B **

REF. 0075.0316.62

FECHA HORA OPERACION DEPO/AUT
02/09/2001 13:40 32 134019

EC ************05/67697/1 280 02/12

IMPORTE
RETIRADO ******25.000 PTS

 (150,25 EUR)

GRACIAS POR SU VISITA

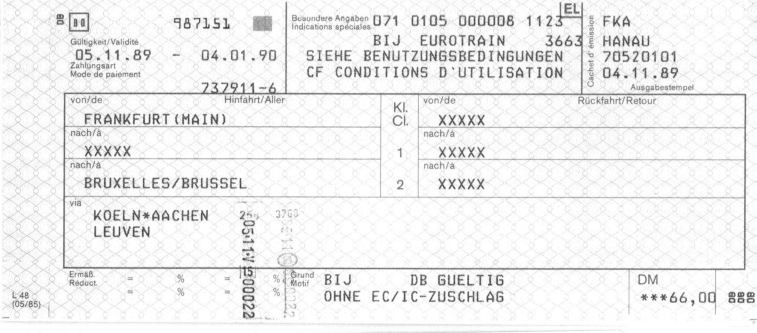

DB 80	987151		Besondere Angaben Indications spéciales 071 0105 000008 1123	EL	FKA
			BIJ EUROTRAIN 3663		HANAU
Gültigkeit/Validité			SIEHE BENUTZUNGSBEDINGUNGEN		70520101
05.11.89 – 04.01.90			CF CONDITIONS D'UTILISATION		04.11.89
Zahlungsart Mode de paiement					Ausgabestempel
737911-6					

von/de	Hinfahrt/Aller	Kl. Cl.	von/de	Rückfahrt/Retour
FRANKFURT(MAIN)			XXXXX	
nach/à			nach/à	
XXXXX		1	XXXXX	
nach/à			nach/à	
BRUXELLES/BRUSSEL		2	XXXXX	
via				
KOELN*AACHEN LEUVEN				

Ermäß. Réduct. = % = %
Grund Motif BIJ DB GUELTIG
OHNE EC/IC-ZUSCHLAG DM ***66,00

L 48 (05/85)

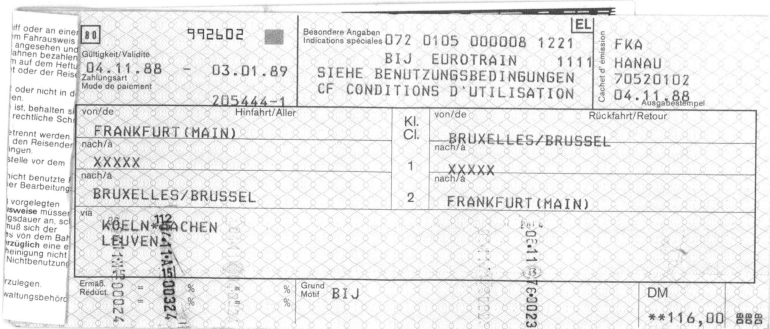

...iff oder an einer
...em Fahrausweis
...angesehen und
...ahen bezahlen
...m auf dem Heft
...t oder der Reise...

...oder nicht in d...

...ist, behalten si...
...rechtliche Sch...

...trennt werden...
...den Reisender
...ingen.

...stelle vor dem

...nicht benutzte
...er Bearbeitung

...vorgelegten
...sweise müssen
...gsdauer an, sc...
...muß sich der
...s von dem Bah
...rzüglich eine e...
...heinigung nicht
...Nichtbenutzung

...zulegen.

...waltungsbehör

80	992602		Besondere Angaben Indications spéciales 072 0105 000008 1221	EL	FKA
			BIJ EUROTRAIN 1111		HANAU
Gültigkeit/Validité			SIEHE BENUTZUNGSBEDINGUNGEN		70520102
04.11.88 – 03.01.89			CF CONDITIONS D'UTILISATION		04.11.88
Zahlungsart Mode de paiement					Ausgabestempel
205444-1					

von/de	Hinfahrt/Aller	Kl. Cl.	von/de	Rückfahrt/Retour
FRANKFURT(MAIN)			BRUXELLES/BRUSSEL	
nach/à			nach/à	
XXXXX		1	XXXXX	
nach/à			nach/à	
BRUXELLES/BRUSSEL		2	FRANKFURT(MAIN)	
via				
KOELN*AACHEN LEUVEN				

Ermäß. Réduct. = % = %
Grund Motif BIJ DM **116,00

Miniatur-Golf · Sportanlagen
P. Nüchter
6370 Oberursel-6, Taunusstraße 42

Tanja

Eintrittskarte
Erwachsene 2,50 DM

04135

SPIEL-PROTOKOLL

Feld	P.-Zahl	Feld	P.-Zahl
1	3	Übertr.	
2	3	10	2
3	5	11	2
4	3	12	1
5	2	13	1
6	1	14	7
7	7	15	1
8	3	16	7
9	2	17	2
Übertr.		18	6
Gesamtpunktzahl			67

Gültig für eine Spielrunde

Keine Haftung für Personen-, Garderoben- und
Sachschäden. Karte auf Verlangen bitte vorzeigen.
ROBIFA, Gütersloh

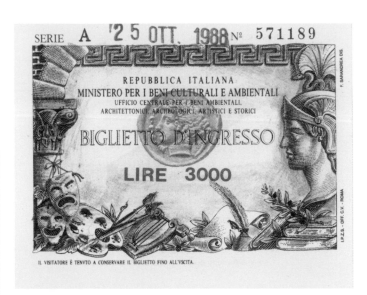

SERIE **A** '25 OTT. 1988 № **571189**

REPUBBLICA ITALIANA
MINISTERO PER I BENI CULTURALI E AMBIENTALI
UFFICIO CENTRALE PER I BENI AMBIENTALI,
ARCHITETTONICI, ARCHEOLOGICI, ARTISTICI E STORICI

BIGLIETTO D'INGRESSO

LIRE 3000

IL VISITATORE È TENUTO A CONSERVARE IL BIGLIETTO FINO ALL'USCITA.

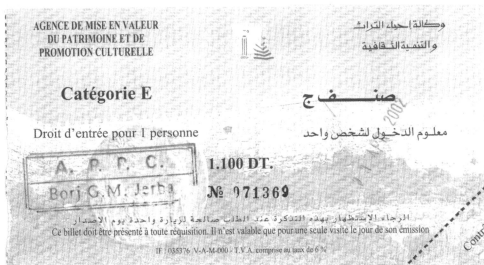

AGENCE DE MISE EN VALEUR
DU PATRIMOINE ET DE
PROMOTION CULTURELLE

وكالة إحياء التراث
والتنمية الثقافية

Catégorie E

صنــف ج

Droit d'entrée pour 1 personne

معلوم الدخول لشخص واحد

A.P.P.C.
Borj G.M. Jerba

1.100 DT.

№ **071369**

الرجاء الاستظهار بهذه التذكرة عند الطلب صالحة لزيارة واحدة يوم الإصدار
Ce billet doit être présenté à toute réquisition. Il n'est valable que pour une seule visite le jour de son émission

IF : 035376 V-A-M-000 - T.V.A. comprise au taux de 6 %

Contrôle

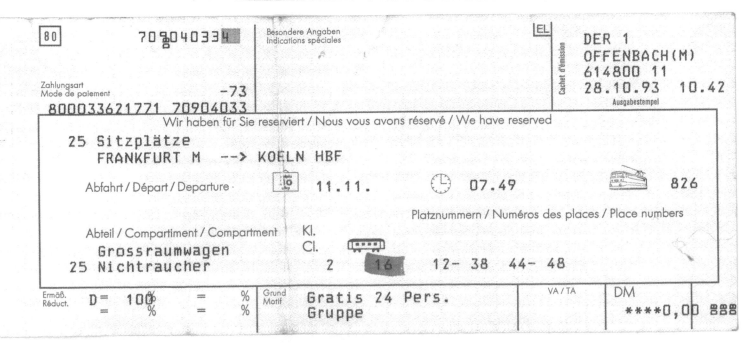

80		70904033		Besondere Angaben Indications spéciales			EL	DER 1 OFFENBACH(M) 614800 11

Zahlungsart
Mode de paiement -73
800033621771 70904033

Cachet d'émission

28.10.93 10.42
Ausgabestempel

Wir haben für Sie reserviert / Nous vous avons réservé / We have reserved

25 Sitzplätze
FRANKFURT M --> KOELN HBF

Abfahrt / Départ / Departure 11.11. 🕐 07.49 🚆 826

Platznummern / Numéros des places / Place numbers

Abteil / Compartiment / Compartment Kl.
Cl.
Grossraumwagen
25 Nichtraucher 2 16 12- 38 44- 48

| Ermäß. Réduct. | D= 100% = % | = % = % | Grund Motif | Gratis 24 Pers. Gruppe | VA / TA | DM ****0,00 |

AU
GRAND MARCHÉ
37, rue Pierre Motte
ROUBAIX

7.80 1
8.95 1
2.70 1
1.55 1
21.00 ES

0120
17:11
10-08-89

COFIROUTE

L'OCEANE
L'AQUITAINE

77, av. R. Poincaré
75116 PARIS
Tél. : (1) 47 55 70 00

CERTIFICAT DE PASSAGE

Le code fiscal doit être
apposé sur le véhicule,
à l'emplacement défini
par le Décret
nº 71.105 du 3-2-71.

0 065 89 22 07 18 1 027.

JOUR TARIF
ANNÉE
KM PARCOURUS VOIE CLASSE PÉAGE
CODE FISCAL

Les Certificats de
passage raturés ou
surchargés sont nuls.

243485 D

Cbh
440700

Dopravní podnik
m. Prahy
Metro, tramvaje, autobusy a.p.

9 8 7
6 5 4
3 2 1

DB

	Erster Geltungstag	Zur Hinfahrt	Zur Rückfahrt gültig bis einschließlich	Ausgabe-Nr
	10.10.86			503314

Klasse XX Tarif IC-ZUSCHLAG************* halber Preis

RES 0

von
nach
über

Verkaufsstelle ZA km DM
XX 0000 ****5,00

FRANKFURT
(MAIN)HBF 11070056

Bitte Rückseite beachten

DB

	Erster Geltungstag	Zur Hinfahrt	Zur Rückfahrt gültig bis einschließlich	Ausgabe-Nr
	10.10.86			503317

Klasse XX Tarif IC-ZUSCHLAG************* halber Preis

RES 0

von
nach
über

Verkaufsstelle ZA km DM
XX 0000 ****5,00

FRANKFURT
(MAIN)HBF 11070056

Bitte Rückseite beachten

DB

	Erster Geltungstag	Zur Hinfahrt	Zur Rückfahrt gültig bis einschließlich	Ausgabe-Nr
	10.10.86 SIEHE RUECKSEITE			503470

Klasse 2 Tarif ERM.FERNRUECKF.(VZK)** halber Preis

von FRANKFURT(MAIN)
nach MUENSTER(WESTF)HBF
über K

Verkaufsstelle ZA km DM
XX 0385 **122,00

FRANKFURT
(MAIN)HBF 11070056

Bitte Rückseite beachten

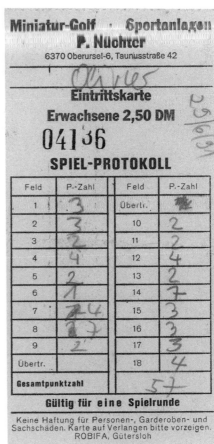

Miniatur-Golf · Sportanlagen
P. Nüchter
6370 Oberursel-6, Taunusstraße 42

Olives

Eintrittskarte
Erwachsene 2,50 DM

04136

SPIEL-PROTOKOLL

25/6/91

Feld	P.-Zahl	Feld	P.-Zahl
1	3	Übertr.	
2	3	10	2
3	2	11	2
4	4	12	4
5	2	13	2
6	1	14	7
7	4	15	3
8	7	16	3
9	2	17	3
Übertr.		18	4
Gesamtpunktzahl			57

Gültig für eine Spielrunde

Keine Haftung für Personen-, Garderoben- und
Sachschäden. Karte auf Verlangen bitte vorzeigen.
ROBIFA, Gütersloh

007268
Haubold, Eschwege

deutsches
filmmuseum
frankfurt am main
Kommunales Kino
SPIO
Eintrittskarte
DM 5,00

Nur für die gelöste Vorstellung gültig
Aufbewahren u.aufVerlangen vorzeigen

014876
Haubold, Eschwege

deutsches
filmmuseum
frankfurt am main
Kommunales Kino
SPIO
Eintrittskarte
DM 5,00

Nur für die gelöste Vorstellung gültig
Aufbewahren u.aufVerlangen vorzeigen

007267
Haubold, Eschwege

deutsches
filmmuseum
frankfurt am main
Kommunales Kino
SPIO
Eintrittskarte
DM 5,00

Nur für die gelöste Vorstellung gültig
Aufbewahren u.aufVerlangen vorzeigen

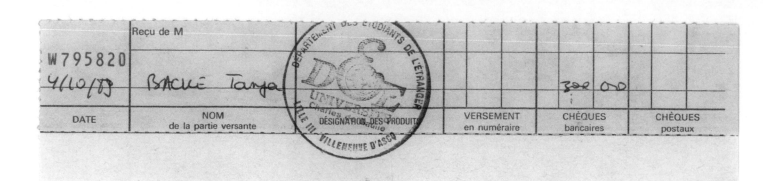

外音

ROEP-NR: 23
DATUM>14/09/2003 KELNER> 0 TIJD>21:44:07

1 火肉古肉
1 大巻

【1反伴 】

HOUSE OF
FRASER
VAT NO 259 9768 79

08/07/95 1878 52431
10 SHOP FLOOR

CLINIQUE
730 000964 11.00
AMOUNT DUE 11.00

CASH 11.00

11:55TOTAL #11.00
801/2 1878 10

A 007898 85140909

€ 1,80

EinzelTicket 13.02.03
Erwachsene 15:47
Uabe 432 KSt 202

Rheinbahn

Rheinbahn Rheinbahn

B 940908

T 152 Pfi reklamaci předložte tento paragon!
Kniha 86814/PR 6 - 586 - 30 M

SEVT 93 161 6 MTZ 11 86

PETIT CASINO
BIENVENUE CHEZ PETIT CASINO
TEL:04.94.81.21.57
83370 ST AYGULF

	VOLVIC 6X1L5	4.02 EUR
	TUC SALE	0.83 EUR
F	EPICERIE 5.50 %	1.72 EUR
	COT.PROVENCE	3.50 EUR
	COT.PROVENCE	3.50 EUR
F	FRUITS/LEGUMES 5.50	2.78 EUR
	SAUCISSON200	2.02 EUR
	4 YAOURT VAN	2.11 EUR
F	CREMERIE 5.50 %	3.72 EUR
	2 x 1.86 EUR	
	6ACTIMEL NAT	3.27 EUR
F	CREMERIE 5.50 %	2.15 EUR
F	FRUITS/LEGUMES 5.50	1.50 EUR
	THON HUIL.OL	3.32 EUR
F	FRUITS/LEGUMES 5.50	1.40 EUR
	BADOIT 1L	0.82 EUR
F	FRUITS/LEGUMES 5.50	3.80 EUR
F	FRUITS/LEGUMES 5.50	2.18 EUR

= T O T A L (17) 42.64 EUR

= T O T A L FRF 279.70=
(1 EURO = 6.559570 Francs)

ESPECE EUR (EUR) 50.00
MONTANT FRANCS 327.98
RENDU MONNAIE (EUR) 7.36
RENDU MONNAIE FRANCS 48.28

001 / 1 / 22/08/2003/18:31:48
Numéro de Ticket : 398813

```
       toom-Baumarkt
         Darmstadt
      Pall.Wiesenstr.72
FASSUNG
4008297031000      6.29
FASSUNG
4008297031000      6.29
FEINSTAUBMAS
4035300149872      8.99
UNIV. MESSER
4388813510081      2.00
TESAKREPP
4005800174087      6.79
HANDWASCHBUE
4043400213027      1.79
DRAHTBUERSTE
4388813514775      2.00
Schraubzwing
4388810461010      5.00
NORMALLAMP.
8711500011527      1.89
ABDECKPLANE
4007518036220      8.99
TESA PAKETBA
4005800001321      6.99
SCHEIBENREIN
4001084071333      6.99
NORMALLAMP.
8711500011527      1.89
SCHR. DREH.
4035300010714      6.49
SCHR.DREHER
4035300010905      7.99
URINSTEINLOE
4000906001619     12.95
WISCHMOPEIM+
4003790014642     11.79
WISCHMOP
4003790014673     11.79
WC-SITZ
4002148809022     19.95
ABFALLSAECKE
4007518064292      3.69

POSTEN        20
S U M M E    140.55
BAR          150.00
ZURUECK        9.45

MWST A     18.33
15.0% IN     140.55
2170 0075/001/112
30.12.97 19:42 VA-00

Mo.-Fr. 8.00-20.00
SA. 8.00-16.00 Uhr
Finanzamt-Quittung
```

```
      DER FRISCHE
       GROSSO
     64293 DARMSTADT

       3X à     1.79
DEPT#05        5.37
       4X à      .99
DEPT#03        3.96
DEPT#06       53.69
DEPT#03        6.99
DEPT#03        6.99
DEPT#03         .30
DEPT#03         .70
DEPT#03        3.49
DEPT#01        1.49
       4X à      .99
DEPT#05        3.96
DEPT#01        1.69
DEPT#01        1.69
DEPT#03        8.99
DEPT#03        2.59
DEPT#03        3.49
DEPT#03        2.99
DEPT#03        9.50
DEPT#01        3.99
ZW-SUM       121.47
    26 POSTEN
SUMME        121.47
BAR          121.50
ZURÜCK          .03

VERK.1 001001 0596
29-11-97   15:09
```

```
      RELAIS H

C.2        08.10.98
AUDIO        46.00

TOTAL        46.00
ARTICLE          1
166 02  08:15   A

      RELAIS H
```

```
          A & P
      Keizerstraat 331
    2584 BG  Scheveningen
    ------------------------

SANCERRE           7,46
SPA ROOD           1,25
STATIEGELD         1,00
SPA ROOD           1,25
STATIEGELD         1,00
SPA ROOD           1,25
STATIEGELD         1,00
LU TUC             0,89
M&M PINDA          3,19
                 --------
Totaal            18,29
Afgerond          18,30
       KONTANT    25,00
Terug              6,70

6,00% van    7,83   0,44
17,50% van   7,46   1,11
Bedrag zonder BTW  16,74

Kassa 003/0020  Bon 0367 PC01 P
Datum 13-07-96  Tijd 16:47 #  6

* = Gratis A&P zegel
       Bedankt.
   Graag tot ziens.
   Tel.nr.: 070-3557215
```

```
      СПАСИБО

VI -5-1   001 3057

0n80  4·0.001.86
0n80  4·0.001.86
0n80  4·0.001.86
0n80  4·0.001.86
0n80  4·0.007.93
0n80  4·0.007.93
0n80  4·0.001.08
0n80  4·0.001.08
0n80  4·0.001.08
0n80  4·0.001.08
0n80  4·0.000.10

0n80  *·0.027.72
```

```
   JURG MONKEL
     PAPETERIE

0.051.10 TL
0.001.50
0.001.50
0.001.50
0.002.80
0.001.50
0.001.50
0.001.50
0.002.60
0.004.80
0.004.20
0.001.30
0.006.80
0.005.00
0.012.00
0.002.60

I II 90
```

```
      СПАСИБО

VI -5-1   001 3057

0n76  4·0.001.86
0n76  4·0.001.86
0n76  4·0.001.86
0n76  4·0.003.90
0n76  4·0.003.90
0n76  4·0.002.07
0n76  4·0.002.07
0n76  4·0.002.07
0n76  4·0.002.07
0n76  4·0.002.07
0n76  4·0.002.07
0n76  4·0.002.07
0n76  4·0.000.20
```

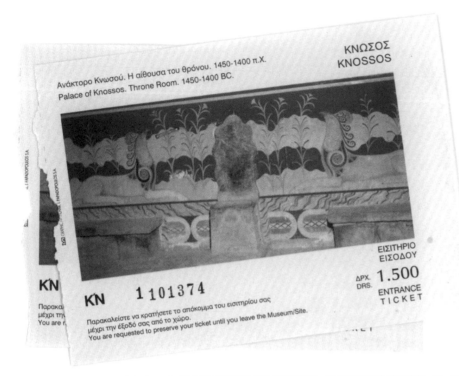

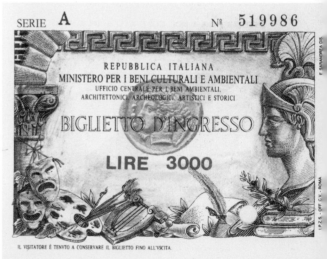

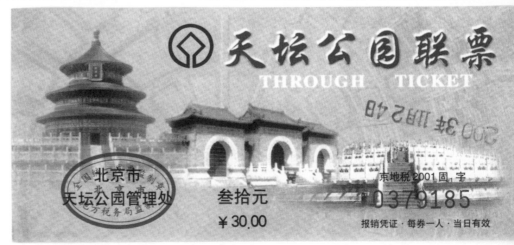

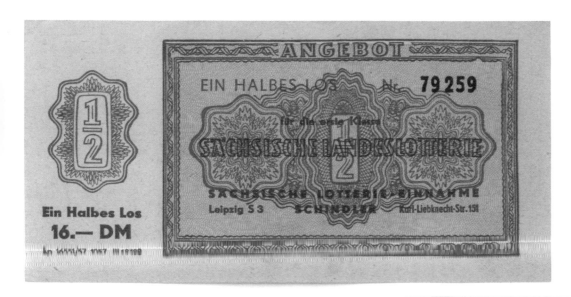

TABLE N°
COUVERTS 7

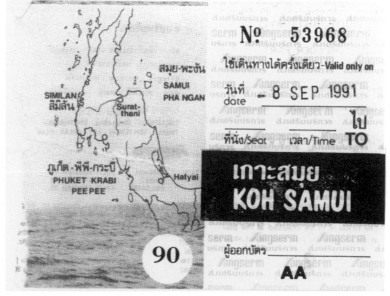

Rotterdam Airport

Parking Ticket

24.11.84 0102 7588 5566
241194-311294 00 0100
MA DI WO DO VR ZA ZO

OCT8 JETON

VAN: 00:00 Prijs
TOT: 23:59 FL. 0.00

Zollverwaltung der DDR

Gebührenbescheinigung 021493

Für die Benutzung der Straßen der Deutschen Demokratischen
Republik bei einer einmaligen Reise von Berlin (West) in
die Deutsche Demokratische Republik (Stufe *L.*) und zurück
wurden nach den geltenden Rechtsvorschriften der Deutschen
Demokratischen Republik

_____*10,— DM*_____
Betrag Währung

entrichtet.

Zollverwaltung der DDR
9. 4. 90
Stempel

ZV 285 VV Halle Ag 309/18432/285/87 III/14/13 IV GZA Friedr./Zimmerstr.

St. GEORGES

MOSAIC MAP CHURCH MADABA

كنيسة القديس جيورجيوس - مادبا

Thanks for The Visit

شكراً للزيارة

(1) J.D. For Services

دفتر ٥٠١٨٤

PATHE
Cinemas

Dali

AUSSTELLUNG DALI: EintausendundEin Träume
Mai – Juli 1988 Wien Palais Harrach
Ermäßigungskarte für 1 Person öS 35,—
inkl. 10% MwSt.

Amtlich
aufgelegt

DRUCK ZAWADIL, WIEN

02242

PARKSCHEIN

Ausfahrt _____

Einfahrt _____

**Keine Haftung für
Schäden durch
Dritte!**

Unsere Geschäftsbedingungen und die
Hausordnung sind an der Kasse ausgehängt
und für alle Benutzer verbindlich.

**Die Benutzung des Parkhauses
erfolgt auf eigene Gefahr.**

09173

BIREKA, 10711 BERLIN

Deutsche Oper Berlin	**Deutsche Oper Berlin** Berlin-Charlottenburg, Bismarckstraße			Kontrolle
2. Rang rechts 4 - 24	Reihe **4**	**2. RANG** RECHTS	Sitz Nr. **24**	**2. Rang rechts** 4 - 24
29.6.64	Für Zuspätkommende Einlaß nach dem 1. Akt / Für verfallene Karten kein Ersatz	**Montag, 29. Juni 64**		29.6.64

Stange, Berlin 61

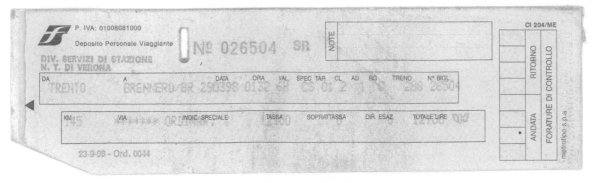

P. IVA: 01008081000
Deposito Personale Viaggiante N° 026504 SR

DIV. SERVIZI DI STAZIONE
N. T. DI VERONA

DA TRENTO A BRENNERO/BR 290399 0132 6H CS 01 2 01 288 26504

KM 45 VIA INDIC. SPECIALE TASSA SOPRATTASSA DIR. ESAZ TOTALE LIRE

23-9-98 - Ord. 0044

NOTE CI 204/ME
RITORNO ANDATA FORATURE DI CONTROLLO

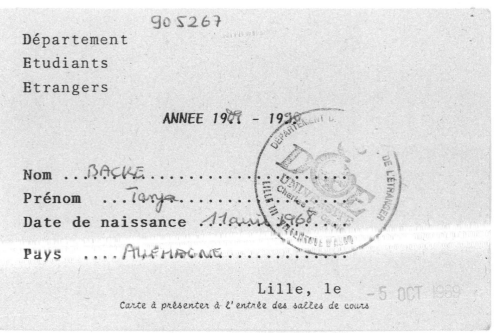

Département
Etudiants
Etrangers

ANNEE 19.. - 19..

905267

Nom ...BACKE..............
Prénom ...Tanja...............
Date de naissance ..11 avril 1961....
Pays ...ALLEMAGNE.............

Lille, le -5 OCT 1989
Carte à présenter à l'entrée des salles de cours

MANHATTAN BISTRO New York, N.Y. 10012
129 Spring Street 212-966-3459

DATE	SERVER	TABLE NO.	AMOUNT	CHECK NO.
		21		075070

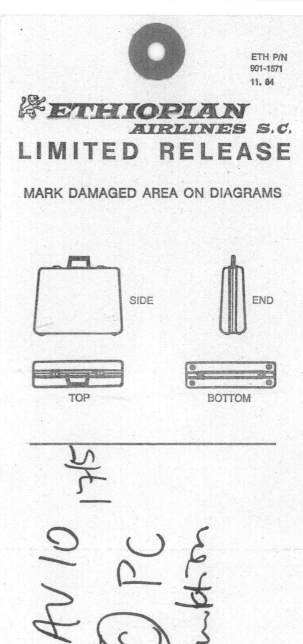

ETH P/N
901-1571
11. 84

ETHIOPIAN AIRLINES S.C.

LIMITED RELEASE

MARK DAMAGED AREA ON DIAGRAMS

SIDE END

TOP BOTTOM

AV 10 175
© PC
Tombota

HI-SPEED FERRIES Fare (including fees)
快達客輪 HK$30.00
Preço 票價連登船費

Sociedade de Turismo e Diversoes de Macau, S.A.R.L.(AGENTS)

MAC HKG 澳門 香港 ECONOMY 經 禮

M08020991
12321AL03c Departure Date 開航日期
CM08019702 C203 SEP/91

MON 星期一
Departure Time 開航時間
5:30PM

HSF 08

03433554

Vide condições no verso **IMPORTANT NOTICE** — see back 重要事項一請參閱背頁

HI-SPEED FERRIES Fare (including fees)
快達客輪 HK$30.00
Preço 票價連登船費

Sociedade de Turismo e Diversoes de Macau, S.A.R.L.(AGENTS)

MAC HKG 澳門 香港 ECONOMY 經 禮

M08020991
12321AL C204 Departure Date 開航日期
CM08019702 2/SEP/91

MON 星期一
Departure Time 開航時間
5:30PM

HSF 08

03433553

Vide condições no verso **IMPORTANT NOTICE** — see back 重要事項一請參閱背頁

1 Deutsche Mark

In 50 Münzen zu 2 Pfennig

Ohne Gewähr, daher beim Empfang zu zählen

1 Deutsche Mark

In 50 Münzen zu 2 Pfennig

Ohne Gewähr, daher beim Empfang zu zählen

ORFIX – 3603

Цена 10 ко

Хранится
у посетителя

М. т. 8 З.

ГОСУДАРСТВЕННЫЙ
ОРДЕНА ЛЕНИНА
ИСТОРИЧЕСКИЙ
МУЗЕЙ

Сер. В В В-6

ЭКСКУРСИОННЫЙ
БИЛЕТ

·24654

Цена 10 коп.

Хранится
у посетителя

М. т. 8 З. №

ГОСУДАРСТВЕННЫЙ
ОРДЕНА ЛЕНИНА
ИСТОРИЧЕСКИЙ
МУЗЕЙ

Сер. В В В-6

ЭКСКУРСИОННЫЙ
БИЛЕТ

24653

Цена 10 коп.

Хранится
у посетителя

М. т. 8 З. № 6

ГОСУДАРСТВЕННЫЙ
ОРДЕНА ЛЕНИНА
ИСТОРИЧЕСКИЙ
МУЗЕЙ

Сер. В В В-6

ЭКСКУРСИОННЫЙ
БИЛЕТ

34030 **SAALBURGMUSEUM** Bad Homburg v. d. H. Eintritt Ermäßigter Preis DM 2,00

85705 **SAALBURGMUSEUM** Bad Homburg v. d. H. Eintritt Erwachsene DM 3,00

55295 **Eintrittskarte** Preis siehe Anschlag Nicht übertragbar Aufbewahren und auf Verlangen vorzeigen. 55295

55294 **Eintrittskarte** Preis siehe Anschlag Nicht übertragbar Aufbewahren und auf Verlangen vorzeigen. 55294

55293 **Eintrittskarte** Preis siehe Anschlag Nicht übertragbar Aufbewahren und auf Verlangen vorzeigen. 55293

67265 **Eintrittskarte** Preis siehe Anschlag Nicht übertragbar Aufbewahren und auf Verlangen vorzeigen. 67265

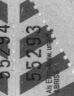

01.71.97 **deutsches filmmuseum** frankfurt am main Kommunales Kino **Eintrittskarte** DM 5,00 Nur für die gelöste Vorstellung gültig Aufbewahren u. auf Verlangen vorzeigen

Berliner Ausstellungen MESSEGELÄNDE **Eintrittskarte** DM-West –,50 Nur zum einmaligen Besuch am Lösungstage

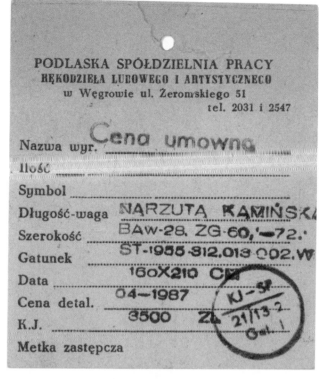

PODLASKA SPÓŁDZIELNIA PRACY
RĘKODZIEŁA LUDOWEGO I ARTYSTYCZNEGO
w Węgrowie ul. Żeromskiego 51
tel. 2031 i 2547

Nazwa wyr. **Cena umowna**

Ilość

Symbol

Długość-waga NARZUTA KAMIŃSKA

Szerokość BAw-28. ZG-60,'-72.'

Gatunek ST-1955-312.013-002.W

Data 16oX210 CM

Cena detal. 04-1987

K.J. 3500 zł

Metka zastępcza

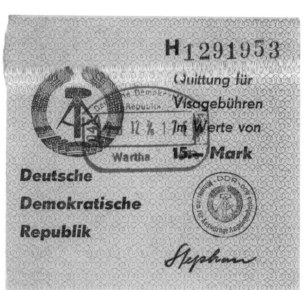

H1291953

Quittung für
Visagebühren
Im Werte von
15,- Mark

Wartha

**Deutsche
Demokratische
Republik**

Stephan

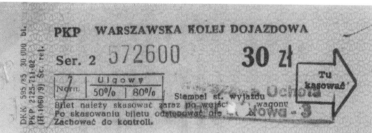

PKP WARSZAWSKA KOLEJ DOJAZDOWA

Ser. 2 572600 **30 zł**

	Ulgowy	
Norm.	50%	80%

Bilet należy skasować zaraz po wejściu do wagonu
Po skasowaniu biletu odstąpić go nie wolno.
Zachować do kontroli.

Tu kasować

KOMUNIKACJA MIEJSKA
BILET JEDNORAZOWY

B 7974593

4000 zł MPK
GNIEZNO

ZACHOWAĆ DLA KONTROLI

Z.G.P.-3

TU KASOWAĆ
ZARAZ PO WEJŚCIU
DO POJAZDU.

I 159A 20 22

Netzkarte ,,72-Stunden-Wien"
"72 hours Vienna" ticket
Carte « 72 heures à Vienne »
Biglietto ,,72 ore a Vienna"
ウィーン72時間フリーパス
im Verkehrsverbund Ost-Region

Gültig laut Tarifbestimmungen Preis inkl. 10% USt.	S 92.-

Bitte Information auf der Rückseite beachten!
Please note information on the back of this ticket!
Information importante au verso!
Pregasi vedere informazioni a tergo!
裏面をご覧ください。

009 N 001519

Diese Karte ist nicht übertragbar und stets mitzubringen! — Bitte Rückseite beachten.

Leserausweis

4	3	2	1
5			0
6	7	8	9

Backe
Name

Tanja
Vorname

Straße

PLZ Wohnort

Wohnungswechsel bitte der Bücherei mitteilen!

Bücher
können nur dort
zurückgegeben
werden, wo sie
entliehen
wurden!

THE PALACE MUSEUM ￥:30.00

THE PALACE MUSEUM ￥:30.00

NEUE PINAKOTHEK
Bayer. Staatsgemäldesammlungen in München

EINTRITTSKARTE
DM 4,00

Gültig für eine Person u. einmaligen Eintritt
Auf Verlangen vorzeigen.

020670 Beckerbillett Hamburg

ALTE PINAKOTHEK
Bayer. Staatsgemäldesammlungen in München

EINTRITTSKARTE
DM 4,00

Gültig für eine Person u. einmaligen Eintritt
Auf Verlangen vorzeigen.

033006 Beckerbillett Hamburg

Prijs 2.50

Op aanvraag te tonen
Geen toegang zonder controlestrook

Ned. Spec. Drukk. Delft 094025

CONTROLE 2.50 094025

Name _____

	€	C
Sohlen: Led., Gum., Prof., Crepe ..		
Langs., Stücke, Spitzen, Stoßpl. v. h.		
Absätze: Gu., Met., Perl.		
Ecken, Bez. neu ausb., Decksohl.		
H.-Futter, Contraf., Riester steppen .	28,80	
Kleben, Ösen, Haken, Reißer		
Längen, Weiten, Färben Nr. _____		

Anzahlung _____

Fertig
Mo Di Mi Do Fr Sa
schw./braun
farbig/weiß
H. D. K. M.
½ - 1 Paar
bis ____ Uhr

5628

H. D. K. M.
½ - 1 Paar

5628

Abholung gegen die ___ Beleg und Barzahlung. Keine
Haftung bei Brand ___ er Diebstahl. Aufbewahrungs-
pflicht nur b ___ Dauer von **6 Wochen.**

28,80

H. D. K. M.
schw./braun
farbig/weiß
½ - 1 Paar
Fertig: Mo Di Mi Do Fr Sa

5628

STUDENTENWERK Frankfurt / Main	STUDENTENWERK Frankfurt / Main	STUDENTENWERK Frankfurt / Main
Essenbon	*Essenbon*	*Essenbon*
DM 3,—	DM 3,—	DM 3,—
siehe auch Rückseite	siehe auch Rückseite	siehe auch Rückseite

104229 BIREKA, 6962 Adelsheim 104229
104228 BIREKA, 6962 Adelsheim 104228
104227 BIREKA, 6962 Adelsheim 104227

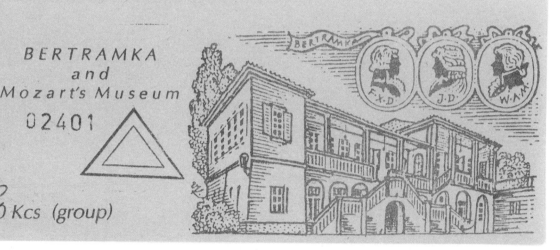

VILLA BERTRAMKA, Mozartova 169, Praha 5

BERTRAMKA
and
Mozart's Museum

02401

Date
Datum
Date

Price 30
Preis 40 Kcs (group)
Prix

VILLA BERTRAMKA, Mozartova 169, Praha 5

BERTRAMKA
and
Mozart's Museum

02402

Date
Datum
Date

Price 30
Preis 40 Kcs (group)
Prix

Johnson Boutique

GALLERIA - NUSA DUA
Blok C2 No. 1-2
Ph. (62) (0361) 72289
BALI - INDONESIA

Date : 2-12-93.

NO: 000476

QTY	DESCRIPTION	US $	YEN	RUPIAH		CREDIT CARD
1	Sepatu Bossir					
						M·C·
TOTAL						84.000,-

ADL flight **SQ**

TRA 552

088976

SINGAPORE AIRLINES

FUNDAÇÃO CALOUSTE GULBENKIAN
Museu Calouste Gulbenkian

BILHETE Nº 4033549

Avenida de Berna, 45 A, 1067-001 LISBOA
tel. (351) 21 782 3000 VALIDO PARA 29-12-2001
www.gulbenkian.pt

2 Bilhete(s) Museu LX.CARD Estrang.

IVA:00% PREÇO 962,0 PTE
 4,80 EUR

巴蜀勝境·文藻勝地

張飛廟

重慶·雲陽
文物保護管理所

每位

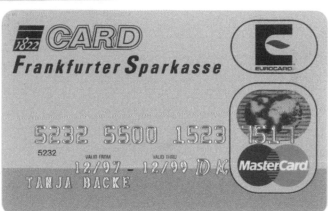

CARD
Frankfurter Sparkasse
EUROCARD

5232 5500 1523 1515
5232
VALID FROM 12/97 — VALID THRU 12/99 DK
TANJA BACKE
MasterCard

此票经北京市地方税务局批准印制
北京市劳动人民文化宫

全国统一发票监制
北京市劳动人民文化宫
地方税务局监制

票价：贰元
¥2.00

34020311010 0011134

副 券

票价:贰元
¥2.00

每券一人 当日有效

34020311010

0011134

旅遊保險凭证
Traveller's Personal Accident Insurance

The People's Insurance Company of China,
Guilin Branch

№ 0001614

壹 元
ONE YUAN
币值：外汇卷
Currency: FEC
姓名
Name
保额 5000 元
Amount
时间
Time

UN, DEUX, TROIS.

Andrée POINARD - Gérard VANIER

Restaurant — 1, Place Neuve Saint-Jean

69005 LYON **Tél. 78.37.65.04**

Table N° *110* Le *12/05/90*

Menu	150
1 Ban	15
1 huîtres	
1 cuti	
Chèque Espèces TOTAL Prix net	

Merci de votre visite

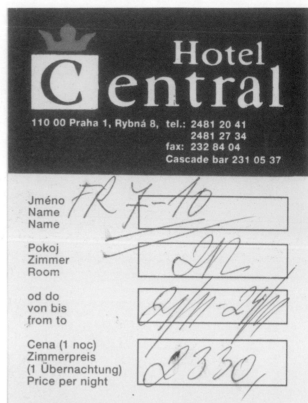

Hotel Central

110 00 Praha 1, Rybná 8, tel.: 2481 20 41
2481 27 34
fax: 232 84 04
Cascade bar 231 05 37

Jméno / Name / Name	FR 7-10
Pokoj / Zimmer / Room	212
od do / von bis / from to	24/11-27/11
Cena (1 noc) / Zimmerpreis (1 Übernachtung) / Price per night	2330,

Prosíme naše hosty, aby v den odjezdu uvolnili pokoj do 12 hodin.

Die Gäste werden gebeten am Tag der Abreise das Zimmer bis 12 Uhr zu räumen.

We beg our guests to leave the room till noon on the day of departure.

苏州丝绸博物馆
SUZHOU SILK MUSEUM
SUZHOU CHINA
票价 柒元
N° 0037924

每位

Hotel Central

110 00 Praha 1, Rybná 8, tel.: 2481 20 41
2481 27 34
fax: 232 84 04
Cascade bar 231 05 37

Jméno
Name
Name

Pokoj
Zimmer
Room

od do
von bis
from to

Cena (1 noc)
Zimmerpreis
(1 Übernachtung)
Price per night

Prosíme naše hosty, aby v den odjezdu uvolnili
pokoj do 12 hodin.

Die Gäste werden gebeten am Tag der Abreise
das Zimmer bis 12 Uhr zu räumen.

We beg our guests to leave the room till noon
on the day of departure.

SECURITY CHECKED

The Ambassador's
Sky Chef, New Delhi

No. 2713 Date 7/03/05

المملكة الاردنية الهاشميه

H.K. OF JORDAN

Departure Tax ضريبة المغادرة
Non-Jordanian غير الأردني
5 JD خمسة دنانير
رقم ٤٠١١٥٤ ون/ت
نسخة المغادر

المملكة الاردنية الهاشميه

H.K. OF JORDAN

Departure Tax ضريبة المغادرة
Non-Jordanian غير الأردني
5 JD خمسة دنانير
رقم ٤٠٠٠٣٣ ون/ت
نسخة المغادر

SV 249700 MED **MED** SV 249700

Medina المدينة

935-6323

saudia
SAUDI ARABIAN AIRLINES

80 NORGE 80 NORGE

بطاقة تمييز العفش

BAGGAGE IDENTIFICATION TAG
This is not the luggage ticket (baggage
check) described in Article 4 of the
Warsaw Convention or the Warsaw
Convention as ammended by the
Hague Protocol, 1955. Carrier will not
be liable for luggage not claimed imm-
ediately on arrival and before leaving
the baggage claim area.

SV 249700

«IZMAILOVO»

«ИЗМАЙЛОВО»

105613 МОСКВА E-613
ИЗМАЙЛОВСКОЕ ШОССЕ 71
МЕТРО „ИЗМАЙЛОВСКИЙ ПАРК"
ТЕЛ. 166-20-01

105613 MOSCOW E-613
IZMAILOVSKOYE HIGWAY 71
METRO STATION „IZMAILOVSKY
PARK" TEL.166-20-01

ТГ

комплекс

Д

BUILDING

Bar-Restaurante EL CASTILLO

EL CASTILLO

CALETA DE FUSTE - ANTIGUA
FUERTEVENTURA

Nº 024634

de de 19

Sr. D.

37 A

Cantidad	C O N C E P T O	Precio	TOTAL
1	Aguacates		450
1	Sopa		200
1	Gambas ajillo		500
1	Pescado		600
			1750
	Campos V tinto		500
	Agua		75
	Cafés..		180
	Agua		75
			2.580

DEBE:

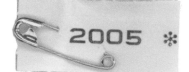

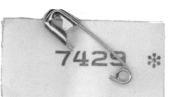

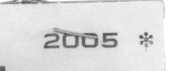

9718

6882 *

3679 *

2005 *

5966 *

2005 *

7429 *

2005 *

If you start flirting it is
going to be quite hot.

Real beauty lies
within simplicity.

Today everything will
change for the best.

You can be sure!

You will overcome
many problems.

You´ll stay a very healthy person.

COLLÈGE INTERNATIONAL
DE CANNES

Nº 1270

Je, soussigné, C.I.C., reconnais avoir reçu

de M BACKE Tanja

la somme de Trois cent soixante dix francs (en espèces)

Savoir

Droits Universitaires : Cours au pair | 370 —

Logement : Août 88

Le responsable :

A Cannes,

Le 25/07/88 198

TOTAL ... 370 —

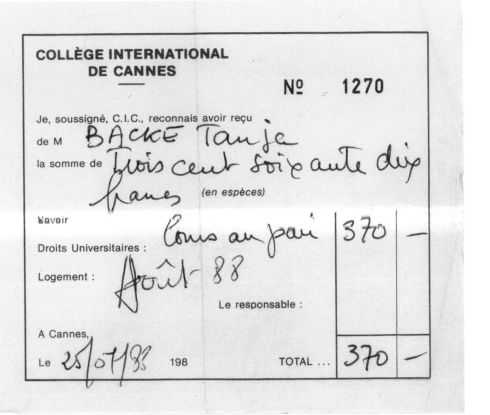

AUTOS DOMINGUEZ
RENT A CAR · AUTOS DE ALQUILER

PUERTO DEL ROSARIO: General Franco, 5 - Telfs.: 85 11 57 - 85 12 31
AEROPUERTO: Teléfono: 85 12 50
JANDIA: Hotel Casa Atlántica - Teléfono: 87 61 68
 Hotel Los Gorriones - Teléfono: 87 08 25
CORRALEJO: Hotel Tres Islas - Teléfono: 86 60 00
 Oliva Beach - Teléfono: 86 61 00
OFICINA LAS PALMAS: Los Martínez de Escobar, 24 - Teléf.: 27 59 97
TELEX. 96849 ADFUE

RESERVATION / RESERVA

Cliente SR.	BACKE		
Fecha llegada	Hora	Vuelo	
Base que alquila			
Coche	Grupo	2.° Coche	
Entrega en lugar	El CASTILLO	Cargo D-95-A	
Observaciones			
Duración 1 DIA	Tarifa 10%		
Paga-CSH	T C	Bono Valor	Bono Número

RESERVA DE KREUTZER Tel.

AGENCIA

RESERVA PARA Tel.

BASE A. DOMINGUEZ QUE DA EL SERVICIO

Esta reserva ha sido preparada por	Fecha	Base que envía
Esta reserva ha sido confirmada por	Fecha	Base

Σ. ΜΠΟΥΛΑΤΑΔΑΚΗ ΑΝΑΣΤΑΣΑΚΗ
ΧΑΡΤΟΜΑΝΙΑ
ΒΙΒΛΙΑ*ΧΑΡΤΙΚΑ*ΦΩΤΟΤΥΠΙΕ
ΠΛΑΤΕΙΑ 1866 ΑΡ.30 ΧΑΝΙΑ
ΑΦΜ 46204794 ΑΔΟΥ ΧΑΝΙΩΝ
FAX (0821)88735

23/08/1996 10:16
000 000003

ΕΙΔ.ΓΡΑΦ *450 Γ

ΕΙΣΠΡ *450
ΜΕΤΡΗΤ *450

 1 Α/ΑΠΟΔ

NOMIMH ΑΠΟΔΕΙΞΗ
 ΑΣ 94000242

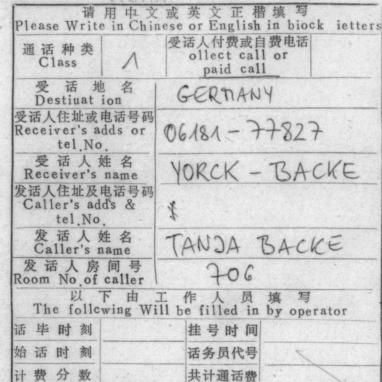

通话种类 Class	∧	受话人付费或自费电话 ollect call or paid call	
受话地名 Destiuation	GERMANY		
受话人住址或电话号码 Receiver's adds or tel.No.	06181-77827		
受话人姓名 Receiver's name	YORCK-BACKE		
发话人住址及电话号码 Caller's adds & tel.No.	⅄		
发话人姓名 Caller's name	TANJA BACKE		
发话人房间号 Room No.of caller	706		

以 下 由 工 作 人 员 填 写
The follcwing Will be filled in by operator

话毕时刻		挂号时间	
始话时刻		话务员代号	
计费分数		共计通话费	

编号 N° 0118965 予交话费_____元
发话人姓名 |
发话人电话号码 |

FUNDACIO JOAN MIRO
PARC DE MONTJUIC
08004 BARCELONA (IVE INCLOS)

19/08/89 11:24
 000#7239

ENTRADA 150

FUNDACIO JOAN MIRO
PARC DE MONTJUIC
08004 BARCELONA (IVE INCLOS)

19/08/89 12:31
 000#7359

ENTRADA 150

DELC

Cappelle Medicee

Data/Date Gio, 17 Maggio 2001

Ingresso previsto
 10:45 - 11:00
Scheduled Entry Time

Prezzo/Price Lit. 8000. €4.13.
Prev./Fees Lit. 0. €0.

FIRENZE MVSEI

Biglietto emesso da Cappelle Medicee

Serie N.
MEDICEE 00093960

外兑1

中国银行　　分行外汇兑换水单　　②粤：NO 1088646
EXCHANGE MEMO

| 国籍
Nationality | France | | | 护照号码
Passport No. | 86DH4481P | 日期
Date 22/8/91 |
| 姓名及签字
Name & Signature | TARHABE | | | 住址/饭店
Address/Hotel | Youth Hostel 307 | |

外币金额 Amount in foreign currency	扣贴息 Less Discount	净额 Net Amount	牌价 Rate	实付外汇券金额 Net Amount in RMB YUAN
700/100	0现金		298.65	296.3P
摘要 Particulars	DJ86.38/现金67			

请妥为保存，以备查验；在六个月内出境时可凭以兑回部分外汇，只限一次。
Please keep this for checking. Part of unused RMB yuan can be reconverted into foreign currency for only one time when holder leaves China within six months.

复核员　　　　　　　经办员

外兑1(三联)

中国银行北京分行外汇兑换水单
EXCHANGE MEMO　　NO 1052975

| 国籍
Nationality | FRENCH | 护照号码
Passport No. | 55058754B | 日期
Date 19/8/91 |
| 姓名及签字
Name & Signature | | 住址/饭店
Address/Hotel | 国家教育学院招待所 | |

外币金额 Amount in foreign currency	扣贴息 Less Discount	净额 Net Amount	牌价 Rate	实付外汇券金额 Net Amount in RMB yuan
100 DM.	2.2	303	303	301.03
摘要 Particulars	现金			

请妥为保存，以备查验，在六个月内出境时可凭以兑回部分外汇。
Please keep this for checking. Part of unused RMB yuan can be reconverted into foreign currency for only one time when holder leaves China within six months

复核员　　　　　　　经办员

寿　NO 0006974

乘座缆车（或滑道）游客平安保险凭证

保险费：每人壹元
保险金额：每人因意外伤害身故给付人民币贰万元，附加意外伤害医疗人民币伍千元
保险期限：游客持票乘座缆车（或滑道）保险起自乘座缆车（或滑道）结束时止
保险责任及索赔手续等内容详见兑条款

（140）

中国人寿怀柔区公司

A. CRON
ODPOČET

razítko směnárny
jméno směnárníka
směnárna č. 1

o výměně valut — deviz č.

* 385590
SRN

4. 10. q Pohořelec 1
místo — dn Praha 1

jméno klienta
Tartare

státní příslušnost

59 05 27 548

číslo pasu

číslo certifikátu

dočasné bydliště

Měna	Druh	Množství	Číslo šeku	Kurs	Kčs
DM		50		17,35	865

Příplatek		
Celkem		865
Výlohy		43
K výplatě		822

podpis klienta podpis směnárny

PRINT 54, 0489

Obraťte!

HOTEL STATE STREET
121 STATE STREET
SANTA BARBARA, CALIF. 93101
PHONE: (805) 966-6586

NAME _____ TARTARE _____

STREET _____

CITY _____ STATE _____

REPRESENTING _____

CAR LICENSE _____ STATE _____

MAKE CAR _____ YEAR _____ NO. IN PARTY _____

REGISTRATION CARD

000186

NOTICE TO GUESTS

ADVANCE PAYMENT REQUESTED

This property is privately owned and the management reserves the right to refuse service to anyone and will not be responsible for accidents or injury to guests or for loss of money, jewelry or valuables of any kind.

UNITED PRODUCTS INC., 846 FORBES BLVD., SO. SAN FRANCISCO, CA 94080

DATE		RATE	ROOM TOTAL	TAX (IF ANY)	MISC.	AMOUNT PAID
IN 9/6	OUT 9/7	40	40 00	4 00	8 00	44.00

	ROOM 117	NAME
TOTAL		MC
SUN.		
MON.		
TUES.		
WED.		TARTARE
THURS.		
FRI.		
SAT.		
TOTAL		9/7

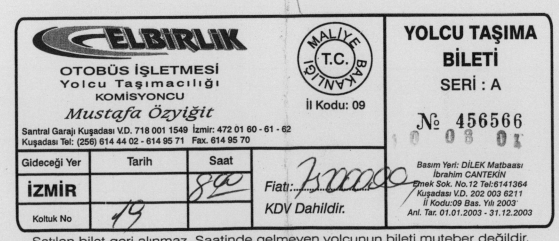

ELBİRLİK

OTOBÜS İŞLETMESİ
Yolcu Taşımacılığı
KOMİSYONCU
Mustafa Özyiğit

Santral Garajı Kuşadası V.D. 718 001 1549 İzmir: 472 01 60 - 61 - 62
Kuşadası Tel: (256) 614 44 02 - 614 95 71 Fax. 614 95 70

MALİYE BAKANLIĞI T.C.
İl Kodu: 09

YOLCU TAŞIMA BİLETİ
SERİ : A

№ 456566

10 08 03

Basım Yeri: DİLEK Matbaası
İbrahim CANTEKİN
Emek Sok. No.12 Tel:6141364
Kuşadası V.D. 202 003 6211
İl Kodu:09 Bas. Yılı 2003
Anl. Tar. 01.01.2003 - 31.12.2003

Gideceği Yer	Tarih	Saat
İZMİR		8 00
Koltuk No	19	

Fiatı:... 15.000.000
KDV Dahildir.

Satılan bilet geri alınmaz. Saatinde gelmeyen yolcunun bileti muteber değildir.

SOMERSET
XU HUI · SHANGHAI

餐券　　**№ 0043300**

MEAL COUPON

Breakfast ☑	Lunch ☐	Dinner ☐
早餐	午餐	晚餐

Name: MR HIL　　Room No: 1106
姓名　　　　　　　房号

Valid Date: 3/1　　Issued By:
有效日期　　　　　发放人

Coupon is good for one person only,
Is non – refundable and non – Transferable; Only valid on the date specified.
此餐券只供一人使用，并不能兑换现金或转让；此券只供在有效日期内使用。

BOARDING PASS / TARJETA DE EMBARQUE
CARTE D'EMBARQUEMENT / BORDKARTE

FLIGHT / CABIN	DATE	SEAT
VUELO / CABINA	FECHA	ASIENTO
VOL / CABINE	DATE	SIEGE
FLUG / KABINA	DATUM	SITZ

106Y 27SEP2 30B X

ORIGIN / DESTINATION
ORIGEN / DESTINO
ORIGINE / DESTINATION
ABFLUGSORT / REISEZIEL

JFK/FRANKFURT

NAME / NOMBRE / NOM / NAME

TARTARE/OLIVIERMR

 △ DELTA AIR LINES

SA NATIONAL PARKS

Entrance Permit　　　　　**R 30 00**

PERMIT　　**A 0075852**

Issued subject to the provisions of the National Parks Act, 1976
(Act No. 57 of 1976), and the regulations promulgated thereunder.

.......... Adults (16 years and older)　　: R.....................

.......... Children (2 to under 16 years)　: R.....................

.......... Amount for Vehicle　　　　　　: R.....................

.......... Children (under 2 years)　　　　: Free

VALID FOR ONE ENTRY

SEE REVERSE SIDE

Date Issued: 9 12-07

Vehicle Reg. No.: MHC 918 GP

Falcon Press

6315 ✳

2005 ✳

6882 ✳

INSPECTED BY NR 1

№ 69209

BALI TOURISM DEVELOPMENT CORPORATION

NusaDua

NUSA DUA SHUTTLE BUS

Rp. 1.000,~

GOOD FOR ONE PERSON
AND ONE TRIP ONLY
NOT REFUNDABLE.

✗ " *Le Rubens* „
S.A.

rue de la Montagne 4 - 1000 BRUXELLES

T.V.A. 426.902.839　☎ (02) 511 32 01

Taxe sur la
valeur ajoutée

Note

№ **09380**　**A**

Mais. GUILLAUME 05-89

DATE **16 3-90**

TOTAL A PAYER — TVA et Service compris　**625.-**

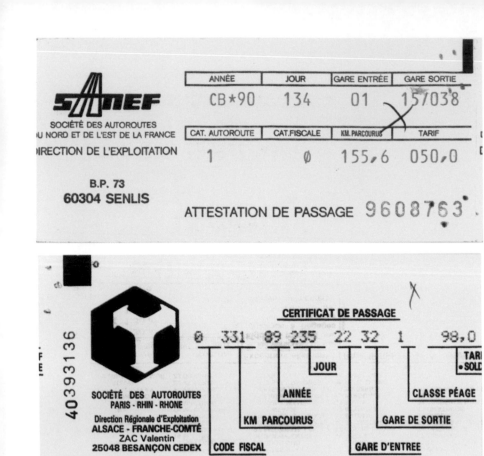

SANEF
SOCIÉTÉ DES AUTOROUTES
DU NORD ET DE L'EST DE LA FRANCE
DIRECTION DE L'EXPLOITATION

B.P. 73
60304 SENLIS

ANNÉE	JOUR	GARE ENTRÉE	GARE SORTIE
CB*90	134	01	157038

CAT. AUTOROUTE	CAT. FISCALE	KM. PARCOURUS	TARIF
1	0	155,6	050,0

ATTESTATION DE PASSAGE 9608763

40393136

SOCIÉTÉ DES AUTOROUTES
PARIS - RHIN - RHONE
Direction Régionale d'Exploitation
ALSACE - FRANCHE-COMTÉ
ZAC Valentin
25048 BESANÇON CEDEX

CERTIFICAT DE PASSAGE

0 331 89 235 22 32 1 98,0

JOUR
ANNÉE
CLASSE PÉAGE
KM PARCOURUS
GARE DE SORTIE
CODE FISCAL
GARE D'ENTREE

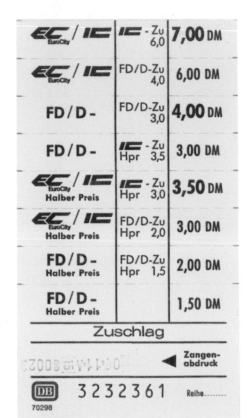

			7,00 DM
EC/IC EuroCity	IC -Zu 6,0		7,00 DM
EC/IC EuroCity	FD/D-Zu 4,0		6,00 DM
FD/D-	FD/D-Zu 3,0		4,00 DM
FD/D-	IC -Zu Hpr 3,5		3,00 DM
EC/IC EuroCity Halber Preis	IC -Zu Hpr 3,0		3,50 DM
EC/IC EuroCity Halber Preis	FD/D-Zu Hpr 2,0		3,00 DM
FD/D- Halber Preis	FD/D-Zu Hpr 1,5		2,00 DM
FD/D- Halber Preis			1,50 DM

Zuschlag

◄ Zangen-abdruck

DB 3232361 Reihe.........
70298

CE TICKET N'EST VALABLE QUE MUNI
DE SES DEUX TALONS DETACHABLES

ACCES PAR ASCENSEUR
VALABLE POUR UNE ENTREE

3 E AGE 12-17 GROUPE

DATE DE LA VISITE	PRIX
13-03-97	28.00 F

DATE EMISSION	CAISSE	TRANS	SERIE
13-03-97	CAS004	595	1299

Ce billet est exclusivement valable pour la période et éventuellement l'heure indiquées. Il
ne peut être ni vendu, ni remboursé, ni échangé. Le porteur ne pourra formuler aucune
..., ni demander d'indemnité en cas de force majeure ou d'événement indépen-
... volonté de la Société Nouvelle d'Exploitation de la Tour Eiffel susceptible de
... fonctionnement de la Tour Eiffel, et d'entraîner, le cas échéant, sa
... partielle au public".

D 30

CHARGE NOTE

Hotel ..

Date ..

Name ..

Room No. ..

Charge for ..

Code

£	£	p	p

Amount

Signature ..

1/ANZUG	A;	4/SOMMERMANTEL	SM;
2/LEICHTANZUG	LA;	5/SACCO	S;
3/WINTERMANTEL F03	WM;	7/COMPOSE-WA.	C;

MAT.-E	KD.-E	ZE.	FUTTER	BUNDPLAD	SA.	SA.-KURZTEXT
550		3	460	901		

FORM.-NR.	ARTIKEL-NR.		SL	STÜCK	GRÖSSE
510461	112500	01		9	50

KUNDEN-NR.	GESAMT-STÜCK	LIEFERTERMIN
541999	53	1511/1511

FORM-BEZEICHNUNG	COMP.-NR. A
AZ Daniel 50 H-Cream	Zungen

AB/POS-NR.	KOMPL.-NR.	S.-DATUM/NR.
20510048002	1712528	PS

1712 5284
charcoal 01037681 00005

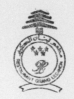

مطعم لبنان الكبير
الرياض - السليمانية
شارع الأمير ممدوح بن عبد العزيز (الثلاثين)
ص.ب ١٧٥٦١ الرمز البريدي ١١٤٩٤
هاتف : ٤٦٣١٨٨٨ - ٤٦٥٨٧٠٥
جوال : ٠٥٥٢٠٢١٠٦

٠٣٢٨٦٧

المطلوب من :

السعر	الصنف
١٢٠	حشاش
٧٥	رياش
٥٥	مشكل
١٥	كبة
١٠٠	مسين
٩٠	عنب
٥٢٥	

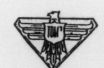

TOM's SILVER
M A N U F A C T U R E
Jl. Ngeksigondo No. 60
Kotagede Yogyakarta 55172
Indonesia
Phone 72818, 73070
Telex : 25416 TOM's I a

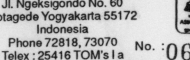

No. : 06184

Banyaknya Quantity	Keterangan Descriptions	Harga Unit Price	Jumlah Harga Total Price
1	BRACELET 158		₱58
		Dis 10%	
		$52	

Silver Alloy 838-925 Guaranted

Yogyakarta, 25/III..... 93
Management

All, that has been bought and
paid up is not returnable

29

ΑΓ. ΡΟΥΜΕΛΗ
AG. ROUMELI

ΑΝΕΝΔΥΚ ΕΔΡΑ : ΑΓ. ΡΟΥΜΕΛΗ - ΧΑΝΙΑ
ΤΗΛ. (0825) 91251 & 91221 ● ΑΦΜ 94124008

ΤΙCΚΕΤ - ΕΙΣΙΤΗΡΙΟ

Β΄ Δ.Ο.Υ. ΧΑΝΙΩΝ

№ 69655

ΚΝ	2273
ΛΤ	114
ΝΑΤ	20
ΦΠΑ	193
ΣΥΝ	2600

ΣΦΑΚΙΑ - ΑΓ. ΡΟΥΜΕΛΗ - ΣΦΑΚΙΑ
SFAKIA - AG. ROUMELI - SFAKIA

ΤΟ ΕΙΣΙΤΗΡΙΟ ΔΕΙΧΝΕΤΑΙ ΣΕ ΚΑΘΕ ΖΗΤΗΣΗ.
TICKET MUST BE SHOWN AT ANY CONTROL
ΕΥΧΑΡΙΣΤΟΥΜΕ - THANK YOU.

ΣΦΑΚΙΑ
SFAKIA

ΑΝΕΝΔΥΚ ΕΔΡΑ : ΑΓ. ΡΟΥΜΕΛΗ - ΧΑΝΙΑ
ΤΗΛ. (0825) 91251 & 90221 ○ ΑΦΜ 94124008

ΤΙCΚΕΤ - ΕΙΣΙΤΗΡΙΟ

Β΄ Δ.Ο.Υ. ΧΑΝΙΩΝ

№ 69656

ΚΝ	2273
ΛΤ	114
ΝΑΤ	20
ΦΠΑ	193
ΣΥΝ.	2600

ΣΦΑΚΙΑ - ΑΓ. ΡΟΥΜΕΛΗ - ΣΦΑΚΙΑ
SFAKIA - AG. ROUMELI - SFAKIA

ΤΟ ΕΙΣΙΤΗΡΙΟ ΔΕΙΧΝΕΤΑΙ ΣΕ ΚΑΘΕ ΖΗΤΗΣΗ.
TICKET MUST BE SHOWN AT ANY CONTROL
ΕΥΧΑΡΙΣΤΟΥΜΕ - THANK YOU.

MRS U/MR Y BACKE
DER TOURS #15

Name

527

Room Number

For your safety, the room number
is encoded on your key. Retain
this envelope for easy recall of
your room number. When
checking out, please bring
your key to the Front Desk.

HOTEL GEORGIA

801 WEST GEORGIA ST.
VANCOUVER, B.C. V6C 1P7
(604) 682-5566

Budi Susanto
S T Y L E
BRIDAL & BEAUTY SALON
JL. C. SIMANJUNTAK 24, PHONE : 4259 YOGYAKARTA
JL. JEND. SUDIRMAN 19, PHONE : 63036 - 61910 (SANTIKA HOTEL) YOGYAKARTA

NAME : ...

ADRESS : ...

DATE : 24 - 11 - 93

*	Make up	Rp.
*	Cuci, blow, styling	Rp. 20.000,-
*	Gunting, cuci & blow	Rp.
*	Keriting pendek / panjang	Rp.
*	Keriting bulu mata	Rp.
*	Set pendek / panjang	Rp.
*	Sanggul modern / daerah	Rp.
*	Meluruskan rambut pendek / panjang	Rp.
*	Cat rambut pendek / panjang	Rp.
*	Creambath	Rp.
*	Menicure - Pedicure	Rp.
*	Facial	Rp.
*	Lain-lain	Rp.
	TOTAL Rp.	20.000,-

№ 03367

TERIMA KASIH

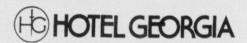

٥٠٠ فلس تبرع بدل خدمات
500 Fils For Services
Mount Nebo جبل نيبو
Thanks for the visit
(شكراً للزيارة)

٥٠٠ فلس تبرع بدل خدمات
500 Fils For Services
Mount Nebo جبل نيبو
Thanks for the visit
(شكراً للزيارة)

139

Royal Orchid Sheraton Hotel
Local Taxi-Meter

ZAXOPHONE

No#.............................

Desti.............................

Plate.. 74 6696

Remark

1) Please keep this card for your own
record in case you have left
behind any items.
2) The hotel is not responsible for any
Liability for this public taxi.
3) Thai law requires the taxi driver to
use the meter at all times.

MEWA
Textil-Mietservice

1-4379-0

533

Tag	Stückzahl	Kunden-Nr.
Fr	**1**	**PS.**

VEHICLE PASS — NUMBER **F310426**

INSTALLATION NAME

VEHICLE YEAR	MAKE	MODEL

VEHICLE LICENSE NUMBER	STATE

DESTINATION

BASE EXCHANGE	COMMISSARY
OPEN MESS	MIL HOUSING
DELIV LOCATION	OTHER
EDUC BUILDING	

EXPIRES (Time & Date)	TOTAL NO IN PARTY	ISSUE OFFICIAL (Time & Date)
14:00 31Jul03	(1)	05? 31.6.03

Detached From
AF FORM 75, 20020601 — COPY 1 - VISITOR

SANEF
SOCIÉTÉ DES AUTOROUTES
DU NORD ET DE L'EST DE LA FRANCE
DIRECTION DE L'EXPLOITATION

B.P. 73
60304 SENLIS

ANNÉE	JOUR	GARE ENTRÉE	GARE SORTIE
CB*89	211	01	15/104

CAT. AUTOROUTE	CAT.FISCALE	KM.PARCOURUS	TARIF
1	Ø	155,6	050,0

ATTESTATION DE PASSAGE **1073613**

SANEF
SOCIÉTÉ DES AUTOROUTES
DU NORD ET DE L'EST DE LA FRANCE
DIRECTION DE L'EXPLOITATION

B.P. 73
60304 SENLIS

ANNÉE	JOUR	GARE ENTRÉE	GARE SORTIE
CB*89	224	15	01/031

CAT. AUTOROUTE	CAT.FISCALE	KM.PARCOURUS	TARIF
1	Ø	155,6	050,0

ATTESTATION DE PASSAGE **6107606**

Verein Sport-Gemeinschaft Hanau-Wilhelmsbad

Datum		Einzel		Mannsch.
7				

Bahn	1. Durchg.	2. Durchg.	Bahn	1. Durchg.	2. Durchg.
1	4		0	3	
2	3		10	3	
3	3		11	3	
4	3		12	2	
5	2		13	2	
6	3		14	7	
7	3		15	7	
8	4		16	5	
9	6		17	6	
0	7		18	4	
	Gesamt				

Gesamt aus
2 Durchg. _____ Punkte -Ø _____

RSU. SANGLAH DENPASAR	No. C.M. OPD.				
	2 9 1 9 0 5				

NOMOR INI SANGAT DIPERLUKAN
JIKA SAUDARA BEROBAT ULANG

N A M A : BACKE, YORCK-DIETR

U M U R : 5? Lk. Pr.

A L A M A T : BALI SOL
GERMANY

№ 089011 PRECIO: **3,50 €**

N.I.F. 31.250.891-D

10 años
1994-2004
TORRE **TAVIRA**
C A M A R A O S C U R A

c/ Marqués del Real Tesoro, 10.
11001 Cadiz (España)
Tlf. y Fax: 956 21 29 10.

www.torretavira.com

قرية الجفتون السياحية

ايصـال تليفون

مه ٠٠٠٧٣١

التاريخ 19.20 11 89

أستلمت انا /

رقم التليفون : 20270914

الجهـة : FRANCE

المـدة : 4 m

القيمـة : 33 جنيه ملم فقط

التوقيـع :

رقم الغرفة :

№)68637
BALI TOURISM DEVELOPMENT CORPORATION

NusaDua

NUSA DUA SHUTTLE BUS

Rp. 1.000,~

GOOD FOR ONE PERSON
AND ONE TRIP ONLY
NOT REFUNDABLE.

ΣΦΑΚΙΑ
SFAKIA

ΑΝΕΝΔΥΚ ΕΔΡΑ : ΑΓ. ΡΟΥΜΕΛΗ - ΧΑΝΙΑ
ΤΗΛ. (0825) 91251 & 90221 ⬦ ΑΦΜ 94124008

TICKET – ΕΙΣΙΤΗΡΙΟ

ISSUED
AG 1996
SFAKION
A SFAKION

B.Δ.Ο.Τ XANION

№ 69655

ΚΝ	2273
ΛΤ	114
ΝΑΤ	20
ΦΠΑ	193
ΣΥΝ.	2600

ΣΦΑΚΙΑ - ΑΓ. ΡΟΥΜΕΛΗ - ΣΦΑΚΙΑ
SFAKIA - AG. ROUMELI - SFAKIA

ΤΟ ΕΙΣΙΤΗΡΙΟ ΔΕΙΧΝΕΤΑΙ ΣΕ ΚΑΘΕ ΖΗΤΗΣΗ.
TICKET MUST BE SHOWN AT ANY CONTROL
ΕΥΧΑΡΙΣΤΟΥΜΕ - THANK YOU.

1 № 140325

Empresa: *los amarillos, s.l.*

B-41/000134

Recorrido: **CHIPIONA**
SEVILLA

Viajero:

IMPORTE	PRECIO	
	Ordinario	Reducido
Incluido S.O.V. e I.V.A	940	
Pesetas		

Fecha - 8 OCT. 1995

Salida **11** Horas

Coche Asiento

MUSÉE HISTORIQUE
DE LA 2ème GUERRE MONDIALE

(Uniformes - Armement - Canons - Véhicules)

Entre Calais et Boulogne sur la côte
D 940 • 62164 AMBLETEUSE
Tél. 21.87.33.01

ENFANT
Entrée : 10 F

№)00307

RCS Calais B 350 007 324

TNT Express Worldwide/Chronopost

712639483

C/N: 01/01 A I R **1**

ORIGIN: VIA:
LYF 19/06/98
FRTX FRT

980619 21:08 CPOST
1e03 LYF

C

DESTINATION:

DELIVERY POSTCODE:
FRANKFURT A **FRT**

60329 D GERMANY

ACC KIT ASSY,APLVISION
1710 DISPLAY

DX50200179WA

DEUTSCH

DATE:22/12/95

Frankfurt
60.

801

NM:ECKART/PETERMR

SEQ : **073**
STN : RIYADH
DATE:10FEB

FRA

LH 0593 10FEB

INS 1) P 2) P 3) S

AIR FRANCE
FRANCFORT
FRA AF 2118 /
CDG AF 083A /

0057 AF 124558
SFO24AUG05 028 1/011Kg
WIPPERMANN/

AIR FRANCE
FRANCFORT
FRA AF 2118 /
CDG AF 083A /

0057 AF 124556
SFO24AUG05 028 1/020Kg
WIPPERMANN/ANNET

213

Nº 67953

ΑΧΘΟΦΟΡΙΚΑ ΔΙΚΑΙΩΜΑΤΑ ΛΙΜΕΝΟΣ ΠΑΡΟΥ
PORTERAGE FEES OF PAROS PORT

ΑΧΘ. ΔΙΚΑΙΩΜΑΤΑ		0,22
ΔΩΡΟ	15%	0,033
ΑΔΕΙΑ	15%	0,033
Μ.Ε.Ε.	14%	0,031
ΜΕΡ. ΣΥΝΟΛΟ		0,317 ~ 0,32
Ι.Κ.Α.	32,11%	0,10
ΚΑΦ	6%	0,02
★ ΓΕΝ. ΣΥΝΟΛΟ € 0,44		

Κ.Υ.Α. ΑΡΙΘ. 10234 - ΦΕΚ 115-Β'/07-02-2000

FR 07103498

COLUMBUS CRUISE CENTER

KA 12Parkp 21.05.05 14:06
Rechnung 00

Kurzparkticket
1 - Nr. 032218
21.05.05 12:49 -
21.05.05 15:48
Dauer 0d02h59'
(USt.) €2,00

Gesamt brutto €2,00

Bezahlung
Bar €2,00

Alle Beträge in EUR.
Lieferdat.=Rechnungsdat.

0220603802
LH603802 BN 46

WIPPERMANN/HANNA 03

TO **FRA**

LH 455 / 24

VIA _____

VIA _____

VIA _____

0220LH603802 LH455/24AUG

0220LH603802 LH455/24AUG

PRINCE OF WALES THEATRE

Coventry Street, London, W1D 6AS
0870 850 0393

MAMMA MIA!
3:00 PM
Saturday
24-JULY-2004

DOOR B
STALLS
L33
Mr A Eggert

ADULT
Booking ref:
902611
£48.25 + 75p
Restoration Levy

Eintrittskarte 006566
Palmengarten -> Cafe
Ein: 13.06.2004 12:53:53

1083030542302530 00

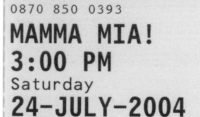

Room no.

Radisson SAS
HOTELS & RESORTS

Bodensee-Schiffsbetriebe **BSB**

Schifffahrt zu den Bregenzer Festspielen

am ___13.08.___ 2005

ab Lindau oder Bad Schachen

Abfahrt		Ankunft
19.35 Uhr	Lindau	ca. 00,15 Uhr
20.00 Uhr	Bad Schachen	ca. 24.00 Uhr
Ankunft Seebühne		**20.25 Uhr**

Rückfahrt nach Vorstellungsende.
Bitte achten Sie auf die Lautsprecherdurchsagen der Bregenzer Festspiele.

€ 15,– inkl.
- Begrüßungsdrink
- Vorverkaufsgebühr
- Hin- und Rückfahrt mit Sonderschiff

5405

M A L T A

HILTON

No. ___65707___

For security reasons, staff are directed not to give you your room key unless you produce this card which is your means of identity. On settling your bill, the Cashier will ask you to hand in this identity card.

The Management

L.50.01

SAT COSTA DE ALMERIA

Reg.(CE)n°1148/2001

Oper.n°04/F04257028/002

And.R.I.A. n°04/40.349

ZUCCHINI

HERKUNFT:
SPANIEN
KLASSE I
KAL.:M (14/21)

FÜLLNETTOGEWICHT:

1 Kg

V	1606	

Artikel	VK
14-82 61 700	38.00 EUR 0088
Größe 25	

Artikel	VK
00-61 60 547	27.90 EUR
Grösse 26	0024

Artikel	VK
Größe	

Furnituren	Strümpfe

⌾ **Lufthansa**

BAGGAGE IDENTIFICATION TAG

LH 736012 **Gran Canaria**

LH 736013 ...TIFICATION TAG

Gran Canaria

EC/IC EuroCity	FD/D-Zu 4,0	6,00 DM
FD/D-	FD/D-Zu 3,0	**4,00** DM
FD/D-	IC-Zu Hpr 3,5	3,00 DM
EC/IC EuroCity Halber Preis	IC-Zu Hpr 3,0	3,50 DM
EC/IC EuroCity Halber Preis	FD/D-Zu Hpr 2,0	3,00 DM
FD/D- Halber Preis	FD/D-Zu Hpr 1,5	2,00 DM
FD/D- Halber Preis		1,50 DM

Zuschlag

◀ Zangen-abdruck

DB 4395128 Reihe.........
70298

5,–

www.nh-hotels.com

nH
HOTELES

▼ Insert and remove

Hotel Santika

YOGYAKARTA

Jl. Jendral Sudirman 19 Yogyakarta 55233 PO.Box 27 YKGD
Telp. (0274) 63036, 61910. Fax. (0274) 62047, Telex 25630 STKIA

MINI-BAR CHARGE VOUCHER

Dear Guest

According to our records, the following items have been consumed from your Mini Bar. Your account will be charged accordingly.
Should you have some drink from your Mini Bar on the day of your departure, please fill in this voucher and hand it to front Office Cashier at check out time.

We hope you enjoyed this facility.
Thank you.

Tamu Hotel Santika yang terhormat,

Sesuai dengan catatan kami, minuman minuman tersebut dibawah telah Anda nikmati dari Mini Bar Anda. Penagihannya akan kami masukkan ke dalam rekening Anda.
Andaikata menikmati minuman dari Mini Bar pada hari keberangkat-an Anda, mohon daftar minuman diisi dan diberikan kepada Front Office Cashier pada waktu check out.

Mudah mudahan anda puas dengan pelayanan kami.
Terima kasih.

Nº 003069

Per Stock	Items	Con sumed	Unit Price	Amount
2	Mineral Water	2	Rp. 3250	
1	Orange Juice		Rp. 5250	
1	Apple Juice		Rp. 5250	
1	Beer- (Can)		Rp. 6750	
1	Guiness Beer		Rp. 9250	
1	Green Sand - (Can)		Rp. 5000	
1	Tonic Water		Rp. 3500	
1	Fanta		Rp. 3500	
1	Coca cola		Rp. 3500	
1	Coke (Can)		Rp. 5000	
1	Sprite		Rp. 3500	
1	Seven up (7 UP)		Rp. 3500	
1	Soda water		Rp. 3500	
1	Pineapple Juice		Rp. 5250	
1	Chocolate		Rp. 3500	
1	Mate (Cashew nut)		Rp. 2500	
1	Peanut		Rp. 2000	
1	Mixed Peanut		Rp. 3500	
1	Pocari Sweat		Rp. 4500	
TOTAL AMOUNT PAYABLE				

PLS. PRINT NAME	ROOM NO.	SIGNATURE	CHECKER
	203.		

SOLFERINO PRESSING

Nettoyage à sec de haute qualité
Spécialiste **DAIM et CUIR**
198, Rue Solferino
59000 LILLE - Tél. 20 54 97 10
SIRENE 302 106 315 00021

MODÈLE OFFICIEL

NOM *Roke* DATE *30 6 90*

ADRESSE

| SERVICE ÉCONOMIQUE ☐ | SERVICE SOIGNÉ ☐ | SERVICE HAUTE QUALITÉ ✓ |

LU	MA	ME	JE	VE	SA		Nº	PRIX
	✓					Pantalon	1	
						Veste	2	15·90
						Costume 2 pièces	3	
						Robe	4	
						Jupe	5	
						Manteau	6	
						Imper	7	
						Pull-Over	8	
						Tailleur	9	
						Blouson	10	
						Chemisier	11	
							12	
						TOTAL		

04 - MOORE PARAGON - PROFFORM - Imprimé en France

Etiquetage composition insuffisant ☐	Autres réserves ☐
Coloris éventuellement instable ☐	RÉSERVES ☐
Tache éventuellement indélébile ☐	☐

CONDITIONS : Conformément aux stipulations de l'engagement national de l'entretien des textiles dont extrait figure au verso.
Valeur d'achat : le client reconnaît avoir pris connaissance des conditions de remboursement, indiquées au barème affiché dans le magasin. S'il estime la valeur de l'objet confié supérieure aux montants dudit barème il doit en signaler la valeur d'achat au moment de la remise de l'objet.
En cas de différend, vous pouvez exiger que soit établi un constat de réclamation.

5198

Gäste-Ausweis
Guest ticket
Tagesausweis Day ticket
Beim Verlassen der Ausstellung werden
Tagesausweise ungültig.
The validity of a day ticket
expires with departure from the exhibition.

007 6 03 1 0840555 04

Tg Verkauf verboten

Die Berechtigung zum Zutritt zur Veranstaltung
erlischt durch den Verkauf dieses Ausweises.

Sale strictly forbidden

This ticket becomes invalid if sold.

643856/002
Ascom AG

Belpstrasse 37
CH / 3000 / Bern 14
Halle 017 A38

007 6 03 1 0840555 04

SCHIRN KUNSTHALLE FRANKFURT

Dauerkarte

[signature]

Die Dauerkarte ist nicht übertragbar und nur zusammen mit dem
Personalausweis gültig

HTI No. 46234

香港快達客輪有限公司
HSF Hongkong Hi-Speed Ferries Ltd.
B22
經濟位 TOURIST CLASS

香港 至 澳門
Hongkong to Macau

開航日期
Sailing Date 2 SEP 1991
開航時間
Sailing Time
票價 $43 +20 (Fees) = $63.00
Fare $68
 FARE + FEE

IMPORTANT : FOR CONDITIONS SEE BACK
VIDE CONDIÇÕES NO VERSO
重要事項：有關條件，請參閱背頁。

Münchner Stadtmuseum
mit Filmmuseum
St.-Jakobs-Platz 1, 80331 München U-Bahn Marienplatz

Druck: Beckerbillett Hamburg (019)

Herr Zwilling

23.11.99 21:15 Uhr
Parkett 8,00 DM

094592 Auf Verlangen vorzeigen. Ohne Preisaufdruck ungültig.

STUDENT
$4.50

9/25/92

12:18PM

Retain For Re-Entry

The Museum... New...

Münchner Stadtmuseum
mit Filmmuseum
St.-Jakobs-Platz 1, 80331 München U-Bahn Marienplatz

Druck: Beckerbillett Hamburg (090)

FREIKARTE
STADTMUSEUM

am 05. Oktober 2001 0,00 DEM

KA201/81434/12:31
239940

Auf Verlangen vorzeigen. Ohne Preisaufdruck ungültig.

WELLS FARGO BANK

ATM No.	Date	Time	Type	Trans. No.
0004A	09-21-92	08:05PM	01	00674

Customer No.	Location
5232950030005453	BROADWY GRANT

Account Accessed	Amount	Total Balance
CHECKING $	200.00	UNAVAILABLE

* See reverse for important information.

THANK YOU FOR USING EXPRESS ATM

HOME LOAN INFORMATION
1-800-CALL-WFB

€ 5.-
€ 2.50

HALLHUBER
Nothing but clothes
Umtausch und Reklamation nur
mit diesem Etikett und Kassenbon.

361 108 001 5 082895

ED-BLAZER, WEIß
MISCHGEWEBE
Grösse DM 249,90
40 EUR 127,77

€ 3⁹⁰
GRÖSSE 70030
 2950
 69 77
070 030 100 007 73

DE 4

€ 3⁹⁰
GRÖSSE
31/33

027368 2 3554 54 0

2931

DE/89

356811 11 44 18
Artikel/Style Colour Größe UK-size

87% Polyester
13% Nylon
Lining:
100% Polyester
Taft

Price:

ACOLLINA CON SNOD BLACK

8 023576 249446
16744 B1DN2182GKANE

0 999991 276023
Pull Roller
G Roller
ROUILLE
6 M
existe du 0 au 12 mois

22580

Artikel 021
361 108 001 5
 Fil 011
0007101729
Artikel 021
361 108 001 5
 DM 249,90
3610329040249906 EUR 127,77

DR|

471
021 2022
203 5500548
GROESSE
44
013
€ 169.00
013
356811 11 C⟨

203 550054 8 44

€ 169.00

BALI N.D.
71-KY 037-01
043B0162B-BL
RP 35.000

Flood Your Senses and Adopt a Fish.
A Fish Adoption is a present with a difference. It's fun, unique and ideal
for Birthdays, Christmas, Valentine's Day, Anniversaries and any
other special occasion. Call (020) 7967 8007 or visit
www.londonaquarium.co.uk
NO RE-ENTRY PERMITTED
5721433180000012673106 16/09/05 11:12

AQL:CAS001 Ticket 64 Trans 37
FAMILY £6.25
(Valid for one admission, only when endorsed above)
www.londonaquarium.co.uk
www.londoncountyhall.com

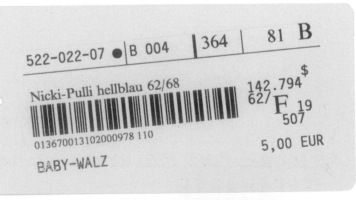
522-022-07 ● B 004 | 364 | 81 B
Nicki-Pulli hellblau 62/68 142.794 $
 627 F
013670013102000978 110 507 19
 5,00 EUR
BABY-WALZ

8908891212L

mit Hilfe

218

IKEA ®
Design and Quality
IKEA of Sweden
Made in Turkey

17436

CA 05404

US :Machine wash. No bleach. Iron
Tumble dry, normal temperature.

WLT353

Made in Turkey
IKEA ®
0023
500.243.91 17436

Made in Turkey
IKEA ®
0020
500.243.91 17436

GIFTIG

80020018189379

DOLCE & GABBANA
MADE IN ITALY

6506

97% **Cotton**
3% **Spandex**

NO WASH IN WATER
NO BLEACH
WARM IRON
DRY CLEANING

18 M+

DKNY

MADE IN
HONG KONG
FABRIQUÉ À
HONG KONG

L
85% COTTON/
COTON
13% NYLON/
NYLON/
2% SPANDEX
ELASTANE/
SPANDEX
ELASTANE
RN 68595

BOSS
HUGO BOSS

EDERICHOMS
THE **FREDERICH**
XL

72% ACETATO
ACETATE
AZETAT
28% POLIESTERE
POLYESTER

MADE IN ITALY

MADE IN VIETNAM
FABRIQUE AU VIETNAM
990305 VP ©
US UK EUR CM
8 7 41 26
602087 011 00

PAT.PAT PEND‡FOR PATS

DD

SHELL: 48% VISCOSE
VISKOS
VISKOSE
VISKOOSIA
48% COTTON
BOMULL
BAUMWOLLE
COTON
KATOEN
PUUVILLAA
4% ELASTANE
ELASTAN
ELASTHAN
ELASTHANNE
ELASTAANIA
LINING: 100% ACETATE
ACETAT
ACETAAT
ASETAATTIA

WASH WITH SIMILAR COLOURS
TVÄTTAS MED LIKNANDE FÄRGER
MIT ÄHNLICHEN FARBEN WASCHEN
LAVER AVEC COULEURS SIMILAIRES
WASSEN MET DEZELFDE KLEUREN
PESTÄÄN SAMANVÄRISTEN KANSSA

30°
48% VISCOSE
VISKOS
VISKOSE
VISKOOSIA
48% COTTON
BOMULL
BAUMWOLLE
COTON
KATOEN
PUUVILLAA
4% ELASTANE
ELASTAN
ELASTHAN
ELASTHANNE
ELASTAANIA

WASH WITH SIMILAR COLOURS
TVÄTTAS MED LIKNANDE FÄRGER
MIT ÄHNLICHEN FARBEN WASCHEN
LAVER AVEC COULEURS SIMILAIRES
WASSEN MET DEZELFDE KLEUREN
PESTÄÄN SAMANVÄRISTEN KANSSA

JANINE ROBIN 4

Francais:
Surface lavable: frotter avec un chiffon
mouillé à l'eau froide
Nouveaux matériaux
Rembourrage: 100% Polyester
Tissu: 100% Coton
Fabriqué pour Habitat Londres W1P 9LD
CE

German:
Oberfläche abwischbar: Mit einem
feuchten Tuch abreiben
Alles neuen materialien
Fullung: 100% Polyester
Bezugsstoff: 100% Baumwolle
Hergestellt fur Habitat London W1P 9LD
CE

Parkschein **von außen gut lesbar**
hinter die Windschutzscheibe legen 654

DREIKRONENSTR.1 9007

PARKZEIT BEZAHLT BIS

öko PAPIER
aus 100% chlorfrei
gebleichten Faserstoffen

BEZAHLT EUR

STD. MIN.

15 JAN 05 14:34 *****0:50

DREIKRONENSTR.1 900

15 JAN 14:34 *****0:50

Dieser Abriss kann als Gedächtnisstütze mitgenommen werden

Parkschein **von außen gut lesbar**
hinter die Windschutzscheibe legen 663

DREIKRONENSTR.1 9007

PARKZEIT BEZAHLT BIS

öko PAPIER
aus 100% chlorfrei
gebleichten Faserstoffen

BEZAHLT EUR

STD. MIN.

15 JAN 05 10:11 *****1:00

DREIKRONENSTR.1 9007

15 JAN 10:11 *****1:00

Dieser Abriss kann als Gedächtnisstütze mitgenommen werden

Eintrittstag: 03.01.99

48 98

50 Jahre LebensmitteLzeitung

2,99 Euro

Aqua Make-up Loewe

Parkschein **von außen gut lesbar**
hinter die Windschutzscheibe legen 1890

VIRCHOWSTR 9022

PARKZEIT BEZAHLT BIS

STD. MIN. BEZAHLT €

12 APR 05 14:53 *****0:20

VIRCHOWSTR 9022

12 APR 14:53 *****0:20

Dieser Abriss kann als Gedächtnisstütze mitgenommen werden

MISSION DU PATRIMOINE PHOTOGRAPHIQUE

HOTEL DE SULLY. PARIS

25 F

*Association française pour la Diffusion du Patrimoine photographique
Association des Amis de Jacques-Henri Lartigue*

N° 89724

Quality Assurance Control

KCW 159

INSPECTED BY NR 1

Boarding commences from the boarding gate, 30 minutes before your flight.

British Airways London Eye

Eye Flight 13/07/2005 18:00

103F5F36B2BD8A9979

Don't forget to visit our gift shop
Fast Track £25.00

Tran:13/07/2005 09:17 Cashier:RIALTO
Order:100841629 Tck:
Tickets are non refundable, non changeable and are not for resale.
Terms and conditions apply – please enquire at County Hall or at ba-londoneye.com
British Airways London Eye is operated by The Tussauds Group.

Boarding commences from the boarding gate, 30 minutes before your flight

British Airways London Eye

Eye Flight 13/07/2005 18:00

10484D69A86FF0A56B

Don't forget to visit our gift shop
Under 5 £0.00

Tran:13/07/2005 09:17 Cashier:RIALTO
Order:100841629 Tck:
Tickets are non refundable, non changeable and are not for resale.
Terms and conditions apply – please enquire at County Hall or at ba-londoneye.com
British Airways London Eye is operated by The Tussauds Group.

Boarding commences from the boarding gate, 30 minutes before your flight.

BRITISH AIRWAYS LONDON EYE
FLIGHT TIME 10:30
BOARDING DATE 23-07-04

WHG5T0V4K00M561F0 23-07-04 10:28

ADULT 11.50
TMT:CAS005 Ticket 137 Trans 59

Tickets are non refundable, non changeable and are not for resale.
Terms and conditions apply – please enquire at County Hall or at ba-londoneye.com
British Airways London Eye is operated by The Tussauds Group.

Boarding commences from the boarding gate, 30 minutes before your flight.

British Airways London Eye

Eye Flight 13/07/2005 18:00

108541AFF2F77D853A

Don't forget to visit our gift shop
Fast Track £25.00

Tran:13/07/2005 09:17 Cashier:RIALTO
Order:100841629 Tck:3
Tickets are non refundable, non changeable and are not for resale.
Terms and conditions apply – please enquire at County Hall or at ba-londoneye.com
British Airways London Eye is operated by The Tussauds Group.

Boarding commences from the boarding gate, 30 minutes before your flight.

British Airways London Eye

River Cruise 07/08/2005 16:45

106E84C672E5BC7DD2

Don't forget to visit our gift shop
Under 5 £0.00

Tran:06/08/2005 20:04 Cashier:CHIPIWA.MATOWANYIKA&BOH
Tickets are non refundable, non changeable and are not for resale.
Terms and conditions apply – please enquire at County Hall or at ba-londoneye.com
British Airways London Eye is operated by The Tussauds Group.

city-parking GmbH

Zentrale Hauptverwaltung:
Alpenstraße 21, 86004 Augsburg,
Telefon 08 21 / 57 70 15

Tiefgaragen Offenbach

Öffnungszeiten:
Bitte beachten Sie den
Aushang im Parkhaus.

Parkticket 001246
Franz.Gäßchen OG
08.07.05 11:52:41

Bitte bezahlen Sie erst, bevor Sie Ihr Fahrzeug aus der Garage fahren.

city-parking GmbH

Zentrale Hauptverwaltung:
Alpenstraße 21, 86004 Augsburg,
Telefon 08 21 / 57 70 15

Tiefgaragen Offenbach

Öffnungszeiten:
Bitte beachten Sie den
Aushang im Parkhaus.

Parkticket 000751
Franz.Gäßchen OG
06.07.05 09:37:26

Bitte bezahlen Sie erst, bevor Sie Ihr Fahrzeug aus der Garage fahren.

Boarding commences from the boarding gate, 30 minutes before your flight.

British Airways London Eye

Eye Flight 07/08/2005 18:00

103B2B2373F7980D0C

Don't forget to visit our gift shop
Fast Track £25.00

Tran:06/08/2005 20:04 Cashier:CHIPIWA.MATOWANYIKA&BOH
Tickets are non refundable, non changeable and are not for resale.
Terms and conditions apply – please enquire at County Hall or at ba-londoneye.com
British Airways London Eye is operated by The Tussauds Group.

Boarding commences from the boarding gate, 30 minutes before your flight.

British Airways London Eye

River Cruise 07/08/2005 16:45

10DDDE931D667B9BB4

Don't forget to visit our gift shop
Under 5 £0.00

Tran:06/08/2005 20:04 Cashier:CHIPIWA.MATOWANYIKA&BOH
Tickets are non refundable, non changeable and are not for resale.
Terms and conditions apply – please enquire at County Hall or at ba-londoneye.com
British Airways London Eye is operated by The Tussauds Group.

Bitte verwenden Sie nur
diese Zahlungsvordrucke !

TIEFGARAGE Congresspark

Gueltig vom 12.06.2005 bis 12.06.2005

Hanauer Parkhaus GmbH

Bereitschaft: Tel. 00181-28600

0908 0300

Ticket
von Oben
nach Unten
durchziehen

```
BelegNr 9421/0602/00602 13.03.0     S. 1/1
Ausw. Parkticket           9,50   R
13.03.04 10:59 - 13.03.04 15:42
Parkdauer: 0 Tg., 4 Std., 43 Min.
Gegeben Ges.              10,00  EUR
Gesamtbetrag               9,50  EUR
MWSt.       16,00 %         1,31  EUR
```

```
Contipark Parkgaragen GmbH

Tiefgarage Hbf.Nordseite

Einfahrt Poststraße

60329 Frankfurt/Main

StNr. 27/413/1002

BelegNr 3727/0621/00621 21.11.04  S. 1/1
Bez. Parkticket            3,00 EUR
21.11.04 19:48 - 21.11.04 20:23
Parkdauer: 0 Tg., 0 Std., 35 Min.
Gegeben Ges.               3,00 EUR
Gesamtbetrag               3,00 EUR
MWSt.       16,00 %         0,41 EUR
```

```
Contipark Parkgaragen GmbH

Parkplatz Hbf.Süd

Karlsruher Straße 15-19

60329 Frankfurt/Main

StNr. 27/413/1002

BelegNr 4056/0603/00603 06.01.05  S. 1/1
Bez. Parkticket            2,50 EUR
06.01.05 15:56 - 06.01.05 16:38
Parkdauer: 0 Tg., 0 Std., 42 Min.
Gegeben Ges.               2,50 EUR
Gesamtbetrag               2,50 EUR
MWSt.       16,00 %         0,34 EUR
```

Lief Nr:100884

Lieferwoche:010

CLEMATIS HYBRIDE
GROSSBLUMIGE WALDREB
STANDORT:
BODEN:
BLÜTE:
1909417

7,50

222

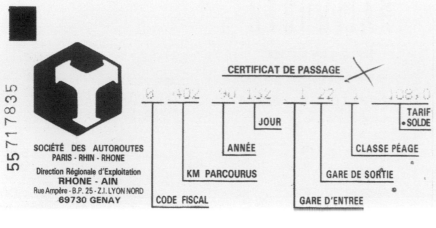

SOCIÉTÉ DES AUTOROUTES
PARIS · RHIN · RHONE
Direction Régionale d'Exploitation
RHONE - AIN
Rue Ampère · B.P. 25 · Z.I. LYON NORD
69730 GENAY

55717835

CERTIFICAT DE PASSAGE
JOUR
ANNÉE
KM PARCOURUS
CODE FISCAL
CLASSE PÉAGE
GARE DE SORTIE
GARE D'ENTREE
TARIF · SOLDE

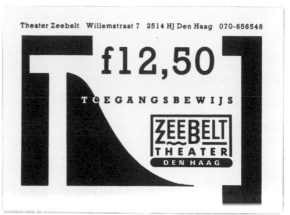

Theater Zeebelt Willemstraat 7 2514 HJ Den Haag 070-656546

f12,50

TOEGANGSBEWIJS

ZEEBELT
THEATER
DEN HAAG

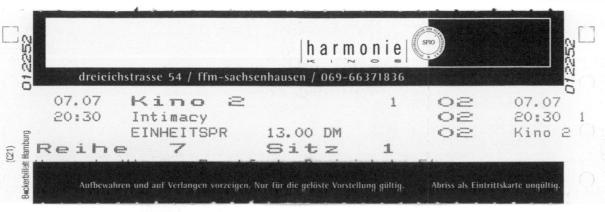

harmonie
KINOS
SPIO

dreieichstrasse 54 / ffm-sachsenhausen / 069-66371836

012252

07.07	Kino 2		1	02	07.07
20:30	Intimacy			02	20:30 1
	EINHEITSPR	13.00 DM		02	Kino 2

Reihe 7 Sitz 1

Aufbewahren und auf Verlangen vorzeigen. Nur für die gelöste Vorstellung gültig. Abriss als Eintrittskarte ungültig.

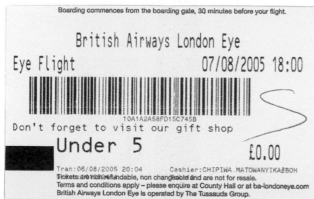

Boarding commences from the boarding gate, 30 minutes before your flight.

British Airways London Eye

Eye Flight 07/08/2005 18:00

10A1A2A58FD15C745B

Don't forget to visit our gift shop

Under 5 £0.00

Tran:06/08/2005 20:04 Cashier:CHIPIWA.MATOWANYIKA$BOH
Tickets are non refundable, non changeable and are not for resale.
Terms and conditions apply – please enquire at County Hall or at ba-londoneye.com
British Airways London Eye is operated by The Tussauds Group.

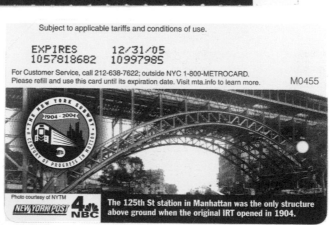

Subject to applicable tariffs and conditions of use.

EXPIRES 12/31/05
1057818682 10997985 M0455

For Customer Service, call 212-638-7622; outside NYC 1-800-METROCARD.
Please refill and use this card until its expiration date. Visit mta.info to learn more.

1904 - 2004
A CENTURY OF PROGRESS IN MOTION

Photo courtesy of NYTM NEW YORK POST 4 NBC

The 125th St station in Manhattan was the only structure
above ground when the original IRT opened in 1904.

天授庵

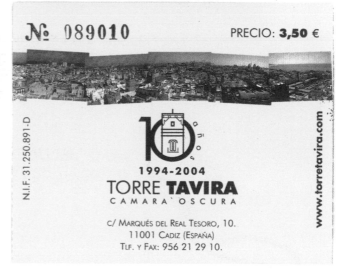

№ 089010 PRECIO: 3,50 €

10 años
1994-2004

TORRE TAVIRA
CAMARA OSCURA

N.I.F. 31.250.891-D

c/ Marqués del Real Tesoro, 10.
11001 Cadiz (España)
Tlf. y Fax: 956 21 29 10.

www.torretavira.com

12.......D

产品合格证

款号： 4KWH8227CA

款式： 毛领长袖开襟外套

尺码： M

成份： 85%腈纶
15%羊毛

面料：

等级： 合格品

标准： FZ/T73005-2002

本品洗涤方法

014
4KWH8227CA M

1000276747 RMB 369.00

€ 2.90

GRÖSSE
13/15

070641 2 3174 77 5

6541/R

DE/89

HALLHUBER

Nothing but clothes
Umtausch und Reklamation nur
mit diesem Etikett und Kassenbon.

321 752 001 5 082747

ED-T-SHIRT, OLIV
"LONDON"

Grösse DM 29,90
L EUR 15,29

Artikel 031
321 752 001 5

3211979040029904 DM 29,90 EUR 15,29

style	color	size	
221125	041	D	42
CORP. BLOUSE		F	44
		I	46
		UK	16
		USA	12

4 011814 252062

D	unverbindliche Preisempfehlung		DM	59,90
NL	aanbevolen detailhandelsprijs		HFL	69,95
B	aanbevolen detailhandelsprijs	BFR FRB	1299,00	
F	prix detail suggéré		FF	225,00
A	unverbindlich empfohlener Verkaufspreis		ÖS	449,00
SF	OVH		FIM	199,00
I	prezzo consigliato		LI	69900
DK	vejledende udsalgspris		DKR	249,00
S	rekommenderat cirkapris		SKR	299,00
UK	recommended retail price		£	22,00
CH	unverbindliche Preisempfehlung		SFR	59,90

42

010 0510355 999 204Z

Groesse
99 € 6,95

01045213 00002 PA
6616 63 019600 10
H Hose Gin

52

Oberstoff/outershell:
97% Baumwolle
3% Elasthan
Futter/lining:
60% Viscose
40% Polyester

52 3

88 4 10

2052 5965

30 P

209474
10/04
6434258
914 50 8333 10 3
Thermo-Fingerhands.

4 042733 726310

EURO 3,99

Artikel 031
321 752 001 5

FII 011

0007225981

Artikel 031
321 752 001 5

3211979040029904 DM 29,90 EUR 15,29

GB

SA

€ 3.90

GRÖSSE 57193
ONESIZE 3945
 51 52

057 193 148 145 28

DE 4

1599 RIBB V-NECK CHARC M

931022290000

9 316393 198127

$59.00

92386 JELLY MORO

* N A 4 9 2 3 8 6 J E 1 9 *
N A4 001 **Lab. 54**

29342 JELLY NATURALE

* L P 5 2 9 3 4 2 J E 5 8 *
L P5 033 **Lab. 02**

010 0507829 999 204Z

Groesse
99 € 6,95

Artikel 00130F Fabric 00ROT

GONNA DUSTYN

w M L Colour 900

COMK 0952

8 300996 620476

Nº 010648

THE ALL ENGLAND LAWN TENNIS CLUB

LEFT LUGGAGE OFFICE

Number of Articles:

..

XH

NM: ECKART/PETERMRSEQ: 073

FRA LH 0593 /10FEB

0000 XH 035213

||||||||||||||||||||||||||

0000 XH 00012

Carrier
Ryanair

Flight	Date
FR4623	08JUN

Dest	Seat Number

XRY

Sec. No
138

Brentanobad

#1770281107 07.07.2003 16:19

EK Erw. 3.00
Gültigkeit 07.07.2003-07.07.2003

Art.-Nr.: 09380
SPEZIAL-BESCHLAGSSCHRAUBEN
6,3x25 mm, Panhead, verzinkt
fuer Transportrollen
8 ST/PC/PZ

4 008057 093804

VIS SPECIALES	SPECIAALSCHROEVE
SPECIAL SCREWS	SPECIALSKRUER
VITI SPECIALI	TORNILLOS ESPEC.

VÄLKOMMEN
530
04 AUGUSTI KL 12:51
FONDSPARA FOR HÖG LANG-
SIKTIG TILLVAXT.
PENSIONSSPARA, SA AR DET
AVDRAGSGILLT

113/1/6785/072/0

832 31	BTG: 31.08.	B: 351.07

KG

VOL (GES/LW):	0,058 /	0,058 CBM
GEW (GES/LW):	6,500 /	5,650 KG
GEW.-STAFFEL:	T	
TOLERANZ :	6,320 -	6,710 KG

|||||||||||||||||||||||||

113/1/6785/072/0

A 31.08. 7:28

11 45 23 XXL 95.--

||||||||||||||||||||

01000405363512

01
6031601

09.05.2003

postmodern
Der Business-Briefdienst

Tel. 0800 / 60 123 60

Kontrolle
04.11.02

11 45 6 XXL 95.--

11 45 6 XXL 95.--

11 45 6 XXL 95.--

11 45 6 XXL 95.--

SERVICE DE CONTROLE

25

En cas de réclamation rappeler ce numéro

marine mit weiTREND

142 220330... 051 505Z

Groesse 5

9,- € 15,95

marine mit oraTREND

142 22033... 051 505Z

Groesse 5

9,- € 15,95

rot mit weiss TREND

142 2203291 051 505Z

Groesse 5

9,- € 15,95

€ 7,90

GRÖSSE 57414
62 6564
8977

057 414 106 237 73

DE4

H.M

4
312- Leder
40 GABLER
Frankfurt Zeil

ARTIKELPASS · BITTE AUFBEWAHREN

166-06-038
FRISKY3
FUNNY FACE 300

EURO 2002

REIT - S 20

23.3.04 ✓ ZSPNL

5
411- Leder
40+7 GABLER
Frankfurt Zeil

ARTIKELPASS · BITTE AUFBEWAHREN

166-06-010 70
SPICY 3 GIRAFFE
FUNNY FACE 300 SER.

EURO 2002

31.1.0 05

B B - S 20 ✓

APNL ✓

1
407- Leder
2D GABLER
Frankfurt Zeil

ARTIKELPASS · BITTE AUFBEWAHREN

92386
JELLY LEATHER

070605

EURO 2002

DA T - N 11

1
310- Leder
40+B GABLER
Frankfurt Zeil

ARTIKELPASS · BITTE AUFBEWAHREN

166-06-025
SMILE3 GIRAFFE
FUNNY FACE 300

EURO 2002

RU S - S 20 ✓

23.04 EVPNL

6
411- Leder
40+7 GAB
Frankf

ARTIKELPASS · BITTE AUFF

166-06-021
CHILLY GIRAFFE
FUNNY FACE 300 SER.

31.1.05

EURO 2002

SLAE S 20 5

BPNL

411- Leder
40+7 GABLER
Frankfurt Zeil

ARTIKELPASS · BITTE AUFBEWAHREN

166-06-010 70
SPICY 3 GIRAFFE
FUNNY FACE 300 SER.

31.1.05

EURO 2002

B - S 20

APNL ✓

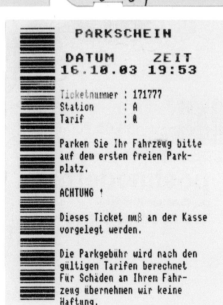

PARKSCHEIN

DATUM ZEIT
16.10.03 19:53

Ticketnummer : 171777
Station : A
Tarif : A

Parken Sie Ihr Fahrzeug bitte
auf dem ersten freien Park-
platz.

ACHTUNG !

Dieses Ticket muß an der Kasse
vorgelegt werden.

Die Parkgebühr wird nach den
gültigen Tarifen berechnet
Für Schäden an Ihrem Fahr-
zeug übernehmen wir keine
Haftung.

2
02- Leder
8 GABLER
Frankfurt Zeil

ARTIKELPASS · BITTE AUFBEWAHREN

29342
NANINI

070605

EURO 2002

GE B - N 11

PARKSCHEIN

Von außen gut lesbar hinter
die Windschutzscheibe legen.

Parkzeitende

15.02. 09:43

Datum 05 Uhrzeit

Krankenh. Nordwest 1
Parkgebühr: 1.00 €

Ausgabe: 15.02. 08:43

Krankenh. Nordwest 1
1.00 € 15.02.05 09:43

Abriß bitte mitnehmen DAMBACH

EXPIRES 06:00PM 17 NOV 99

REMEMBER:
YOU MUST VALIDATE YOUR METCARD
BEFORE EACH TRIP

2-HOUR
FULL FARE
ZONE 1 $ 2.30
ISSUED 03:24PM 17 NOV 1999
019 1417 00071786

07

DM 129⁰⁰

GROESSE 27000
40 1941 9
 21 12

027 000 904 031 22

DE

DM 69⁹⁰

GROESSE 85573
38 1912 9
 80 04

085 573 903 830 43

949 /36/74007/519 D

A 0717.230 1 000 70

DM	EURO
16.-	8.18

X

252 /42/21633/709 D

A 1977.000 0 140 55

DM	EURO
62.59	32.-

140

256188

6,99

**TEEKANNE GOLD-TEEFIX
25ER KANNENPORTION**

+ 64190 W48N 4009300001034 20078 Z 16

STYLE: KCJ45009
COLOR CODE: 101
SIZE: L
WOMEN'S

T8335

6 33233 77499 0

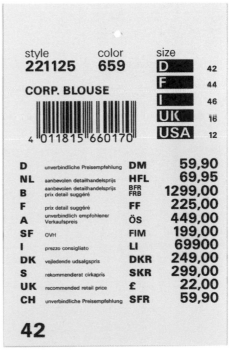

style	color	size	
221125	**659**	D	42
		F	44
CORP. BLOUSE		I	46
		UK	16
		USA	12

4 011815 660170

D	unverbindliche Preisempfehlung	DM	59,90
NL	aanbevolen detailhandelsprijs	HFL	69,95
B	aanbevolen detailhandelsprijs	BFR	1299,00
	prix detail suggéré	FRB	
F	prix detail suggéré	FF	225,00
A	unverbindlich empfohlener Verkaufspreis	ÖS	449,00
SF	OVH	FIM	199,00
I	prezzo consigliato	LI	69900
DK	vejledende udsalgspris	DKR	249,00
S	rekommenderat cirkapris	SKR	299,00
UK	recommended retail price	£	22,00
CH	unverbindliche Preisempfehlung	SFR	59,90

42

11,99

**TWININGS TEE 250G
EARL GREY**

V 64190 W25Z 70177024314 23118 Z 12

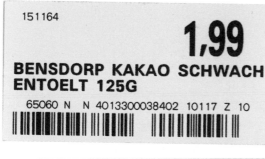

151164

1,99

**BENSDORP KAKAO SCHWACH
ENTOELT 125G**

65060 N N 4013300038402 10117 Z 10

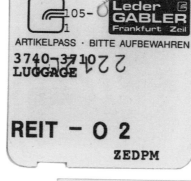

3
105-
1

Leder GABLER
Frankfurt Zeil

ARTIKELPASS · BITTE AUFBEWAHREN

3740-3710
LUGGAGE

221

REIT - O 2

ZEDPM

2000004 809003
9803
332/000 000
40/911/

29,95

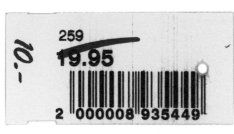

259
19.95
10.-

2 000008 935449

DR| |||||||||||

LE| |||||||||||

2,04 €	**3,99** DM

**MILFORD FAMILY 125G
BROMBEERE/HIMBEERE**

64190 4002221656307 14069 Z 10

134758

1,02 €	**1,99** DM

**BAD HEILB. DEUTSCHER
BRUSTTEE 8ST.**

64190 4008137002450 14069 Z 12

281895

BAR WALTER SPAGHETTI STORE
PIAZZA REZZONICO 7
6900 LUGANO
IVA INCLUSA Nr.456 995
TELEFONO 091 922 20 60

MIGUEL

2 CIOCC.CALDA 5.33Euro 8.00

IVA 7.60 % 0.38Euro 0.57

TOTAL Frs **8.00**
 5.33 Euro
CONTANTI 8.00

VEN.
14-10-2005 14:49:57 CAS 1 4D FATT 000077/1

ARRIVEDERCI E GRAZIE

Kew
ADULT
Valid On: **16/08/05**

KGD:CAS019 Ticket 138 Trans 82

IEGA00VJW00MB803K 16/08/05 11:07

Discover more about the Gardens' plants, landscapes and heritage
with Kew's Guide Book, available at the ticketing desks.
SOUVENIR GUIDE BOOKS AVAILABLE £4.95

KDA/uticktBD Whilst in the Royal Botanic Gardens you are subject to its regulations, copies of which are available at the ticketing desk.

Flood Your Senses and Adopt a Fish.
A Fish Adoption is a present with a difference. It's fun, unique and ideal
for Birthdays, Christmas, Valentine's Day, Anniversaries and any
other special occasion. Call (020) 7967 8007 or visit
www.londonaquarium.co.uk
NO RE-ENTRY PERMITTED
3721433180000012871584 16/09/05 11:12

AQL:CAS001 Ticket 65 Trans 37
ADULT £8.75

(Valid for one admission, only when endorsed above)
www.londonaquarium.co.uk
www.londoncountyhall.com

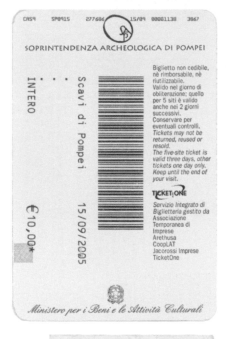
CAS9 SP0915 277606 15/09 00001138 3867

SOPRINTENDENZA ARCHEOLOGICA DI POMPEI

INTERO Scavi di Pompei

€10,00* 15/09/2005

Biglietto non cedibile,
nè rimborsabile, nè
riutilizzabile.
Valido nel giorno di
obliterazione; quello
per 5 siti è valido
anche nei 2 giorni
successivi.
Conservare per
eventuali controlli.
Tickets may not be
returned, reused or
resold.
The five-site ticket is
valid three days, other
tickets one day only.
Keep until the end of
your visit.

TICKETONE

Servizio Integrato di
Biglietteria gestito da
Associazione
Temporanea di
Imprese
Arethusa
CoopLAT
Jacorossi Imprese
TicketOne

Ministero per i Beni e le Attività Culturali

Posteitaliane
UFFICIO POSTALE
POMPEI
VIA SACRA 3

15/09/2005 - 14:22

SERVIZI POSTALI
DOMICILIA LE TUE BOLLETTE !

P138

Posteitaliane
UFFICIO POSTALE
POMPEI
VIA SACRA 3

15/09/2005 - 12.32

SERVIZI POSTALI
DOMICILIA LE TUE BOLLETTE !

P107

"FARMACIA"
BALDI VINCENZO
LOC.TORRETTA
S.MARCO DI C/TE
P.IVA 00192510659

 EURO
ART 1 9,10
TOTALE 9,10
CASSA 20,00
RESTO 10,90

04/09/2005 18-55
SCONTR. FISCALE 120
 /YFMC 11002449
TEL.0974 966020

Al Nukaly Intl Trading Company
Al Alavi Market
Gabil Display
Jeddah, Southern 21444
Phone: 6423063

Sales Receipt

Transaction #: 19707
Date: 14/12/2005 Time: 10:30:13 PM
Cashier: 03269 Register #: 1

Item	Description	Amount
2052315000000	ALNUKALY ELEGAN MIXED	SAR 30.00
	0.3 @ SAR 100.00	
2052315000000	ALNUKALY ELEGAN MIXED	SAR 30.00
	0.3 @ SAR 100.00	

```
                   ==================
        Sub Total      SAR 60.00
           Total       SAR 60.00

        CASH Tendered  SAR 110.00
        Change CASH    SAR 50.00
```

19707
Thank you for shopping
Al Nukaly Intl Trading Company
Have a nice day

Posteitaliane

UFFICIO POSTALE
POMPEI
VIA SACRA 3

15/09/2005 - 14:49

SERVIZI POSTALI
DOMICILIA LE TUE BOLLETTE !

P142

BAR MARIETT
di TAMBRO TOMMASO & C.SAS
VIA VITT. EMANUELE, 86
COMO
TEL. 031 267106
P.I. 02686380136

```
                        EURO
CAFFE'                  0,80
CAFFE'                  0,80
TOTALE                  1,60

11-10-05   10-15   SF.    30
   /VF AA 90000353
```

FRA

LH 0593 15DEC

Kew
ADULT
For the latest news and events visit
www.kew.org

Valid On: **16/08/05**

KGD:CAS019 Ticket 137 Trans 82

MEGA00VJW00MSK03K 16/08/05 11:07

Discover more about the Gardens' plants, landscapes and heritage
with Kew's Guide Book, available at the ticketing desks.
SOUVENIR GUIDE BOOKS AVAILABLE £4.95

KDA/utick#0Whilst in the Royal Botanic Gardens you are subject to its regulations, copies of which are available at the ticketing desk.

Flood Your Senses and Adopt a Fish.
A Fish Adoption is a present with a difference. It's fun, unique and ideal
for Birthdays, Christmas, Valentine's Day, Anniversaries and any
other special occasion. Call (020) 7967 8007 or visit
www.londonaquarium.co.uk

NO RE-ENTRY PERMITTED
1721433180000012475106 16/09/05 11:12

AQL:CAS001 Ticket 63 Trans 37
FAMILY **£6.25**

(Valid for one admission, only when endorsed above)
www.londonaquarium.co.uk
www.londoncountyhall.com

```
        *** V O N S ***
     A BETTER PLACE TO SAVE
     09/06/92  9:17AM STORE 427
     CUST 150 REG  1 OPR C.NICO

     VON NGT CERL          2.49*
     FRENCH BAGUE          1.70*
            2.14 LB @ 1/0.59
     SALADETTES            1.26*
     JM HOMOG MLK           .63*
     SMKR APRICOT          1.49*
     CONT YOGURT            .79*
     SERVICE DEL           2.35*
     JC.BAR/WEIGH          1.70*
     JC.BAR/WEIGH           .96*
     VAC WAFR HAM          2.76*

        TOTAL             16.13
     CRAYOLA 24            1.79 TX
     CRAYOLA 24            1.79 TX

        TOTAL             19.99
     NON-CASH             19.99

     SUBTOTAL             19.71
     TAX PAID               .28
     TENDERED             19.99

        .00 CHANGE

     USE YOUR VONSCLUB CARD
     FOR ADDITIONAL SAVINGS
```

```
קפה הפרד בע"מ
דיזנגוף 217, ת"א, טל:5042784 03
עוסק מורשה:030000112
תאריך הדפסה:09/09/98   שעה:47:0
מאריך ושעת הבון עקור: 19/09/98 17:00

חשבונית מס/קבלה
מס' 77498 מקור
27:

שולם
מזומן סה"כ:M01D
סה"כ = 170.00
לתשלום = 170.00
שולם מזו = 170.00

סה"כ 170.00

שבא
17:00 19/09/98
ישראכרט
התקבל על חשבון
חשבונית מס' 77498

701-007:
סה"כ 170.00
```

```
   Z O O
 FRANKFURT

10 13-04-98  12:11
   01/1  368864
1 * TASTE :   06
FAMILIEN-TAG I
  15.00     15.00
  ----------
TOTAL      15.00
  ==========

+++++++++++++++++++

 Vielen Dank fuer
  Ihren Besuch
```

```
Farmacia Cortez
Rua de Sao Nicolau N-93
1100 Lisboa
Contr.N. 500662010
2001.12.31 C.              (  137)
Factura/Recibo nro 564882
-------------- Cliente ----------------

                       (Consumidor Final)
----------------------------------------
Produto    P.V.P  IVA Qde. Valor

MUST.OLEO DER  1650.0 17%  1   1650.0
                  8.23          8.23
----------------------------------------
   Total Escudos......:  1650.0
     Euro .........:     8.23

- Processado por computador - IVA Incl -

****************************************
O NOSSO CONSELHO SEMPRE A SUA DISPOSICAO
****************************************
```

```
RELAIS H VOIES 21/22
BIENVENUE DANS NOTRE MAGASIN
    GARE DE L'EST
   *** DUPLICATA ***

PUBLICATIONS A REFER    90.00
          HS            40.00
  T A L      (2)        0.00=

          CES            .00

    X    H. T.    TVA.    T.C.
  ------  ------  ------  ------
  0    127.33    2.67    0.00

   *** DUPLICATA ***

     se   002   Le 08/    1998
     et  240879   à 16:   08
```

```
        B F T - GROSSTANKSTELLE
         EGINHARD   M E N K
        AN DER UMGEHUNGSSTR. 25
           63452  H A N A U
        TEL.06181/87427 FAX 86936

*BENZIN                         *
*902  26,53 & DM      40,03 *

BAR                   40,03
GESAMT        DM       40,03

MWST   15,00%         5,22
     0 3886 01/07/95          1A01

     VIELEN DANK UND GUTE FAHRT
```

```
AVALON AND MAJESTIC
700 OCEAN DRIVE
MIAMI BEACH FL
                    33139
  TARTARE      OLIVIER

  .. 08/30  19:42      08/31  10:01

        65.00              01

   5232950030005453           308

  FOLIO # 0830-1415      PAGE #  1

  08/30        ROOM           65.00
         1 NIGHT  AT    65.00
  08/30        FLA TAX        4.23
         ROOM TAX = 6.50%
  08/30     1 TOUR TAX        3.25
  08/31        PAID MC       72.48CR
         *** BALANCE ***       .00
```

THANK YOU FOR STAYING AT THE AVALON
AND MAJESTIC HOTELS!!!!

```
   THANKS FOR SHOPPING HARTFIELDS
   REG. SALE          4759 02
   ALA MOANA CENTER       0136

   S   9727108    P  1  12.00
            14.99 ORIGINAL
   S   9595612       1  21.99

            SUBTOTAL    33.99
      4.00 PCT TAX       1.36
            AMOUNT      35.35
   S166135   MASTER CARD  35.35

   ACCT # 5232950530297830  11/95

   HN   017485   TOTAL    35.35

   0136 04/04/94 12:47 02   4759
```

QUITTUNG Nr. 187

Taxi-FAHEEM
BRÜDER-GRIMMSTR 20
63450 HANAU Taxe 72
Steuernr.228013263
0174/2193979
07:45 19.12.04

FAHRER Nr. 30001
WAGEN Nr. 1

FAHRTSTRECKE km 10,4
TARIFSTUFEN: 4,2

FAHRPREIS EUR 16,10
INCL. 7,0 % MWST.

TRINKGELD EUR

6 Personen zum Normaltarif

DEUTSCHE
VERKEHRS-KREDIT-BANK
FRANKFURT HBF S

04/05 022 04.11.88

 15.10

 FRANKREICH VERKAUF
FF 327,50
KURS 30,20000
= DM 98,90
GEB. 1,00
TOTAL DM 99,90

********** MAMMOUTH ILLKIRCH *********
********** CENTRE DE VIE ************

 ORANGES PLATEAU 29,00
 TAMPON PERIO 17,00
 CAMEMBERT 11,30
 VASSAL CAMEMBERT 7,95
 FROMAGE COUPE 12,75
 OKAY SERVIETT.X100 11,30
 REMISE 29% 3,28-
 DENT.DENDEL BI-FLU 3,75
 HUILE GT DIESEL 5L 44,55
2x2,35 BAGUETTE FRAICHE 4,70
 BUISSON CHEVROTIN 7,90
 CONSIGNE 1,00
 W.SAURIN CASSOULX3 32,50
 STAND SCHMITT 16,10
 BEURRE DRULINGEN 4,50
 FRUITS ET LEGUMES 11,65
 **** TOT 212,67
VP CARTE BANCAIRE 212,67
 A RENDRE ,00

29/02/92 13:07 1050 27 0138 114
*************** MERCI **************
*********** A BIENTOT **************

********** MAMMOUTH ILLKIRCH *********
********** CENTRE DE VIE ************

CARTE BANCAIRE 29/02/92 13:07

MAMMOUTH ILLKIRCH

0700560016

 4974000679188929

MONTANT TOTAL : ****212,67 F

027/ 0138/ 0000114/016/ /S

 222·20 +
 139·20 -
002
 83·00 T
 561·80M*

 179·00 +
 10·00 +
 15·00 +
003
 204·00 T

BÜRGER
NUMMERNSCHILDER
AM RÖMERHOF 19
60486 FRANKFURT

REG 02-07-03
B04

SCHILDER ·18,00
MwSt.16% ·2,48
BAR ·18,00

#905267
 4
→179·00 I
 4
→179·00 T
Ch 4
→179·00

021089
0176N

```
       AUMAR
Cardenal Bueno Monreal
 n 56 41012-SEVILLA
   NIF:A-28670396
```

```
Via 12 Peajista 001002
E.S. 01 Las Cabezas
       Tronco
12/06/2005 a las 16:56
Cat. 1   Importe 5.15
TARJETA IVA 16% INC.

Num: 5232XXXXXXXX3618
El descuento que
proceda figurara en
factura

226A05
```

Everything Coca-Cola
3785 Las Vegas Blvd. S.
 LAS VEGAS NV 89109
 1-800-810-COKE
Store #: 104 Reg #: 3
Emp:#104043 Debra Trn #: 91512
Date : 08/07/2005 20:58
* Sale *
Item# Qty Price Total

```
*** Sale ***

70041     PO  DOTTLE CAP 4)(0
       1 @      0.75       0.75
NA

Subtotal                  0.75
Tax @ 7.50%               0.06
          --------------------
Total                     0.81
------------------------------------
Total Units Sold: 1
Cash                      1.00
Change Due               (0.19)

Returns/Exchanges must be within
    30 days with receipt.

Thank you for shopping at
 Everything Coca-Cola!
```

```
      0010403091512010443
```

```
16/08/03                 14:17
RELAIS DU SENEGUIER
AUTOROUTE A7
13680 LANCON PROVENCE
TEL : 04 90 42 99 20
8799600131301 KGI S45 T4
Q498  C06  3022  5705
ACCES.  6000         6.10

TOTAL EUR            6.10
CARTE BANCAIRE
------000341390300-
001192455 0300 3506 0418
       101 0         S1 @0
AUT:432547       04 6727
   SIGNATURE CLIENT

    TICKET CLIENT
    A CONSERVER

POUR INFORMATION
TOTAL   =      40,01 FRF
1 EURO = 6,55957 FRF

LE RELAIS DU SENEGUIER
   VOUS REMERCIE
```

```
Bonnes Vacances
```

```
Bal No: 2  Client No: 136
DATE: 26/08/2003
VENDEUR No : 2

   kg      €/kg        €
0,120     7,00       0,84
0,270     2,50       0,68
1,160     2,20       2,55
       non pesé +    0,90
       non pesé +    1,52

  5 Articles

 TOTAL:        6,49

   Payé       10,00
   Rendu       3,51

1 EURO = 6,55957 F

Total en FRF     42,55 F

Merci de votre visite
```

```
   NÄHZENTRUM
  B E R G M A N N
 NÜRNBERGER STRAßE 37
    63450  HANAU
  TEL. 06181/21544
  FAX  06181/26942

GOLD ZACK 8327     2,30
--------------------------
ZW.SUMME           2,30
B A R              2,30
MWST 16%           0,32

#000003          4
FRE  2 JAN 2004 17:31:12

  VIELEN DANK FÜR
  IHREN BESUCH
  BEEHREN SIE UNS
  BALD WIEDER
```

```
SILM    SRL
VIA DEL PONTE MOBILE 12
RAVENNA TEL.0544/450307
  ------
PARTITA IVA 00215620394
 NON FISCALE
AUTO            0.70
TOTALE        €0,70
CHIPCARD

#975   REG. 003 OP. 1
16-06-2005 12:33 SF.975

 NON FISCALE
```

AUMAR
Cardenal Bueno Monreal
n 56 41012-SEVILLA
NIF:A-28670396

Via 21 Peajista 002336
E.S. 01 Las Cabezas
Tronco
12/06/2005 a las 12:56
Cat. 1 Importe 5.15
TARJETA IVA 16% INC.

Num: 5232XXXXXXXX3618
El descuento que
proceda figurara en
factura

11F311

Ministero per i Beni e le Attivita' Culturali
**Complesso Abbaziale
di Pomposa (Fe)**
GRAT. JUN It arch
EUR 0,0
Op. 1 16/06/0005 16:00 Tr. 352.
Concessionaric Novamusa S.r.l.
Banca Antonveneta

Ministero per i Beni e le Attivita' Culturali
**Complesso Abbaziale
di Pomposa (Fe)**
BIGLIETTO INT. ST
EUR 4,00
Op. 1 16/06/0005 16:00 Tr. 352.
Concessionaric Novamusa S.r.l.
Banca Antonveneta

Ministero per i Beni e le Attivita' Culturali
**Complesso Abbaziale
di Pomposa (Fe)**
BIGLIETTO INT. ST
EUR 4,
Op. 1 16/06/0005 16:00 Tr. 352.
Concessionaric Novamusa S.r.l.
Banca Antonveneta

CAJA DE AHORROS
EL MONTE

5232 5502 3502 5700

MASTERCARD 7-05 RED 6000 CAJA: 2098
259/00002 VENTA 16-06-05 12:12

CALZADOS EL POLLO
LARGA 7
131606331 BT340021012

910696

 xxxxx70,00 EUR

COPIA PARA CLIENTE

Ⓜ MARUZEN
[京都河原町店]
☎ (075)241-2161 Fax(075)241-0653

毎度有り難うございます
下記代金額収いたしました

03年 10月 03日 (金) 20:07 TM

109Bks.on Japan 777

 1品 小計 ¥777
税対象額 ¥777
税率 5.0%消費税等 ¥38
現計 ¥815
預 ¥1,015 釣 ¥200

0074-0100 担当00001 #0415

(1 EURO = 166.386 PTAS)

NOVO CENTER
F R U T E R I A

VEND-C N.----
02MAY05 21:35

 Kg EURO/Kg EURO
 1.205 1.80 2.17

VENT. 1 TOTAL 2.17

GRACIAS POR SU VISITA

TOTAL 361 PTAS
(1 EURO = 166.386 PTAS)

NOVAMUSA S.r.l.
Basilica di sant'apollinare
in classe - Via romea sud
48100 - RAVENNA
P.IVA: 01846350831

 EURO

EDITORIA
 4 * 0.3 1,20

SUBTOT 1,20
TOTALE EURO 1,20
TOT. LIRE 2.324
Contanti 1,20
RESTO 0,00

Op. 1 CASSA. 0002 N.PZ 4
Numero transazione:58
16-06-05 12-09 SF. 51
/MF RR 52000395

```
-----------------------------------------
  COMPROVANT  DE  PAS
  COMPROBANTE  DE  PASO

AUTOPISTAG, C.E.G.A.        NIF A-08209769
#1.GB1.1# P1#c1U1#1       08008 BARCELONA

22-08-89      FRONTERA BA.      15
Via : 04   Dir.:SORTIDA-SALIDA
Estac. Origen: LLORET           07
Cobrador Num.: 0801   Clas. Veh.: 02
IMPORT-IMPORTE : Pts.          600
Incl. I.V.A. . . 12.00 %
Tar. Cred. Num.: 4974000502099223
Emissor-Emisor : VISA
```

```
      GGNPA  ALCATRAZ  STORE
           SAN FRANCISCO BAY

      89136 Reg 2 ID   2  2:41 pm 09/22/92

  1 POSTCARD        1 @   .60     .60
  SUBTOTAL                        .60
  TAX                             .05
  TOTAL                           .65
  CASH PAYMENT                    .65

      PLEASE SUPPORT YOUR NATIONAL PARKS!
```

```
      БАЛТИЙСКИЙ  БАНК

DATE:         01.05.03
TIME:            15:39

TERMINAL:  00100155

ADDRESS:   KRONVERSKIY 13/2
CITY:      ST.PETERSBURG

CARD NUMBER
-------------3190

TICKET NO  210697

WITHDRAWAL     1000.00 RUB

****  THANK YOU  *****
```

```
NEOLUXOR s.r.o.
   DIČ:CZ62577620

----------------------------- Kč
Franz Kafka und Prag          250.00 1
Die Verwandlung               200.00 1

Cena1  5%  428.50 daň   21.50   450.00

          Celkem s DPH          450.00
      =============================
17:35  Placeno hotově       450.00 Kč
04.03.05 17:35/SK06512610/P006512757
```

```
       JOUECLUB AIX
     1 PLACE DES CHAPELIERS
     13100 AIX EN PROVENCE
     TEL : 04.42.27.74.33
     FAX : 04.42.27.10.84
     MERCI DE VOTRE VISITE

1.00 COFFRET.6.CU   14.10   14.10
1.00 LIVRE.PHOQUE    6.90    6.90

-----------------------------------
S/TOTAL EU           21.00
TOTAL EURO           21.00
Espèces :            21.00
Dont TVA : 19.60 % SUR   21.00   3.44
TOTAL TICKET FRANC       137.75
Recu EURO    50.00 Rendu EURO    29.00
01/09/2003 Heure ; 15:25:17 N°:     26
  Vend.01 Cais.  1
```

PARKZEIT ENDET

Datum Uhrzeit

06.09.03 15:37

Bezahlt Standort

2,00EUR NEVEN-DU-MONTSTR

PARKSCHEIN 3597

von außen gut lesbar hinter
die Windschutzscheibe legen.

```
16/08/03                    07:56
RELAIS DE DAGNEUX
AUTOROUTE A 42
01120 DAGNEUX
TEL : 04 72 25 10 80
8799508210101 VPG S45 T4

QUART 171 C09   L2      7271
PREM.98                 56.77
VOLUME E03 R1          50.69L

ESPECES EUR             56.77

LE RELAIS DE DAGNEUX
VOUS REMERCIE
```

```
Ticket hinter die Wind-
schutzscheibe legen.
EUROBETRAG GEGLÄTTET !!!
095 Am Salzhaus

Nr. 1057 10:24 20.10.03
Parkzeitende
```

11:24
20.10.03
EUR 2.00

```
095 Am Salzhaus
Parkbeleg Nr.  1057
P-Ende 11:24 Mo 20.10.03
Betrag      EUR 2.00
```

BITTE WARTEN
AUFRUF

ANTRAGSTELLUNG

ZIMMER 314

NR.:A15

TELENORMA 2.07.03 8:52

```
Von aussen gut lesbar
hinter die Windschutz-
scheibe legen

Klinser

Nr. 0326  16:25 30.08.99
Parkzeitende
```

17:25
30.08.99
DM 4.00

```
Klinserstraße
Parkbeleg Nr.  0326
P-Ende 17:25 Mo 30.08.99
Betrag        DM    4.00
```

Von außen gut lesbar hinter die
Windschutzscheibe legen

Parkschein-Nr. 5911

Datum PARKZEIT ENDET Uhrzeit

26.07.05 14:32

0,50EUR FRANZ.ALLEE

Bezahlt Standort

```
Ticket hinter die Wind-
schutzscheibe legen.
EUROBETRAG GEGLÄTTET !!!
77 Kaiserstraße

Nr. 0007  10:33 20.06.03
Parkzeitende
```

11:33
20.06.03
EUR 2,00

```
77 Kaiserstraße
Parkbeleg Nr.  0007
P-Ende 11:33 Fr 20.06.03
Betrag      EUR    2,00
```

PARKSCHEIN

von außen gut lesbar hinter
die Windschutzscheibe legen.

1126

PARKZEIT ENDET

Datum Uhrzeit

24.09.04 15:11

Bezahlt Standort

2,00EUR DORTUSTR.7 13:06

Abriss bitte mitnehmen!

Datum · bezahlt bis · Uhrzeit

24.09.04 15:11

Bezahlt Standort

2,00EUR DORTUSTR.7

```
Ticket hinter die Wind-
schutzscheibe legen.
EUROBETRAG GEGLÄTTET
303 Grüneburgweg

Nr. 1812 13:49 28.10.0
Parkzeitende
```

14:49
28.10.03
EUR 2,00

```
303 Grüneburgweg
Parkbeleg Nr.  1812
P-Ende 14:49 Di 28.10.
Betrag      EUR 2,00
```

PARKZEIT ENDET

Datum Uhrzeit

12.01.99 18:33

Bezahlt Standort

02,00 NEUEN DU MONT-STR.

PARKSCHEIN 730
von außen gut lesbar hinter
die Windschutzscheibe legen.

PARKSCHEIN

Von außen gut lesbar hinter
die Windschutzscheibe legen.

4301

P a r k z e i t e n d e

21.10. 15:03

Datum '98 Uhrzeit

PP Stadthalle
2.00 DM

PP Stadthalle
2.00 DM 21.10.98 15:03

Abriß bitte mitnehmen DAMBACH

PARKSCHEIN

DATUM ⟵ ZEIT
25.08.99 14:48

Ticketnummer : 152561
Station :
Tarif :

Parken Sie Ihr Fahrzeug bitte
auf dem ersten freien Park-
platz.

ACHTUNG !

Dieses Ticket muß an der Kasse
vorgelegt werden.

Die Parkgebühr wird nach den
gültigen Tarifen berechnet
Für Schäden an Ihrem Fahr-
zeug übernehmen wir keine
Haftung.

PARKSCHEIN
von außen gut lesbar hinter
die Windschutzscheibe legen.

PARKZEIT ENDET

Datum Uhrzeit

20.07.00 10:03

Bezahlt Standort

DM02,00 TRANKGASSE

3292

Bitte warten Sie
auf Ihren Aufruf

Zentrales Bürgeramt

1. Stock

172

BOSCH Do. 25.05.00 08:56

TAXOMEX	QUITTUNG
Zürich / Nyon	Muss nicht im Auto deponiert werden
BEZAHLT BIS	**DATUM**

10:29 16 JUN 00

AC1320 0.00 NR 222

RHÄTISCHE BAHN

PONTRESINA
10:09 000616

محطة وقوف السيارات

Parking Autos

10,00 DH دراهم

№ 000903

الجمهورية التونسية
وزارة التجهيز والاسكان
الادارة العامة للجسور والطرقات

بطاحات جربة

نقل سيارة خفيفة

وصل 0 AVR 2002

№ 283250

التاريخ :

الثمـن : 0,800 د

الاستظهار بهذا الوصل عند الاقتضاء

Freib Hausen

#1720303720 26.05.2001 14:47

EK Jug. Tag 3.50
Gültig von 26.05.2001 bis 26.05.2001

BelegNr 8013/0606/00606 16.02.02 S. 1/1

Bez. Parkticket 5,50 EUR
16.02.02 11:42 - 16.02.02 15:31
Parkdauer: 0 Tg., 3 Std., 49 Min.
Gegeben Ges. 6,00 EUR
Gesamtbetrag 5,50 EUR
MWSt. 16,00 % 0,76 EUR

TG DuMont-Carré

MKM Mundorf GmbH&Co. Immob. KG
Steinstr.2-4
53844 Troisdorf-Sieglar
Tel.:02241/263-0
Fax:02241/263-200

Freiba ausen

#1720303719 26.05.2001 14:47

EK Erw. Tag 5.00
Gültig von 26.05.2001 bis 26.05.2001

STÄDTISCHE BÜHNEN FRANKFURT AM MAIN

OPER | SCHAUSPIEL | BALLETT

GROSSES HAUS
CHINA - DOGS DM 25,00
SA 11.03.89, 20.00 UHR

REIHE 18 Rechts
PLATZ 28

Für verfallene Eintrittskarten kein Ersatz. Umtausch oder Rücknahme
nur bei Vorstellungsänderung. Karte bitte bis Vorstellungsschluß aufbewahren.
Bei Verspätung Einlaß nur bei Aktschluß.

060/04

143902029260

THEATER DER STADT FRANKFURT AM MAIN

OPER | SCHAUSPIEL | BALLETT

BALLETT FRANKFURT
AS A. GARDEN ... DM 9,50
SA 14.05.94, 20.00 UHR

REIHE 20 Parkett rechts
PLATZ 26

Für verfallene Eintrittskarten kein Ersatz. Umtausch oder Rücknahme
nur bei Vorstellungsänderung. Karte bitte bis Vorstellungsschluß aufbewahren. 44/06
Bei Verspätung Einlaß erst zur Pause.

709002033444

LES PHILOSOPHES
28 RUE VIEILLE TEMPLE
75 PARIS TEL.01-48-8 49-64
www.cafeine.com

TABLES 51

OUVERTS: 1
FACTURE 407

1 NOISETTE AGNEAU 14.00
1 1/2 EAU MINERALE 4.50
1 COTE RHON 4.50
1 CREME BRULEE 6.50
1 EXPRESSO 2.50

S/TOTAL 32.00

DONT TVA 19.60 5.25

* TOTAL * 32.00
OUVERT TOUS LES JOURS DE 9H A 2H
SERVICE COMPRIS 15% SUR LE HT ET HS
Majoration 0.50 Euros par consommation
a partir de 22 heures

DIM 06 OCT 02 0:48 matrix

STÄDTISCHE BÜHNEN FRANKFURT AM MAIN

OPER | SCHAUSPIEL | BALLETT | TAT

BALLETT FRANKFURT
BALLETTABEND DM 12,50
MI 14.06.95, 20.00 UHR

REIHE 16 Parkett links
PLATZ 6

Für verfallene Eintrittskarten kein Ersatz. Umtausch oder Rücknahme
nur bei Vorstellungsänderung. Karte bitte bis Vorstellungsschluß aufbewahren.
Bei Verspätung Einlaß erst zur Pause.

044/05

713002018044

SKIPPERHUUS
NORDDEICH TEL. 04931/998485
BEI
HERTA UND GALT

29- 7-1999 (DON) 20:07

TISCH-NR 2

2 x @ 6.50

COTES DU RHONE 13.00
MINERALWASSER 2.80

STEUER 1 16% 2.18
G. STEUER 2.18
BAR 15.80

POSTEN 3
VIELEN DANK FÜR IHREN BESUCH
KELL 05 #0000 R 9324

HARVEY'S CAFE-BAR
60316 FRANKFURT
TEL: 069/497303

25/05/99 21:20
000000#6431
 TISCH-#:0013
0005 CLERK005

RECHNUNG
A. SALDO 0.00
 2x 2.50
ESPRESSO 5.00
 2x 9.00
J. DANIELS 18.00
 -2x 9.00
J. DANIELS R-18.00
OSBORNEVETERANO 5.50
Z. W. S. 10.50
MWST. ZWS 10.50
16%MWST 1.45
NETTO 9.05

BAR 10.50

Parkplatz Bürgerweide
Bremen

04.12.99 15:48:56 P1/12 075320
05.12 06:00 02 1826 4,00

- Einstellbedingungen und Öffnungszeiten siehe Aushang.
- Parkgebühr bitte bei der Abholung Ihres Fahrzeugs am Kassenautomaten zahlen.
- Parkschein sorgfältig aufbewahren - nicht knicken.
- Vor Wärme und Nässe schützen.

BREPARK · Telefon 04 21 / 1 74 71 - 0 NDK

MMK Museum für Moderne Kunst
Frankfurt am Main

Domstraße 10
D-60311 Frankfurt am Main
Telefon +49 (0)69 / 212 30 447
Fax +49 (0)69 / 212 37 882
mmk@stadt-frankfurt.de
www.mmk-frankfurt.de

Öffnungszeiten
Di, Do, Fr, Sa, So 10–17 Uhr
Mi 10–20 Uhr, Mo geschlossen

Café Triangolo
Telefon +49 (0)69 / 28 90 07
Di–So von 10–1 Uhr, Mo geschlossen

Erwachsene 5,00 EU 17.05.2003

032351 © On Kawara: *Dec. 16, 1969*, 1969; Today-Series No. 93 und No. 94; je 25,5 × 33 cm; Acryl (Liquitex) auf Baumwollgewebe

GOETHE HAUS

FRANKFURTER GOETHE-HAUS UND GOETHE-MUSEUM

Tageskarte gültig zum Eintritt in das Goethe-Haus und Goethe-Museum.

Kostenloser Eintritt für Mitglieder des Freien Deutschen Hochstifts.

Informieren Sie sich über weitere Vorzüge einer Mitgliedschaft!

Besuchen Sie die Sonderausstellungen, die Veranstaltungen, die Bibliothek des Freien Deutschen Hochstifts!

FREIES DEUTSCHES HOCHSTIFT
FRANKFURTER GOETHE MUSEUM
GROSSER HIRSCHGRABEN 23-25
60311 FRANKFURT AM MAIN

TELEFON (0 69) 1 38 80-0
TELEFAX (0 69) 1 38 80-2 22

www.goethehaus-frankfurt.de

Bauliche oder organisatorisch bedingte zeitweilige Schließung einzelner Räume des Goethe-Hauses und Goethe-Museums begründet keinen Anspruch auf Rückerstattung des Eintrittspreises.

Druck & System: Beckerbillett Hamburg (129)

Studenten EUR 2,50 424857 150804

H A M B U R G E R
KUNSTHALLE
28. September 2001 bis 6. Januar 2002

Eintritt EUR 7,50 170102

Druck & System: Beckerbillett Hamburg (091) 051429 Auf Verlangen vorzeigen. Ohne Abriss ungültig.

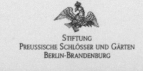

STIFTUNG
PREUSSISCHE SCHLÖSSER UND GÄRTEN
BERLIN-BRANDENBURG

Schloss Sanssouci

mit Führung 8,00 EUR

Datum: 24.09.04
date:

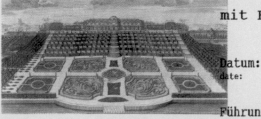

Eintrittskarte

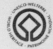

Führungsbeginn: 17:00 Uhr
Start of the guided tour:
Commencement de la visite guidée:

Nur gültig für den genannten Führungsbeginn
Only valid for the specified tour
Valable seulement pour la visite guidée indiquée

Druck: Beckerbillett Hamburg (054)

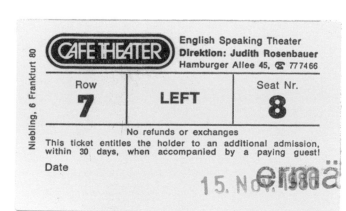

CAFE THEATER

Niebling, 6 Frankfurt 80

English Speaking Theater
Direktion: Judith Rosenbauer
Hamburger Allee 45, ☎ 77 74 66

| Row **7** | **LEFT** | Seat Nr. **8** |

No refunds or exchanges
This ticket entitles the holder to an additional admission,
within 30 days, when accompanied by a paying guest!

Date

15. Nov. 1980 ermä

WAIKIKI TROLLEY.

OLD TOWN TOUR

MONTH
JAN FEB M..
APR MAY JUN
JUL AUG SEP
OCT NOV DEC

ALL DAY PASS • ADULT № 519436

1 2 3 4 5 6 7 8 9 10 11 12 13 14 15 16
17 18 19 20 21 22 23 24 25 26 27 28 29 31

DB
IC - Zuschlag
☐ Platzreservierung
2.Kl 5,00 DM
Hanau (DER)
07085

DB
IC - Zuschlag
☐ Platzreservierung
2.Kl 5,00 DM
Hanau (DER)
06253

WAIKIKI TROLLEY.

OLD TOWN TOUR

MONTH
JAN FEB M..
APR MAY JUN
JUL AUG SEP
OCT NOV DEC

ALL DAY PASS • ADULT № 519435

1 2 3 4 5 6 7 8 9 10 11 12 13 14 15 16
17 18 19 20 21 22 23 24 25 26 27 28 29 31

052901 Max Glas München

34. Internationale
Handwerksmesse
München 13.-21.3.82

EINTRITTSKARTE DM 5.—
(incl. 13% Mehrwertsteuer)
Quittung zum einmaligen Besuch.
Bitte aufbew. u. auf Verlangen vorzeigen.

ABRISS 052901

004069 Beckerbillett Hamburg

Staatsgalerie moderne Kunst
Bayer. Staatsgemäldesammlungen in München

EINTRITTSKARTE
DM 0,50
Gültig für eine Person u. einmaligen Eintritt.
Auf Verlangen vorzeigen.

001714 Beckerbillett Hamburg (072)

Große Hafenrundfahrt

Barkassen-Centrale Überseebrücke Günter Ehlers

FAHRKARTE
Erwachsene

Preis und Bedingungen laut Aushang

Liegeplatz: Vorsetzen – Ponton · Tel. (040) 37 31 68

09823 Billett-Fuss, 6834 Ketsch

Sternpalast-
Lichtspiele GmbH
Hanauer Str. 1
6369 Schöneck 1

Sonder-
veranstaltung

SANEF

SOCIÉTÉ DES AUTOROUTES
DU NORD ET DE L'EST DE LA FRANCE
DIRECTION DE L'EXPLOITATION

B.P. 73
60304 SENLIS

ANNÉE	JOUR	GARE ENTRÉE	GARE SORTIE
CB*89	202	15	01/031..

CAT. AUTOROUTE	CAT.FISCALE	KM. PARCOURUS	TARIF
1	Ø	155,6	050,0

ATTESTATION DE PASSAGE 2172066

41970

STUDENTENWERK
Frankfurt / Main

Essenbon

DM 3,—

siehe auch Rückseite

BIREKA, 74 740 Adelsheim 41970

241

Maui Sun

BACKE
NAME

ROOM NO.

9.4.94
DATE

NO. OF ITEMS

04997

Maui Sun

NO. OF ITEMS

109

04997

Maui Sun

BACKE
NAME

ROOM NO.

9.4.94
DATE

NO. OF ITEMS

04998

Maui Sun

NO. OF ITEMS

109

04998

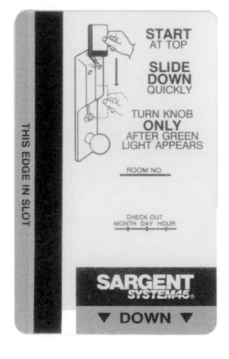

THIS EDGE IN SLOT

START
AT TOP

SLIDE
DOWN
QUICKLY

TURN KNOB
ONLY
AFTER GREEN
LIGHT APPEARS

ROOM NO

CHECK OUT
MONTH DAY HOUR

SARGENT
SYSTEM45®

▼ DOWN ▼

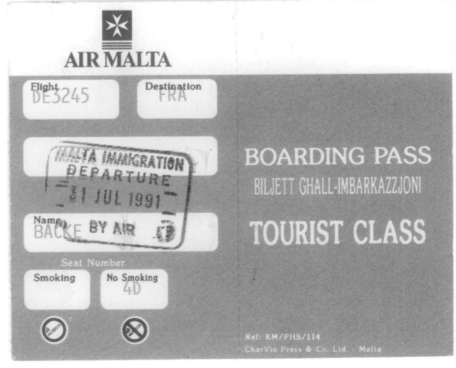

AIR MALTA

Flight
DE3245

Destination
FRA

MALTA IMMIGRATION
DEPARTURE
31 JUL 1991
BACKE BY AIR

Name

BOARDING PASS
BILJETT GHALL-IMBARKAZZJONI

TOURIST CLASS

Seat Number

Smoking

No Smoking
4D

Ref: KM/PHS/114
CharVin Press & Co. Ltd. - Malta

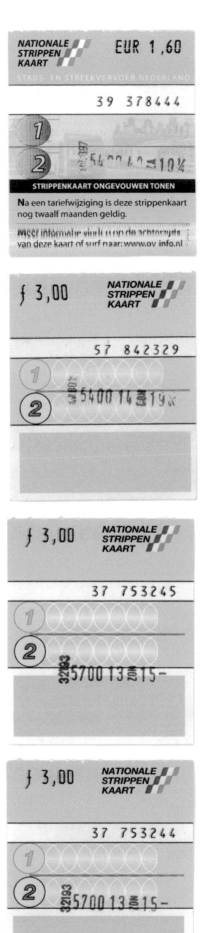

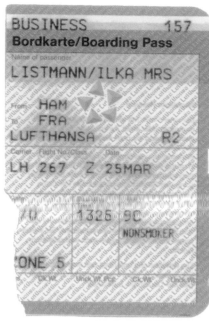

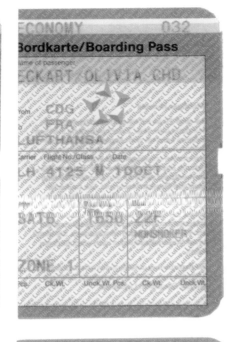

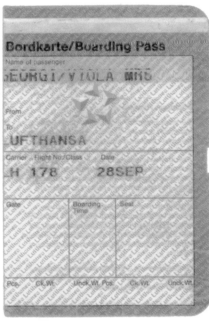

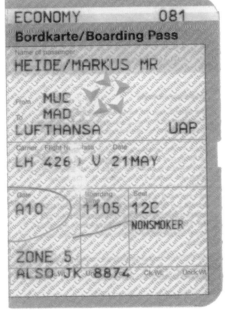

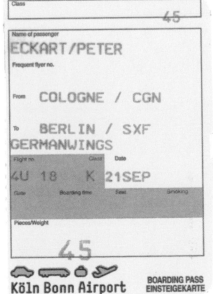

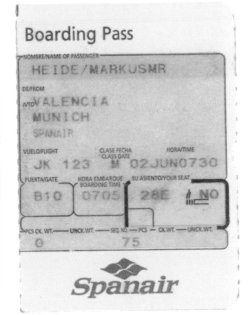

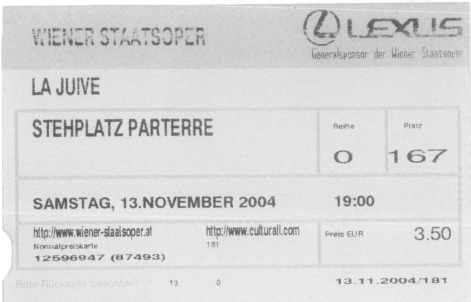

WIENER STAATSOPER

LA JUIVE

STEHPLATZ PARTERRE

	Reihe	Platz
	O	167

SAMSTAG, 13.NOVEMBER 2004 19:00

http://www.wiener-staatsoper.at http://www.culturall.com
Normalpreiskarte 181 Preis EUR 3.50
12596947 (87493)

Bitte Rückseite beachten! 13 0 13.11.2004/181

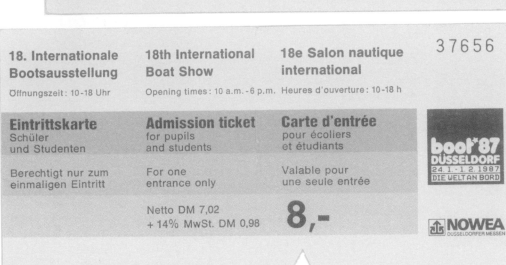

18. Internationale Bootsausstellung	18th International Boat Show	18e Salon nautique international	37656
Öffnungszeit: 10-18 Uhr	Opening times: 10 a.m.-6 p.m.	Heures d'ouverture: 10-18 h	
Eintrittskarte Schüler und Studenten	**Admission ticket** for pupils and students	**Carte d'entrée** pour écoliers et étudiants	boot '87 DÜSSELDORF 24.1.-1.2.1987 DIE WELT AN BORD
Berechtigt nur zum einmaligen Eintritt	For one entrance only	Valable pour une seule entrée	
	Netto DM 7,02 + 14% MwSt. DM 0,98	**8,-**	NOWEA DÜSSELDORFER MESSEN

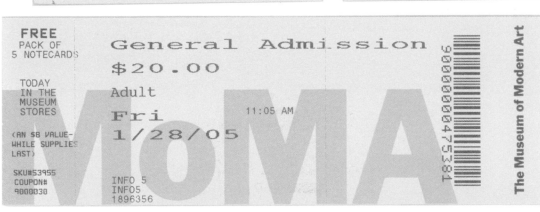

FREE PACK OF 5 NOTECARDS

TODAY IN THE MUSEUM STORES

(AN $8 VALUE– WHILE SUPPLIES LAST)

SKU#53955 COUPON# 9000030

General Admission
$20.00
Adult
Fri 11:05 AM
1/28/05

INFO 5
INFO5
1896356

9000000475381

The Museum of Modern Art

MUSEUM LUDWIG

AKTUELLE INFORMATIONEN UNTER
www.museum-ludwig.de

Ein Museum der
Stadt Köln

Kulturpartner
WDR 3

Cruel Voll EUR 4,00 150204

Druck & System: Beckerbillett Hamburg (023) 077309

NATIONALE
STRIPPEN
KAART

EUR 2,40

STADS- EN STREEKVERVOER NEDERLAND

05 255317

① ② ③

STRIPPENKAART ONGEVOUWEN TONEN

Na een tariefwijziging is deze strippenkaart nog twaalf maanden geldig.

Meer informatie vindt u op de achterzijde van deze kaart of surf naar: www.ov-info.nl

鶴亀の庭

F T F

Tages-/One-Day Ticket
19.10.-23.10.2005
2054 7620 2327

19.-23.10.2005

FRANKFURTER
BUCHMESSE
GASTLAND ›KOREA‹

Freikarte Fachbesucher/Tageskarte
Complimentory One-Day Ticket/Trade Visitor

G F T

Tages-/One-Day Ticket
19.10.-23.10.2005
2024 7946 3093

19.-23.10.2005

FRANKFURTER
BUCHMESSE
GASTLAND ›KOREA‹

Voucher One-Day Ticket/Trade Visitor
Gutschein Fachbesucher/Tageskarte

¥:162

全國各大商場、專賣店
統一零售價（RMB）

766 /64/20081/422 D
A 3417.274 2 552 62

EURO
15.-

SURF CONTEST

52

X

Kunde

Typ

Kennzeichen

245

Daniel Gross

This index represents 23,000 words and terms that were collected from the various tickets that appear in this book. Through a process of scanning and word recognition software, nearly 85% of the total contents were converted from image data to textual data. The remaining 15%, representing texts of a sub-7pt font size, printed in unusual or difficult to read fonts, of non-latin origin, or those printed in low contrast, hard to read formats, were excluded due to technical constraints. The resultant collection of expressions, both grammatically meaningful and nonsensical, are reproduced below, some terms repeating several times to accurately reflect their rate of occurrence within the book.

aan / Ranslagnummer / abb / Abbildung / Abdruck / aber / Abfahrt / Abfahrt / Abfahrt / abgeben / abgehängt / Abholer / Abholtag! / Abholung / ABI / ABOVE / above / Abreise / Abriß / Abriss / abroad / Abschnitt / Abschnitt / Abschnitt / absence / Absender / Absender / absolute dingly / account / ACCOUNT / account / Account / ACCOUNTS / ACCT / ACCT / acesso / acht / achten / ACHTER / achter / achterzijde / achterzijde / achterzijde / ACHTUNG/ Achtung / Achtung / Achtung / Achtung / ACHTUNG / ACHTUNG / Achtung! / Achtung! / ACKNOWLEDGE / acknowledge / ACKN
ADULTE / ADULTO / ADVANCE / ADVANCE / Advice / ADVICE / Advice / aérienne / AEROPORT / AEROPUERTO / Affaires / Affaires / Affaires / Affaires / Affaires / Affaires / affiché / Afgiftedatum / Afgiftepunt / Afgiftepunt / AFTER / AFTER / after / after every / AFX Baggage / again / again / ag
Airline / Airline / Airline / AIRLINE / AIRLINE / Airline/Flight / Airline/Flight / Airlines / AIRLINES / AIRLINES / Airlines / AIRMAIL / AIRPORT / AIRPORT / AIRPORT / AIRPORT / Airport / Airports / AIRWAYS / AIRWAYS / AIRWAYS / AIRWAYS / Airways / Airways / Airways / Airwa
Alle / Allee / ALLEGEES / allemand / ALLEZ / allow / ALLOW / ALLOW / alp / Alpenstraße / Alpenstraße / ALPHA / alquila / als / ALSACE / als Gedächtnisstütze / ALSO / alt / alt / ALT / ALT / Alt / Alt / ALTE / Alter / Alter / Alter / ALTERED / Alu / alu / ALZ / am / AM
AMOUNTS / AMSTERDAM / Anî / ana / ANANAS / Anbau / ANCONA / and / and / AND / and / and / and / and / AND / AND / AND / AND / AND / and / and / and / and / and / and / and / and / AND / and / and / and / and / and / and / AND PASSENGER / anerkan
ankreuzen / Ankunft / Ankunft / ANNEE / ANNÉE / ANNÉE / ANNÉE / ANNULES / ano / ano / Anruf / ans / ans / ans / ans / ans / ans / ans / ans / ans Anschlußermäßigung / Anschlußkarte / Anschrift / Anschrift / Anschrift unvollständig / Anspruch / ANTALYA / antes / Antibe
ly / apporté / apposé / approval / APPROVAL / APRES / APRES / APRES / APRICOT / APRIL / Ara / ara / ara / Arbeiten / Arbeiten / arc / arc / arc / arcade / Arch / ARCHEOLOGIC / ARCHITECTONIC / ARCHITETTONIS / Archipelbuurt / are / are / are / are / are / area / AREA / AREA
ARTIKEL / Artikel / Artikel / Artikel / Artikel / Artikel Bzl / ARTIKELPASS / ARTIKELPASS / ARTIKELPASS / ARTIKELPASS / ARTIKELPASS / ARTIS / ARTS / ARTS / ASCENSEUR / Aschaffenburg / ASIENTO / ASK / ask / ASSIETTE / assimile / ASSOCIATION / ASSOC
AU DELA / Audio / Audio / Audio / Audio / auf / auf / Auf / Auf / auf auf / Auf / Auf / Aufbewahren / Aufbewahren / Aufbewahren / Aufbewahren / Aufbewahren / AUFBEWAHREN / AUFBEWAHREN / aufbewahren / aufbewahren / auf der / aufs
Ausgabelandes / Ausgabelandes / Ausgabestelle / Ausgabestelle / Ausgabestelle / Ausgabestelle / ausgeschlossene / ausgeschlossene / ausgeschlossene / Aushang / Aushang / Aushang / Aushang / Aushang / Aushang / aushängen / AUSLAND
AUTORISE / AUTORISE / AUTOROUTE / AUTOROUTE FISCALE / AUTOROUTES / AUTOROUTES / AUTOROUTES / Autos / AUTRE / AUTRE / AUTRE / Autres / AUTRES GENRES / aux / AUX / AUX / aux / aux / aux / aux / AUX / aux / aux / available / AVAILABLE / Available / AVAILABLE / avai
BAGGAGE / Baggage / Baggage / BAGGAGE / BAGGAGE / baggage / BAGGAGE / BAGGAGE / Bagage / BAGGAGE / Baggage / BIGUETTE / BAGUETTE / Bahn / Bahn / bahn / Bahn / Bahn / BAHN / BAHN / Bahn / Bahn / Bahn Teilnehmerausweis / BAHT / baht / BAHT / BAHT / BAL / BALANCE / BALANCE / BALANCE / BAL
Bankastraat / BANKING / BANKING / Banknoten / BAR / BAR / BAR / BAR / bar / bar / bar / Bar / BAR / Bar / Bar / Bar / Bar / Bar / Bar / Bar 231 / Barang / BARANG / Barano / Barcelona / BARCELONA / Barcelona / BARCELONA POSTCARDS 30 / BARDEUL / BARZAHLUNG / BARZAHLUNG
beachten / Beachten / beachten / beachtet / beachtet / Bearbeitung / BEAU / beauty / BEBIDAS / BEBIDAS / Beordenung / become / becomes / Bedeung / BEDIEHUNG / Bediente / bedingte / Bedingungen / Bedsheet / BEEHREN / been / been / been / BEEN / Beendigung / Beer / Beer
BEIJING / being / Beiträge / Bel / bel / belastungurtarief / BELEG / BELEG / Beleg / Belehrung / Belehrung / belges / BELGES / BELGIC / Belgische / Belgischen / below / below / bemühen / bemüht / bemüht / Ben / benachrichtigt / bénéficiant / bénéficiant / benutze /
Berlin / Berlin / BERLIN / BERLIN / Berlin Tel / Berlin Tel / Bernhard / BESANÇON / beschädigen / Bescheides / Bescheinigung / Bescheinigung / Bescheinigung 759 / beschleunigt / Besitz / Besitz / Besondere / Besondere / besonderes / besonderes / besonders / Be
BEURRE / BEVERAGES / bevor / bevor / bevor / Bevorraten / bewahren / BEWOHNERS / beyond / bezahlen / bezahlen / bezahlen / bezahlen / BEZAHLT BIS / Bezahlt / BEZAHLT / Bezahlt / Bezahlt / Bezahlt / Bezahlt / Bezahlt / Bezahlung / Bezeichnung / B
BILLET / billet / billet / billet / billet / BILLET / billet / BILLET / Billet conserver pendant / BILLETS / bin / Binnenverkehrs / Binnenverkehrs / Binnenverkehrs / Binnenverkehrs / Bio / Bio / Bio / Block / birds / birds / birte / Birth / Birth / birth / birth / birth / bis / bis
Blanket/Quilt / BLAZER / BLU / bleach / BLEACH / BLEIFREI / bleue / block / block / blockhaus / blockhaus / BLOND / BLOUSE / BLOUSE / Blouses / Blouses / BLOUSON / Blouson / BLOW / BLOW / BLOW / BLOW / BLUE / BLÜTE / Blvd / Board / BOARD / BOARDING / BOARDING / Boarding / BOARDI
BOARD TIME / Boat / Bockenheimer / BODEN / Bodensee / Body / Book / bom / Bom 0342 / Bonn / Bonn Airport / Bon / Book / Book / BOOKING / Booking / BOOKING / BOOKS / BOOKING REFERENCE / booth / Bootsausstellung / boras / boras / boras / BORD / border / border / Bording / bor
Briefmarken / bringing / bringing / bringing / BRISE / BRISE / BRISE / BRISE / BRISE / brise / brise / BRITISH AIRWAYS/Frankfurt / BRITISH / BRITISH / BRITISH / BRITISH / BRITISH / BRITISH / BRITISH / British / British / British / British / British / British / British / Britis
BUCHFAHRKARTE / Buchhandlung / Buchmesse / BUDAPEST / Budapest / Budapest / Budapest / Buddha / Bueno / BÜHNEN / Building / BUISSON / Bundesbahn / Bundesagenzschutz / Bundesagenzschutz / BUREAU / BUREAU / Bureau / BURG / BURG / BURG / Burg / Bürger / BURGER / Bür
CACHAT / Cachet / Cad / CADIZ / CAFE / Café / Café / Café / Café / Café / CAISSE / caisses / CARDHOLDER SIGNATURE / CASA / Calais / CALCULATION / CALCULATION / CALCULATION / CALIF / call / CALL / call / call / caller / call NOM / Cambio / came / CAMER / Camisa / CAMPI
card / card / Card / Card / CARD / CARD / CARD / card / card / card / CARD / Card / Card / card / card / CARD / card / CARD / CARD / Card / CARD / Card / Cardenal / Cardenal / CARDHOLDERS / cardholder's / Cardholders / CARD MEMBER COPY / Cards / Cards / CARD SURNAME /
Carry / Carry / CARTE / Carte / CARTE / carte / Carte / Carte / CARTE / carte / Carte / Carte / CARTE / CARTE / CARTE / CARTE / Carte / Carte / CARTE / Carte / CARTE / Carte acces bord / CARTE PEP / cartes / CAS / cas / cas / cas / cas / cas / cas / cas / CAS / CASA
CENT / CENTER / Center / Center / centre / CENTRE / CENTRE / ce paiement / CEREALE / certaines / Certific / CERTIFICAT / CERTIFICAT / CERTIFICAT / Certificate / Certificate / Certificate / certificate / Certificate/7 / Certificats / ces / Ces / Ces / Ces / CES / CASA
CHARGED / charged / CHARGES / CHARGES / Charges / Charges Frais / CHARGE FRAIS / Charge / CHARLEROI / CHARLES / check / Check / CHECK / check / check / CHECK / CHECK / check / CHECK / check / CHECK / Checked / checked / CHECKED / CHECKED / Ch
chèques / chèques / Chèques / chèques / CHÈQUES / Cheques accept / Cheques acceptés / Chèques AUTOROUTES / cher / CHEUROTIN / chiff / Child / Children / Children / CHILLY / China / CHINA / China / China / China / China / Chine / CHINESE / CHINESE / CHIPCARD / CHIPS / Chocolate
CLEANING / clearly / CLENT / clef / Clerk / client / client / CLIENT / cliente / CLIENTE / clientèle / Clipper / CLOSE / clothes / clowns / CLUB / Club / Club / CLUB / CLUB / cm / coats / Coats / Coca / Coca / Coca Coca / CODE / Code / CODE / CODE / CODE ISSUED /
Colour / COLOURING / column / com / com / Comensales / COMIDAS / COMIDAS / commence / commences / commences / commences / commence / Commerce / COMMERCIAL / COMMUNAUTÉ / COMP / Compania / COMPANY / COMPANY / Company / Compartment
ditions / CONTRACT / Contract / Contado / Contado / conditions / conditions / conditions / conditions / conditions / CONDITIONS / Conditions / conditions / conditions / CONDITIONS / conditions / conducteur / conductrice / cone / confié / CONFIRM / confirmada / Confi
ta / Corbata / Corenol / corn / corner / corns / CORECT / CORP / CORP / CORPORATION / CORPORATION / CORPORATION / CORPORATION / CORSAIRE / Cortos / Cortos / Cost / COSTUME / COTE / CÔTE / côte / côté / Coton / Cotton / Count / Count' / counter / counter / Country / Country/S
crossing / CRT / Cruise / Cry / Cultral / Cul / cul / cult / CULTURALI / Culturali / Culturali / Culturali / CULTUREL / CULTURELLE / Culturelle / CULTURELLE / Culturelle / Culturelles / Culturelles / Culturelles / Cumulus / cuolquier / Cupon / CURLY / CURRENCY / currer
CUSTOMS SERVICE / CWL / D/1A / d / D / d'41 / D'ACCÈS / D'ACCES BORD / d'accèsbord / d'accès bord / D'ACCÈS BORD / D'ACHAT / d'achat / d'achat / d'achat / d'achat / d'achat / d'annuler / d'annuler / D'ANTIBES / d'application / d'arrêter / D'ART / D'ASCQ / D'ASCQ / D'EMBARQUEMENT
Deutschlands / dalah / dadurch / Dagtekening / daher / Dahir / Dahir / Dahir / Dahir / DAHL / DAHL / daily / DAILY / DAILY / DAIM / Dale / Dale / Dale / Dale / DALI / DALI / damaged / DAMAGED / dan / Dank / Danmark / DANK / DANK / DANKE! / DANKEN / DANKESCHOEN / DA
DATE / Date / Date / date / DATE / DATE / Date / Date / date / Date / DATE / DATE / Date / Date / Date / Date / DATE-CLASS / Date / Datum / Datum / DATUM / DATUM / DATUM / DATUM / DATUM / DATUM / Datum / Datum / Datum / Datum /
DEC / Deckung / DECLARATION / declaration / DECLARATION / déclare / déclare / DECLASSEMENT / déclin / DÉCOMPTE / Decousser / Décret / DEDUCTED / DEFINITIF / DEJEUNER / Déjeuner Bar Téléphone / DEL / DEL / DEL / DEL / DEL / DEL / DEL 74 / Delhi / Delhi / DELHI / Delivered / D
den / den / den / den / den / denen / Dennoch / Dennoch / DENPASAR / Départ / departing / DEPARTMENT / DEPARTMENT / DE PARTIR / Departure / DEPARTURE / DEPARTURE / departure / DEPARTURE / DEPARTURE / Departure / Departure / Departure / Departure
DER / der / der / der / der / DER / DER / DER / der / der / der / der / DER / DER / der / dergent / deren / DERRIERE / DERRIERE / DERRIERE / derrière / derrière / der Verkehrsverbund / des / des / des / DES / des / des / DES / des / des / des / des /
TION / Destination / destiné / destinée / Destine/Destination / détérioren tissu / Deutsche / Deutsche / DEUTSCHE / Deutsche / Deutschen / Deutschen / Deutschen / DEUTSCHE POST / Deutscher / DEUTSCHER / Deutsches / deutsches / DEUTSCHLAND / DEUX TROIS / DEVANT
die / die / die / die / die / Diebstahl / Diebstahl / Diebstahl / Dienstag / Dienstreglsgiftche / Dienststelle / Diese / Diese / diese / DIESEL / diesem / diesem / Diesen / dieser / dieser / dieser / diesern / dieses / dieses / Dieses / Dieses / Dietz /
Divers / DIVERS / dejeuner / DOC / DOC / DOCUMENT / Document / DOCUMENTA / DOGS / doit / DOIT / doit / DOIT / DOIT / doit / DOLLAR / DOLLAR / DOLLAR / DOLOMITI / DOMINGUEZ / DONS / Don / Don't / Don't / Don't / Don't / done / Donnerstag / DON'T / DOOR / door / DOOR A
duplicata / durant / duration / Durch / Durch / durch / Durch / DUREE / durée / durée / DURING / During / duties / duties / DUTT / DUTY / DUTY / E / Ei / Each / each / each / EACH / earn / EASTERN / easy / eat / EAU / eben / ECONOMY / écart fiche / eck / ECKART / ECKART/Ps
CHARGED / charged / CHARGES / CHARGES / Charges / Charges Frais / EHANGE / EINFACHE / einfache / einfache / einfache / EinFahrt / Einfahrt / einführen / einführen / einführen / Eingang / EINHEITSPRACHE / einige / EINIGUG / EinlaB / Einlegen / einlegen / einmaligen / ei
einverstanden / Einverständnis / Einverständnis / Einzahlrverschein / Einzelband / Einzelfahrausweis / Einzelfahrt / Einzelheiten / Einzelheiten / einzelner / Einzelticket / Einzelticket / einziger / Eisenbahn / Eisenbahn / Eisenbahn / EISENBAHNEN
TEN / encoded / ENCONTRE / ENCOURT / end / End / End / Endemol / ENDET / ENDET / ENDET / ENDET / ENDORSEMENT / ENDORSEMENTS / endossable / ENFANT / Enfant / enfants / enfants / engagée / engagée / English / enjoy / enquire / enquire / enquire / en Returns/Exchan
1 / entrance / ENTRANCE / Entrance / entrance / ENTREE / ENTREE / Entree / ENTREE / entrée / ENTREE CARE / Entreer / ENTREE SORTIE / entrega / entregado / entrichtent / Entry / Entry / entry / Entry / entrschlemen / entweiten / entwerten / entwerten / Entwerter / E
erst / erst / erst / erst / erst / erstattet / erste / ersten / ersten / Erster / erteilte / Erw / Erw / Erw / Erw / ERWACHSENE / Erwachsene / Erwachsene / Erwachsene / Erwachsene / Erwachsene / Erwachsene / Erwachsene / escribedan / Escadoe / ESENTE / E
ETICKET/ITINERARY / Etikett / Etiket / Etiquetage composition insuffisant / ÉTRANGERS / ETRE / ETRE / ÊTRE / être / être / être / être / être / Étudiants / étudiants / Eugene / EUR / EUR / EUR / EUR / EUR / EURkg / EUROkg / EURO / EUR / EURO / Euro / EURO / EURO / EUR
EXCHANGE / EXCHANGE / EXCHANGE / Exchange / EXCHANGE / EXCHANGE / Exchange / exclusivement / exercise / EXERCITO / EXÉRCITO FORTE / exiger / exit / EXIT / exotic / Expected / Expected / expiration / EXPIRES / EXPRÉS / EXPRÉS ENTRADA / EXPRESS / Express / Expre
na / Facsimile MANDA HOTEL / Factor / Factura / Factura/Recibo / FACTURE / Faden / Fahrausweis / Fahrausweis / Fahrausweis / Fahrausweis / Fahrausweisen / Fahrgeld / Fahrkarte / Fahrkarte / FAHRKARTE / FAHRKARTE / Fahrkarte 27300 / Fahrplan / FAHRPREIS / Fahrrad / Fah
grounds / Fait / FAKTUR / Fall / Falle / Falle / family / family / FAMILY / family required / fam. must be paid again / Farbe / FAR/WEIGHT / Farbe / Farben / Farben / Farben / Farben / FARCIES / FARE / FARE / fare / FARE / fare / FARE / FARE / FARES / farm / farm / FARF
Fenster / fer / fer / fériés / FERRIES / FERRIES / Ferries / Fertig / Festnetz / Festnetz / Festpiele / Fettem / Fetten / Feu / Fête / FIBRES / fiche / fiche / fiche / fiche / FICHE / figurant / figurant / figurana / figure / figures / FIGURES / fi
Flecken / FLEUR / FLEUR / FLIGHTS / FLIGHT / Flight / Flight / Flight / Flight / Flight / Flight / Flight / Flight / FLIGHT / flight / Flight / flight / Flight / flight / FLIGHT / FLIGHT/CABIN / FLIGHT CRL304 / FLIGHT / FlightNo/C
for / for / for / for / for / for / for / for / FORDERKREIS / Foreign / Foreign / FOREIGN / foreign / foreign / FOREIGN / FOREIGN / foreign / foreign / foreign / foreign / foreign / foreign / Foreign / Foreign / FORFAITAIRE / FO
FRA / FRA / FRA / FRA / Fragile / FRAICHE / Frais / Frais / FRANC / Français / Français / FRANCE / FRANCE / FRANCE / France / FRANCFORT / FRANCHE / FRANCHI / FRANCI / Frank / Frankfurt / FRANKFURT / FRANKFURT / FRANKFURT / Frankfurt / FRANKFURT / FRANKFURT / F
Frères / freundlichem / FRF / FRF / fri / Fri / Friday / FRISCHOBST / FRITERIE / from / From / from / From / from / FROM / FROM / FROM / from / from / From / from / FROMTO / FROM/TO / FRONTEN / Front / Front / FRONTERA / FRONTERA /
ne / G / Galß / GALLERIA / Gambas / garattggig / Garden / Garder / Garder / Garderobe / Garderoben / Garderobenschein / Garderobenschein / Garderobe GARE / GARE / GARE / GARE / GARLIC / GARTEN / Gartenachmesse / Gartenordnung / Gartenordnung /
Geburtstag / Geburtstag / Geburtstag / Gedächtnisstütze / Gedächtnisstütze / gedruckt / geehrte / geehrte / geehrter / geehrter / geehrter / Geen / Geen / Geen / gefahr / Gefahr / Gegeben / Gegen / gegen / gegen / GEGENWERT / GEGENWERT /
Gemeente / Gemein / Gemein / Gemein / Gemeinsamen / Gemeinsamer / Gemeinsamer / Gemeinsamer / Gemeinsamer / Gemeinsamer / gen / genehmigter / Genehmigung / Genehmigung / General / GENERAL / générales / General / Gentlemen / Gentlemen/Caballeros / genügt /
sen / geschlossen / geschlossen / geschützt / geschützt / geschützt / gestempele / gestempelte / gestion / gesund / getan / getrennt / getrennt / getrennt / Gewebe / gez / gez / gezwungen / GIF / gift / Giftig / gifts / gifts / gilt / Gilt / Gilt / Gilt / GIRAFFE / GIRAFFE /
GULDEN / GÜLTIG / gültig / Gültig / Gültig / gültig / gültig / gültig / gültig / Gültig / Gültig Bureau / Gültigkeit / Gültigkeit / Gültigkeit / Gültigkeit bereits / gut / gut / gut / gut / gut / gut / GUTENBERGS / Güterstock / Haag / Haag / HAAM / Haan / Haan / habea
Hand / hand / hand / hand / HANDICRAFT / HANDLE / Handled / Handnumerce / HARTFIELDS / HARVEY'S / has / has / HATS / Hauptbahnhof / Hauptverwaltung / Hauptverwaltung / Hauptverwaltung / HAUS / Haus / HAUS / haute / HAVE / have / have / Have / have /
HEURE / heures / hier / hier / Hier / HIGHWAY / HIN / Hin / Hin / Hinfahrt / Hinfahrt / Hinfahrt/Aller / Hinfahrt/Aller / HINTER / hinter / hinter / hinter / hinter / hinter / HISTORIQUE / Historiques / Historiques / Höchst / Hochstifts / Hoc
Hose / Hospitalstrasse / hosty / hot / hot / HOTEL / Hotel / Hotel / Hotel / Hotel / hotel / Hotel / Hotel / HOTEL / HOTEL / Hotel / Hotel / HOTEL / Hotel / Hotel / HOTEL / HOTEL / hotel / Hôtel / Hotel/Rubber / HOTELS!!!! / HOTEL / hour / hour / hour / HOUR / Hours / hours 3/07 / HOUSING / HOW / HOW /
Ihnen / ihnen / ihnen / IHNEN / ihr / Ihr / Ihr / Ihr / Ihr / Ihr / Ihre / ihre / Ihre / Ihre / Ihre / Ihre / Ihre / Ihren / Ihren / Ihren / Ihren / IHREN / Ihren / IHREN / IHREN / IHREN / IHREN / Ihrer / Ihrer / Ihrer / Ihrer / Ihres / Ihres / IMPRATICULATI
Imprimerie / Imprimerie / in REMARKS / inca / incl / inkl / INKL / INCLUDING / including / including / INCLUDING / incluido / INCLUS / INCLUS / India / india / INDIA / INDIAN / INDICATION / Indications / Indications / INDIQUANT / indique / indiquées / INDIVISIBLE /
Injury / Injury / ink / INKASSO / INKL / inkl / inkl / INLEVEREN / inn / Inn / INNER / innerhalb / Inpaticid / in Regelzügen / inspector / inspector / INSPECTORS / instable RESERVES / installé / INSTITUTO / instruccion / Instrucciones / Instructions / Instru
into / into / inutiles / Invalid / Invalidenstraße / INVITATION / INVOICE / INVOICE / inwerking / IN WHITE AREA / irreversible / irreversibler / ISSUE / ISSUE / ISSUE / Issue / ISSUE / ISSUE / Issue / ISSUE / ISSUED / ISSUED / issued / issued / ISSUED /
Jahren Age / Jahrzehnten / JAKARTA / Jakarta / Jalan / JALONS / JAMBON / Jan / JANDIA / JANEIRO / JANDIE / JANUAR / Januar / JANVIER / JAPAN / JAPAN / jardinage / JACK DANIELS / Jean / Jean / jeden / jeden / jeden / jeden / JELLY / JELLY / JELLY / Jeune / Jeune / Jeu
Juist / Juist / JUKE / Juli / JUMLAH / Jumlan / Jumerc / JUN / Juni / Juni / Juveniles / Juveniles / Juvenile / kaart / kaart / KAART / KAART / kaart / KAART / KAART / KAART / KAART NATIONALE / KAESE / Kaffe / Kaffeesahne / Kaffeesahne / Kaffesahne / KAKAO / kann /
Keine / keine / keine / keinen / keinen / Kempinski / Kempinski / ken / Ken / Kennedy / Kennzeichen / Kennzeichen / kenn / key / key / key / KIDS / Kind / Kind / Kind / Kind / Kind / Kind / Kinder / Kinder / Kinder / KLASSE / Klasse / Klasse / Klasse / klasse / KLEIDERKUR / KI
Krankenhaus / KREDIT / Kreisbahn / Kreisbahn / KREISWERKE / Kuchen / KULTUR / Kunden / Kunden / Kunden / Kunden / Kunden / Kunden / Kunden / KUNDEN / Kunden / Kundenfahrplan / Kundenfahrplan / KUNDENFAHRPLAN / Kundenfahrplan / Kundenservice / Kundin / Kundin
l'administration / l'arme / L'ARQUITECTE / l'engagement / l'intention / L'EST / L'ETE / L'étudiant / L'EXCEPTION / L'EXPLOITATION / L'EXTÉRIEUR / L'EXTÉRIEUR / l'objet / l'objet / L'OFFICIER / lab / L'ACE / LA CLASSE / Ladies / Ladies / Leichte / Leichter /
Leave / leaves / leaves / leaves / leaving / leaving / leiche / lecken / LEESBAAR / leemaar / LEFT / left / left / left / left / left / LEFT / Leg / legen / legen / legen / legen / législations / législatives / législatives / LEGUMES / leicht / Leichte / Leichter /
LHR LONDON / LIABILITY / liability / Liability / Liability / LI BETAALD / LICENSE / license / Lichtbericht / Lieferdatum / Lieferung / Liegeplatz / lies / LIEU / lift / LIFT / LIFT-F / LIGHT / LILI / Lille / Lille / LILLE / LILLE / LILLE / LILLE / limitation / LIMITATIONS / limitations / LIM
WOOL / LIVRAISON / L'OBJET / LOCAL / local / Local / LOCATION / LOCATION / location / location / Location/number / locaux / Loewe / Logement / Loi / Loi / loir / LONDON / LONDON / London / London / LONG / LONG / loops /
maanden / maanden / maanden / maanden / Maatschappij / Macau / MACHINE / MACHINE / MACHINE / MACHINE / MADAME / Made / Made / magasin / Maggio / Magistrat / mail / mail / mail / Main / Main / MAIN / Main Hbf / Main Hbf / Main HBF / mais / MAJOREE / MAJOREE / MAKE /
maritimes / MARK / Marka / MARK / MARK / MARK / MARK / Markierung / Markierung / Markierung / Markierung / Maroc / Maroc / Maroc / MARQUES / Martime / MASTER / Matte / materials / Mathildenplatz / Matrikel / matric / Matthiae / may / may / may / MEAL / MEAL / Meda / M
MERCI / MERCI / Merluza / MESSAGE / Message / Message / MESSUNG / met / met / MET / met / met / Meter / meter / MetroCard / MetroCard / MÉTROPOLE / Metropolitan / Metternich / mia / MIAMI / MICH / Middle / midi / Mietservice / Milde / Milieu / MILL / Min / Min / Min / Min /
Mischfroot / mit / MIT / MIT / MIT / mit / mit / mit mit / mitbringen / mitgenommen / mitgenommen / Mitglieder / mitnehmen / mitnehmen / Mitte / Mitteilung / mitteln / MIX / Mixed / my / MMR / Mobidienst / MBX / Mixed / mp / MMR / Mobile / MOBILE / MOCKBA / MODE / Mode / MODE / MODERNE / Moderne / M
months / months / Monuments / Monuments historiques / MOORE / more / MORO / MORT / MOTIVERING / Mount / Mount / MOUSQUETAIRES / mouths / Mr / Mrs / MRS / MRS / MRS / MRS / MRS / MRS / MRS / MRS / Müllverbrennungsanlagen / MÜNCHEN / München / Münchner
MwSt / MwSt / MÜSt / MwSt / MwSt / N / N013959 / n'avez / n'est / n'est / n'est / n'est / n'est / n'est / N°/Class / N° 9002500F / N° bis / Naam / Naam/voorletters / naar / naar / nach / nach / nach / nach / nach / nach / NACH / nach / nach / nach / nach / NACH
Name / NAME / NAME / Name / Name / NAME / NAME / Name / Name / Name / Name / Name/initial / NAME / NameBOARDING / name/initial / NAME OF PASSENGER / NAME CLIVIER / Name Signature / Nebsli / NARBONNE / NATIONAL / NATIONAL / NATIONA
NATIONALE / NATURE / NATURE / NATURELLE / Naturjogurt / nautique / NAVIGATION / NAVIGATION / Nazionalità / nebenstehenden / Nederlandse / needs / need to / NESKE/NKAHI / NESKE/CHARLOTTE / NESKE/JOHANN / Net / net / net / Net / Net / NET'S / N
night / night / NIGHT 6500 / nit / No / No / No/Class / No/Class / No/Class / No 0725135 / noch / nochmal / nochmal / nochmal / nochmal / nochmal / nog / nog / nog / nog nom / Nom / NOM / Nom / NOM / nom / nombre / Nombre / Nome / nom / N
nose / NOT / NOT / NOT / not / not / not / NOT / not / not / not / not / not / not / not / Notausgang / NOTAUSSTIEG / NOTIE / NOT TRANSFERABLE / NOTA / Note / NOTE / NOTE / noter / noter / NOTGOOD / Nothing but clothes / NOTICE / Notice / N
NUMBER / number / Number / number / Number / Number / NUMBER / numbers / numbers / Numero / Numero / Numeros / Numéros / Numéros / Nummer / Nummer / Nummer / nur / nur / Nur / nur / nur / Nur / Nur / nur / nur / nuts / OASIS / Obsthof / obensteher
Öffnungszeiten / Öffnungszeiten / Öffnungszeiten / one / ohne / Ohne / Ohne / ohne / Ohne / Ohne / Ohne / Ohne / OIL / OLI / OLI / OLI / Olivia / TARTARE / ON BEHALF / onder / one / ONE /
OPERA / Opera / OPERAS / OPERATED / operated / operated / operated / Opération / operator / Openpassage / opgeled / Opmerkingen / ORANGE / Orange / Orchid / ordenances / ORDER / orders / ORDERS / Orders / Ordinance / Ordinance / Ordnungsamt / Ordnungs
our OUR / OUT / out / OUT / out / out / OUT / outside / OUVERT / Ouvert / OUVERT / Over / Over / over / over / over / over / OVER / Overall / Overcoats / overleaf / overleaf / OVERSEA / OVERSEA / own / own / own / owned / owned / P2 / Pack / Packing / Paella / PAGE / PAID /
PARCOURUS / PARCOURUS / PARE / PARE / PARE / PARE / pare / pare / Parf / parfait / PARIS / Paris / PARIS / PARIS / PARIS / PARK / park / Park / Park / PARK / Park arena / Park B1 / Parkbeles / Parkdauer / Parkdauer / parkeerapparatuur / parkeerkaart / parkeerkaart / PAR
Parkschein / PARKSCHEIN / Parkticket / Parkticket / Parkticket / Parkticket / Parkticket / Parkticket / ParkUhrzeit / PARKZEIT / PARKZEIT / PARKZEIT / PARKZEIT / PARKZEIT / PARKZEIT / PARTICIPANTS / participant Nom / PARTICIPANT NOM / Participantes /
PASSAGE / PASSAGE / Passage / PASSAGE / PASSBOARDING / passenger / passenger / passenger / passenger / PASSENGER / PASSENGER / PASSENGER / PASSENGER / PASSENGER / PASSENGER / PASSENGER / PASSENGER / PASSENGER / PASSENGER / PASSA
Pause / Pause / PAVILLON / PAYABLE / PAYE / PAYE / PAYE / PAYE / Payez / Payment / PAYMENT / PAYMENT / PAYMENT / PAYMENT MODE / payments / Pays / PEAGE / PEAGE / PEAGE / Peak / PEAK / PEAK / PEAK / Peanut / Peanut / Pecan / pendant / pendant / per / per / p
sonnel / personnes / Persons / PERSONS / PERTHUE / Peso / PETERSBURG / Petit / Petit / Pfefferminztee / Philippine / PHOENIX / Phone / Phone / Phone / Phone / Phone / Phone / photo / PHOTO / PIACE / Piccadilly / Pick / PICK / PIE / Piece / Pier / Pier / Pilz / PIN / pin / Pineapple / Plaa
Plätze / Plätze / Platznummern Numeros / Platzkarteninhaber / Platznummern / Platznummern / Playa / please / Please / Please / PLEASE / Please / PLEASE / Please / Please / Please / Please / Please / Please / Please / Please / Please / PLEASE / Please / Please / PLEASUR
PORQUEROLLES / PORQUEROLLES / PORT / port / Port / PORT / PORT / PORT / Porte / porte / PORTE/GATE / porteur / PORTUGUES / POS / POS / POS / POS / POS / POS / POS / POS / possession / possession / possession / Post / Post / POSTCODE / POSTE / Postes / P
pour personne / pouvez / PRAG / Prag / PRAGUE From / Praha / Praha / Prahy / PRE / Pre / Prec / Precio / PRECIO / PRECIO / Precios / Precios / Preço / preço / Preis / Presa documenta / Predo / préférable / PREIS / Preis / Preis / Preis / Preis /
sented toute / PRESQUE / PRESS / PRESS / Press / PRESSE / Pressing / Pressing / Pressing / PREUSSISCHE / previsto / PRICE / Price / Price / Price / Price / Price / Price / Price / Price / Price / Price / PRICE CUSTOMER / Price Date / PRI
PROCEDURE / products / products / Produkte / Programminderungen / Programminderungen / PROLONGE / PROMOTION / PROMOTIONS / PROOF / property / property / PRORITAIRE / protected / protected / protected / Protection / PROTOKOLL / PROTOKOLL / provide / provide / PROVIN
QIAN / QU'AUX / qu'il / Quai / quante / qualité / Quality / Quality / Quan / Quantità / Quantità / quantity / quarters / que / que / que / que / QUE / que / quel / QUI / QUICKLY / quite / Quittung / Quittung / Quittung / Quittung / QUITTUNG / R / R / Rabatt / ROBIN
LE / read within / Real / REAL / REALISMUS / REAR / recall / recargo / RECEIPT / RECEIPT / receipt / RECEIPT / receipt RECEIPT / Receiver's / Receiver's / receipt Receptionist / Reception / Rechnung / Rechnungen / Rechnungsnum
do / Reductie / Reductie / REDUTI / REEDEREI / RÉEXPEDITION / réexpédition / REF / REF / ref / REF / reference / REFERENCE / REFERENCE / REFERENTIE / refill / REFUNDABLE / REFUNDABLE / REFUNDABLE / REFUNDABLE / REFUNDABLE / refundable / refuse / refuse / Reg / Reg /
Reisegepäck / Reisegepäck / REISEN / REISEN / Reisenden / Reisenden / Reisenden / Reisepass / REISEVERANSTALTER / REISEVERANSTALTER / REISEVERANSTALTER / reißen / reißen / rekening / Reklamation / RELAIS / RELEASE / Relevé / RELEVEE VOTRE / Remark / REMARKS / REMARKS /
réquisition / réquisition / resale / resale / resale / Reserv / reserva / RESERVATION / RESERVE / RESERVE / réservé / réservé / reserved / reserved / reserved / reserves / reserves / réserves / reservert / reservert/Nous / reserv
return / returnable / returnable / returned / Rev / reverse / REVERSE / reverse / RHIN / RHONE / RHONE / rechnem / ride / RIEM / Riem / Right / Right / right / right / right / RIO / RIO DE JANEIRO / rinforzement / RISE / Rita / River / River / RIV
ROYAL / ROYAL / ROYAL / Royal / Royaume / Royaume / Royaume / Rückerstattung / Rückfahrt / Rückfahrt / Rückfahrt / Rückfahrt/Retour / RückfahrtMonat / Rücknahme / Rückseite / Rückstände / R
SALADETTES / SALDO / Sale / SALE / SALE / PAYMENT / Salon / SALON / Salon / same / SAMSTAG / SAN / SAN / SAN / Sanctuary / Sand / SANGATTE / SANS / sans / sans / SANS / sans / SANTOS / SANTOS LOPES / satisfy / SATZ / Saudi / Saudi Arabia / sauf / savez / SF
SCHWACH / Schweizer / SCIENCES / Scientifique / Screens / SEA / Sea / Seat / Seat / Seat / Seat / Seat / SEAT / SEAT / SEAT / SEAT / SEAT / Seat / Seat / SEAT / Seat/Siège / Seattle / Seating / SEBASTOPOL / sec / Sec / Sec / Seconda Validité / secou
SEMAINE / SEMAINE / SEMAINE / SEMANA / SEMESTERBESCHEINIGUNG / SEMPRE / SENCKENBERG / SENLIS / SENLIS / Señoras / SEPT / SEPT / September / September / sera / sera / ser
Service / Services / Service / Services / servicio / SET / setting / seul / seule / seule / seule / seule / SEULEMENT / Seven / SEVILLA / Shampoo / SHANGHAI / Sherif / Sherry / Ship / Shipping / Shipping / Shirt / Shirt / Shirts /
side / side / SIDE / side / SIDE / side / SIDE / SIDE / Sie / Sie / Sie / Sie / Sie / Sie / Sie / Sie / Sie / Sie / SIE / SIE / SIEGE / SIEGE / siehe / siehe / SIEHE / SIEHE / SIEHE / sign / SIGN / sign / sign / sign / sign / sign / signaler / signant /
sind / sind / SINGAPORE / SINGAPORE / Singapore / Singapore / SINGAPORE / SIRENE / SIROP / SITE / Site / Sites / Sitte / sitz / Sitzplätze / Sitzplatz / Sitzplätze / six / six / size / size / SIZE / size / Skirt / Skirts / Skirts / SMOKE / SMOKING / snails /
Sol / Sol / SOLD / SOLD / sold / Sold AUTOROUTE / SOLFERINO / Solferino / Solitude / SOLO / Sommer / Sonder / Sonderausstellung / Sonderschrift / Sonneneinstrahlung / Sonntag / Sonntag / Sonstiges / sont / sont / sont / sorgfältig / SORTIE /
SPECIALES / spéciales / Spécialistes / SPECTAUX / specified / spectacle / SPEISEEIS / SPICY GIRAFFE / SPIEL / SPIEL / SPIELBANK / Spielrunde / Spielrunde / Spielstätte / Spoorwegen / Spoorwegen / Sportanlagen / Sportanlagen / Spring / Sprite / Staatsgalerie / Staa
Standort / Start / Start / start / START / STARTPUNKT / STARTS / STATE / STATED / STATED / STATES / States / STATION / STATION / station / STATION / station / Station / station / STATIONNEMENT / STATIONNEMENT / STATIONNEMENT / STATIONNEMENT / STATUS J
Stoff / Stoff / Stoffen / STORA / STORE / STORE / STORE / STORE / storiques / Störungsdienst / Str / str / Straat / Straßenverkehr / Straftat / STRASBOURG / Strasbourg / Strasbourg / Straße / Straße / Straße / Straße / Straße / Straße / Straße / Str
Stud / Student / STUDENT / Studenten / Studenten / STUDENTENWERK / students / Stühle / Stunden / Stunden / Stur / StuU / StuU / style / Suave / SUB / subject / SUBJECT / subject / subject / subject / subject / subject applicable / subséqu
supervisor / Suppe/Dessert / SUPPLEMENT / supplement / supported / SUPREME / SUR / SUR / sur / sur / surcharge / surcharge / surcharges / surf / surf / Surf / Sur/dem / surrounded / SUSSIGKEIT / Sweatshirt / Sweater / Sweater / Sweatshirt / swiss / sym
tarifefuäzzig / TARIF / TARIF / TARIF / TARIF / TARIF / TARIFA / Tarifa / Tarifbestimmungen / Tarifbestimmungen / Tarifen / Tarifen / Tarifen / TARIFES / TARIFES / TARIFSTUFEN / TARIFVERBUND / TARIFVERBUND / Tarifzonen / Tarifzonen
teilen / Teilnehmerausweis / Teilnehmerausweis / TEILNEHMERIN-KARTENNAME / Teilnehmermerkarte / Teilnehmerkarte / Teilzonen / Tel / Tel / Tel / Tel / Tel / TEL / Tel / Tel / Tel / TEL / Tel / Tel / Tel / Tél / Tél / TEL / Tel&Fax / TELECARTE / TELECOMMUNICATIONS /
TEMPLE / TEMPORAIRE / temporary / temporary / TEMPS / ten / Termin / TERMINAL / TERMINAL / TERMINAL / TERMS / TERMS / terms / terms / terms / textes / Textil / textiles / THAI / THAI / THAILAND / Thailand / Thailand / THAN / THAN / Than / THREE / THROUGHOUT / THROUGHOUT
THEATER / THEATERSAAL / THEATRE / THEATRE / them / The Flyer / there / There / THERE IN / Thermo / Thermopapier / these / these / these / The Tussauds / thin / THIS / This / This / This / this / this / this / this / TIME / time / Time / time / TIME / time / times / timetable / TIPPING / TISCH / Titel / Titel/Re
TOUR / TOUR / TOUR / tour / tour / TOURISM / TOURIST / TOURS / tous / tout / Toute / toute / Toute / Toute / toute / toute / toute / Towel / Town / TRACE / Trace / Trace / Trabe / TRAITE AGENT / Trajet / Trajet / TRAMWAYS / trans / Trans / Trans / Transaction /
transporteurs / Trattoria / TRAVEL / TRAVEL / Travel / Travel / Travel / traveler / Travelers / Travelers / Travelers / traveling / traveling / TRAVELLING / TRE / tre / TRE / TREASURE / TREASURE / TREND / Tres / TRESOR / TRI / tri / Triangolo / Triangolo / Tribunal / TRIBUNA
twaalf / twaalf / twaalf / Twe / twenty / Typ / typ / TYPE / Type / Type / über / Über / über / Über / über / über / über / Übergangstarif / Überseebrücke / übertragbar / übertragbar / übertragbar / Übertragbar / UdSS / UdSSR / UHR / Uhr / Uhr / Uhr / Uhr / Uhr / Uhr
Und / und / und / UND / und / UND / und / und / und / under / under / under / under / Under £ 003 / under £300 / Underground / Underground / Undergrounds / Underpants / understand / understand / Underyears / une / une / une / u
une / une / UNS / uns / unser / unseren / unser / unter / unter / unter / unter / unter / unter / unter / unter / unterbrechen / Unterbrechung / unterschrieben / Unterschrift / Unterschrift / unterzei
behörde / Vervielfältigung / Verlangen / Verlangen / Verlangen / Vermarktungsgeld / Vermarktungsgeld / Vermieten / vermieten / verreisen / verreisen / Verlust / Verlust / verte / verzichten / verzichten / Via / Via / Via / via / VIA / VIA / VIA / VIA / via / VIA / VIA / Víctor / Víctor / Viché
VISITE / VISITE / visite / VISITE / visite / VISITE / VISITORS / visitors / visitors / VITTELOISE / VO / VOID / VOIES / VOIGT-EGGERT/EVELIN / Voir / voire / voire / voiture / vol / vol / vol / VOL / Vol / VOLET CONSERVER / Volnummer / Volksbühne / VOLLMILCH / VOLLMILCH / Vo
Vorname / Vornamen / Vorsetzen / Vorsprachen / Vorstellungende / Vorstellung / Vorstellung / Vorstellung / Vorstellungsänderungen / Vorstellungen / Vorsteuerabzugsverbot / Vorverkaufsgebühr / vorzeigen / vorzeigen / vorzeigen / vor zug
Wagen / WÄHRUNG / Währung / Währung / Währung / Währung des Ausgabelandes / Wait / Waiter / WAITER / Ware / WARM / Wärme / Wärme / Wärme / WARNING / WARNING / Warsaw / Warsaw / warten / WARTEN / WASCHE / Wash / waschbar / Wassereid / Wasserdä
werden / werden / werden / werden / werden / werden / werden / wesentlich / West / WEST / WESTFALEN / Wharf / wich / WISH / Wisma / Wissenschaftsstadt / with / with / WITH / WITH / WITH / WITH / WITH / with / with / WITH / with / with / WITHDRAW / within / within / within /
Wir / wird / wird / wird / wird / wird / wird Wirtschaft / wish / wish / WISH / Wisma / Wissenschaftsstadt / with / with / WITH / WITH / WITH / WITH / WITH / with / with / WITH / with / with / WITHDRAW / within / within / within /
years / years / years / Yen / YEN / YES / YES / YES / YES / YES / yes / YOGURT / Yogyakarta / YOGYAKARTA / YOGYAKARTA / YORCK / Yorck / York / York / YOU / you / you / you / you / YOU / you / YOU / you / You'll / YOU HAPPY / Young / YOUR / your
Zahlungsvordrucke! / ZAHLUNGSVORDRUCKE! / ZAKJE / Zapfstelle / zeichnen / Zeit / Zeit / Zeit / Zeit / Zeit / ZEIT / Zeit / Zeit / Zeit / Zeit / ZEITANGABE / Zeitkarten / Zeitkarten / Zeitkarten / Zeitpunkt / ZEITUNG / ZEITUNG / Zentrale / Zentrale / zentrale /
Zubringerdienst / Zubringerdienst / Zucchini kg / Zucker / Zucker / ZUG / Zug / Züge / Züge / zugleich / zum / Zum / Zum / zum / ZUM / ZUM / zum / zur / zur / zur / Zur / Zur / Zur / zur

ADDITIONAL / additional / Address / ADDRESS / Address/Hotel / Address/Hotel / adds / adds / ADM / ADMISSION / admission / admission / ADRESS / Adresse / ADS / Adult / Adult / Adult / Adult / ADULT / ADULT / ADULT / ADULTE /
AGENT / AGENTS / AGENTS / AGENTS / Agents / Agents / agree / agree / agree / agree / AGREEMENT / Agreement / Agreement / Agreement / Agreement / AGT / Agua mineral / A HEURES / AHORROS / aimable / ainsi / AIR / AIR / Air /
Ball / BALLETT / BALLETT / BALLETT / BALLETTABEND / BALLETT TAT / Ballroom / BANANEN / Banc / bancaire / BANCAIRE / Bancs / Band / Band / Band / Band / BANGKOK / Bank / Bank / Bank / Bank / Bank / BANK / BANK /
BOARDING / Boarding / BOARDING / Boarding / BOARDING / boarding / Boarding / Boarding / Boarding / Boarding / Boarding / BOARDING / BOARDING / Boarding / Boarding Boardingpass / BOARDING / Boarding /
BUS / bus / bus / bus / bus / BUSE / Buses / buses / Buses London / BUSINESS / BUSINESS / Business PLEASURE / but / BUTTER / BUTTERFLY / Buy / Buy / BUYER / BUG Potsdamer / by paying / by paying / c / CAAC / CAAC / CABIN / Cabin / Cacao /
CHANGE / Change / changeable / CHANGE / Change / chaque / chaque / CHARCUTERIE / CHARGE / charge / CHARGE / CHANGE / CHARGE / CHARGE / Charge / Charge/Tips /
COIN / COINS / COINS / COINS / Coke / CONF / esl / eul / Cola / Cola / Cola / coli / coli / Coli / colis / Collect / collect / collect / collection / COLLÈGE / collezionato / COLOGNE / COLOGNE / Cologne / Colonia / COLOR / color / Colors /
CURRENCY / currency / currency / currency / currency / currency / currency / currency / Curtain / Customer / CUSTOMER / Customer / Customer / Customer / CUSTOMER / CUSTOMER / Customer's / CUSTOMS / CUSTOMS / Customs / Customs /
DELIVERY / DELIVERY / délivre / DELTA / DELTA / DELTA / dem / dem / dem / DEM / dem / Demand / demand / demand / demand fare must be paid / DENISE / DEMISSION / DEMISSION / den / den / den / den / den / Den / Den /
DES / DES / des / des / des / DESCRIBED / described / DESCRIPTION / Description / DESCRIPTION / Description / descuenta / deshalb / Design / DESIGNATOR / Desk / dessus / dessus / DEST / DEST / DESTINATAIRE / DESTINATI / Destination / DESTINA-
DOWN / DOWN / DOWN / DOWN! / Dress / Dress / Dresses / Dresstido / dringend / drink / DRINKS COFFEE / driver / DRIVERS / droit / Droit / DROIT / droits / Droits / drol / Druck / Druck / Druckspuier / Dry / DRY / Dry / dry / dry / du / Duane / Duane /
ENVALEUR / envelope / envia / EQUIVALENT / equivalent / er / erfahren / erfahren / erfolgt / Ergänzen / ergänzen / ergänzen / Ergänzungskarte / erhalten / erhalten / erkennen / erklärt / erlaubt / erlisch / Ermäßigung / Ersatz / Ersatz / erst /
FREE / Free / FREE / frei / FREIE / Freien / Freien / freien / FREIES / freigeben / FREIKARTE / Freitag / Frères /
GATE / Gate / Gate / GATE / GATE / GATE / Gate / GATE / gate / gate / gate / gate / GATES / gauche / gauche / GAÜDI / GAUDI / GAZFUSE / geb / geben / gebeten / Gebiedscode / Geboortedatum / geboren / Gebühren / Gebührenordnung / Geburtstag / Geburtstag /
HOME / home / home / home / Home / home / homefather / HONOLULU / HONOURED / hope / Hora / Hora / Hora / Hora / horaire / horaire / horaire / HORAIRE / horaire / Horas / Horas ENFANT / horn / hört 4 PRAHA /
INTERNATIONAL / INTERNATIONAL / INTERNATIONAL / INTERNATIONAL / INTERNATIONAL / international / International / international / Internationale / internet / Intimacy / into / into /
KUNSTHALLE / KUNSTHALLE / Künstlerhaus / Kurbetriebe / KURHAUS / KURS / KURS / KURSWERT / Kurzstrecke / Kurzstrecke / KURZTEXT / Kürzungen 2004 / KWANGCHOW/HONG / KWANGCHOW/HONG / KYOTO / KYOTO / L'ACHAT / l'Action / l'Action /
MALE / MALER / MALT à / malta / MALTI / Malventee / MAMMA / MAMMOUTH / MAMMOUTH / management / Management / Mandarin / MANHATTAN / MANICURE / Manipulationen / Mantel / Mantel / many / MARQ / MARCQ / MARIN / MARINE / marine / maritimes / maritimes /
NATIONAL / national / national / National / Nationale / Nationale / Nationale / Nationale / NATIONALE / NATIONALE / Nationality / Nationality / NATIONALS Passport / NATIONALS /
OUVERTURE / ouvre / oval / oval / OVATE / over / owner / OWNER / OWNER / P / P / Pa / pa / PAID / paid / PAIEMENT / paiement / PAIEMENT / paiement / PAIEMENTS UUES / parkeerkaartje / Palace / Palma / PALMAS / PALMENGARTEN / PALMENGARTEN / pantallas / PANTALON / Pantalones /
PLACE / Place / PLACE / Place / placement / PLACER / PLACER / Placero / places / places / places / Placez / Plage / Plan / plancha / plancha / plano / plants / plants / Plate / PLATEAU / PLATZ / Platz / Platz / platz / platz / PLATZ / PLATS / PI œTZ / PLATZ /
ROAD / Road / ROB / Roch / romea / Röntgen / ROOM / ROOM / Room / Room / Room / ROOM / Room / ROOM / ROOM / Room / ROOM / ROOM / ROOM / room / room / room / ROOM / ROOM / Room No / ROSARIO / Rosenmontagszug / rot / Rote / Route / route / Route / ROUTE / Row /
SHOP / shop / shop / SHOPPERS / Shopping / SHOPPING / shopping / SHOT / should / should / should / Should / Show / Show / show / Show / Show / show / show / shown / sich / SICH / SICH / sich / Sicherheit / Sicherheitsgebühren / Sicherheitskontrolle / Sicherheitskontrolle / städtl.-/
THANK / THANK / Thank / THANK YOU / that / THE / THE / THE / THE / THE / THE / THE / THE / THE / THE / the / the / the / the / the / the / the / THEATER / Theater / Theater / THEATER /
TRANSACTION / TRANSACTION / transactions / TRANSACTIONS / TRANSFERABLE / TRANSFERABLE / Trans No / Transport / TRANSPORT / transport / TRANSPORT / TRANSPORT / Transport / Transportation / transport / transport / transport / transporteur / transporteurs /
VALID / valid / VALID / Validité / Validité / VALID UNTIL TIME INDICATED / Valor / Valor / Valor / valuables / Valuta / van / VAN / van / VANCOUVER / van dien / Vaterland / Vaubäan / Vegas / VEGAS /
VOTRE / VOTRE / votre / VOTRE / votre / votre / VOUCHER / VOUCHER / voucher / voyage / voyage / voyage präsenter / WARDKI / WÄHREND / WÄHREND / wann / wenn / wenn /
WITHOUT / WITHOUT / without / without / without / WITHOUT / without / without / Wool / worden / worden / WRITE / Write / written / wünschen / wurden / wurden / wurden / x / X / XX Erwachsenen / XX Kinder / X-CLASS / XXS / y / yean / yean / YEAR / year / years /
zusammen / zusammenwirkenden / zusammenwirkenden / zusammenwirkenden / zusätzlicher / Zuschlag / ZUSCHLAG / Zuschlag / Zuschlag / Zuschuss / zuständig / zuständigen / Zutreffendes / Zutritt / zu unterst / Zuwiderhandlung / zwangsweise /

Vincent van Baar
1958 / is a design director at Studio Dumbar in Rotterdam, the Netherlands. His work covers a range of projects, from 2- and 3D identity programmes to the leading Dutch design magazine *Items*. He teaches at the Design Academy in Eindhoven. If The Hague, where he lives with his wife and four children, is a notoriously boring city of diplomats and ambassadors, Vincent feels very much at home there in that he can best be described as a diplomat himself, always busy bringing designers together for lectures and drinks at his favourite place, Theater Zeebelt. He collects anything printed during the industrial era, and loves 'type with character'.

Tanja Backe
1968 / studied graphic design in Lille, France and at the HfG Offenbach, Germany. She joined Studio Dumbar in The Hague, the Netherlands, in 1997. Founded and led Studio Dumbar in Frankfurt for three years until the birth of her daughter Mara. In 2002 she founded the design studio backe design, with a special focus on exhibition and corporate design. Since childhood she has collected all kinds of typography, and sand from all over the world. She lives with her husband and three children in Frankfurt, Germany.

Daniel Gross
1973 / studied graphic design in Offenbach, Germany and then typography in Arnhem, the Netherlands. Founded the design studio Catalogtree with Joris Maltha, with whom he shares a deep and sincere fascination with large collections of all kinds, especially numbers. Their main interest is bringing to light the information that lies dormant beneath the surface that Microsoft Excel is not able to show. Both teach interactive design at the Arnhem Academy of Visual Arts. It may also be worth noting here that the first 397 images found by Google Image Search for the search term 'catalogtree' are from their own website, followed by an image from Tom Mansfield's Nursery in 398th place.

Very special thanks to all my friends for their contributions to and support for this project:

Olivia Alig, Jana Augustinova, Vincent van Baar, Karin and Yorck Backe, Annika Balser, Claudia Biner, Manuel Cuyàs, Matthias Dietz, Christel and Hans-Peter Eckart, Peter Eckart**, Olivia, Mara and Milan Eckart, Anselm Eggert, Carmen Galán, Viola Georgi, Marius Gothe, Daniel Gross, Markus Heide, Lina Herold, Bernd Hilpert, Peter Hoepermans, Klara Kletzka, Caroline Leu, Ilka Listmann, Cristina Lladó, Rob Man, Alexandra Meixner, Emilie Müller, Isabel Naegele, Maja, Christian, Charlotte and Johann Neske, Martin Pesch, Holger Petersen, Gabi Pfrüner, Ramon Prat, Bernhard Prümper, Kerstin Ruppert, Matthias and Johnny Schinke, Cosima Schneider**, Andreas and Benjamin Spamer, Christel Stratschka, Olivier Tartare, Louis and Gaspard Tartare, Anna Tetas, Graham Thomson, Cilia and Hendrik Tovar, Dorothée Véron-Tartare, Evelin Voigt-Eggert, Sabine Weinheimer, Markus Weisbeck, Annette, Lea and Hannah Wippermann.

** special thanks!

Published by
Actar

Book concept and collection
Tanja Backe

Texts
Vincent van Baar
Tanja Backe
Daniel Gross

Pages 2 and 3 photograph
Tanja Backe

Layout
Tanja Backe and Manuel Cuyàs

Digital reproduction
Carmen Galán

Production
Actar Pro

ISBN 978-84-96540-16-3
DL B-8887-2007

Printed and bound in the EU

Distribution
Actar D
Roca i Batlle 2 i 4
08023 Barcelona, Spain
T + 34 93 417 49 93
F + 34 93 418 67 07
office@actar-d.com
www.actar-d.com